# GIOVANNI BELLINI

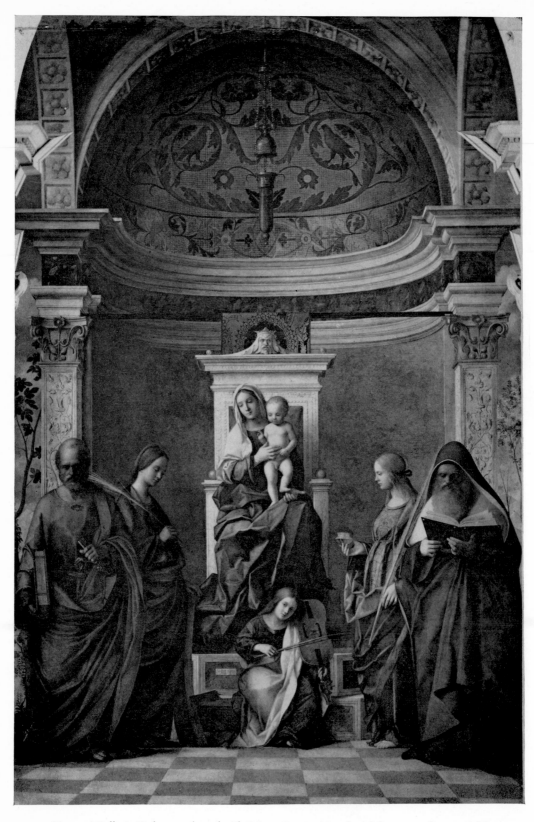

Giovanni Bellini, *Madonna enthroned with Saints.* Canvas (transferred from wood), 500×235. Signed IOANNES/BELLINVS/MCCCCCV. Venice, Chiesa di S. Zaccaria

# GIOVANNI BELLINI

GILES ROBERTSON

OXFORD
AT THE CLARENDON PRESS
1968

*Oxford University Press, Ely House, London W. 1*

GLASGOW NEW YORK TORONTO MELBOURNE WELLINGTON
CAPE TOWN SALISBURY IBADAN NAIROBI LUSAKA ADDIS ABABA
BOMBAY CALCUTTA MADRAS KARACHI LAHORE DACCA
KUALA LUMPUR HONG KONG TOKYO

PRINTED IN GREAT BRITAIN
AT THE UNIVERSITY PRESS, OXFORD
BY VIVIAN RIDLER
PRINTER TO THE UNIVERSITY

IN MEMORIAM

P. C. R.   D. S. R.

L. M. C. J.

# Preface

IT has not been my intention in writing this book to survey the whole of the surviving material that issued from Giovanni Bellini's studio during an activity extending over more than sixty years, or even the whole of that part of it in the production of which we may suppose him to have had a major personal share. I have sought rather, by considering an extensive selection of works, generally autograph but in a few exceptional cases of mainly studio execution, to illustrate his significance as an artist and to trace the development of his art. In such a selective process there lies the danger of suppressing evidence which does not accord with the writer's preconceived views. I have tried to avoid this but the reader must judge how far I have been successful. To have attempted a complete survey would have encumbered the discussion with much material of only secondary significance.

I think that it is possible in few if any of the matters under discussion to reach finality and I am sure that many of my conclusions will be invalidated by the progress of further research. I have not hesitated to advance, I hope with due caution, a number of speculative ideas in the hope that even if only by arousing disagreement they may serve in the end to provide fresh illumination.

Except in a few cases of works only once referred to, books and articles are cited in the footnotes only by the name of the author and the date of the work; full titles and other details of publication may be found by reference to the Bibliography at the end of the book. Dimensions and materials of the works illustrated are given under the plates.

In the production of such a work as this one incurs obligations too wide and numerous for a complete catalogue; some particular obligations are acknowledged in the footnotes. I would like particularly to mention here the help I have received

over many years in considering Bellinesque problems from Professor Johannes Wilde and Professor Ellis Waterhouse. The first draft of the book was completed during a year at the Institute for Advanced Study at Princeton, N.J. and I must express my deep thanks to the Faculty of the Institute for electing me to a membership. Without the opportunities for uninterrupted work offered by the Institute and the unrivalled resources of the Marquand and Firestone Libraries of Princeton University, of which members of the Institute are generously made free, this would have been a very different book. My special thanks are particularly due to Professor Millard Meiss of the Institute for all sorts of help, advice, and encouragement. My Colleague Mr. Roger Tarr has kindly read the whole text in proof and has made many valuable suggestions.

An increased scale of illustration has been made possible by a generous grant from the Carnegie Trust for the Universities of Scotland.

<div align="right">GILES ROBERTSON</div>

*Department of Fine Art*
*University of Edinburgh*

# *Acknowledgements*

PERMISSION to reproduce photographs is gratefully acknowledged as follows:

By gracious permission of Her Majesty the Queen, XXIII *a*, XCI.

By courtesy of Georges Groc, Albi, XXXVI. Pinacoteca Provinciale, Bari, LXIX *b*. Staatliche Museen Berlin, Gemäldegalerie, XLII *a*, LV, LX *b*, XCIV *b*; Kupferstichkabinett, Berlin, LII *b*, XC *a*. Barber Institute of Fine Arts, Birmingham, II *a*, LXXXVI *b*. City of Birmingham Museum and Art Gallery, XCIX *a*. Isabella Stewart Gardner Museum, Boston, Mass. XLIII *b*. Institute of Arts, Detroit, CVI *b*. Soprintendenza alle Gallerie, Florence, LIV *b*. Art Gallery and Museum, Glasgow, LXXVIII *a*. British Museum, London, VII *a–b*, IX *a*, XI *a*, XVI *a*, XXIII *bc*, XXXII *a*, XXXIV *b*, LXXXI *b*, CXI *b*, CXVII *a*. Courtauld Institute, London, CXI *a*. Courtauld Institute and the Trustees of the Chatsworth Settlement, VIII *a*. National Gallery, London, XV, XVI *c*, XVII, XXXVII *b*, XLII *b*, LXIV *b*, LXXV *a–b*, LXXXII *a*, LXXXIX, CII, CIII, CX, CXII *b*, CXIX *a*. National Gallery, London, and Wittelsbacher Ausgleichs-fonds, Munich, XXX, XXXI *a–b*. Mansell Collection, London, Frontispiece, XIV *a–b*, XXV, XL *a*, XLVII *a*, LIX *a*, LXI, LXV, LXVIII, LXX, LXXI, LXXIII, LXXIV, LXXVII, LXXXI *a*, LXXXII *b*, LXXXIII, LXXXVIII *b*, XCIII, XCVI, C, CV, CVI *a*, CVII, CVIII *a*, CXVII *b*. Royal Academy of Arts, London, and the respective owners, X *a*, LIV *a*, XC *b*. Count Antoine Seilern, London, VIII *b*, LII *a*. Museo d'Arte Antica, Milan, XX *b*. G. M. Gathorne-Hardy Esq., Newbury, V *a*. Frick Collection, New York, LVII. Frick Art Reference Library, New York, and Mr. and Mrs. Charles Hickox, XCII. Mr. Robert Lehman, New York, XIX *a*. Metropolitan Museum, New York, XIX *b*, LXXIX *b*, CI *a*. Ashmolean Museum, Oxford, XXXIII, XXXIV *a*. Bibliothèque nationale, Paris, II *b*, III *a–b*, IV *a*. J.-E. Bulloz, Paris, CXIX *b*. Photographie Giraudon, Paris, XIII *a*, John G. Johnson Collection, Philadelphia, XX *a*. Nationalmuseum, Stockholm, XCV *b*. Museum of Art, Toledo, Ohio, CXII *a*. Gallerie dell'Accademia, Venice, XXII *a*, XXXV *a*, XLV *a*, LXIII *b*, LXVI, LXXIX *a*, CIX, CXX. O. Böhm, Venice, XLIV *a–b*, XCVIII. Museo Civico Correr, Venice, I, XII, XIII *b*, XVIII *a*, XLIII *a*. Museo Correr and respective owners (photographs taken at the Venice Exhibition 1949), V *b*, VI *a–b*, IX *b*, X *b*, XI *b*, XVIII *b*, XXI *a–b*, XXII *b*, XXIV *a–b*, XXVI–XXIX, XXXII *b*, XXXV *b*, XXXVII *a*, XXXVIII, XL *b*, XLI, XLV *b*, XLVI, XLVII *b–c*, XLVIII–LI, LIII, LVI, LVIII *a*, LIX *b*, LX *a*, LXII, LXXII, LXXVI, LXXVIII *b*, LXXX, LXXXIV–LXXXV, LXXXVI *a*, LXXXVII *a*, XCIV *a*, XCV *a*, XCVII, XCIX *b*, CI *b*, CXIII, CXIV. Museo Civico di Castelvecchio, Verona, LXIV *a*. Kunsthistorisches Museum, Vienna, CXVIII. National Gallery of Art, Washington, IV *b*, LVIII *b*, LXIII *a*, LXXXVII *b*, LXXXVIII *a*, CVIII *b*, CXV, CXVI. Jugoslavenska Akademija Znanosti i Umjetnosti, Zagreb, LXIX *a* and *c*.

# Contents

# List of Plates

*Above all we want the only man who seems to me to have united the most intense feeling with all that is great in the artist as such—John Bellini.*

RUSKIN TO DEAN LIDDELL,
12 OCTOBER 1844

# I

*Introduction. The Renaissance in Venice.*
*Flemish influences in Venice.*
*The documented facts of Giovanni's life.*
*Giovanni and Venetian Humanism*

'Er jst ser alt vnd jst noch der pest jm gemoll'—'He is very old and is still the best in painting.' In writing this of Giovanni Bellini in February 1506[1] Albert Dürer probably had particularly in mind his great altar-piece, completed the year before for the church of S. Zaccaria (Frontispiece and Pl. xcviii), which Ruskin once pronounced to be one of the two best pictures in the world.[2] Before turning to trace systematically the development of Giovanni's art from its beginnings, as we shall attempt to do in later chapters, we may pause to consider this supreme achievement of his old age, for he was certainly not less than seventy and probably about seventy-five at the time of its execution. In a square loggia, bounded by four arches, of which the outer one is formed by the marble frame of the picture and the inner one is closed by a curved apse, its vault decorated with a mosaic of scroll-work on a gold ground, the Virgin is seated on a high marble throne, supporting on her left knee the Child who stands and blesses with his right hand. On the lowest step of the throne sits a young angel, playing on a *lira da braccio* supported on his left shoulder, seemingly absorbed in the harmony of his playing, a harmony which pervades the whole picture and which accentuates rather than disturbs its inner stillness and reminds one of the musical silence which Dante found in the sphere of Saturn.[3] To the Virgin's right stand St Catherine and St Peter, to her left St Lucy and St Jerome, while through the arches on each side we look out on to a narrow strip of landscape, showing plants, trees, distant mountains, and cloud-flecked sky. All is informed and unified

---

[1] See p. 13, n. 4 below.

[2] In the lecture *The Relations between Michelangelo and Tintoret*, the seventh in the course on sculpture delivered in Oxford, 1870–1 (Ruskin, J. 1903–12, xxii. 83–4). The other best picture was Giovanni's triptych in the Frari. Later, in *St Marks Rest*, 1884, he placed Carpaccio's *Two Courtezans* in the Correr in some respects above either (Ruskin, J. 1903–12, xxiv. 363–4).          [3] *Paradiso*, xxi. 58 ff.

by a soft envelope of light, which fuses the colours, red and pink, blue and grey, orange, brown, green, and gold into a single whole, yet letting them retain their individual identity and purity. Here we have neither the Roman severity of the *Madonna of the Victories*, painted ten years earlier by Giovanni's brother-in-law, Andrea Mantegna, nor the splendid rhetoric of Titian's *Pesaro Madonna* of some twenty years later, but a point of such perfect balance of form and content, of intention and expression, of drawing and colour, and of such penetrating harmony as goes far to justify Ruskin's claim.

This, like the greater part of Giovanni's surviving work, is a specifically religious picture and one never doubts the absolute sincerity nor the depth of his religious conviction; though we shall see that at the very end of his career he was able to broaden his outlook so as to infuse a specifically pagan subject-matter with a sense of the divine in nature and make the *Feast of the Gods* in Washington a complement to his earlier achievement and not a contradiction of it. The sense of the divine is here realized through the perfect synthesis of two complementary streams of development which characterize European painting in the fifteenth century: that of the mathematical reconstruction of three-dimensional space through the scientific study of linear perspective, which was centred on Florence, and that which was centred on the Low Countries and which rendered space in terms of absolutely just empirical observation of the circumambience of light. The former contributes to the divine quality of the picture by its stress on the eternal order and harmony of mathematical truth, the latter by its divine irradiation. To illustrate the nature of this synthesis by citing concrete examples, without raising at this point any consideration of actual historical connection, we might say that in this work Giovanni has fused the achievement of Masaccio in his *Trinity* fresco in S. Maria Novella in Florence with that of Jan van Eyck in his *Virgin of Canon van der Paele* in the Hospital of St John in Bruges. It is the glory of the Venetian school to have achieved such a synthesis and, by developing the flexibility of the Northern technique of oil-painting, to have transmitted the achievements of the fifteenth century on both sides of the Alps as a living tradition and not as a body of theoretical instructions or antique exemplars. This synthesis and broadening of technique were, to a great extent, the personal achievement of Giovanni Bellini.

Venice did not assume this synthesizing role until late. The explosion of Giotto's genius in nearby Padua scarcely affected her, and the leading painter of Venice active in the first half of the fourteenth century, Paolo Veneziano, shows in his work a combination of pronounced Byzantine and muted Gothic elements which

gives it a wholly medieval character. This is maintained in the work of his pupil Lorenzo, active in the third quarter of the century, though here it is the Gothic element which predominates, the Byzantine influence being in the main confined to the facial types. There is an essentially provincial character about Lorenzo's work which seems to have been implicitly recognized by his contemporaries when in 1365 they entrusted the decoration of the Sala del Maggior Consiglio in the Doge's Palace to the Paduan Guariento. This was the most important public commission of the period and he executed on the end wall the great *Paradise*[1] which was later, after being wrecked by the fire of 1577, to be covered by Tintoretto's canvas. Significantly the continuation of the decoration of this hall, with scenes from Venetian history, was entrusted in the early years of the new century to another artist from outside, Gentile da Fabriano, the chief Italian exponent of the International Gothic style, and carried further by his follower Pisanello of Verona. The replacement of these historical scenes in the last quarter of the century and beyond, by Gentile and Giovanni Bellini and their followers, with canvases which also perished in the fire of 1577, forms one of the most important and worst-documented chapters in the history of Venetian painting, to the detailed consideration of which we shall have to return. The International style of Gentile and Pisanello was followed by the leading Venetian painters of the first half of the century, Jacobello del Fiore and Michele Giambono.

Just as the great advances in Tuscan art which mark the fifteenth century began in sculpture, in the work of Ghiberti, Brunelleschi, Jacopo della Quercia, Nanni di Banco, and Donatello, so it was first through the work of sculptors that they were transmitted to Venice. Niccolò di Pietro Lamberti was in Venice as early as 1416, probably accompanied by his son, Pietro di Niccolò, and though not an advanced sculptor by Tuscan standards—one may indeed conjecture that for him the attraction of Venice lay precisely in the less strenuous and more conservative nature of its artistic atmosphere—he certainly brought something fresh with him. He was followed, after 1424, by Nanni di Bartolo, called Rosso, who had worked with Donatello on the group of the *Sacrifice of Isaac* on the Florentine campanile and who was probably mainly responsible for the splendid group of the *Judgement of Solomon* on the corner of the Doge's Palace by the Porta della Carta, executed between 1424 and 1438, which is the first work in Venice that really breathes the new spirit.[2]

---

[1] For the reconstruction of Guariento's fresco and an evaluation of its importance see Saxl's fascinating lecture *Petrarch in Venice* (Saxl, F. 1957, i. 139–49).

[2] For a review of the various attributions of this group and a rather more cautious judgement see Pope-Hennessy, John 1955, pp. 221–2.

Although Lorenzo Ghiberti is known to have been in Venice in 1424–5 we do not know of his having executed any work there, and if he had done anything important he would surely have recorded it in the autobiographical section of his *Commentaries*.

The first Florentine painter of the new generation whom we know to have come to Venice was Paolo Uccello, who worked as a master-mosaicist at St Mark's from 1425 to 1428. We know nothing effectively of his work there,[1] but at this stage of his development he was still primarily an exponent of the International Gothic; and one may guess that his debt, in the decorative character of his later work, to the Byzantine style of the mosaics among which he had worked in Venice, was greater than his contribution, at this stage at least, to the development of a more modern style in Venetian painting. If he did make any substantial contribution to the Venetian tradition it should be linked rather with a probable later visit in the 1440s.

Markedly Tuscan characteristics are found in the early work of Antonio Vivarini, whose first dated work is of 1440, but they do not seem to link up with any possible tradition established more than ten years earlier by Uccello, nor yet very plausibly with the work of Fra Filippo Lippi who is known to have been working in Padua in 1434. They have been connected with the style of Masolino who, it is thought, may have visited Venice either on his way to Hungary about 1427 or on his return journey, but this is very problematic.[2] In this connection we might also recall that Fra Angelico was paid for an *Annunciation* for the church of S. Alessandro at Brescia in 1432,[3] a church which still contains a painting of this subject ascribed to Jacopo Bellini of which the composition seems to derive from an Angelican model.

The decisive contacts between Tuscan and Venetian artists occurred in the 1440s. Andrea del Castagno visited Venice in 1442, as we know from his signature on the apse frescoes in the chapel of S. Tarasio at S. Zaccaria, and he may have been accompanied by Domenico Veneziano, already artistically a naturalized Florentine; while Donatello worked in Padua from 1443 to 1453. Castagno, in addition to the frescoes mentioned, provided in the cartoon for the mosaic of the *Dormition of the Virgin* in the Cappella dei Mascoli in St Mark's a splendid exemplar of the monumental style in architecture and figures, as it had been established in Florence by Brunelleschi and Masaccio in the third decade of the century.[4] In Padua Donatello, perhaps

[1] See Salmi, M. 1950, p. 22 and Muraro, M. 1956.

[2] See Pallucchini, R. (n.d.), p. 11, where he quotes Longhi for the view that Masolino's return from Hungary may have taken place as late as the quinquennium 1435–40.

[3] See Pope-Hennessy, John, 1952, p. 167.    [4] See Muraro, M. 1959 (1) and Hartt, F. 1959.

the leading genius of the Florentine Renaissance, not only provided a wealth of models in his work for the high altar of the Santo but, by his presence in the city for ten years, incalculably affected the development of its artistic life. He influenced the character of the rising school of painting associated with the disreputable *entrepreneur* Francesco Squarcione, whose personal abilities lay rather as a spotter and exploiter of talent in the young than as a creative artist,[1] and his example was vital in the artistic formation of the most brilliant of Squarcione's pupils, Andrea Mantegna, the first fully Renaissance artist of North Italy. Mantegna in turn contributed more than any other artist to the formation of the early style of his contemporary and brother-in-law, Giovanni Bellini.

So far we have dealt only with the influence of Tuscan artists who travelled to North Italy or sent their works there. Jacopo Bellini, the father of Gentile and Giovanni, presents us with the opposite case, that of a Venetian painter who probably spent some time during his formative years in Florence and imbibed something of Tuscan art at its source. We know that Jacopo was a pupil of Gentile da Fabriano, after whom he is said to have named his elder son.[2] We know too that a Venetian pupil of Gentile's, named Jacopo, was in trouble in Florence in 1423 for having assaulted the rowdy son of a local lawyer who had been throwing stones into the courtyard of Gentile's house, where valuable statues and pictures were exposed. This Jacopo then took service for a year on the Florentine galleys, was condemned for the assault in his absence, and arrested on his return the following autumn, remaining in prison through the winter.[3] Unfortunately the documents give the name of this Jacopo's father as Piero, whereas we know that the father of Jacopo Bellini was called Niccolò. Nevertheless, it seems likely that Jacopo Bellini is the person in question since it would be a curious coincidence if Gentile had two Venetian pupils called Jacopo. In this case the appearance of the name Piero for the father might be explained simply as a scribal error, of a sort that sometimes occurs in legal documents even today, or else as due to Jacopo having given a false patronymic, not wishing to associate his father's name with his disgrace. Gentile was admitted to the guild in Florence in November 1422 and if Jacopo was with him when he arrived he would have had time to see a good deal of what was going on there before he left on the galleys some time between 11 June 1423 when the assault took place and 2 September when he was condemned *in absentia*.

[1] See Fiocco, G. 1959, pp. 59–72, and Muraro, M. 1959 (2), p. 96.

[2] The proof of the tradition that Jacopo was a pupil of Gentile da Fabriano is found in the copy of the inscription from his destroyed fresco of the Crucifixion in the Duomo at Verona of 1436, printed in Ricci, C. 1908, i. 11. In the fourth line we should read 'toto' for 'veneto'.          [3] Ricci, C. 1908, i. 49, doc. iv.

The comparatively small quantity of Jacopo's work as a painter which has come down to us hardly seems to show as much Tuscan influence as one might expect in an artist who had been in Florence in those exciting years. Some of his Madonnas, especially that at Lovere, and his *Christ on the Cross* at Verona do recall Fra Angelico, but no surviving works of Angelico's can be certainly regarded as having been executed as early as the time of Jacopo's supposed visit. In many ways the most significant works of Jacopo's that survive are the drawings of the two so-called sketch-books in the Louvre and the British Museum. The unitary character of these volumes (which would more properly be regarded as pattern-books than sketch-books) has been conclusively demonstrated by Röthlisberger;[1] but he has also advanced plausible grounds for dating them in the mid 1450s, and if they are so late, the somewhat naïve use of Renaissance elements of ultimately Tuscan origin, both in regard to perspective and the employment of antique detail, will no longer appear as that of a pioneer, as it did when the volumes were accepted as of substantially earlier date, but may rather be seen as reflecting the influence of Jacopo's son-in-law, Andrea Mantegna. One does not feel that the author of these drawings, whose eclecticism and mingling of Gothic and Renaissance elements has led some authorities, though undoubtedly wrongly, to distribute them between a number of hands and over a period of about thirty years,[2] had any very fundamental grasp of the significance of the new movement.

Indeed a far deeper understanding of the new ideas of spatial construction basic to contemporary Florentine art is revealed, under a veil of late Gothic decoration, in the great canvas triptych painted by Antonio Vivarini and Giovanni d'Alemagna in 1446 for the Scuola della Carità, which passed with the buildings of the Scuola to the Venice Academy.[3] This is the first Venetian altar-piece which brings the Virgin and her attendant saints into a single picture-space, unified by perspective, and anticipates the similar structure of Mantegna's altar-piece in S. Zeno at Verona by more than a decade. It is exactly contemporary with the beginning of Donatello's work on the high altar of the Santo at Padua, where a similar scheme was carried out in three dimensions, and it is possible, but by no means certain, that the painting in Venice reflects knowledge of his design.

The assimilation of Renaissance forms in the decorative elements of paintings and in their frames was also slow. Although Antonio Vivarini and Giovanni d'Alemagna incorporated some such elements, no doubt ultimately of Donatellesque origin,

[1] Röthlisberger, M. 1956.     [2] Tietze, H. and Tietze-Conrat, E. 1944, pp. 94–114.
[3] Rep. Pallucchini, R. (n.d.), pl. 62.

in the decoration of the vault of the Ovetari chapel in the Eremitani at Padua carried out between 1448 and 1450, they were executed in such a florid, late Gothic manner as to disguise their Renaissance character;[1] and such forms do not begin to appear in painting in Venice itself before the 1460s, parallel with their gradual adoption in architecture and decorative sculpture.

In this sphere the first break with the Gothic tradition, and a very hesitant and partial one, seems to come in the unfinished portal of SS. Giovanni e Paolo, which may have been begun in 1458.[2] Here we find a mixture of florid late Gothic forms and classical motives which is similar to Antonio Vivarini and Giovanni d'Alemagna's decorations in the vault of the Ovetari chapel.

In the gateway of the Arsenal[3] of 1460 we find a much more decisive break with the past. The study of this monument is complicated by the additions and modifications made to it in the following century as a memorial to the victory of Lepanto; but when these have been eliminated we are still left with a work with no residual Gothic element and which seems designed to assert the position of Venice as heir to the Roman heritage of the Byzantine empire, perhaps with a conscious reference to the gates of Constantinople. It is extremely interesting to compare this with the Arco Foscari[4] in the Doge's Palace, and we may see in the contrast the symbol of the aged Foscari's disgrace and the reorientation of Venetian policy away from the mainland towards the eastern Mediterranean, in reaction to the Turkish threat brought home by the fall of Constantinople.

Another monument of the transition from Gothic to Renaissance in Venetian architecture is the project for the Cornaro–Sforza palace on the Grand Canal, the Ca' del Duca, which was probably begun in 1461 but never carried above the lower courses.[5] Although the bases of the angle columns have floriated scrolls at the corners, like those of the portal of SS. Giovanni e Paolo, the rustication of the façade looks directly forward to the first complete building in Renaissance style in Venice, the church of S. Michele in Isola begun by Mauro Coducci in 1468 or 1469, which was to some extent modelled on Alberti's Tempio at Rimini.[6]

In sculpture the impulse for the development from Gothic to Renaissance forms after the middle of the century seems to have come primarily from Lombardy. The earliest securely dated work of sculpture in Venice which shows the adoption of

[1] Rep. Pallucchini, R. (n.d.), pls. 86–9.

[2] Paoletti, P. 1893, i. 74. The document of 3 January 1458 cited by Paoletti makes it clear that work has not begun at that date. He thought the doorway should be dated some ten years later.

[3] Ibid., pp. 139–41.

[4] Ibid., pp. 42–5.

[5] Ibid., pp. 34–6.

[6] Ibid., pp. 164–72.

fully developed Renaissance decorative forms is the small relief of the Virgin and Child against a curved coffered background, framed with pilasters, entablature, and crowning ornament, which now stands over the altar in the chapel of S. Clemente in St Mark's and is inscribed DVCE SERENISSIMO DNO CRISTOFORO MAVRO MCCCCLXV.[1] The general style of the work is in many ways close to that of Antonio Rizzo, as we see it later in such a work as the Tron monument in the Frari, and there is reason to suppose Rizzo was active in Venice at least as early as 1464 since he is commemorated in two epigrams by a Venetian humanist who died in that year.[2]

In a painting of the *Madonna enthroned with Saints* by Bartolomeo Vivarini now in Naples,[3] also dated 1465, we see similar but more delicate forms in the decoration of the throne which are rather more reminiscent of the style of Pietro Lombardo. Pietro, though Lombard by origin, is an important figure in the story of contacts between Tuscany and Venice, as he had certainly visited Florence before he undertook the construction of the Roselli monument in the Santo at Padua in 1464. He is not generally thought to have come to Venice until after the completion of that work in 1467,[4] but his work in Padua might have been well known to any Venetian artist before this date. His specific relation to Giovanni Bellini will be considered in a later chapter. The tomb-slab of Alvise Diedo in SS. Giovanni e Paolo also of 1465 shows fully Renaissance forms in its incised decoration. A throne of basically Renaissance type but of rather heavier decorative detail is found in the miniature decorating the *Promissione* of Doge Cristoforo Moro, now in the British Museum, for which Leonardo Bellini was paid in 1463.[5]

At the beginning of this chapter I defined Giovanni Bellini's position in terms of a synthesis of the earlier achievements of the Tuscan and Flemish schools, and I have tried to indicate the main sources of Tuscan influence for an artist of his generation in Venice. With regard to Flemish influence we cannot be so specific. The indirect transmission of Eyckian influence through Antonello da Messina, who is known to have visited Venice in 1475–6 and who may possibly have been there earlier, is undoubtedly important, but this is surely far from the whole story.[6] Millard Meiss has drawn attention to elements in Mantegna's style which seem to reflect Eyckian influence. He also detects some Eyckian influence in Filippo Lippi's *Madonna* of 1437

---

[1] Rep. Planiscig, L. 1921, fig. 216 p. 203, with misleading attribution to Pyrgoteles.

[2] Pope-Hennessy, John, 1958, p. 349.     [3] Rep. Pallucchini, R. (n.d.), pl. 150.

[4] Pope-Hennessy, John, 1958, pp. 350–1.

[5] B.M. Add. MS. 15816, rep. British Museum, Reproductions from Illuminated Manuscripts, Series I, 1910, pl. xlviii.     [6] For Antonello's influence see below, pp. 56–9.

at Tarquinia Corneto, which he thinks may be due to his having seen Flemish works when in Padua a few years earlier.[1] It is tempting to see an Eyckian St Jerome as the prototype of the roundels of the Fathers of the Church by Niccolò Pizzolo in the vault lunettes of the Ovetari chapel, now destroyed; though the miniature of *Petrarch in his Study*, which forms the frontispiece of a manuscript of an Italian translation of his *De Viris Illustribus* in the Landesbibliothek at Darmstadt and which is said to have been produced in Padua about 1400, anticipates this Eyckian scheme to a remarkable degree and suggests the possibility of an independent Paduan tradition of this sort of realism.[2] Certain early works of Giovanni Bellini's, such as the *Blood of the Redeemer* in the National Gallery, the *Christ Blessing* in the Louvre, and the *Pietà* in the Brera, seem to show, in their pathos, in a certain angularity of design, and in their handling of light, a direct contact with the art of Rogier van der Weyden. Unfortunately we have practically no documentation of artistic contacts between Venice and Flanders at this time, though the little Eyckian portrait of Marco Barbarigo, probably painted in London about 1450, may well have been in Venice from soon after this date.[3] On the other hand, it is very probable that a number of the Flemish paintings recorded by Marcantonio Michiel in Venetian private collections in the third decade of the sixteenth century may have been there much earlier.[4] We do know of at least one important work of van der Weyden's at Ferrara, and though we have no proof that Giovanni ever visited this city as we know his father did, it is more likely than not that he did so.[5]

We have now outlined the background against which the development of Giovanni's art must be viewed. Before starting to trace this development in detail we should consider what the documentary sources tell us of his life, his background, and his personality. The date of his birth has an important bearing on the dating of his early work. Marin Sanuto, in recording his death on 29 November 1516, leaves a tantalizing blank for his age, as he had done nine years earlier when recording the

---

[1] Meiss, M. 1956, p. 62.

[2] The Pizzolo roundels are reproduced in Fiocco, G. 1959, pls. 108–11. For a reproduction of the Darmstadt miniature of Petrarch and a discussion of its relation to a much repainted fourteenth-century fresco in the Sala dei Giganti at Padua see Mommsen, T. E. 1952, fig. 5 and p. 107. See also Pächt, O. 1963, p. 134 and Meiss, M. 1963(1), p. 169.  [3] See Davies, M. 1945, p. 36.

[4] See Michiel, M. A. 1884, *passim*. In 1502 Pietro Bembo lent two paintings by a Flemish master to Isabella d'Este, a *St John*, and a *Veronica*—see Cian, V. 1887, pp. 85–6.

[5] See the accounts of Rogier's triptych at Ferrara by Cyriac of Ancona and Bartolomeo Fazio, most conveniently accessible in Panofsky, E. 1953, i, p. 2 nn. 4 and 7 (pp. 361–2). Habicht, V. C. (1931, p. 55) has drawn attention to an apparent borrowing from the Rogier *Entombment* in the Uffizi which may have been in Ferrara, in the *Crucifixion* ascribed to Giovanni in Pesaro, but the attribution of this picture to Giovanni seems to be wrong (see below, p. 53).

death of Gentile.[1] Vasari states that Giovanni died 'having reached the age of ninety years' which would give us 1426 for the year of his birth.[2] Such a date has had its recent supporters but its acceptance involves grave difficulties. Vasari, in his first edition, states that Giovanni was older than Gentile, and in his second edition implies it though he does not specifically say so, but we have much better authority for believing the contrary.[3] Gentile was evidently regarded as his father's heir and was employed before Giovanni in the work of the renovation of the Sala del Maggior Consiglio; and Francesco Negro, in his *Periarchon* or *De Principiis*, which he dedicated to Doge Leonardo Loredan and which consequently must have been composed between 1501 and 1521, that is to say at the latest within five years of Giovanni's death and probably in his lifetime, states specifically that Gentile was 'major natu'.[4] Since Jacopo Bellini's wife, Anna Rinversi, made her first will in 1429 in a form that indicates that she was expecting her first child, and since we know from her last will that she was certainly Gentile's mother, it follows that he cannot have been born before 1429; and consequently, if we accept Francesco Negro's statement which is more authoritative than anything else we have on the subject, Giovanni cannot have been born earlier than 1430.

It has been suggested that Giovanni may not have been the son of Anna Rinversi on the ground that he is not mentioned in her last will of 1471, in which her property was divided between her sons Gentile and Niccolò,[5] and that he was either the son of Jacopo by an earlier marriage or was illegitimate. Both hypotheses, in so far as they are taken to indicate that he was really older than Gentile, are equally

---

[1] The entry for Giovanni's death is quoted verbatim below, p. 154. That for Gentile runs as follows: 'Adì 23 Febbraio . . . Noto ozi fo sepulto a San Zane Polo Zentil Belin, optimo pytor, qual *alias* fo mandato al padre di questo signor turco, dil qual ebbe la militia; sì che per esser famoso, ne ho fato qui memoria. Havia anni . . .; è restato il fratello, Zuan Belin, ch'è più excelente pitor de Italia. *Etiam* in questi mexi morse a Mantoa Andrea Mantegna.' Sanuto, M. 1879–1903, vi., col. 552.

[2] Vasari, G. 1878–85, iii. 172–3.

[3] The statement that Gentile was the younger brother occurs on p. 449 of the 1550 edition. The fact that this specific assertion is omitted in the second edition (1568) may indicate a deliberate correction based on information received on his visit to Venice in 1566, though he did not revise his text sufficiently to eliminate the implications of this view.

[4] Cited in Michiel, M. A. 1884, p. 9.

[5] Anna Rinversi's two wills are printed in Ricci, C. 1908, i. 50 and 59. It is usually supposed that the references to a son Niccolò in the will of 20 November 1471 should be emended to Niccolosia, the daughter who married Mantegna, but this seems unlikely. The name occurs twice in the will, and if Niccolosia had been intended surely she would have been described as Mantegna's wife. It has been argued that the bequest must be to a woman since in addition to half the residue it included a dress, but testamentary transvestism seems to have been common in Venice—see for instance the will of Niccolò Bellini, Jacopo's father, printed by Ricci on page 48, where he left his wife an extensive wardrobe. Here the bequest of 'unam meam vestem pani bruni' was certainly to provide dark cloth for mourning and might be for either sex.

irreconcilable with Francesco Negro's statement, which cannot be twisted into meaning that Gentile was the younger, but the heir because Giovanni was a bastard. In fact the hypothesis of illegitimacy seems quite unnecessary and Giovanni's omission from the will (the daughter Niccolosia was also omitted, unless we accept a not wholly convincing emendation of the text) may be more easily explained by the hypothesis that he had already received his portion of the estate under Jacopo's will, which has not come to light. Against the hypothesis of illegitimacy is the absence of any specific tradition to this effect in Vasari or Ridolfi: this is the sort of gossipy detail that both liked to record. Indeed Ridolfi, in his very positive assertion that Giovanni was the younger son, seems to be deliberately correcting Vasari. On the other hand, Vasari's statement, that Mantegna took to wife 'una sua [Jacopo's] figlia e sorella di Gentile', without mention of Giovanni can legitimately be read as evidence that he believed that Gentile and Giovanni were only half-brothers.[1] An ingenious argument based on the identification of a group of portraits in Gentile Bellini's *Miracle of the Cross at the Ponte San Lorenzo* in the Accademia as those of the male members of the Bellini family has recently been put forward by Felton Gibbons, to suggest that the child who was expected in 1429 was the daughter Niccolosia who married Mantegna in 1453 and that Gentile was born in 1430–1 and Giovanni not till about 1433.[2] It may seem a little unlikely that Niccolosia was neither married nor professed as a nun by the age of twenty-four or that Mantegna would have married a girl a little older than himself, but it is quite possible. All that we can say with relative certainty is that the weight of the evidence suggests that Giovanni was not born before 1431. Since Dürer regarded him as very old in 1506 and Vasari's 'ninety years' seem to reflect a tradition that he was very old when he died, we should not advance the date later than necessary and 1431–2 would seem a reasonable assumption.

By 1459, when his signature first appears as witness on a document, Giovanni was living away from home;[3] but this need not imply either that he was illegitimate or that he had severed all professional connection with his father's workshop, perhaps rather that he was already married although we do not meet any mention of his wife in documents before 1485. Her name was Ginevra and she died between 1489 and 1498 when their son Alvise, who seems himself to have died soon afterwards, made his will. It is possible that Giovanni later remarried taking a young wife who

---

[1] For Ridolfi's assertion that Gentile was the older see Ridolfi, C. 1914–24, i. 56. For Vasari's reference to Niccolosia as 'sorella di Gentile' see Vasari, 1878–85, iii. 389.

[2] Gibbons, F. 1963.     [3] Paoletti, D. 1894, p. 11.

long outlived him.[1] In any case, even if Giovanni was established as an independent painter by 1459 he seems to have returned to work with his father the following year when Jacopo, Gentile, and Giovanni signed, in that order, the altar-piece now unhappily lost in the Gattamelata chapel in the Santo at Padua. The occurrence of Gentile's name before Giovanni's name is further evidence that he was the elder.[2] There is, as we shall see, possible evidence in surviving works for Giovanni's activity in his father's workshop during the 1460s,[3] and as late as 1471 we find a reference in a letter which implies a belief on the part of the writer that Gentile and Giovanni were at that time sharing a studio.[4] When Gentile was sent on his official mission to Constantinople in 1479 we find that Giovanni was appointed immediately to carry on his work in the Doge's Palace.[5]

The documents which concern the execution of actual works, lost or surviving, or at least such of them as are relevant, will be referred to as we trace Giovanni's artistic development, but another group of documents, the references to him in the writings of contemporary humanists, should be mentioned here.[6] Felice Feliciano of Verona, who is well known to students of painting from his connection with Mantegna and for his interest in palaeography and the revival of antique forms of letters, addressed a flowery Latin letter to 'Famosissimo in orbe pictori Joanni Bellino de Venectiis'. Similar letters were addressed to Mantegna, to Marco Zoppo, and to another painter, probably Cossa. They are undated but are thought to have been written about 1474–5, and the appearance of Giovanni in this company illustrates interestingly his association with the Paduan school which is stylistically so clearly reflected in his earlier work.[7] Among the epigrams of Raffaele Zovenzone of Triest, who had studied under Guarino in Ferrara in the early 1450s, we find a number containing complimentary references to both Giovanni and Gentile Bellini; and the dedication of the Trivulzian manuscript of his poems to Giovanni Hinderbach, bishop of Trent, refers to his own portrait, by Giovanni Bellini, as adorning the book. Unfortunately no portrait survives there, but the evidence of

---

[1] Cecchetti, B. 1887, p. 204, lists the will of Maria, widow of the painter Giovanni Bellini of 18 December 1554, but for a possible alternative husband see Gronau, G. 1909, p. 266.

[2] Recorded by Fra Valerio Polidoro, *Le Religiose Memorie . . . della Chiesa del Glorioso S. Antonio . . . di Padova*, 1590, quoted in Vasari, G. 1878–85, iii. 176.

[3] See below, p. 39.

[4] See the letter from Elisabetta (Morosini) Frangipane from Veglia to Pietro and Marco di Paolo Morosini in Venice, of 11 May 1471 in which she asks them to arrange for Gentile and Giovanni to teach 'la rason del desegno' to 'pre Domenego nostro'. F. S. 1891.

[5] See Lorenzi, G. B. 1868, p. 88 doc. 192, and p. 91 doc. 195.

[6] I have to thank Professor Roberto Weiss for his help and encouragement in this part of my investigation.

[7] See Pratilli, L. 1939–40, pp. 63 ff.

the dedication is of the greatest value in documenting Giovanni's activity as a book-illustrator. Included in the text are several epigrams addressed to Gentile Bellini, one referring to an antique torso of Venus in his possession, and one to Giovanni referring to the living likeness of his portraits.[1] An epigram of Pierio Valeriano refers to a bust of Plato 'apud Bellinos Venetiis'.[2] Among the epigrams of Giorgio Sommariva in the manuscript in the Biblioteca Comunale at Verona are a pair of sonnets; the first addressed by Giovanni to Gentile Bellini congratulating him on his success in painting the portrait of the Sultan Mahomet, and on the sultan's gift of a golden chain, the second by Gentile to Giovanni thanking him and saying that given the same opportunity he would have scored the same success. The second sonnet is entitled *Responsum G. S. nomine Gentilis Bellini*, which clearly indicates that it is Sommariva's composition, but the first is simply headed *Gentili Bellino Equiti Aurato pictori Joannes Bellinus frater*, which rather seems to indicate that it is an original composition of Giovanni's. As a work of literature it is not impressive—Giovanni, if indeed he is the author, was certainly better employed at his easel—but it is interesting as indicating his cultural aspirations.[3]

While, individually, none of these references is perhaps of great importance, the picture which they give collectively of Giovanni's humanist interests is valuable, especially in view of the conventional spheres in which Giovanni's activity as a painter mainly lay, religious paintings, historical canvases, and portraits. The chief works which can be directly related to the interests illustrated here are the five little *Allegories* in the Venice Academy, the *Feast of the Gods* in Washington, and the *Venus* or *Lady at her Toilet* in Vienna. The only document that throws any light on Giovanni's personal character is Dürer's letter of 1506 to which reference has already been made. The light thrown is agreeable. Where other artists are jealous, we see Giovanni welcoming the stranger, praising him in public, visiting him in private, and asking for a specimen of his work. This is our only glimpse of the personality of the man, and it is but a glimpse, but it accords well with the character we should wish to infer from the thoughtful, calm, and generous warmth of the work of the artist.[4]

---

[1] Ziliotto, B. 1950, pp. 76–8, 109, and 164.    [2] Quoted in Biadego, G. 1907, p. 20.    [3] Ibid., pp. 23–7.

[4] Dürer, A. 1956, pp. 43–4. Dürer to Willibald Pirckheimer in Nuremberg, 7 February 1506. The full text of the passage runs as follows: 'Jch hab vill guter frewnd vnder den Walhen, dy mich warnen daz jch mit jren moleren nit es vnd trinck. Awch sind mir jr vill feind vnd machen mein ding in kirchen ab und wo sey es mügen bekumen. Noch schelten sÿ es und sagen, es sey nit antigish art, dorum sey es nit gut. Aber Sambelling der hett mich vor vill czentillomen fast ser globt. Er wolt geren ettwas von mir haben vnd ist selber zw mir kumen vnd hat mich gepetten, jch solt jm etwas machen, er wols wol czalen. Vnd sagen mir dÿ lewt alle, wy es so ein frumer man seÿ daz jch im gleich günstig pin. Er jst ser alt vnd jst noch der pest jm gemoll. Vnd das ding daz mir vor eilff joren so woll hatt gefallen, daz gefelt mir jcz nüt mer.'

# II

*The earliest works.*
*Giovanni Bellini or Andrea Mantegna.*
*The problem of the miniatures in the*
*Arsenal MS. and of the pen-and-ink*
*drawings*

WHEN we undertake to reconstruct Giovanni Bellini's career we find ourselves faced with difficulties both of attribution and of chronology. His earliest work that is both signed and dated is the *Madonna degli alberetti* of 1487 in the Venice Academy, painted when he must have had at least thirty years of activity behind him. Although there are signed works which are certainly much earlier than this none of them is closely datable, and although there are others plausibly assigned to him for which a reasonably close dating may be inferred from documents, none of these is actually signed or documented as his. The paintings in the Scuola di S. Girolamo mentioned in seventeenth-century sources as dated 1464 have not survived,[1] and though a date of 1472 is reported by Zanetti and Moschini as on the signed *Pietà* in the Doge's Palace it is no longer to be read there.[2] The four triptychs from the church of the Carità, now in the Venice Academy, are documented as having been commissioned at various dates between 1460 and 1464 and must have been completed by 1471,[3] while the polyptych of St Vincent Ferrer in SS. Giovanni e Paolo stands over an altar which was under construction in 1464.[4] With regard to the triptychs however, there is no documentation or tradition to connect them with Giovanni, and though the polyptych is recorded as his by Sansovino the degree of

[1] First recorded by Ridolfi in 1648 (Ridolfi, C. 1914–24, i. 64): 'In concorrenza d'altri Pittori lavoró per la Compagnia di San Girolamo due quadri della vita di quel Santo. L'uno lo dimostra a sedere a canto alle mura del suo convento sermoneggiando co' suoi frati, che gli siedono intorno in semplice positure, chi di loro si appoggia a debil legno, altro ritto l'ascolta; evvi un Frate, che dispiega alcuni drappi sopra ad una loggia: e finsevi nel piano sepulture ed herbette molto naturali.

'Nel altro vedesi il medesimo Santo nello studio suo posto ad uno scabello in atto di leggere, e vi son Frati che stanno studiando ed altri favellano insieme: ed evvi qualunque cosa espressa con molto artificio e diligenza: e v'iscrisse il nome e l'anno 1464.'

[2] See below, p. 46–7.  [3] See below, pp. 39–43.  [4] See below, p. 43.

authority which should be accorded to this attribution is uncertain. Although, as I shall explain in the next chapter, I do not think that either of these sets of panels could have been produced without at least a considerable degree of participation from Giovanni, this can only be assessed after we have formed an idea of his earlier style from more clearly authenticated works, and we cannot make these panels the basis of our study.

We may presume that Giovanni received his first education as an artist in the studio of his father, Jacopo, and it has been suggested that the little panel of the *Crucifixion* (Pl. 1) in the Correr, which originally formed part of the same predella as the *Descent into Limbo* in Padua, may show the hand of Giovanni in his father's workshop. This does indeed seem possible, but it is difficult to isolate with certainty a personality beyond Jacopo's here.[1] Over ninety years ago Crowe and Caval-caselle indicated the little painting of *St Jerome*, now in the Barber Institute, Birmingham (Pl. 11*a*), as the earliest surviving product of Giovanni's hand, showing us how his style grew out of that of his father.[2] This picture, which they had seen in the sale-room, but of which they did not know the ownership when they wrote, remained virtually unknown until it reappeared at the Southesk sale at Christies in 1948 and passed into the possession of the Barber Institute in the following year, when it was also shown in Venice. Recently the attribution to Giovanni has been disputed by Heinemann, who has given it to Lazzaro Bastiani.[3] One looks in vain in Lazzaro's work for anything that would parallel the luminosity and delicacy of the Barber picture. The lion derives from a sheet of studies in Jacopo Bellini's Louvre sketch-book and this would accord well with the attribution to Giovanni though, of course, it does not prove it.[4] The signature occupies a rather large central cartellino, similar to that which carries the inscription in the *Transfiguration* in the Correr Museum, and runs IHOVANES BELINVS. It appears to be contemporary. The odd, but not unparalleled, spelling of the Christian name seems more likely in a genuine than in a fraudulent inscription. The evidence of the signature is fully borne out by the quality and the style of the picture. The combination of elements clearly drawn from Jacopo's work—the elongated proportions of the saint and the sweeping lines of the rocks—with a delicacy and feeling for light that is so characteristic of Giovanni's work throughout his career would indicate him as the painter even were the picture unsigned or the signature false. Since the signature appears to be genuine

[1] For the attribution of this picture see Pallucchini, R. 1959, p. 127.
[2] Crowe, J. A. and Cavalcaselle, G. B. 1912, i. 140.
[3] Heinemann, F. 1959, i. 219.
[4] Louvre sketch-book, f. 72ᵛ. Rep. Ricci, C. 1908, i, pl. 86. Goloubew, V. 1912, pl. lxxvii.

this picture provides a sound base for the reconstruction of Giovanni's earliest activity.

The limited extent of the influence of Mantegna in this picture is remarkable. The frightened rabbit in the left corner certainly recalls him but we do not find his sharp sculptural style either in the forms of the rocks or of the drapery nor is any of the repertory of Squarcionesque decorative forms deployed here. The rather weak and spindly forms of the letters on the signature, with the marked serifs on the 'B' and the unusual feature in the 'N' of the diagonal stroke being much thinner than the uprights, are very primitive compared to those in even the earliest works of Mantegna that have come down to us, and stand in sharp contrast to what Giovanni himself was to achieve in the inscriptions on the *Transfiguration* in the Correr and the *Pietà* in the Brera—or indeed in the signature of the earlier *Pietà* at Bergamo.[1] The subordination of incident in the landscape and the suffused effect of atmosphere look forward to the period when Giovanni had developed beyond the influence of his brother-in-law, so powerfully evident in his immediately succeeding works. The extremely delicate handling of light in this picture and, in particular, the rendering of the book which the saint is holding open with his left hand, make one wonder whether, even at this stage, the direction of Giovanni's individual development, was not to some extent determined by the influence of Eyckian models.[2] Gilding is used for the highlights on the rocks and on the haystack in the middle distance, as it is later on the drapery of Christ in the *Agony in the Garden* in London, and this, combined with the general delicacy of the work, suggests that he might already have had some experience as an illuminator, an art which his cousin Leonardo may have been practising in Jacopo's studio since 1443.[3]

We see here that at the very outset of Giovanni's career light has the same cohesive function as it fulfils with the added richness of long experience in such a work of his later years as the altar-piece in S. Zaccaria with which we began our study. The date that we should assign to this picture, on the other hand, cannot be determined with any certainty. There is a certain innocent immaturity about its conception but it is technically a work of considerable accomplishment. If we accept that Giovanni was born in the early thirties we might suppose this work to date

---

[1] Cf. Meiss, M. 1960, *passim.*

[2] For Eyckian influence in north Italy see Meiss, M. 1956, *passim.*

[3] Leonardo Bellini is documented as entering Jacopo's studio in this year. He is not specifically documented as a miniature painter until 1463 but since he witnessed a document in the house of the miniaturist Battista da Bologna in 1448 it seems likely that he followed this specialization from the beginning. See Moretti, L. 1958, pp. 58 and 63.

from about 1450 but hardly from very much earlier. Such a dating would make it possible to accept as Giovanni's next surviving works the four miniatures added in 1452–3 to the manuscript of the life of St Maurice, presented in 1453 by Jacopo Antonio Marcello to Jean Cossa and now in the Arsenal Library at Paris.[1] These miniatures have been claimed by Meiss as the work of Mantegna and there is much in favour of this view. Nobody who has taken the trouble to examine this manuscript could doubt that the miniatures are the work of a major artist; and the claim put forward by Fiocco and more tentatively by Moretti that they are the work of Giovanni's cousin Leonardo Bellini, a professional miniature-painter, is decisively contradicted by the very limited nature of Leonardo's achievement, the outline of which has been clearly established for us on the basis of documented work by Moretti himself.[2] Only Andrea and Giovanni come seriously in question. In the present state of our knowledge it does not seem to me possible to decide definitely between them. The arguments in favour of Mantegna's authorship are fully and clearly set out by Meiss. Against it we might urge the Venetian quality in the treatment of light, which is admitted by Meiss; the fact that at a later stage of his career Mantegna declared himself unused to working in miniature;[3] and the conspicuous absence from these miniatures of the repertory of decorative forms— swags of fruit, putti, knotted ribbons, etc.—which he was at this moment deploying on the walls of the Ovetari chapel and which were well suited to book decoration and generally used for it by illuminators of the Paduan school, at any rate a little later.

In support of Giovanni's authorship we may point particularly to the quality and function of the light, the rich and suffused colour and the fluid drawing. The architecture of the chapter-hall is closer to some of the drawings in Jacopo's books than to any known work of Mantegna's; and the elongated, small-headed figures, especially those standing at the back of the chapter-hall, resemble the figures there and even more those in the *Crucifixion* panel in the Correr which, as we have seen, some authorities regard as not Jacopo's but Giovanni's. Jacopo's authorship would seem to be excluded on qualitative grounds and by the very forward-looking quality of the miniatures, but we might expect to find a closer reflection of his style in Giovanni's work than in Andrea's. The principal objection to an attribution

[1] For a full description of the manuscript and discussion of the date and authorship of the miniatures see Meiss, M. 1957 and Meiss, M. 1963 (2), p. 52 n. 14, where he makes the point that the upward tilt of the head in the portrait of Marcello and the 'plateau composition' of the landscape in the 'Chapter' miniature are Mantegnesque features which do not recur in Giovanni's work.

[2] Fiocco, G. 1958, p. 56, and Moretti, L. 1958, p. 60.    [3] See below, p. 20.

to Giovanni is the lack of any positive evidence, which we have in the case of Andrea, that he had achieved this degree of sophistication so early in his career. We are finally left with a choice between seeing them as the earliest Mantegnesque works of Giovanni's or as works of Andrea's showing himself unusually sensitive to the influence of Venice and of the Venetian family to which he was just at this time uniting himself in marriage; as, indeed, a Bellinesque type of Mantegna, a phenomenon which we undoubtedly find later in his work in the *Dormition of the Virgin* in the Prado.[1] We shall have to consider this question of the relation between Giovanni and Andrea further, especially in connection with their drawings, and perhaps in the course of these later discussions the reader's mind may become clearer as to the authorship of the Arsenal miniatures. At any rate there is a prima facie case for Giovanni's authorship which justifies their detailed discussion here as possible early works.

The manuscript is of small size, the leaves measuring only 18·7 x 13 cm., and the miniatures with which we are concerned are four in number (the book also contains miniatures by a Lombard painter which do not concern us). The miniature of the *Chapter of the Order of the Crescent* (Pl. 11*b*) is designed with austere simplicity and symmetry. We look into the chapter-hall from the back, the whole end wall being removed for our benefit so that the interior is exposed like that of a doll's house. We see in the foreground the back of a row of knights which strongly recalls the row of back-view apostles in Giotto's *Last Supper* in the Arena chapel, a work with which Giovanni may have been no less well acquainted than Andrea. A further row of knights is seen down each side of the hall, the presiding senator being seated on a raised throne, half-way down the left-hand side. The knights have robes of red, sometimes of a purplish, sometimes of an orange, tinge and all wear black hats. In the centre of the end wall is a tall doorway closed by a grill on each side of which stands a pair of very tall and slender figures in scarlet robes, and above the doorway is a statue of St Maurice in armour with lance, shield, and martyr's palm. The predominant red of the figures is set off by a green tapestry woven with decorative plant-forms which covers the lower part of the walls. Above this, in each side wall, are three very large plain arched windows while a flat timber ceiling, of a warm brown, supported on four massive beams, closes the room at the top. The floor is flagged with a check of warm white and brown-grey, and the walls are of a colder white, which takes on a brilliant blue tone in the shadows to the left. Through the grill we see the back of a tall figure on guard, dressed in blue with

[1] See below, p. 21.

purplish shadows, and beyond him a brilliant green landscape falling away from the threshold. Above this is a blue sky flecked with white clouds and further parts of this sky and landscape are seen in narrow strips through the side windows, exactly as they are more than thirty years later in Giovanni's Frari triptych. It is difficult to convey how far this formal symmetrical scheme is enlivened by the brilliance and subtlety of the light and colour.

The full-length figure of St Maurice which stands over the doorway of the hall is exactly repeated in a separate full-page miniature (Pl. III a), where he stands on a narrow strip of turf against the background of the plain vellum of the page. The general type of the figure is certainly very Mantegnesque, though the winged helmet can again be most closely paralleled in Jacopo's *Crucifixion* in the Correr. It might perhaps be thought surprising to find Mantegna portraying the commander of the Theban Legion in an armour which, if it pays some tribute to the antique, is yet essentially a Gothic one, but he did the same some years later with St George in his picture in the Venice Academy. The armour here is highlighted with gold, a practice which we find in Giovanni's work in the Barber *St Jerome* and the National Gallery *Agony*. If this figure is to be accepted as Giovanni's it must be accounted among the works in which he approximates most closely to his brother-in-law, and the same must be said of the third miniature in the manuscript, the portrait of *Marcello* (Pl. IV a). The parallels which Meiss draws between this head and various works of Mantegna's are very striking and yet there is something in the extreme sensitivity of the modelling and illumination and in the colour, with the brilliant blue shadow behind the profile, which may seem to belong rather to Giovanni's personality. For the full profile pose we may cite the close parallel of a drawing in Jacopo's sketch-book,[1] though this might of course have been as available to Mantegna as to Giovanni; and the Eyckian pose, behind an inscribed parapet, looks forward, as Meiss has noted, to Giovanni's *Portrait of a Boy* in the Barber Institute. There is a quiet self-possession about this head which is nearer that of Giovanni's *Leonardo Loredan* in London than to the nervous, even tortured energy of Mantegna's *Cardinal Mezzarota* in Berlin, who seems, like another cardinal, to be 'puzzled in a question about Hell'.[2] Of the portraits ascribed to Mantegna this comes nearest to the *Portrait of a Man* in Washington (Pl. IV b), but this profile, close as it is to some of the 'assistenza' in Mantegna's Ovetari chapel frescoes, yet has a quality of softness and a gentleness that does not altogether fit with Mantegna's heroic

[1] Louvre sketch-book, f. 23ʳ. Rep. Ricci, C. 1908, i, pl. 19. Goloubew, V. 1912, ii, pl. xx.
[2] John Webster, *Duchess of Malfi*, v. v. 1.

manner. This might of course be attributed to the rather poor condition of the picture, but it seems to me that it may rather represent a positive quality, a quality of Giovanni's art rather than Andrea's, and that we may have here the earliest surviving portrait of Giovanni's, corresponding in portraiture to his early Mantegnesque religious paintings.

This miniature also strongly recalls the drawing made five years earlier by Pisanello for his medal of Alfonso of Aragon,[1] and the tradition of the inscribed allegorical reverse to a medal, which Pisanello had elaborated, must have suggested the fantastic design of the fourth miniature, which confronts Marcello's portrait in the manuscript (Pl. III *b*). Here a solid but lively eyed elephant, wreathed about with a ribbon of a delicate blue, bears strapped to his back by a wide girth with an enormous buckle a miniature lagoon well stocked with fish and fowl from which rises a model of the Doge's Palace. A winding scroll bears the words of a dialogue between the elephant, whose head is turned to look up, and the figure of Venice over the central window of the upper story of the palace. For the interpretation and historical circumstances of this inscription and of the cryptogram under Marcello's portrait the reader is referred to Meiss's book.[2] As with the full-page St Maurice miniature the background is left blank here, but little rocky mounds fill the corners on each side of the elephant and these are strikingly reminiscent of the forms of the landscape in the Barber *St Jerome*.

In 1480 Federigo Gonzaga, writing to the Duchess of Milan who had asked him to get Mantegna to execute some small-scale work for her, said that he had asked the artist but that he was unwilling—'el qual me dice che la seria opera più presto da miniatore che sua perche lui non e assueto pingere figure picole.'[3] It was probably some three years earlier that Raffaele Zovenzone sent the manuscript of his poems to Giovanni Hinderbach with a dedicatory letter in which he apologized for not visiting his patron in person and continued: 'Sed habebis expressam in libelli pagina faciem hanc quem nobilissimus pictor Joannes Bellinus imitatus est.'[4] Though unfortunately no portrait survives in the manuscript this seems clear evidence that it once contained a miniature portrait by Giovanni. Thus we have evidence that some twenty-five to thirty years later Andrea was unwilling to paint a miniature

[1] Louvre, Vallardi 2307 f. 61. Rep. Hill, G. F. 1929, pl. lxiii.

[2] Meiss, M. 1957, pp. 9–15. The reading of such letters of the cryptogram as occur only once is arbitrary, and one may substitute any other unidentified letter; perhaps HARAI would give better sense than FARAI in the second line.

[3] Letter from Federigo Gonzaga, Marquis of Mantua, to the Duchess of Milan, 20 June 1480, printed in Kristeller, P. 1901, p. 480 doc. 36.          [4] Zilliotto, B. 1950, p. 164.

and Giovanni was actually doing so—the *Descent into Limbo* at Bristol, which is of about the same date, is further evidence of Giovanni's activity as a miniaturist at this stage of his career[1]—but we cannot argue too confidently from this about his activity in the early fifties. In the last resort the probability of Mantegna's authorship must depend on how far we accept the concept of a Bellinesque element in his work. I have already mentioned the Prado *Dormition of the Virgin* as evidence of this; and the arguments by which Adolfo Venturi supported his attribution of the painting to Giovanni, though they do not convince as to the actual authorship of the picture, acutely underline its approximation to Giovanni's style.[2] Formerly the majority of what are now accepted as Giovanni's early paintings went under the name of Mantegna but now, apart from Venturi's attribution of the Prado picture and the doubt which I have just raised about the Washington portrait, the division of paintings between the two artists would be broadly agreed. In the field of drawings this is not so, and before continuing the study of Giovanni's early paintings we should turn to consider his relation to Andrea as a draughtsman and what drawings, if any, can be reasonably accepted as his.

The task of distinguishing Giovanni's drawings was first undertaken by Morelli[3] and he applied to it the same principles of stylistic and morphological analysis as he used in distinguishing his paintings. The result was that among the pen-and-ink drawings assigned by tradition to Mantegna he assembled a small but reasonably coherent group which seemed to show a more painterly and atmospheric style than drawings which are authenticated as Mantegna's either by genuine signatures like the *Judith and Holofernes* of 1491 in the Uffizi or by the direct approximation of their style to his paintings and engravings, like the *Madonna and Child with an Angel* in London. Morelli's group was later enlarged by von Hadeln,[4] applying the same principles. There is no doubt that this division of the drawings corresponds neatly to that which is universally accepted as correct with regard to the paintings, and it is widely regarded as having equal validity. Yet its acceptance involves grave difficulties, which led Clark in 1930[5] (though he afterwards changed his view) and later the Tietzes,[6] to restore a substantial number of these drawings to Mantegna. The difficulty arises from the fact that not only can none of these drawings be closely linked with any authenticated compositions of Giovanni's (which would not in itself be very serious), but that it seems impossible to exclude from the group

---

[1] See below, p. 75.        [2] Venturi, A. 1924, pp. 139 ff.        [3] Morelli, G. 1892–3, i. 271.
[4] Hadeln, D. von, 1925, pp. 16 and 46–52, and 1932, *passim*.
[5] Clark, K. 1930, p. 182–7, and 1932, *passim*.        [6] Tietze, H. and Tietze-Conrat, E. 1944, pp. 73–94.

drawings which appear on the face of them to be preliminary studies for works authenticated as by Mantegna or closely associated with him. The crucial drawing is the wonderful study in the Gathorne-Hardy collection which relates to the lower part of the fresco of *St James Led to Execution*, (Pl. v *a*) formerly in the Ovetari chapel. This drawing was unknown to Morelli but it is now generally thought that it is by the same hand as the *Pietà* in the Venice Academy (Pl. vi *b*) and the *Entombment* in Brescia (Pl. vi *a*), which are central to the Morelli group; though von Hadeln and more recently Muchall-Viebrock have rejected this view.[1] Now the Brescia *Entombment*, and a similar sheet of studies with variants of the body of Christ on one side and a study of two of the Three Maries on the other in London (Pl. vii), are related to the upright engraving of the *Entombment* (B. 2), generally recognized as a product of Mantegna's studio; while another drawing, similar in style, the *Christ at the Column* (Pl. viii *b*), now in Count Seilern's collection in London, is even more closely related to a similar engraving. Moreover, another drawing, at Chatsworth (Pl. viii *a*), also claimed by Morelli for Giovanni, is a variant of the left wing of Mantegna's S. Zeno altar.

Berenson has dismissed almost entirely the possibility of identifying the authorship of drawings by their relation to finished compositions,[2] and it is very likely true that the majority of drawings closely related to finished painted compositions will turn out on examination to be copies after them rather than preliminary studies, and the more exactly they correspond to the finished work the more likely this is to be the case. There will even be cases—though not perhaps so numerous as Berenson suggests—where very considerable variations from the finished work betray no more than the haste or the fancy of the copyist, but the principle as laid down by Berenson seems much too sweeping and may perhaps be seen as a rather unfortunate attempt to preserve the study of drawings as a field of pure dilettantism. In all cases where a drawing shows a recognizable relation to a finished composition we must ask ourselves, without applying any general principles, whether, in this particular instance, the character of the drawing and especially the nature of the points in which it differs from the finished composition suggest that it is a copy or variation or, on the other hand, that it represents a logical step in the evolution of the finished design.

In the case of the Gathorne-Hardy drawing I do not myself think it possible that, whoever drew it, it represents anything but a preliminary stage in the evolution

---

[1] Hadeln, D. von, 1925, p. 34 and 1932, p. 229. Muchall-Viebrock, T. 1942, p. 73.
[2] Berenson, B. 1938, I. xii.

of the design of the fresco. To save Giovanni's authorship, while admitting this, it has been suggested that this is a copy by Giovanni of a lost study by Mantegna for his fresco,[1] and stress has been laid on the stylistic differences which distinguish this and related drawings from such undoubtedly authentic drawings of Mantegna's as those referred to above. But the style of a drawing must be judged with reference to its intention. The Uffizi *Judith* and the *Virgin and Child with an Angel* in London are highly finished works and one may reasonably regard the Uffizi drawing as a complete work of art in its own right, perhaps one of the earliest examples of a 'presentation drawing', and the London one as either the same thing not fully completed or else as a detailed study for graphic reproduction, and all the highly finished drawings of Mantegna's as falling into these categories. Such drawings do not necessarily tell us anything of the style and technique which Mantegna would have used in preliminary studies for large-scale figure compositions. If we are to suppose that the Gathorne-Hardy drawing is a copy by Giovanni of a preliminary study by Mantegna for his fresco, what did such a study look like? Surely not very like the Uffizi *Judith* or the London *Madonna*. In fact when we come to visualize such a study we shall find ourselves driven to suppose something very much like the actual drawing itself. To me the conclusion that the Gathorne-Hardy drawing can only be Mantegna's own preliminary study for his fresco is inescapable, however disturbing such a conclusion may be.

The drawing at Chatsworth, connected with the left-hand panel of Mantegna's S. Zeno altar, seems to be in just the same position.[2] One cannot understand the purpose of this drawing as a variation of Mantegna's finished picture, though it is interesting to note that it was made at a time when the design for the frame had already been determined, since the profiles of the basis of the frame pilasters at each side of the drawing are correctly rendered. We can, I think, understand the problem which Mantegna was exploring here. He wished to arrange his flanking saints in such a way as to emphasize the recession of the composition in depth, but this has resulted in their becoming crowded on the left, leaving an uncomfortable gap on the right. In the finished picture he has solved this problem both by grouping the figures slightly more widely and by narrowing the field to be filled by the introduction of wider painted rectangular pillars behind the half columns of the

---

[1] Paccagnini, G. 1961, p. 174, accepts this solution which Fiocco had proposed in 1933 (pp. 185–6), but Fiocco (1949, p. 42) was himself later more cautious: '[Giambellino] che interpreta l'affresco famoso di Padova, e forse si giova di qualche studio che l'ha preceduto.'

[2] Tietze H. and Tietze-Conrat, E. 1944, no. A. 295 p. 84. The graphic quality of the drawing does not seem very high, and it may be a student's copy of a lost drawing of Mantegna's.

frame. Again it seems to me perverse to regard the variant poses of the *Christ at the Column* in Count Seilern's drawing[1] as anything but stages towards the final solution represented by the engraving (B. 1). The relation of the drawing of the *Entombment*[2] in Brescia and the similar sheet of studies in the British Museum[3] to the upright engraving (B. 2) is not quite so close, but its nature is the same, and in the studies of the lying nude on the verso of the British Museum sheet we seem also to see the first steps towards the composition of the foreshortened *Dead Christ* in the Brera. Von Hadeln was surely wrong in rejecting all connection between the engravings and the drawings,[4] and the profoundly Mantegnesque character of the engravings makes implausible Clark's suggestion that they themselves are products of Bellini's studio.[5]

We thus find the contemporary study of Mantegna's drawings at the opposite pole to that of Michelangelo's. In Michelangelo's case, critics basing themselves on his free preliminary studies refuse to recognize his hand in such finished master-pieces as the *Archers Shooting at a Herm* and the *Bacchanal of Children* at Windsor; in Mantegna's case starting with the highly finished pieces like the Uffizi *Judith* and the British Museum *Virgin and Child with an Angel* they are unwilling to accept his authorship of the free preliminary studies. If the conclusions suggested here were accepted they might open the way to a revaluation of Mantegna: the stoic mar-moreal clarity of his finished paintings would then be seen as involving the bridling of freer, more romantic, and pictorial elements, which only find expression in his preliminary sketches. But to pursue an inquiry along these lines would lie outside the scope of the present book.

Considering how close Giovanni sometimes comes to Mantegna in his early paintings it would not be surprising if his style of drawing were at times equally close, and the acceptance of some drawings of this type as Mantegna's does not mean that none can be by Giovanni; but a plausible line of distinction is very hard to draw. The resemblance of the figure of Christ in the beautiful upright *Pietà* drawing in the Venice Academy (Pl. VI *b*)[6] to that in Giovanni's painting in the Correr (Pl. XVIII *a*) is so close that one would like to see the drawing as Giovanni's, but can we really separate it from the Brescia *Entombment*? The fine *Pietà with*

---

[1] Tietze, H. and Tietze-Conrat, E. 1944, no. 317 p. 88.
[2] Ibid., no. A. 291 p. 83.
[3] Ibid., no. A. 311 p. 87. Popham, A. E. and Pouncey, P. 1950, no. 12 p. 8.
[4] Hadeln, D. von, 1932, p. 230.
[5] Clark, K. 1932, p. 235.
[6] Tietze, H. and Tietze-Conrat, E. 1944, no. 323 p. 89.

*St John and Two Maries* in the Louvre (Pl. v *b*)[1] and the related drawings in Rennes[2] and in the British Museum[3] would seem at first sight to form a slightly different group which might well be Giovanni's. The Tietzes have made suggestive comparisons between the Louvre drawing and a number of late paintings but the prominence given to the haloes would be surprising in the context of later work and the only parallel to the cross in Christ's halo is in the early *Pietà* in the Doge's Palace (Pl. xxiv *b*); if stylistic resemblances are to be any guide at all this drawing must be by the same hand as the sheet in the British Museum with the studies for an *Entombment*[4] which we have seen reason to regard as Mantegna's. The *Standing Saint with a Book* in the British Museum (Pl. ix *a*)[5] is perhaps a more plausible candidate, and might carry with it the drawing with four rather similar figures formerly in the Koenigs collection, Haarlem,[6] though they are weaker, perhaps too much so for either Giovanni or Mantegna. On the other hand, it seems to me that the beautiful *Standing Saint* in the Venice Academy[7] (Pl. ix *b*), one of the original group claimed for Giovanni by Morelli, should be returned to Mantegna on purely stylistic grounds. Indeed this seems to me a most valuable drawing, mediating between the 'fine manner' of the presentation type drawings Mantegna's authorship of which is undisputed, and the 'coarse manner' of the preliminary drawings for which I have argued Mantegna's authorship but which are widely ascribed to Giovanni. Byam Shaw has claimed for Giovanni a drawing in the École des Beaux-Arts, Paris, representing the *Descent into Limbo* (Pl. xiii *a*): it is closely related both to the engraving from Mantegna's school (B. 5), generally taken to follow a design of the master's, and to the painted version in Bristol widely accepted as Giovanni's and, according to Byam Shaw, is intermediate between the two.[8] If we were to accept

[1] Tietze, H. and Tietze-Conrat, E. 1944, no. 319 p. 88.

[2] Ibid., no. 321 p. 89.

[3] Ibid., no. 343 p. 92. Popham, A. E. and Pouncey, P. 1950, no. 13 p. 8, pl. xii. Parker, K. T. 1927, no. 42 p. 30. Parker notes the inscription 'Udine' on this drawing as intended to indicate the authorship of Giovanni Martini da Udine. The putti on the verso, which seem to be by the same hand as the recto drawing, do have a curious resemblance to those in the work of this painter: cf. especially the signed and dated Madonna of 1498 in the Correr, Rep. Berenson, B. 1957, i, fig. 488. One would be unwilling to ascribe so free a drawing to this timid provincial painter, but the evidence demands consideration.

[4] See above, p. 24. Note especially the rendering of Christ's head and hands in both drawings.

[5] Tietze, H. and Tietze-Conrat, E. 1944, no. A. 307 p. 86. Popham, A. E. and Pouncey, P. 1950, no. 11 p. 8.

[6] Rep. Hadeln, D. von, 1925, pl. 57. Tietze, H. and Tietze-Conrat, E. 1944, no. A 305 p. 86. A related but finer study of *Three Saints* was sold at Christies as Mantegna, 7 July 1959, Lot 60.

[7] Tietze, H. and Tietze-Conrat, E. 1944, no. A. 325 p. 90. Gamba's suggestion (1937, pp. 49–50) that the drawing might be for Giovanni's altar of San Giovanni Evangelista in the Carità is ruled out by the descriptions of that picture which show that it represented not an isolated figure of the saint but an incident from his life. See below, pp. 53–4.

[8] Byam Shaw, J. 1952, p. 327.

this it would show that Giovanni also had a 'fine manner' in drawing closely related to that of Mantegna; but it seems that in spite of its being, like the *Battle of the Sea Gods* at Chatsworth, in the same direction as the engraving, it should rather be regarded as Mantegna's original design. Not only do some of the points in which it differs from the engraving point in the direction of Mantegna and not of Giovanni—in particular, the forms of the rock behind the figures on the right-hand side with short broken ends such as we find in the oblong *Entombment* engraving (B. 3) and the *Madonna of the Stone Quarries* are quite unlike anything in Giovanni's work—but close parallels can be drawn between details in this work and in works that are certainly by Mantegna or his immediate assistants. The drawing of the head of the unfinished devil with a trumpet is extremely close not only to the head of Holofernes in the signed Uffizi drawing of 1491, but also to the *sinopia* of the fresco of the *Ascension* from S. Andrea at Mantua.[1] The fact that the face of Eve is left blank would not show in that case, as Byam Shaw suggests, a hesitation on Giovanni's part to reproduce the aged features of the engraving for which, in the Bristol painting, he substituted a young face; rather the hesitation will have been Mantegna's resolved in opposite sense by Giovanni, in the Bristol picture, and by the engraver.

The sheet with two studies of St John the Baptist, formerly in the Koenigs collection, Haarlem[2] and the related sheet in the collection of Col. J. W. Weld[3] (Pl. x a) seem again more probably Mantegna's work. The figures on the Koenigs sheets are closer both in form and feeling to the same saint in the San Zeno altar than to anything in Giovanni's authentic work (the somewhat similar painting of the Baptist in a private collection in Bologna recently claimed for Giovanni is of uncertain status).[4] In the Weld drawing the motive of the figure with the knee drawn up has been connected with Mantegna, and the composition of the central group with the Baptist bending down to speak to the foreground figure, whose head and shoulders only are seen, reminds us of the soldier in a similar position in the *Crucifixion* from the S. Zeno predella in the Louvre, and in a general way of the disposition of figures in the Eremitani frescoes rather than of anything in Giovanni's work.

[1] Rep. Paccagnini, G. 1961, pl. 51.

[2] Tietze, H. and Tietze-Conrat, E. 1944, no. A. 305 p. 86, pl. clxxxvi. 4. The Koenigs sheet disappeared during the war. The drawing of *Four Saints* referred to above, p. 25, was joined to this sheet, though not originally part of it.                                                                          [3] Gronau, H. D. 1949, p. 244.

[4] Rep. Berenson, B. 1957, i, fig. 203. Pallucchini, R. 1951, fig. 32. This picture is not known to me in the original. I cannot see in it a work of Giovanni's and would suspect that the author was Alvise Vivarini.

Among the drawings assigned to Giovanni by von Hadeln the one that seems to me the most plausible is the *Seated Man* formerly in the collection of A. G. B. Russell and now in the Boymans Museum Rotterdam (Pl. xi *b*).[1] While this fascinating drawing is clearly closely related to such works as the Gathorne-Hardy *St James Led to Execution*, it could be the work of another artist working in the same manner and it is not compositionally connected with any work related to Mantegna or his studio. As far as the subject and its treatment goes, but not it seems to me in its graphic quality, this drawing relates to the little panel of an unidentified classical scene painted in gold on a black ground formerly in the Contini collection in Florence (Pl. xxxv *b*), which I believe to be a work of Lauro Padovano executed in Giovanni's studio.[2] The beautiful pen-and-ink drawing of a *Nativity* in Count Seilern's collection in London might show a more advanced stage of Giovanni's adaptation of Mantegna's manner to his own needs; but its close relation to the mythological drawing ascribed to Cossa from the Skippe collection now in the Lehman collection, New York, which cannot be plausibly assigned to Giovanni, makes me doubtful of the attribution. This drawing finds its closest parallel in Giovanni's painting in the central panel of the predella of the *Coronation of the Virgin* in Pesaro and I shall discuss it further in that connection.[3]

There are two further pen-and-ink drawings which may be broadly considered to be in the Mantegnesque manner and which are widely ascribed to Giovanni, the *Madonna* (Pl. x *b*) in the Koenigs collection in the Boymans Museum, Rotterdam,[4] and the one formerly belonging to Professor Tancred Borenius in London.[5] These two drawings are clearly by the same hand but it is not clear that it is the same hand as that which executed any of the other drawings which we have been considering. The Boymans drawing has been regarded as a preliminary study for the *Madonna* in the Huntingdon collection, Pasadena, which is a very pedestrian product of the Bellini studio in the eighties, but it is quite clearly copied from a sculptured relief, as is shown by the way the shadows are cast on the background, and the Tietzes have drawn attention to some close parallels in contemporary sculpture. The Borenius drawing seems more likely to be after a painted model, but both drawings make the impression of being records of existing compositions rather than preliminary designs. The quality of the draughtsmanship though superficially attractive is fundamentally weak and I do not think they are the work of an artist of any great stature.

[1] Tietze, H. and Tietze-Conrat, E. 1944, no. A. 304 p. 86.
[2] See below, p. 48.          [3] See below, p. 72.
[4] Tietze, H. and Tietze-Conrat, E. 1944, no. A. 303 p. 85.
[5] Ibid., no. A. 315 p. 88. The drawing is now in the Sonnenberg Collection, New York.

Before leaving the question of the distribution of existing drawings between Giovanni and Mantegna I should like to consider one of a very different character, the black chalk study in the British Museum of a man's upturned head which was formerly ascribed to Melozzo da Forlì and for which Giovanni Bellini's name has been tentatively advanced (Pl. xi *a*).[1] Such an attribution is certainly attractive and comparisons suggested in the *British Museum Catalogue* with the Vincent Ferrer polyptych and the Pesaro *Coronation* are suggestive, but we should remember that Mantegna's work as a mural painter in fresco must have involved the production of numerous studies of this type, none of which seem to have come down to us. If we are to take the broader view of Mantegna's graphic activity which it seems to me the surviving drawings dictate, and particularly if we accept the Gathorne-Hardy drawing as his preliminary study for the fresco, we must ask ourselves, without being too much mesmerized by the detail and sharp finish of the end product, what the various intermediate stages would have looked like and whether there might not be room there for something very like this.

The results of this inquiry are, from the point of view of reconstructing Giovanni's artistic personality, disappointingly negative. We must recognize that there is no solid basis, outside the sphere of stylistic criticism, on which a study of Giovanni's earlier activity as a draughtsman can be founded. The plausible results obtained by Morelli and von Hadeln from a division of the drawings by stylistic criteria taken over from the paintings, conflict very seriously with the internal evidence supplied by the drawings themselves as to their connection with finished works in other media; for we find a sizeable number of drawings which are ascribed to Giovanni on stylistic grounds giving evidence of being preliminary steps in the evolution of finished designs which were the product of Mantegna's hand or at least his studio. My own view is that we must accept these drawings as Mantegna's and that we are forced to the conclusion that though we may possess some 'Mantegnesque' drawings of Giovanni's, such as the *Seated Man* in the Boymans Museum, there is nothing in this category which we can accept as indubitably his. It will be recognized at once that the broader view of Mantegna's activity which is the corollary of the narrowing of our view of Giovanni's would tend to support Meiss's attribution of the Arsenal miniatures to Mantegna, though it does not prove it.

[1] Popham, A. E. and Pouncey, P. 1950, no. 16 p. 10.

# III

*The work of the 1460s.*
*Lauro Padovano*

ALTHOUGH the use of light in the Barber *St Jerome* is very characteristic of Giovanni the colour there is exceptionally restrained; in what I would take to be his next surviving work on panel, the small *Pietà* at Bergamo (Pl. XIV *a*), colour is, as in the miniatures of the Arsenal manuscript, of primary importance. It is indeed probably because it loses so much in a monochrome reproduction that this lovely little work, which was not included in the Venice exhibition, has been comparatively neglected. The brilliant red of the Madonna's mantle and the two shades of blue in that of St John set the tone of the picture, but this is sustained by an extraordinary wealth of local colour in the painting of the flesh, while the heads are relieved against the dark ground by delicately etched edgings of gold glory. The eyes of both the Virgin and St John are red with weeping. The formal and colouristic elements cannot be isolated from the emotional content of the picture. This is a tragic vision which is a sort of first study for the great *Pietà* of the Brera, but it has also in it an element of greater harshness which looks forward rather to the polyptych of St Vincent Ferrer in SS. Giovanni e Paolo, and the authentic signature here, IOHANNES. B., is important in that it establishes a point of reference for that puzzling ensemble in Giovanni's authenticated work.

The formal frontality of the design reflects something of the strength of the Byzantine tradition in Venice, so that the Greek inscriptions above the figures seem wholly in place. Yet we feel also the influence of another sort of rigidity, that of the pathetic angular art of Rogier van der Weyden, which is to be seen particularly in the pose of Christ and in the head of St John; although the pose of the saint, with his cheek supported on his hand, seems to derive from one of the putti in Donatello's bronze relief of the *Pietà* from the Santo altar at Padua. Another austere

influence may be that of Mantegna, whose three panels at the top of his *St Luke* polyptych in the Brera seem to be reflected here. If this is so it gives us a valuable cross-check on our dating, since the Brera painting was commissioned in August 1453 and the final payment made in February of the following year. One might well imagine that this picture was executed very little later than this date.

In the *Transfiguration* in the Correr Museum in Venice (Pl. xii) the treatment of the drapery and the marmoreal clarity and emotional intensity of the figures are closer to the style of Mantegna, and it seems more reasonable on chronological grounds to regard this as due to the direct imitation of Mantegna on Giovanni's part, rather than, as Hetzer has suggested,[1] to the common influence of the work of Castagno on both painters. The formal hieratic composition, on the other hand, is also more specifically Byzantine than that of the *Pietà*. In the landscape and the lighting of the picture, however, we see Giovanni's personal vision and touch fusing all these elements together and making them his own. We find here that light has the same unifying function as in the Barber *St Jerome*, while the use of colour is similar to but richer and more complex than that in the Bergamo *Pietà*. The picture which originally terminated in a cusped arch has been cut at the top, where we see the lower part of a red glory which probably originally contained the dove or a bust of the Father. Below this is a splendid sky flecked with clouds, reminiscent of that seen through the grill in the Chapter miniature in the Arsenal manuscript, against which Christ's figure shines, its drapery 'white as the light' between the brilliant violet, blue, red, and orange draperies of the two prophets. The draperies of the group of apostles against the more sober background of the mountain are quieter in key, yellow, pink, aubergine, and green, and the white of Christ's robe is picked up untransfigured in that of James's mantle. This marvellously varied harmony of colour in a figure group anticipates Giovanni's final masterpiece, the *Feast of the Gods*. It is in the landscape, however, that Giovanni's individuality finds its fullest expression. The mountain is highly formalized and the system of the rocks, like that of the drapery of the figures, owes much to Mantegna, but the dark distance to the left, with its winding river reflecting the brightness of the sky in its distant reaches, develops further the substantial and emotive use of light that we have seen in the Barber *St Jerome*. This emotive quality is particularly seen in the silhouette of the tree and the point of the Gothic spire against the sky. The river reappears flowing darkly across the left-hand corner of the foreground. In this love of water as well as in the effect of atmospheric saturation with which the

[1] Hetzer, T. 1957, i. 13.

light is rendered we glimpse the fundamental contrast between Giovanni's art and that of his brother-in-law. In Mantegna's work natural forms, distorted to a sort of sculpture, are presented with an unnatural clarity and there is an extraordinary sense of aridity. His *Madonna of the Stone Quarries* in the Uffizi may be taken, though perhaps an extreme case, to represent his lunar ideal of natural landscape.

Although it is not very large by the standard of Giovanni's later work this picture, which must have been originally nearly five feet high, is evidently a monumental altar painted for a church and not, like the other works we have considered, for private devotion, and the handling of the detail is correspondingly slightly coarser. It seems possible that it formed the central panel of a small polyptych and the accompanying panels might have given more evident relevance to the quotation from the Book of Job, MISEREMINI. MEI. SALTEM. VOS. AMICI. MEI., which appears on a large centrally placed *cartellino* at the foot of the panel, since its reference to the Transfiguration seems obscure. Perhaps, on the other hand, it is a prayer by the donor of the picture not directly relevant to its subject. The beautiful classical majuscules in which this inscription is written seem to stand between the two styles which Mantegna employed, in the signature on the *cartellino* and in the saint's name on the arch in his *S. Eufemia* of 1454 in Naples.[1] They are similar to those Giovanni had employed in signing the Bergamo *Pietà*. As to the date we are again without positive evidence. It must surely be later than the Birmingham *St Jerome* and could be contemporary with the Bergamo *Pietà*, which might indeed have formed part of the same complex were not the differences in scale of the figures too disturbing. The Transfiguration was made a Feast of the Church in 1457 and this might well have furnished the occasion for such a commission, but the devotion is older than this in Venice, and an earlier date for the picture cannot be ruled out; although the silver altar of this subject in S. Salvatore which used to be dated to the fourteenth century has now been shown to be of mid-fifteenth-century date and perhaps to depend partly on Giovanni's composition.[2]

In the *Transfiguration* the distant landscape is only glimpsed on each side of the mountain, while in the little *Crucifixion* also in the Correr Musem (Pl. XIII b) similar but more complex forms make a panorama across the whole panel. This is another small private work and the delicacy of its execution matches that of the Barber *St Jerome*. Gilding is again used in the groups of cherubs in the sky revealed in the cleaning of 1946. The composition is related to a drawing in Jacopo's Louvre sketch-book,[3]

[1] Meiss, M. 1960, p. 104.        [2] See Mariacher, G. 1961.
[3] F. 55ʳ. Rep. Ricci, C. 1908, i, pl. 65. Goloubew, V. 1912,ii, pl. lvi.

where there is an even heavier concentration of cherubs in the sky and where the gesture of the clasped hands, here given to the Virgin, is found in the St John. As in the Bergamo *Pietà*, the simplicity of composition and the expression of deep emotion remind us of the contemporary work of the Flemish school. The influence of Mantegna, though still strongly present especially in the draperies, is not quite so marked as in the *Transfiguration*, which would lead one to assign this work a slightly later date.

In this landscape too there is water and an increasing observation of light and atmosphere and from its study we may pass to that of the first of Giovanni's un-disputed masterpieces, a work which he equalled only at the highest peaks of his later achievement and which he never surpassed; the *Agony in the Garden* in the National Gallery, London, (Pl. xv). This subject was treated by Jacopo Bellini in a drawing in his British Museum sketch-book[1] (Pl. xvi *a*) and twice by Mantegna; once in the panel from the predella of the altar in S. Zeno at Verona, which is now in Tours (Pl. xvi *b*), executed between 1456 and 1459, and again in that in the National Gallery, London (Pl. xvi *c*), of which the date is not known. The germ of the other compositions undoubtedly lies in Jacopo's drawing, in which he has followed a practice common in his sketch-books of executing a self-contained composition on the right-hand page of a double opening and later extending it with a landscape on the left. Traces of this dichotomy are still clearly to be seen in Mantegna's S. Zeno predella which thus seems certainly to precede both his own and Giovanni's versions in London. This is important as determining their date to be not earlier than 1456, and probably at least a year or two later, since one would not expect the detailed designing of the predella panels to have been among the first tasks undertaken in connection with the S. Zeno commission. The chronological relation between the two London pictures is much more difficult to determine, and indeed it would, I think, be an unprofitable exercise to attempt it. On the other hand, a comparison between them is extremely valuable for the definition of Giovanni's style at this stage of his development and for the isolation of its peculiar characteristics.

What strikes us immediately is the relative compactness of Mantegna's composition and the diffuseness of Giovanni's. Mantegna's Christ kneels directly above the closed group of the apostles; in Giovanni's picture each figure is carefully separated. Similarly the forms of the landscape in Mantegna's picture draw the whole com-position together while Giovanni's lies wide open. The element of coherence there

[1] Ff. 43$^v$–44$^r$.

is supplied not by the architectural interlocking of forms but by the divine cement of the light of dawn flooding over the landscape. The lowlands still lie in the last shadow of night just as sleep still presses on the three apostles, foredone with watching, but the sky is aflame, and the sun, already touching cloud, turret, and hill-top, is about to come up. The essential truth of the presentation is startling especially when we note the actual inconsistencies in the sources of light in the picture, silhouetting the hills and horizon and lighting the under-edges of the clouds but also shining on the face of the building on the hill to the left and falling on the back of Christ's figure, casting his shadow before him on the rock. The vividness with which an individual perception of the actual appearance of nature is here realized takes us back to the fresh vision of the natural world in the work of Conrad Witz and the master of the 'G hand' miniatures in the Turin hours. Light is seen here not, as in Mantegna's work, as the even medium through which, by its opposition to shadow, solid form is realized, but as something positive, a vibrating envelope by whose action the separateness of discrete forms is conciliated into a single whole—a many-coloured thing. This formal function of light is inseparable from its emotional contribution to the content of the picture. Light is seen here as love, the divine element permeating and binding nature and man in a single order. This realization of the formal and spiritual function of light is the true essence of Giovanni's achievement.

We can, as we have seen, infer a date later than 1456 for this picture by reference to Mantegna's S. Zeno predella, and a date in the first half of the 1460s would seem to accord well with the outline of Giovanni's development as we have tentatively drawn it. Another picture, also in London, the *Blood of the Redeemer* (Pl. XVII) is closely related to the *Agony* in style and cannot be far removed from it in date, though the somewhat softer treatment of the forms of the landscape would suggest that it is a little later. In this deeply moving picture we see particularly clearly the two influences under which Giovanni was at this period developing his absolutely individual style, that of his brother-in-law Mantegna, on the one hand, and that of contemporary Flemish painting, on the other. We see the Flemish influence in the linear character of the figure group and the way in which this is made to heighten the pathos of the presentation, as it is in van der Weyden's paintings, and in the type of Christ's face which recalls the work of the same master. The architecture of the city on the left has also a very northern character. We see equally plainly Mantegnesque inspiration in the firm perspective structure of the foreground platform and reference to the antique in the modelling of

Christ's figure, and in the reliefs which decorate the parapet which closes the pavement at the back. The folds of Christ's loin-cloth and of the angel's robe also recall this master.

This pattern of composition, with Christ embracing the cross and pouring the blood from his wound into a chalice, had been devised in Tuscany at the end of the previous century and in several examples it is found as the decoration of the door of a Sacrament Tabernacle. The scale of the London panel would accord well with such a use, and the hinges and keyhole which this would imply might have been accommodated in the moulded frame which certainly originally surrounded the panel. Unfortunately the back of the panel has been planed down and gives us no additional information, but it is tempting to think that this was the original destination of a painting whose purpose does not seem otherwise altogether clear.[1] The strongly architectural character of the foreground setting would harmonize very well with that of a tabernacle designed according to the Renaissance forms which were establishing themselves in Venice during the 1460s.[2] As I said a moment ago, I think that this picture while close in date to the *Agony* must be substantially later. I formerly suggested that it could be fairly securely dated before the issue of the bull of Pius II *Ineffabilis Summi Providentia* on 1 August 1464. The object of this bull, however, was to stop a theological dispute between the Dominicans and the Franciscans with regard to the veneration of the Holy Blood which had been raging for some years, and its effect was not to discountenance the devotion (to which Pius himself, as he tells us in his *Commentaries*, was sympathetic) but to freeze the *status quo*, which implied its continuance.[3] If we date the London *Agony*, by relation to the S. Zeno predella, about 1460, the *Blood of the Redeemer* might be as late as 1465.

There are elements, as I have said, in the figure of Christ which are deeply reminiscent of the tragic eloquence of contemporary Flemish painting. At the same time there is in this figure a classic elegance and self-sufficiency, and the pose, apart from the left hand, is almost identical with that of the bronze figure of the *Idolino* in the Archaeological Museum in Florence. This, however, cannot be its source: for this figure was only discovered some sixty years later, and moreover

[1] For the history of this iconographical type and for examples of its use for the decoration of a tabernacle door see Middledorf, U. 1962 and Horster, M. 1963. I have to thank the Director of the National Gallery for information about the back of the panel.

[2] See above, pp. 7 ff.

[3] See Robertson, G. 1960. For the text of the Bull *Ineffabilis Summi Providentia* see Raynaldus, *Annales Ecclesiastici*, x, Lucca, 1755, no. CIV, p. 381.

the pose here is clearly directly derived from earlier versions of the same subject which are themselves less classical. This shows us that the classicism which we see here is not due to the direct imitation of an antique example but to the absorbtion by Giovanni of the message of classical art, in the same way that we see it absorbed and re-expressed in the work of Donatello, Mantegna, and Piero della Francesca. The reliefs decorating the balustrade are, on the other hand, essays in the direct imitation of classical models, very much in Mantegna's vein. The subject of the right-hand relief was identified by Saxl as the story of Mucius Scaevola,[1] but this can hardly be correct since the caduceus held by the seated figure identifies him as Mercury and the gesture of the standing figure is a normal one for burning incense. One would like to see some interpretation which related the thymiaterion in the centre to the chalice held by the angel which it so closely resembles. The other scene represents a sacrifice to the dead, and as Davies has pointed out this pagan ceremony seems to be cancelled by Christ's outstretched hand.[2]

In the landscape Meiss has drawn attention to the contrast between the serenity of the open view and neat city in the clear light on the left and the gloom and ruin on the right.[3] The two figures in the left background—the foremost wearing a blue robe and carrying a white cloth—who seem to be proceeding from the dark to the light make the impression of having more than merely incidental significance. Their grouping suggests a priest with his acolyte taking the host to someone dying and this would be an appropriate incident, but the blue robe and the fact that the white cloth is grasped in the hand and does not cover anything excludes such an interpretation. Perhaps we have here a very modest expression of donor portraiture, which could indeed have hardly been more openly rendered if the panel is really a tabernacle door. A point of contrast between this picture and the *Agony* is the solid rendering of the halo in paint with a decorative border of cufic lettering. This is a type of halo which is found in several of Jacopo Bellini's Madonnas and in some of Mantegna's work but is not common in Giovanni's. It occurs elsewhere, I think, only in the *Trivulzio Madonna*, the *Pietà with two Putti* in the Correr, the *Pietà* in the Doge's Palace, and the *Madonna with the Sleeping Child* in the Venice Academy.

The Correr *Pietà* (Pl. xviii *a*) is in many respects closely similar to the *Blood of the Redeemer*, but it has not the extreme delicacy of that work and is harsh where that work is tender, recalling in this the earlier *Pietà* in Bergamo. It is not easy to explain this discrepancy in terms of chronological development. These pictures

[1] Saxl, F. 1939, p. 351.     [2] Davies, M. 1961, p. 61.     [3] Meiss, M. 1945, pp. 175–6.

seem rather to represent contemporaneous variations of manner. The contrast is particularly interesting as it seems to show, within what would be generally conceded as the authentic autograph production of Giovanni, differences such as, in a much more acute form, separate more disputable works, like the Carità Triptychs and the polyptych of *St Vincent Ferrer* from masterpieces like the *Pietà* in the Brera. The general arrangement and the relative scale of the putti to the figure of Christ here seem to reflect Donatello's bronze relief of the same subject from the Santo altar, but the actual forms are closer to those of Mantegna in the S. Zeno altar and this is one of the works in which Giovanni approaches his brother-in-law most closely. We can see this clearly if we compare the Correr picture with the signed *Christ in the Tomb* in the Poldi-Pezzoli Museum in Milan (Pl. xiv *b*). This is a very delicate and restrained work, and the contrast between the pale flesh of Christ with his white loin-cloth and the solemn landscape with its evening shadow, where the river winding far into the distance reflects a sky whose bars of cloud are tinged with pink, serves to throw into relief the dramatic Mantegnesque elements in the Correr picture. In spite of the greater softness of modelling in the *Blood of the Redeemer* the figure of Christ there is extraordinarily close to that in the Correr picture, and both strongly recall Count Seilern's drawing of *Christ at the Column* and that of the *Pietà* in the Venice Academy. If, as I have suggested above, those drawings should be ascribed to Mantegna, this further underlines the Mantegnesque character of this phase of Giovanni's activity.

These pictures may be accepted as the extreme point of Mantegna's influence; by contrast the *Christ Blessing* in the Louvre (Pl. xviii *b*), which cannot be far removed from them in date, represents Giovanni's closest approximation to contemporary Flemish art. Compared to the Correr *Pietà* with its classical beauty of form there is something almost unsophisticated in the rigid simplicity of the white-smocked figure, filling the picture with its candidly shining flat angular forms in a way that shows a rare inner kinship to the art of van der Weyden.

Before considering the *Pietà* in the Brera, in which all the diverse elements of Giovanni's early style are drawn into a perfect synthesis, we must consider both his early activity in a field with which he is particularly associated, that of the Madonna and Child, and also his early activity as a painter of monumental altarpieces, exemplified in the four triptychs from the church of the Carità now in the Venice Academy and the polyptych of *St Vincent Ferrer* in SS. Giovanni e Paolo. The Madonna paintings of this period which I want especially to consider are the two in New York, the *Davies Madonna* in the Metropolitan Museum, and that

in the Lehman collection, that in the Johnson collection in the Philadelphia Museum, and the *Trivulzio Madonna* in the Castello Sforzesco in Milan. The *Madonna* in the Museo Malaspina in Pavia seems to me too much repainted to afford a satisfactory basis for study, while that in the Rijksmuseum at Amsterdam and its replica in Berlin appear to be studio versions of a lost original of the period of the *Vincent Ferrer* polyptych.

It is not possible to arrive at an exact chronology for these early Madonnas or even to be quite certain of their proper sequence. The *Davis Madonna* (Pl. xix *b*) is perhaps the earliest, as it is in some ways the most beautiful. The relation of the figure-group to the landscape and the quiet solemnity of the whole composition recall the Correr *Pietà*, but apart from the clear and sculptural handling we are not very conscious of the influence of Mantegna here. The motive of the Madonna adoring the sleeping Child was a favourite one in the Vivarini studio and had been used by Antonio at least as early as 1450 in his polyptych in Bologna and probably earlier in the undated *Strauss Madonna*, while in her general character the Madonna owes much to Giovanni's father Jacopo. In fact the ingredients of the picture are somewhat similar to those of the Barber *St Jerome*, though the work is considerably more mature and seems unlikely to date from before 1460. The solemn quiet of the composition is echoed by the colour—light blue in the Madonna's mantle, pink in her robe, and dark green in the cushion under the Child's head. By contrast the *Lehman Madonna* (Pl. xix *a*) is colouristically one of the most brilliant and indeed startling of Giovanni's creations. The experience of every student who comes to this picture knowing it only in a monochrome reproduction has been well described by Berenson.[1] Indeed both in its formal elements and its colour this represents a more direct approximation to Mantegna than we expect. This is the only composition in which Giovanni has introduced the hanging swag of fruit, a Squarcionesque motive to which Mantegna remained long faithful; and though the colours—light crimson in the ribbons hanging from the swag, vermilion in the fruits, crimson in the Child's hood, and vermilion in his tunic, with blues of varying but great intensity in the sky and the Virgin's mantle, purple in her robe, and white in her veil—are not those that Mantegna himself uses, the brilliance and intensity of the combination surely derive from him.

The *Johnson Madonna* (Pl. xx *a*) has often been regarded as one of Giovanni's earliest works, but although Berenson's counter-suggestion of a date about 1470 is surely too late[2] there are reasons for suggesting a date not earlier than the mid-

---

[1] Berenson, B. 1916 (1), p. 71.          [2] Ibid., pp. 65-71.

sixties. Even if Berenson was over-confident in deriving the pose of the Child
from that of an incidental figure in Mantegna's *Circumcision* in the Uffizi (and the
resemblance though not conclusive is suggestive) the strongly Mantegnesque
character of the Child is undeniable, and in Giovanni's work he finds his closest
parallels in the supporting putti of the Correr *Pietà*. The spidery hands and papery
drapery, on the other hand, suggest a quite different influence, that of contem-
porary sculpture. We may particularly compare the Lombard statuette of the
*Madonna and Child* from the Foulc collection, now also in Philadelphia,[1] in the
style of the Mantegazza brothers, which can hardly have been created before
the mid-sixties if so early, and the related *Madonna* in the Madonna dell'Orto, Venice.
In contrast to the almost garish effect of the Lehman picture the colour here is
strikingly sober—dark blue-green for the Madonna's mantle, red for her dress, and
a sort of brown-aubergine for the Child's tunic. The background, which might
be taken for gold in a reproduction, is a cloudless blue sky. No landscape is visible.
This picture is particularly valuable among the uncertainties of Giovanni's earlier
work, as it bears a signature which, though damaged, is unambiguous and per-
fectly authentic.

The *Trivulzio Madonna* (Pl. xx *b*), now in the Castello Sforzesco at Milan, also
still retains just enough of its original signature to certify Giovanni's authorship,
which might otherwise have been doubted since it is in several respects rather
uncharacteristic. In the *Lehman Madonna* we saw an excursion into a richer and
more brilliant gamut of colour and the exceptional adoption of Squarcionesque
decorative motives. In the *Trivulzio Madonna* we see an enrichment of rather a
different sort, one of texture and decoration which looks back to the still funda-
mentally Gothic Madonnas of his father Jacopo, from which the halo, richly
ornamented with cufic lettering and gilding and set formally behind the Madonna's
head in a vertical plane, is directly derived. The rich brocade of the stuffs and the
decoration of the edge of the Madonna's dress with embroidery of gold and pearls
are also old-fashioned features. On the other hand, the colour is close to that of
the *Johnson Madonna*—pale pink for the Madonna's mantle and blue for her dress, a
sober dark green for the Child's tunic and a bluer green for the cushion on which
He sits, and a clear blue sky for the background—and the types of the Madonna
and Child are also close to those in this picture. For these reasons I think we should,
in spite of the dependence on Jacopo, date this picture no earlier than the mid-
sixties.

[1] Reproduced in Malaguzzi-Valeri, F. 1904, p. 117.

Such a recrudescence of his father's influence, even if it reflects in part at least the requirements of the patron rather than the preference of the artist, would be consistent with the hypothesis that he returned to direct collaboration in his father's workshop at this period. Such a hypothesis would seem to offer the least unsatisfactory explanation of the character of the panels of the four triptychs from the church of the Carità now in the Venice Academy (Pls. XXI, XXII, and XXIV *a*). We have no documentation or reliable tradition as to the authorship of these panels, which are first mentioned by Boschini in the seventeenth century as works of the school of the Vivarini.[1] We do, on the other hand, have considerable evidence as to their date.[2] We know that at the time of the suppression of the Scuola della Carità and the secularization of the church in 1807 they stood over four altars *sotto la barca*, that is to say under the gallery which ran across the nave of the church to form the choir, and further that four altar-pieces to occupy this position were ordered at various dates between 1460 and 1464; and we may presume that they were complete at least as early as the dedication of the altars in 1471. It has generally been assumed that the existing panels are those to which the documents refer and consequently that they are of prime importance, apart from the question of Giovanni's connection with them for determining the character of Venetian painting in the sixties. This view has, however, been attacked by Arslan in two careful and well-argued articles, in which he maintains that the panels which we possess are not the originals executed in the 1460s but represent an undocumented replacement which took place not earlier than 1490 and perhaps as late as the first decade of the sixteenth century.[3] If we are to accept this view the works then lose all historical significance and we would need to consider them no further.

To a great extent Arslan's articles consist of comparisons with works known to be later in date than the sixties and the assertion that the features which the Carità panels have in common with them could not have occurred earlier. This is an unsatisfactory line of argument: for our knowledge of what was or was not possible at a given date depends not on any intuitive sense but on the evidence of documented works, which is precisely what the Carità panels claim to be. He excludes Mantegna's S. Zeno altar from the discussion with the assertion that it is a 'unicum assoluto'. It is extraordinarily improbable that it should be so and the evidence of the Carità panels is that it was not. If they were produced with the participation of Giovanni what is more likely than that he would have been

---

[1] Boschini, M. 1664, p. 358.     [2] For the documentation of the Carità triptychs see Gallo, R. 1949.
[3] Arslan, E. 1951 and 1962.

influenced by his brother-in-law's major independent altar-piece? Similarly Arslan insists that the costume of the angel in the lunette of the *Annunciation* and of the flying angels in the lunette of the *Pietà* are influenced by Tuscan models of the last quarter of the fifteenth century, occurring first in Venetian painting in Carpaccio's *Blood of the Redeemer* in Udine of 1494. But (apart from the fact that Carpaccio's angels there are taken over from Giovanni's in his *Barbarigo Madonna* of 1488) exactly this type of costume is found in the angel in Giovanni's *Blood of the Redeemer* in London and in those in Bartolommeo Vivarini's *Madonna Enthroned* in Naples of 1465, and a very similar costume is found in the flying angels supporting the bust of St Mark at the top of the Porta della Carta of the Doge's Palace, which date from the 1440s.

Not only do the detailed arguments for the later dating of these panels appear unsatisfactory, but the basic hypothesis of a substitution some time between 1490 and 1510 is extremely difficult to accept. If we bear in mind that we are dealing with works not in some remote provincial parish church in the foot-hills of the Alps but in one of the major churches of Venice, it is not easy to visualize the circumstances under which earlier panels would have come to be replaced after 1490 by ones which, even in the 1460s, would with their gold grounds have appeared a little archaic. A further argument for the early dating of these altar-pieces may be drawn from the appearance of the lower part of a triptych of closely similar form, showing a standing Madonna flanked by the Baptist and St Sebastian, in the background of Bellano's relief of the *Miracles of the Ass* in the marble framing of the reliquary cupboard in the sacristy of the Santo at Padua, executed between 1469 and 1472. Not only the arrangement but the character of the figures, especially that of St Sebastian, is so close to the Venetian panels as to make one suspect a direct connection, perhaps through Jacopo's lost Santo altar-piece of 1460.[1]

What Arslan's analysis does usefully reveal is the extent of the forward-looking elements in the triptychs; and this confirms Berenson's hypothesis of Giovanni's collaboration in the series, since such elements in Venice in the 1460s could hardly stem from any other source.[2] Nevertheless, this hypothesis raises considerable difficulties. Even the finest parts of the series, such as the panel of *St Anthony Abbot* (Pl. xxii *b*) and the head of *St Dominic* fromt he lunette of the *Trinity* (Pl. xxiv *a*) are sensibly coarser than the works which we have so far considered, and much of the remainder is of a standard below anything that we have a right to ascribe to Giovanni. Although Arslan has over-stressed the Vivarinesque elements

[1] See above p. 12.    [2] Berenson, B. 1916 (2), pp. 62–78.

in these panels such elements do seem to be present and one has the impression that someone concerned in the work had served in the Vivarini studio. It does not seem very likely that the work was actually farmed out to more than one studio—the panels display too great a consistency for that—but one does have the impression of the activity of a large studio somewhat loosely controlled. In his later years we know that Giovanni presided over a large workshop but it does not seem likely that he did so as early as the 1460s; though it is possible, as Gibbons has suggested, that the studio might have been temporarily enlarged to cope with this commission.[1] We know, on the other hand, that Jacopo Bellini, by then one of the senior artists practising in Venice, was still receiving commissions as late as 1466.[2] The studio of Jacopo would seem *a priori* a likely place for the origin of these panels, and if we suppose that Giovanni returned at this time to assist his father, this would explain the forward-looking elements and those which specifically recall his individual style.

In view of the fragmentary state of our knowledge of Jacopo as a painter it is not very easy to confirm this hypothesis by comparison with painted works. On the other hand, significant parallels can be drawn between these panels and some of the drawings in the books in the British Museum and Louvre. In the first place the general arrangement of the figures, as it were in separate niches with shell terminations (which Arslan claims to be derived from Antonio Rossellino's sculptured altar-piece in S. Giobbe), can be paralleled in several drawings, particularly that on folio 67[r] of the Louvre book; though the shells are, as in the Rossellino example, the other way up.[3] The unusual motive of the standing *Madonna* (Pl. XXI *b*) is also paralleled there in the drawing on folio 68[r],[4] and the central motive of the *Trinity* lunette is closely linked with the drawing on folio 56[r] of the British Museum book.[5] These parallels reveal a fundamental similarity in the stylistic make-up of the Carità triptychs and the so-called sketch-books, both showing an ecclecticism embracing Tuscan elements. More detailed stylistic comparison cannot so easily be drawn. Arslan has pointed out that the drapery in the standing *Madonna* is more modern and less calligraphic and Gothic in the panel than in Jacopo's drawing, but striking resemblances remain, especially in the crumpled folds at the bottom of the skirt. If we remember that the drawings are perhaps some ten years older than the paintings, and that the actual designing of the panels, though

[1] Gibbons, F. 1965. p. 147.    [2] Ricci, C. 1908, i, doc. xix p. 56.
[3] Rep. Ricci, C. 1908, i, pl. 79. Goloubew, V. 1912, ii, pl. lxix.
[4] Rep. Ricci, C. 1908, i, pl. 80. Goloubew, V. 1912, ii, pl. lxx.
[5] Rep. Ricci, C. 1908, ii, pl. 56 *a*. Goloubew, V. 1912, i, pl. lxiv.

done in Jacopo's studio and with reference to the material in his sketch-books, may have been entirely left to assistants, the parallels may still appear significant. Some of the actual designing is probably due to Gentile, some to Giovanni, while some seems to be due to another artist who may have been trained in the Vivarini studio.

The exact history of the relations between Giovanni, his father, and his elder brother is obscure. As we have seen there is documentary evidence that Giovanni was living away from home in 1459 but also evidence that he was collaborating with his father and brother in the following year. It seems likely that independent activity and collaboration may have gone on side by side. To assess the value of the Carità panels for an understanding of Giovanni's development is not altogether easy, seeing how far the work was evidently one of collaboration, but we may say that the emphasis throughout is rather on strength than on delicacy and that delicacy has indeed been deliberately sacrificed to an effort after monumental effect. We have seen something rather similar in comparing the Correr *Transfiguration* with such works as the *Agony* and, in both cases, we should remember that the coarser works were designed for a setting where general effect was more important than detail. In spite of the crudities of even the best panels from the Carità series, such as the *Baptist* from the *St. Laurence* triptych (Pl. xxi *a*) and the *Anthony Abbot* from the *St Sebastian* triptych (Pl. xxii *b*) and parts of the *Trinity* lunette (Pl. xxiv *a*), there is a positive gain in monumental effect to counter-balance the great loss in sensitivity of handling, and we see here the appearance of something which made a vital contribution to Giovanni's total achievement. In seeking for models which may have helped Giovanni to this achievement we should think not only of Mantegna and his S. Zeno altar, but also of Castagno and of the work of Marco Zoppo, who is known to have been in Venice in 1461 and 1462. The possible influence of contemporary sculpture, particularly that of Donatello's Santo altar and his wooden figure of the *Baptist* in the Frari and that of Pizzolo's altar in the Ovetari chapel, must also be borne in mind.

Two drawings ascribed to Giovanni present parallels with the panels of the Carità altars. The *St Sebastian* in the British Museum (Pl. xxiii *b*) recalls Mantegna's figure in Vienna, but also Giovanni's figure of Christ in the London *Blood of the Redeemer*. It might well be a preliminary study for the figure of the saint in the Carità panel (Pl. xxii *a*). A resemblance has been rightly noted between the roughly drawn head in black chalk on the back of this sheet (Pl. xxiii *c*) and the head of St John in Giovanni's *Agony in the Garden* in London.[1] This head also recalls the rough

---

[1] Popham, A. E. and Pouncey, P. 1950, no. 18 p. 12. Tietze, H. and Tietze-Conrat, E. 1944, no. 308 p. 86.

studies in black chalk on the backs of the Carità panels and the *Vincent Ferrer* altar-
piece, but it seems to me that the majority of those scribbles represent the lunch-
hour recreations of the junior apprentices in the studio rather than the hand or ideas
of the master.[1] Even the much praised study of a nude man with a horse on the back
of Giovanni's *Peter Martyr* in Bari seems to me to be the rather conventional
work of a pupil.[2] The splendid *Head of an Old Man* at Windsor (Pl. XXIII *a*), which is
among the finest drawings ascribed to Giovanni and one of those where the attribu-
tion is most convincing, has been claimed as the preliminary study for the *St
Anthony Abbot* of the Carità panels.[3] This seems probably to be correct, but if so the
comparison serves to show how far even the better parts of the Carità complex fall
below Giovanni's highest standard. To see the true parallels to this head in Giovanni's
work we must look forward to the heads of the flanking saints in the Pesaro *Coro-
nation* and to those in the Vatican *Pietà* which originally surmounted that work.
There is, however, a calligraphic element in the drawing which suggests that it
should not be dated so late but rather to the time of the Carità panels, certainly
not to the end of the century as proposed by the Tietzes.[4] The inspiration of the
*St Anthony Abbot* figure, with its shrinking pose, seems to derive from the *St
Prosdocimus* of Donatello's Santo altar and the drawing may be regarded as
intermediate between Donatello's statue and the painted panel.

The figure in which we seem to come closest to Giovanni as he has revealed
himself to us in the smaller works already studied is that of *St Dominic* in the
lunette of the *Trinity*. The character of this figure leads us directly to what, if we
accept Giovanni's authorship, must be the earliest of his surviving major altar-
pieces, the polyptych of *St Vincent Ferrer* (Pls. XXV—XXVIII *a* and XXIX) which
stands over the second altar to the right in the nave of SS. Giovanni e Paolo. This
work is recorded as being Giovanni's by Sansovino in 1581, and it is extremely
probable that his notice derives from the lost portion of Marcantonio Michiel's notes,
dealing with Venetian churches, though this cannot be proved.[5] With regard to
the date we know from a document that an altar for the Scuola of St Vincent
Ferrer was being constructed in 1464, which assures us that the panels will not have
been begun earlier than that date and suggests that they will have been executed
about this time or a little later.[6] This would place them immediately after the
Carità panels, which seems plausible on purely stylistic grounds. A cross-check on

---

[1] Fogolari, G. 1932.       [2] Frizzoni, G. 1914, pp. 38–39.       [3] Parker, K. T. 1928, pp. 19–20.
[4] Tietze, H. and Tietze-Conrat, E. 1944, no. 328 p. 90.
[5] Sansovino, F. 1581, p. 23ᵛ. For Sansovino's use of Michiel see Hadeln, D. von 1910.
[6] Fogolari, G. 1932, p. 388.

the dating is provided by the close stylistic relation between the polyptych panels and the panel of the *Legend of Drusiana* in the Wittelsbach collection which probably formed the predella of an altar-piece datable between 1468 and 1471.[1]

Arslan has attacked the early dating of these panels and their attribution to Giovanni on much the same grounds as in the case of the Carità panels, though he recognizes their superior quality.[2] Some of the arguments for a later dating of these panels are more substantial than those advanced in respect of the triptychs. First of all there is the motive, in the central panel of the predella, of the man turning round to speak to his servant, which seems clearly to be connected with a similar passage in a group of the Gonzaga family in Mantegna's fresco in the Camera degli Sposi in the castello at Mantua. Since the whole of that decoration is dated 1474 a necessarily later date might be inferred for the panel. On the other hand, the date probably records the completion of a work of which the planning and even the execution may have begun considerably earlier, and if the artist had had any close link with Mantegna he might have derived the motive from a preliminary study rather than from the finished fresco. It has also been pointed out that the form of the polyptych, with the square panels of the *Annunciation* in the upper register over the figures of the flanking saints, does not otherwise occur in north Italy until a later date; while it is found in the polyptych in Messina painted by Antonello in 1473, before he is known to have visited Venice, so that it is possible that this system was introduced to Venice by Antonello himself in a work now lost.[3] On the other hand, this form does not seem to have any more recognizable ancestry in Naples or Sicily than in the Veneto, and it is possible, as I shall argue later, that Antonello had in fact visited Venice earlier than 1473 and that his Messina polyptych may in this respect depend on that of *St Vincent Ferrer*.[4]

The detail of the frame has also been held to indicate a substantially later date for the painting. Fogolari supposed that the present frame was a replacement, made in the early sixteenth century, of an original frame of Gothic character, but this does not seem likely and the letter, probably of 1523, which he cites plainly refers to the construction of the present marble frame in which the whole polyptych and its wooden frame is set.[5] It is undoubtedly true that this type of polyptych and frame decoration enjoyed great popularity, especially in provincial centres, at a date later than the sixties of the fifteenth century—it was indeed to be imposed on Titian for his altar-piece in SS. Nazzaro e Celso in Brescia, finished as late as 1522.

[1] See below, p. 47.    [2] Arslan, E. 1952.    [3] Robertson, G. 1950.
[4] See below, p. 58.    [5] Fogolari, G. 1932, p. 389.

The scheme is rare in Venice itself in painting though there are several examples in sculpture, for instance one in stone in one of the transept chapels of SS. Giovanni e Paolo itself and a wooden one in the Frari devised as a setting for Donatello's *Baptist*. It seems at least possible that the *Vincent Ferrer* polyptych is the prototype which was copied in the provinces, but denied its natural development in Venice itself since it was eclipsed in popularity by the centralized unified type of composition introduced during the eighth decade by Bellini in his burnt altar-piece, also in SS. Giovanni e Paolo, and by Antonello in his in S. Cassiano.

As we have seen in the first chapter, the materials for tracing the development of Renaissance forms in Venice are very imperfect. It certainly does not seem possible to point to any other piece of wood sculpture of so developed a Renaissance character to which one could definitely assign a date in the seventies or earlier, but we must again refer to the S. Zeno altar of Mantegna. This, which should not be dismissed as an isolated phenomenon, shows that a carved altar of Renaissance design was possible in North Italy not only before 1470 but before 1460; and if we are to suppose, as seems probable, that Mantegna furnished the design himself, it is equally possible that here the design may have been furnished by Giovanni. That a Renaissance low-relief decoration of this general type was part of the repertory of artists working in Venice by the mid sixties is proved by the frame of the marble relief in the chapel of S. Clemente at St Marks and the Madonna's throne in Bartolomeo Vivarini's altar-piece in Naples, which are both dated 1465.[1]

The question of dating is vital to that of attribution, for if the work is Giovanni's it is not possible to integrate it into a rational presentation of his work at a date later than the early seventies at the latest. Since it does not seem possible to establish with certainty that the panels must have been executed after this time we must proceed to a stylistic examination to see whether they do seem to be by the same hand as works authenticated as Giovanni's. If we conclude that they may be so, we must consider their significance in his development and total achievement. First of all we have to decide whether, as has been sometimes suggested, we are faced here with a diversity of hands. In so far as the whole complex presents a certain incoherence this hypothesis is tempting but study of all the panels under favourable conditions in the 1949 exhibition did not confirm it; on the contrary, their most striking common feature is their hard vitreous quality of surface and modelling, which seems to show them as undoubtedly (with the possible but not likely exception of the predella) the work of a single hand. The real diversity visible in

[1] See above, p. 8.

the panels seems to be rather that of a single hand reproducing diverse models than that of a collaboration of artists producing separate panels.

Since Longhi focused attention on this work in 1914 by reviving Sansovino's attribution to Giovanni, critical opinion has been sharply divided both as to its quality and its authorship.[1] A majority of critics have followed Longhi and some have acclaimed the work as not only authentically Giovanni's but among his greatest masterpieces; while others, though admitting Giovanni's authorship, have done so with regret, and a stubborn minority has refused to recognize his direct connection with the panels altogether. Among those who have denied Giovanni's authorship there has been no agreement as to an alternative name and none of those put forward seems really plausible. The more one studies Bonsignori the more one becomes impressed by the quality of the *Vincent Ferrer* panels as something beyond his range, and the same may be said of Bartolomeo Vivarini. As to Gentile Bellini, whose authorship I at one time favoured myself,[2] there is really very little material for direct comparison, but what there is does not suggest that anything as powerful as this could be from his hand; and Carpaccio is really out of the question. Nevertheless, their essentially Paduan qualities—the hardness of handling throughout and the way in which the light serves, as in Mantegna, to separate forms rather than to unify them—do make it difficult to accept these panels as the authentic work of Giovanni.

There is, on the other hand, another work, apparently genuinely signed by Giovanni, which presents somewhat similar characteristics and which seems to give good grounds for accepting the *Vincent Ferrer* panels as at least issuing from his studio. This is the *Pietà* in the Doge's Palace (Pl. XXIV b). This canvas is in very bad condition, but since it has been freed from the repaints of the sixteenth and eighteenth centuries its relation to Giovanni's other work can be fairly judged and it seems really close in style though now at least inferior in quality to the *Vincent Ferrer* panels. The situation is complicated by the fact that the picture, although not now dated, is reliably reported once to have borne so late a date as 1472. This is first reported by Zanetti[3] in the eighteenth century and one might suppose, careful student though Zanetti was, that he had made a mistake, especially since before its restoration in 1948, when the additions and alterations of the sixteenth century were removed, it bore also the inscription MDLXXI / RENOVATVM, which might have been a source of confusion. Moschini's edition of Ridolfi's life of

[1] Longhi, R. 1914, pp. 241 ff. For the full bibliography of this work see Pallucchini, R. 1959, p. 134.
[2] Robertson, G. 1950.    [3] Zanetti, A. M. 1771, p. 49.

Giovanni of 1831, however, reports both dates as on the picture in a form which makes it difficult to suppose he did not actually have two inscriptions before him.[1] The date is further confirmed by the presence of St Nicholas in the picture, which would indicate the Dogeship of Nicolò Tron (1471–3). It is very difficult to believe that this really represents Giovanni's own hand in 1472. Hendy's suggestion that the hand is Gentile's,[2] which was received with some favour in the catalogue of the 1949 exhibition, does not seem very probable, even though there is evidence that Gentile and Giovanni were collaborating at about this time,[3] since the style of at least the main group is closer to that of the *Vincent Ferrer* panels than to any authenticated work of Gentile's.

On the other hand, the hypothesis that an able assistant working for Giovanni was entrusted with the execution of the *Vincent Ferrer* polyptych and the *Pietà* in the Doge's Palace would offer a possible explanation of the facts, and I would like to suggest that their execution might be ascribed to the hand of Lauro Padovano. Although Lauro is known to us from documentary sources chiefly as a miniature painter,[4] there is reason to believe that he may have been collaborating with Giovanni in the production of altar-pieces around 1470, that is to say just at the period in which we are interested. Marcantonio Michiel in his notes on the church of the Carità, the only part of his notes on Venetian churches which has survived, records the altar-piece of *S. Giovanni Evangelista*, which we know to have been executed between 1468 and 1471,[5] as the work of Giovanni and states that he thought that the predella was the work of Lauro.[6] This predella is almost certainly identical with the panel with scenes from the story of Drusiana which was formerly in the Kaufmann collection in Berlin and now forms part of the Wittelsbach collection (Pls. xxx, xxxi). The close relation between this panel and at least the predella of the *Vincent Ferrer* altar-piece has been widely recognized, though Arslan has dissented,[7] and it has been thought that if the Drusiana panel is by Lauro so is the *Vincent Ferrer* predella. There has also been an alternative tendency to see the Drusiana pictures as an integral part of Giovanni's work, and to reduce Lauro's

---

[1] Moschini, G. A. 1831, p. 21 n. 3: 'Vi si legge Joannes Bellinus MCCCCLXXII. In un canto sta scritto MDLXXI renovatum.' The signature now visible reads IOHANES · BELLINVS.

[2] Hendy (1945, p. 11) regarded the 'mis-spelt' signature as part of the sixteenth-century additions, but it survived the restoration of 1948 and was apparently considered genuine. The lettering looks convincing. The source of the design is a drawing of Jacopo's in the Louvre sketch-book, fol. 53ʳ. Rep. Ricci, R. 1908, i, pl. 63. Goloubew, V. 1912, ii, pl. liv.    [3] See above, p. 12, n. 4.

[4] For Lauro Padovano see Gronau, G. 1921 and Moschetti, A. 1928.

[5] See Fogolani, G. 1932, p. 389 and Paoletti, P. 1893, i, p. 183.

[6] Michiel, M. A. 1884, p. 231.    [7] Arslan, E. 1952, p. 134.

part, if it is accepted at all, simply to the execution. I do not agree about this; there seem to me to be qualities of style in the Drusiana panel which are not quite those of Giovanni. A tendency to envelope the figures in long oval folds and the striking and rather dry classicism seen particularly in the profile of the kneeling woman in the central section are both unlike his work. There are a number of other works which can be associated with the Drusiana predella and thus with Lauro which it would be best to discuss before approaching the question of his possible execution of the main panels of the *Vincent Ferrer* altar itself.

First of all there is the drawing of the *Crucifixion* (Pl. xxxII *a*) in the British Museum, whose close relation to the Drusiana panel has been stressed by Popham and Pouncey.[1] We do indeed seem to see here the same particular sense of form which distinguishes the Drusiana panel from authenticated works of Giovanni's. Very closely related to this and to the Drusiana picture is the little panel in gold on a black ground with an unidentified classical subject, formerly in the Stroganoff collection and later in the Contini collection in Florence (Pl. xxxv *b*).[2] This work naturally challenges comparison with the similar feigned reliefs in the background of the *Blood of the Redeemer*, and the contrast between the dry and incisive drawing of the Contini panel and the more painterly feeling of the detail of the London panel is similar to the differences which we have noted between the Drusiana predella and authenticated works of Giovanni's. Another work which seems to me to display similar stylistic characteristics and at the same time to link up closely with the *Vincent Ferrer* altar-piece is the lovely drawing of a child which passed from the collection of Mrs. Broun Lindsay to the Ashmolean Museum, Oxford (Pl. xxxIII). The attribution of this drawing to Giovanni himself has been increasingly questioned[3] and the problem of its exact relation to him has been confused by the appearance of an almost identical child in the painting of the *Madonna* formerly in the Winthrop collection, New York, and now in the Fogg Art Museum at Cambridge, Mass. This picture has the appearance of a work of the eighties, a date

[1] Popham, A. E. and Pouncey, P. 1950, no. 15 p. 9. Tietze, H. and Tietze-Conrat, E. 1944, no. 312 p. 87. The Tietzes' discussion of this drawing is marred by a confusion between the chapel of St Nicholas in the cathedral at Verona where Jacopo Bellini executed a fresco of the Crucifixion in 1436 and the Gattamelata chapel in the Santo at Padua, where he executed an altar-piece of unknown subject in 1460.

[2] Dr. Victorine von Gozenbach Clairmont points out to me that the pose of the seated figure in this work is derived from an ancient statue or statuette of a philosopher such as the *Hermarchos* in the Archaeological Museum, Florence, or the *Metrodoros* in Copenhagen, both reproduced Schefold, E. 1943, p. 121.

[3] The drawing was accepted by the Tietzes (1944, no. 316 p. 88) but Longhi, cited in Pallucchini, R. 1949, p. 222, has proposed an attribution to Alvise Vivarini. The likeness to the baby in Alvise's *Madonna* from Montefiorentino at Urbino is marked, but not, I think, so much so as its likeness to the Christ Child in the St Christopher of the Vincent Ferrer polyptych.

at which it would be difficult to associate a drawing with such markedly Paduan characteristics with Giovanni's activity. The Winthrop picture is, however, so complete a ruin that it would be very difficult to determine its date, if indeed it is basically an original picture and not an imitation. The repetition of an earlier design at a later period in Giovanni's workshop is vouched for by the relation of the *Madonnas* in Berlin and Amsterdam, which must be studio versions of an early original which is lost, to the painting in Verona where we find the same design repeated in a much more developed manner.[1]

I do not think it is possible to find a closer parallel to the Child in the Ashmolean drawing than the Christ Child on the shoulder of St Christopher in the *Vincent Ferrer* polyptych. It seems to me that it has also a close relation to the *Drusiana* predella and the British Museum *Crucifixion* drawing and thus forms a valuable connecting link. The head in black chalk on the back of the sheet (Pl. XXXIV *a*) recalls that on the back of the British Museum *St Sebastian* and the scribbles on the backs of the Carità and *Vincent Ferrer* panels. The squared drawing of a female saint, in pen and wash, has a drapery system which may be broadly compared to that of many figures among the earlier products of Giovanni, but it is perhaps closest to the Virgin in the *Crucifixion* formerly in the Contini collection in Florence (Pl. XXXII *b*); which itself seems, on general grounds of style, to go with the Drusiana and Vincent Ferrer panels and which might be plausibly ascribed to Lauro. It is tempting to think that this is the 'Nostro Signore in Croce' which Boschini records as surmounting the altar-piece of S. Giovanni Evangelista in the Carità of which the Drusiana panel formed the predella.[2] If the female saint is Lauro's we should probably also ascribe to him the pen-and-wash drawing of the *Virgin and Child* in the British Museum (Pl. XXXIV *b*), claimed by Hendy for Giovanni and recognized by the Tietzes as close to the generation influenced by Mantegna's first style.[3]

A painting which seems to show an earlier phase of Lauro's development is the panel in the Venice Academy with St Ursula, four virgins, and a kneeling nun which bears the false signature of Caterina Vigri and the date, probably also false, of 1456 (Pl. XXXV *a*). We may particularly note the resemblance of the profile of the right-hand virgin to that of the kneeling woman in the centre of the *Drusiana* panel. This is clearly a much less mature work and its markedly Mantegnesque

[1] For the Verona Madonna see below, p. 79. I have to thank the Authorities of the Fogg Art Museum for allowing me to see the Winthrop picture in the restoration studio in 1963.     [2] See below, p. 54.

[3] Hendy, P. 1932, p. 67. Popham, A. E. and Pouncey, P. 1950, no. 17 p. 11. Tietze, H. and Tietze-Conrat, E. 1944, no. 313 p. 88.

characteristics would indicate the likelihood that Lauro was a pupil of Andrea's. Such a hypothesis might explain the appearance in the *Vincent Ferrer* predella of the motive related to that in the frescoes of the Camera degli Sposi at Mantua to which I have drawn attention. If Lauro had been a pupil of Mantegna's we might also ascribe to his hand the two dedication miniatures in the manuscript of Guarino's Latin translation of Strabo of 1459 now in the library at Albi. These represent Guarino presenting his book to Jacopo Antonio Marcello and Marcello presenting it to René of Anjou (Pl. xxxvi). Meiss has ascribed these miniatures to the studio of Mantegna and Fiocco to Marco Zoppo,[1] citing the drawings in the Rosebery volume in the British Museum in support of the claim. There is certainly some general resemblance to Zoppo's work, but the Albi miniatures lack just those qualities of sinuous and expressive outline which justify the attribution of the British Museum volume to Zoppo, and this attribution is unacceptable. Mantegna's studio seems a highly probable place of origin and it would be perfectly consistent, as far as we know, with Lauro being their author. There is nothing surprising in the idea that Lauro might have proceeded from the studio of Mantegna to that of his brother-in-law. Both the merits and the slight awkwardnesses of these miniatures seem to link them closely to the *Drusiana* and the *Vincent Ferrer* panels, especially to the *Vincent Ferrer* predella. Meiss has drawn attention to the attempt to give the miniature which represents Marcello presenting the book to René a convincing local setting in Provence by the introduction of the palm-tree in the background and of French shoes with long points into the costume, and he has suggested that for some of the details he was using a French or Flemish model. I should like to elaborate this hint by a comparison of this miniature with the coloured drawings by the René Master decorating the paper manuscript of King René's *Livre des tournois* in the Bibliothèque nationale,[2] and to suggest that Marcello had received from René or Cossa some work by the René Master, perhaps a drawing of René and his court, which he lent to Lauro as a model. I think the influence of this model, remained with Lauro and affected the grouping of his figures both in the *Drusiana* and the *Vincent Ferrer* predellas.

The argument with regard to Lauro and the *Vincent Ferrer* polyptych may be summed up as follows. We have in this altar-piece an impressive work, obviously closely related to Giovanni in style; but its harshness seems contrary to Giovanni's practice in other works apparently approximately contemporary with these panels,

[1] Meiss, M. 1957, pp. 30–51. Fiocco, G. 1958, p. 57.

[2] Bibl. Nat. MS. Fr. 2695. One drawing rep. Wescher, P. 1945, fig. 45; others *Verve*, iv, no. 16, 1946. Ring, G. 1949, p. 207, dates them about 1460.

which must have been executed between 1464, the date of the construction of the altar, and about 1472, the date of the *Pietà* in the Doge's Palace. Sansovino, the earliest writer who mentions the *Vincent Ferrer* polyptych, ascribed it to Giovanni, and was in this very probably following Michiel. We have in the *Pietà* of the Doge's Palace a work which presents much the same harshness as the *Vincent Ferrer* panels but which seems to be authentically signed by Giovanni and which is reliably recorded to have once borne the date 1472. We have in the *Drusiana* predella a work which Michiel thought (though he does not appear to have been certain of this) was by Lauro Padovano. On grounds of style this panel would seem to have been painted by the same hand as the predella of the *Vincent Ferrer* altar-piece. It seems quite possible that the two predellas and the main panels of the polyptych could be by the same hand. The drawing of a child at Oxford seems to be by the same hand as the main panels of the polyptych and is stylistically consistent with the *Drusiana* predella and with the drawing of the *Crucifixion* in the British Museum which has been independently assigned to the painter of the *Drusiana* panel. A possible inference is that, on both sides of 1470, Giovanni was entrusting important work to an able assistant who might be identified with Lauro Padovano. I have set out the argument like this in order to reveal its extreme tenuity. A particularly unsatisfactory feature is that it relies on a rather tentative statement of Michiel's, that he thought the predella of the altar in the Carità was by Lauro Padovano, to overturn another attribution which probably derives from him, that of the Vincent Ferrer polyptych to Giovanni. However, his statement about the Carità altar does seem to indicate that he had reason to suppose that Lauro was active not only as a miniaturist and that he had worked as an assistant in Giovanni's studio. If we fail to recognize Giovanni's own hand in the panels of the polyptych, Lauro is clearly a possible candidate for their execution, though the case would be greatly strengthened if we could point to any evidence for his activity as a painter on a scale greater than that of the *Drusiana* predella and the *St Ursula* in Venice.

Even if we do conclude that the execution of the *Vincent Ferrer* polyptych is to be assigned to an able assistant, Lauro or another, we must, I think, accept that the over-all conception was Giovanni's. I would suppose that he had furnished exact cartoons for the three main figures (Pl. XXVI) and the *Pietà* (Pl. XXVIII *a*), but that the two panels of the *Annunciation* (Pl. XXVII) were less strictly controlled. In the main panels we certainly see an attempt to obtain a monumental effect through the imitation of wood sculpture, especially of Donatello's *Baptist* in the Frari. There are also elements in the central figure of St Vincent which suggest a possible contact

with the art of Piero della Francesca (probably his lost frescoes in Ferrara), in the simple geometry of the figure and particularly in the treatment of his right hand. The *Annunciation* panels are rather curious and here the hypothetical executant assistant may have been left more to his own devices. The half-figure of the angel (Pl. xxvii *a*) is curiously flattened and has the appearance of a relief, while the figures in the other panels recall statues in the round, and it seems indeed to owe its origin to a relief sculpture—Donatello's Evangelist symbol from the Santo altar—and this borrowing seems ill-digested. The flatness of the figure, with its ugly profile (and it is the insensitive ugliness of this profile above all else that makes it so difficult to accept Giovanni's hand here at least) contrasts oddly with the three-dimensional effect in the corresponding panel of the Virgin, achieved by a subtlety of lighting which makes one suspect its ultimate derivation from an Eyckian model.

The harshness of the painting here seems to develop elements present in earlier works of Giovanni's, especially the Bergamo *Pietà*, the Correr *Transfiguration*, and in a lesser degree the *Pietà with two Putti* also in the Correr; and it certainly remains a question whether, in his search for an effective style for monumental church paintings, Giovanni could have hardened his own practice to this point. In this connection it is interesting to compare the *Pietà* from the top register of the polyptych (Pl. xxviii *a*) with the *Pietà with two Angels* in Berlin (Pl. xlii *a*). Although the date of 1465–70 proposed for this picture in the old Berlin catalogue is rather too early it is surely less misleading than the late datings, after the Rimini and London *Pietàs*, proposed by recent criticism.[1] The colour and the technique of this picture reveal it as unquestionably earlier than the *Coronation of the Virgin* at Pesaro (Pl. xlvi). It is in many ways closely related to such works as the *Frizzoni Madonna* (Pl. xliii *a*) in the Correr and represents the culmination of Giovanni's earlier manner. The colour, with the contrast of the flat turquoise-blue sky and the pink cloth behind Christ, is particularly beautiful. This picture must date from the early seventies and shows indeed Giovanni's style at the time of the Doge's Palace *Pietà* in an autograph and well-preserved example. The contrast with the *Pietà* from the Vincent Ferrer polyptych which presents a closely similar scheme is very striking. It raises insistently the question of whether in that work, even allowing for its being some years earlier in date, we are not approaching Giovanni at second hand, receiving his concept through the mediation of a harsher executant.

I have insisted on the Paduan character of the Vincent Ferrer polyptych and this

[1] Moschini, V. 1943, p. 22. Pallucchini, R. 1959, p. 61. Heinemann, F. 1959, i. 50.

may be thought of to a great extent in terms of the influence of Mantegna, but there is present too the influence of another pupil of Squarcione's—Marco Zoppo. The paintings lack his particular linear mannerisms, but certain details like the boot-lace forms in the hair strongly recall him, and the acceptance of the polyptych as Giovanni's and indeed as Giovanni's autograph work would be the necessary prelude to ascribing to him the *Head of the Baptist* in Pesaro (Pl. xxvIII *b*), as has been advocated by Longhi.[1] That this picture is extremely closely related to the work of Zoppo is beyond question, but it may also be urged that there is a delicacy about it and a Bellinesque quality in the lighting which it would be hard to parallel in Zoppo's authenticated work. If we accept the polyptych as wholly Giovanni's then we could well see this as a further development of the influence of Zoppo visible there; alternatively, and this seems to me the better reading of the evidence, we can see this as a work in which Zoppo, active in Venice in the sixties and seventies, approximates closely to his great Venetian contemporary. Another work in Pesaro has been claimed for this period of Giovanni's activity, the small *Crucifixion* with the Virgin, St John, the Magdalene, and two angels (Pl. xxxvII *a*). In spite of the distinguished critics who have hailed this disagreeable little picture as a masterpiece of Giovanni's,[2] it is impossible to find satisfactory parallels either for the staccato rhythms of the landscape and the figure group or for the harsh bright colour in his authentic work, and the attribution must be decisively rejected. This is a pity as its acceptance would allow us to include in Giovanni's *œuvre* a picture with a more direct borrowing from van der Weyden than we have yet encountered; for the Magdalene clearly depends on some such figure as the same saint in van der Weyden's *Entombment* in the Uffizi, a picture which may indeed at this time have been in Ferrara.[3] One should, I think, look for the author of this brightly coloured panel among the miniature painters, but if the Drusiana panel be Lauro's the hand here is not his, and though the picture contains Bellinesque reminiscences, such as the flying angels who are close to those in the Carità triptychs, one would not necessarily look for the author in Venice.

It is unfortunate that the main panel of the altar-piece of S. Giovanni Evange-lista in the Carità, of which the *Drusiana* panel formed the predella, is lost, since the literary sources suggest a picture of a type which is not represented in Gio-vanni's surviving work, a large-scale narrative picture. Gamba conjectured that it

---

[1] Longhi, R. 1927, p. 134.

[2] The attribution was originally proposed by Berenson and accepted by Fiocco, Gronau, Gamba, and Mos-chini. For bibliography see Pallucchini, R. 1949, p. 66.

[3] Habicht, V. C. 1931, p. 55.

represented a full-length standing figure of the saint and that the pen and ink draw-ing in the Venice Academy, for which I have argued a return to Mantegna,[1] was a study for it, but we can be sure that the picture was not of this type from Boschini's brief but suggestive description. He writes: 'Nella Capella di San Giovanni, dalla parte sinistra dell'Altare Maggiore, vi è una Tavola con molti casamenti, e quantità di figure; si dice concernenti la vita di S. Giovanni Battista: come anco a basso, vi è un' altro comparto in picciolo, con molte figure, e di sopra nella cima, nostro Signore in Croce; opera tutta di Vittore Carpaccio.'[2] We should note that 'molti casamenti' does not mean, as Cust translates it in Ludwig and Molmenti's *Carpaccio*, 'many divisions',[3] but that many buildings were represented in the picture. Evidently the picture showed an incident from the life of the saint in a townscape setting. It is usual for the *Ascension of St John* to be presented in architecture and I suspect, but this cannot be more than a suspicion, that not only was this the subject here, but that we have a reflection of Giovanni's picture, adapted to the subject of the *Assump-tion of the Virgin*, in Gerolamo da Vicenza's little panel, signed and dated 1488, in the National Gallery, London (Pl. xxxvii *b*). The reference of the altar to the Baptist instead of the Evangelist is a mistake of Boschini's, the attribution to Car-paccio his fancy.

I have left to the last the consideration of the *Pietà* in the Brera (Pl. xxxviii) not because it is absolutely the latest work in the series we have been considering (indeed in embracing the *Pietà*s in the Doge's Palace and in Berlin we have moved chronologically somewhat further, for though we have no positive evidence to date the Brera picture we could hardly advance it much beyond 1470) but because it represents in some ways the fullest development and most perfect expression of Giovanni's earlier manner. To praise or even to attempt to describe the beauty of this picture seems an impertinence. The whole work has a largeness of form greater than that which the Vincent Ferrer polyptych, for all its effort, had achieved, combined with a tenderness of surface and detail as great as any of his earlier works and such as the polyptych seems deliberately to have rejected. There is no over-emphasis of the drama of grief here, but a deeply restrained rendering of the beauty of sorrow that makes this one of the great classic achievements of European art. The colour is muted: a blue so dark as to be nearly black for the mantle of the

---

[1] See above, p. 25. Gamba, C. 1937, p. 49–40.

[2] Boschini, M. 1664, pp. 358–9. Boschini's attribution to Carpaccio of a picture which Michiel and Sansovino had given to Giovanni Bellini illustrates the extent to which his attributions rest on his own connoisseurship and not on tradition. It does not have to be seriously considered.

[3] Molmenti, P. and Ludwig, G. 1907, p. 195.

Virgin and the robe of St John, a pale purplish pink for the Virgin's robe, and a light blue for St John's mantle, while a touch of warmer colour is given by his auburn hair. The main emphasis of the lines of the figure group is starkly vertical and contrasts with the simple horizontal lines of the sarcophagus, the ends of which are not seen, and with the striations of cloud in the sky. As in the Poldi-Pezzoli *Pietà*, in which much that we see here is prefigured, and in the Correr *Transfiguration*, water flows through the background landscape. There is a perfect balance here between means and intention. Giovanni has developed the traditional tempera technique, which he inherited from his predecessors in Venice, to the fullest possible extent. We may suppose that Giovanni himself recognized this work as a special achievement, for instead of the usual signature just giving his name he added in beautiful classical lettering on a *cartellino* on the front of the sarcophagus a Latin couplet:

HAEC FERE QVVM GEMITVS TVRGENTIA LVMINA PROMANT

BELLINI POTERAT FLERE IOANNIS OPVS.[1]

---

[1] 'When these swelling eyes evoke groans this (very) work of Giovanni Bellini could shed tears.' The hexameter is perhaps a reminiscence of Propertius i. 21. 3: Quid nostro gemitu turgentia lumina torques.' I must thank Professor Charles Brink for help in translating the couplet and for the reference to Propertius.

# IV  *Antonello da Messina and the work of the 1470s*

THE formal language of the Brera *Pieta*, as well as its emotional intensity, is unimaginable without, behind it, the frozen passion of van der Weyden, but the technique is still that of dry hard tempera where modelling is achieved by hatched shadows which give the crisp edges and clarity of wood-sculpture. In the Brera *Pietà* this method is refined to a point where it achieves a subtlety of lighting and modelling comparable to that of Flemish painting, but there is as yet no approximation to the actual Flemish technique of oil glazes. In the works which follow the *Pietà* in the early seventies, such as the *Madonna with the Sleeping Child* in the Venice Academy, the *Frizzoni Madonna* in the Correr, or the *Pietà with two Angels* in Berlin, we see further experiments in this direction but no radical change. Acquaintance with the works of Flemish painters was insufficient, by itself, to achieve this; for such a development a direct contact with a painter trained in the Flemish method was necessary. The 'secret of the van Eycks', whatever its exact technical nature, was plainly seen at the time, and may still be seen today, as a major revolution in the methods available to the painter, and in Vasari's account of the progress of Italian Renaissance painting the role of the pioneer who had introduced this secret to Italy was assigned to Antonello da Messina.[1] Although almost every detail with which Vasari decks out this story may be shown to be false, the tale, at least as regards Venice, seems yet to be basically true.

It is natural that the complete mastery of the Flemish method which this Sicilian-born artist displays should have come to be ascribed to direct contact with Jan van Eyck and that Antonello should be represented as having travelled to Flanders to become his pupil, but we now know that this is hardly possible since he cannot

[1] Vasari, G. 1878–85, ii. 568 ff.

have been more than a boy at the time of Jan's death. Any journey to Flanders is indeed extremely improbable.[1] The natural metropolitan centre for an artist born in Messina would be Naples and that is where we would expect Antonello to have received his training. Alfonso I of Aragon, who had reigned there since 1442, collected Flemish paintings perhaps more assiduously than any of his contemporaries; but this would not, in itself, have imparted the Flemish technique to Antonello any more than the undoubted presence of such works in Venice did to Giovanni. For the source of Antonello's, and so ultimately of Giovanni's, knowledge of the new technique we must turn to the rival whom Alfonso had expelled from Naples in 1442, King René of Anjou who had reigned there since 1438. The Neapolitan Pietro Summonte, who although he made his records of the early history of painting in Naples as late as 1524, seems to have been a careful and well-informed inquirer, tells us that Antonello was the pupil of the Neapolitan painter Colantonio and that Colantonio, who had intended to go to Flanders to study under Jan van Eyck, had in fact been instructed in Naples by René himself.[2] The century of the common man has not taken kindly to the notion of a royal artist of great historical significance, but a study by Pächt[3] has drawn attention not only to the profoundly Eyckian character of the art of the so-called René Master but to his early and long association with the king and the substantial though not conclusive reasons for identifying him with the king himself. In any case Pächt's researches entitle us to say that René's entourage at this period embraced a master whose style was of obviously Eyckian derivation, and that such a painter may very probably have imparted the knowledge of the technique to Colantonio from whom Antonello will have learned it.

[1] Antonello can hardly have been born before 1430 and Jan died in 1441. Lauts, J. 1940, p. 9, makes the excellent point against a Flemish journey that the Flemish influence which we see in Antonello's work is essentially Eyckian whereas if he had gone to Flanders after Jan's death one would expect his work to show rather the influence of van der Weyden.

[2] For the text of Summonte's letter to Marcentonio Michiel see Nicolini, F. 1925, pp. 157–75. The reliability of Summonte was attacked by Morelli (1892–3, ii. 185–6), who was excessively distrustful of literary evidence, but has been accepted by such more recent writers as Nicolini and Ring, G. (1949, p. 206 no. 97), and is confirmed both by the fact that one work which he assigns to Colantonio (the *St Jerome* now in the Naples Museum, rep. Ring, fig. 29 p. 205) stands in exactly the right relationship to works in René's entourage and to Antonello, and by Pächt's demonstration of René's links with Eyckian painting.

[3] Pächt, O. 1956, pp. 41 ff. Pächt is concerned with the work of the 'René Master' as a miniature painter, and the question of the oil technique is not directly relevant to his study, but it seems reasonable to assume that a painter who had achieved so deep an understanding of the pictorial style of Jan van Eyck would also have acquired knowledge of his oil technique. If, as I think is very probable, the René Master is to be identified with the 'Master of the Aix *Annunciation*' (which would rule out his identity with René, who can hardly be supposed to have spent his time painting altar-pieces for the tombs of deceased linen-drapers in towns under his rule) we should see this to be the case.

By a singular stroke of good fortune, just when Giovanni was seeking a more flexible medium which would allow his art its natural expansion, Antonello came to Venice. The date of his visit used to be placed at about 1473, but it has been shown by documents that he arrived to execute his most important commission there—the altar-piece formerly in the church of S. Cassiano—in August 1475 and remained there until the spring of the following year, and this is generally assumed to have been his first and only visit. On the other hand, the style of the portrait of *Jörg Fugger* (Pl. XLV *b*) ascribed to Giovanni Bellini, now in the Contini collection in Florence, which is dated 20 June 1474, seems to show the influence of Antonello. To account for this Gronau suggested that portraits by Antonello must have been known in Venice before his visit, but since their influence seems to extend to the technique this explanation is hardly sufficient. Another possibility is that Antonello had himself already visited Venice. Though his presence in Messina is well documented between 1460 and 1465 and again in 1473 and 1474 his movements between 1465 and 1473 are very uncertain, and the possibility of a visit to Venice towards the end of this period cannot be excluded. Such a hypothesis might explain the relation between Antonello's Messina polyptych of 1473 and the *Vincent Ferrer* polyptych in SS. Giovanni e Paolo in terms of Antonello imitating the Venetian altar-piece. Further confirmation of such an idea might be sought in the *Christ at the Column* in Detroit in which the harshness which has led some people to dispute Antonello's authorship might be regarded as a reflection of the same model. It cannot be argued that what we think of as the Antonellesque portrait was really invented in Venice by Giovanni and adopted by Antonello only on his visit in 1475 since, though the majority of his dated portraits are of this year or later, his *Young Man* in Berlin is, like the Fugger portrait, dated 1474; nor would it seem likely that the two artists had achieved this result independently by the study of Flemish models, as Giovanni's evident study of such models in earlier works had not extended to the technique.[1]

The San Cassiano altar-piece was one of the most famous works in Venice in its day, but in the changing fashion of the early seventeenth century it was discarded from the church and wholly lost sight of until 1914 when Berenson identified a Madonna in Vienna as its central fragment.[2] Later Wilde was able to identify two

---

[1] The Fugger portrait is recorded to have been inscribed, when discovered, JOERG FUGGER A DI XX ZUGNO MCCCCLXXIIII, but the inscription was later covered when the panel was strengthened. See Gronau, G. 1930, p. 205. For Antonello's movements see Bottari, S. 1959, pp. 501 ff.

[2] Berenson, B. 1916 (2), pp. 98–123. *A Madonna at Vienna and Antonello's San Cassiano Altarpiece*. Borenius, T. (1913) had already suggested that the Vienna picture was a copy of the centre of the lost altar-piece.

further fragments in the depot of the Vienna gallery and engravings of two more in Teniers's *Theatrum Pictorum*, of which the originals have not come to light. This permitted him to offer a reconstruction of the altar-piece certain as to the disposition of the main figure group, which presupposes a unified architectural setting, but necessarily, conjectural as to the details of the architecture itself (Pl. XXXIX *a*). From this we see that it belonged to the type of altar-piece which became standard in Venice in the last quarter of the fifteenth century, and which is typified in Giovanni's from San Giobbe in the Venice Academy.[1] Although the exact date of the San Giobbe picture is not known it is certainly substantially later than Antonello's visit;[2] but no such certainty can be claimed with regard to Giovanni's painting of the same type which used to stand over the first altar to the right in the nave of SS. Giovanni e Paolo, where its lovely marble frame still survives. The painting itself was burnt in the disastrous fire of the night of 16 August 1867 which gutted the Chapel of the Rosary where it and Titian's *Death of St Peter Martyr* had been temporarily placed. It is clear that the design of this altar-piece (Pl. XXXIX *b*) and of that of Antonello's cannot be independent of one another, and if we are seeking to assess Giovanni's achievement the question as to whether he created this type of design or received it from Antonello assumes considerable importance. The absence of any documentation for Giovanni's work and the destruction of the work itself make this task difficult. The general appearance of Giovanni's painting is known to us from the line engraving in Zanotto's *Pinacoteca veneta*, though the unreliability of this engraving may be gauged from the fact that it is the wrong shape at the top to fit correctly into the frame. There are also a number of water-colour copies of which the best seems to have been that which formed the basis of the smudgy plate in Fry's volume.

Older writers unanimously regarded this picture as an early work on the ground that it was painted in tempera, and this opinion was confirmed, evidently after careful consideration of the original when it had been cleaned, by Crowe and Cavalcaselle.[3] Fry, on the other hand, suggested a dating in the early eighties and this view has been widely accepted.[4] Fry's arguments are mostly on general grounds of style, which is a risky criterion when our knowledge of the actual appearance of the work is so imperfect, but a further argument which he advanced can be positively refuted. He correctly noted the Lombardesque character of the architecture but followed this up with the statement that 'the Lombardi began to work

[1] Wilde, J. 1929, pp. 57 ff.
[3] Crowe, J. A. and Cavalcaselle, G. B. 1912, i. 154.
[2] See below, p. 83 ff.
[4] Fry, R. E. 1900, pp. 31–2.

in Venice about 1480'. As has been already pointed out in an earlier chapter[1] Pietro Lombardo was certainly active in Venice by the early 1470s and perhaps before 1465. Fry notes but dismisses the argument from technique, but in view of Crowe and Cavalcaselle's considered statement we should not do this. Placing the work as they do between the *Madonna with the Sleeping Child* in the Venice Academy and the *Coronation of the Virgin* at Pesaro, their statement that the lost altar-piece was in tempera clearly means that it resembled in its technique the former rather than the latter. On the other hand, the fact that this picture did not reflect the direct influence of Antonello in its technique does not prove conclusively that it must have been executed before the S. Cassiano altar-piece and so could not reflect its design; since, as Crowe and Cavalcaselle very justly observed, 'even after Antonello's arrival Giovanni may have hesitated before painting a large altar-piece in the new medium with which he was imperfectly acquainted'—and this would apply even if his acquaintance with the technique had begun during a slightly earlier visit of Antonello's and he had already been experimenting with the technique in a small portrait in 1474. If we were to accept the arguments of Longhi and others for dissociating the change in Giovanni's technique from Antonello's visit and dating the Pesaro *Coronation* to 1473 or even earlier the priority of the design of Giovanni's altar-piece would be assured, since it must necessarily be dated earlier than the Pesaro picture on Crowe and Cavalcaselle's evidence; but reasons for dating the *Coronation* later than 1475 will be given in due course.[2]

The *Madonna with the Sleeping Child*, in the Venice Academy (Pl. XL *a*) is particularly valuable as a document for the understanding of the lost altar-piece since, in spite of its modest size, it belongs to the category of monumental altar-pieces rather than that of highly finished Madonnas for domestic settings. There can be little doubt that it originally formed the centre of a triptych or polyptych of a type familiar to us in the work of Bartolomeo and Alvise Vivarini.[3] It is this context, not studio execution, which accounts for the relative coarseness of its finish when compared with such exquisite works as the *Frizzoni Madonna* (Pl. XLIII *a*) in the Correr or the much-damaged *Madonna* (Pl. XLIII *b*) in the Gardner Museum in Boston, which show the same basic stylistic characteristics, a delicate and classicizing refinement of the manner of the 1460s. One may imagine that the finish of the lost picture was very similar to that in the *Madonna with the Sleeping Child*.

[1] See above, p. 8.                                                                      [2] See below, pp. 66 ff.

[3] For instance Bartolomeo's *Polittico di Cà Morosini* in the Venice Academy, of 1464, which anticipates the motive of the sleeping child and Alvise's (with the same motive) from Montefiorentino, now at Urbino, of 1474, rep. Pallucchini, R. (n.d.), pls. 149 and 224.

Judged on its own merit, apart from any consideration of its significance in Giovanni's development, the *Madonna with the Sleeping Child* is one of his most moving creations. The motive, which he had already used in the *Davis Madonna* in New York, is a conscious echo of the theme of the *Pietà*. The Child is shown older and more developed that is usual in a Bellini Madonna, and his attitude, utterly relaxed in sleep, with one arm hanging down, points forward poignantly to the figure taken from the Cross. In the decoration of the Madonna's throne in this picture we see the first positive signs of the influence of Pietro Lombardo on Giovanni's painting, though they must have been in contact earlier as the frame of the Vincent Ferrer polyptych is purely Lombardesque in style. The refined character of this style, which reflects something of the art of Luca della Robbia and of the marble sculptors who had matured in Florence during Donatello's absence in Padua, the Rossellino brothers and Desiderio da Settignano, is echoed in the Frizzoni and Gardner *Madonnas* and in the *Madonna with the Sleeping Child*. But its influence was seen much more clearly in the lost altar-piece: not only in the frame, which must indeed have been carved in the Lombardo workshop, and in the feigned architecture which follows that of the frame exactly, but also in the figure work. We may point in particular to the resemblance of the two female saints on the right to the *Annunciate Virgin* beside the choir-arch of San Giobbe (Pl. xliv *b*) and the three putti at the foot of the Virgin's throne to the four in the pendentives of the sanctuary dome there (Pl. xliv *a*). In these instances one certainly sees Giovanni as the follower, absorbing through Pietro new Florentine influences, and thus the dating of Pietro's works will bear on that of Giovanni's. His work in San Giobbe is first mentioned in 1485. Pope-Hennessy dates the putti to about 1475 and the Annunciation somewhat later, but some of the evidence rather suggests that the sanctuary may have been structurally complete as early as September 1470, which would allow us to give the statues a considerably earlier dating.[1]

Further internal analysis of the picture produces results which are equally inconclusive though not uninteresting in themselves. First we may note the close resemblance of the design of the Virgin's throne, and to a lesser extent of her pose and that of the Child, to those in Gentile Bellini's *Madonna* in the National Gallery, London. The two compositions cannot be independent and one would think of Gentile as the imitator in this case, since the design of the throne in Giovanni's

---

[1] Pope-Hennessy, John, 1958, p. 351. The fact that Moro's tomb slab, in the centre of the sanctuary, is dated September 1470, more than a year before his death, and the month in which he made his will providing for the completion of the church, suggests that this part was already structurally complete at that date, though this hypothesis is not easily reconciled with some of the other evidence.

picture is intimately linked with the architectural setting. We have no precise means of fixing the date of Gentile's picture beyond the fact that he signs himself 'Eques', which indicates that it cannot have been painted before 1469, the year in which the Emperor Frederick III conferred this title on him; but since the Gothic character of the wood in the background suggests a relatively early date,[1] this evidence tends to support Giovanni's priority over Antonello.

There are two pictures among Giovanni's surviving works which, in addition to the *Madonna with the Sleeping Child*, seem to be particularly close to the lost altar-piece: the *Santa Giustina* of the Bagatti Valsecchi collection in Milan (Pl. XL *b*), which resembles the female saints, and the *Pietà* at Rimini (Pl. XLI), where the four putti are the brothers of those who sing at the foot of the Virgin's throne. It will be noticed that these two pictures, which are among the most beautiful of Giovanni's works of this period, are related to precisely those parts of the lost altar-piece in which we have distinguished Pietro Lombardo's influence, and they underline the significance of this renewed indirect contact with Florentine art for Giovanni's development. The *Santa Giustina* has been linked with a document of 1475, the approximate date independently determined for it by Berenson on stylistic grounds, though Longhi has challenged the relevance of the document.[2] The Rimini *Pietà*, on the other hand, has frequently been held to be earlier than 1468 through its identification with a picture of the Dead Christ supported by two putti, which Vasari records as in the church of San Francesco at Rimini and as having been executed for Sigismondo Malatesta who died in that year. Our information about the origin of this picture has recently been enlarged in a study by Campana, but the situation appears more confusing than before.[3] Campana has, in the first place, drawn attention to the substantial differences between the passages dealing with this picture in Vasari's first and second editions, and in the second place produced documents to show how a picture of this subject by Giovanni Bellini came to San Francesco at Rimini from a different source. With regard to Vasari it seems as if the somewhat abbreviated version in the second edition is not intended to modify

---

[1] Davies, M. 1961, p. 49.

[2] The document from the Borromeo archives, published by Biscaro, G. 1914, p. 96, refers to the 'figura de Sancta Justina' sent from Venice. The context of the construction of the Borromeo mausoleum in San Francesco Grande at Milan does suggest a sculpture, to which Longhi, 1949, p. 281, says the word 'figura' is more appropriate (but cf. *Vocabolario degli Academici della Crusca*, 2nd ed. 1622: 'Figura . . . per impronta, o immagine di qualunque cosa, o scolpita o dipinta. Lat. Imago, statua.').

On the other hand, the inscription s. GIVSTINA DE BOROMEIS which even if not original is surely old seems to confirm the relevance of the document, since it plainly puts the picture in a Borromean context. For Berenson's dating, see 1916 (2), p. 56.

[3] Campana, A. 1962.

or add to what he said in the first, which represents more fully the information which he had on the subject; and we should not forget that the final draft of the first edition was completed in Rimini. The important sentence runs as follows: 'Né ancora dirò tutto quel che di suo egli mandò per il dominio di Venezia, e molti ritratti di principi che egli fece, senza le altre cose spezzate di alcuni quadroni fatti loro; come in Riminio al S Sigismondo Malatesta un quadro d'una Pietà che ha due puttini che la reggono la quale è oggi in San Francesco in quella città.'[1] It seems clear from this passage that Vasari supposed that the panel with a Dead Christ supported by two 'puttini' in San Francesco at Rimini had formed part of a larger complex painted for Sigismondo. We are immediately reminded of the arrangement of the Vincent Ferrer polyptych, where a *Pietà* of this type occupies the centre of the upper register, and we may wonder whether Vasari, who speaks of two 'puttini' where the picture now at Rimini has four, is not speaking of a different picture now lost. It would be tempting to identify this with the picture in Berlin, which might possibly have been executed before 1468 though I should hardly think this likely, but the word 'puttini' does not seem very appropriate to the adolescent angels there, and indeed the use of this word would support the view that he really was speaking of the present picture.

On the other hand, the further evidence produced by Campana may be read as supporting the view that there really were two pictures of this subject in Rimini. This consists of the will and inventory of the Riminese Doctor of Laws, Rainario di Ludovico Migliorati, councillor of Pandolfo (IV) di Roberto Malatesta. In his will made on 17 February 1499, a few days before his death, he left directions for the construction of his tomb 'apud eclesiam Sancti Francisci de Ariminio in eclesia Sancti Antonii penes dictam eclesiam Sancti Francisci existente' in a funerary chapel of specified dimensions 'cui capelle ipse test[at]or reliquit et voluit dari et reponi unam ipsius testatoris tabulam depictam manu Johannis Bellini in qua est depicta imago domini nostri Iesu Christi Salvatoris mortui et sublati de cruce in forma pietatis'. This chapel was to be administered by the brothers of St Francis to whom an endowment was left. In Migliorati's inventory the picture is described as 'una ancona o vero taula dove è dep[i]nta la imagine del N.S. in forma di pietà discese della croce'. It seems that the chapel was never constructed and it is possible that the picture was transferred to S. Francesco when the church of S. Antonio was renewed internally in 1547, the year that Vasari came to Rimini. What is interesting here is that there is no hint of a Malatesta provenance for Migliorati's picture. As

[1] Vasari, G., *Le Vite . . .* , etc., 1st ed. 1550, p. 453. Text of 2nd ed. reprinted 1878–85, iii. 170.

a favoured servant of the house (his executor was Violante Malatesta, the wife of Pandolfo (IV)) he might have obtained such a work, but one feels in that case it is likely that he would have made mention of this in his will and it is perhaps more reasonable to suppose that he had got the picture direct from Giovanni. It seems to me in any case that the style of the Rimini picture is entirely irreconcilable with a date as early as 1468, as it appears, particularly in the heads of the putti, to show the influence of Antonello. We may account for Vasari's statement in various ways. Perhaps he was speaking about this picture but his information was wrong, or he was simply assuming a provenance from Sigismondo for anything in the *tempio*— though the terms of the passage from the first edition do suggest that he believed himself to have rather more positive information. Perhaps, on the other hand, he was making a correct statement about another picture which is not now identifiable.

The *S. Giustina* (Pl. XL *b*) is in many ways close to the *Madonna with the Sleeping Child* but has a finer finish which may reflect Antonello's influence and which the lost altar-piece perhaps did not possess. Nevertheless, these two pictures enable us to measure our loss in the SS. Giovanni e Paolo altar-piece more accurately than any other works. The *S. Giustina* is a splendid classical production in which the asperities of the Vincent Ferrer panel are smoothed down without loss of strength or monumentality. On the other hand, her face lacks the human and emotional contact between the artist and his subject which one almost always finds in Giovanni's work, and this perhaps lies at the root of Berenson's early aberrant attribution of this picture to Alvise Vivarini.[1] By contrast the *Pietà* (Pl. XLI) is one of the most deeply felt and in the literal sense lovely of Giovanni's works. In the Brera *Pietà* we are conscious chiefly, as in Giotto's fresco at Padua, of the stoic suffering and tenderness of the Mother and the Beloved Disciple. Here Christ is sad indeed, but not agonized—he has suffered for others rather than himself— while the child angels who support his beautiful body, compassionate without any trace of sentimentality, seem the emanations of the supreme love that has led him to this sacrifice. The upright *Pietà* in the Mond bequest in the National Gallery, London (Pl. XLII *b*), which takes up the theme of that in Berlin but develops it with the resources of the new technique, is surely somewhat later than that at Rimini, just as the Berlin one is somewhat earlier. The angel on the spectator's left looks forward to the *Madonna with the Greek Inscription* in the Brera. The head of the other angel is very different and in some ways closer to those of the putti at Rimini,

[1] Berenson, B. 1895, pp. 100–4. Subsequent recantation, 1916 (2), pp. 38–61.

but it seems to have been very heavily repainted. I have spoken of a certain in-sipidity of the head of the *S. Giustina*; the very beautiful drawing of a *Young Woman* in the Venice Academy (Pl. XLV *a*) shows a head somewhat similarly treated but with a much more vivid individuality. One could very well imagine that the saint's head had been produced by a process of abstraction from just such a study as this. Although, in the absence of comparative material, it would be impossible to prove Giovanni's authorship of this sheet, the attribution is plausible and attractive and the date between 1470 and 1480 proposed by the Tietzes reason-able.[1]

The attempt to fix an exact date for Giovanni's lost altar-piece has narrowed the possibilities to something very near the documented dates of Antonello's, but finality eludes us and the question of priority must be left open. If we seek for the origins of a composition of this type we might look to Piero della Francesca's altar-piece from Urbino in the Brera, which was probably painted a year or two earlier. But while it is similar in placing a unified group of the Madonna and saints in an architectural setting, it lacks the distinctive feature of a high podium raising the Madonna's throne and bringing her above the level of her attendant saints, making the figure composition a pyramid; and it also lacks the low viewpoint which we find both in Giovanni's altar-piece and Antonello's,[2] which would give the painting, as it stood in the church raised over its altar, the appearance of leading the eye into an actual chapel opening off the church. This is the effect so vividly described by Vasari in connection with Masaccio's *Trinity* Fresco in S. Maria Novella: 'A vault . . . drawn in such excellent perspective that it seems as though a hole were pierced in the wall.'[3] Masaccio's fresco, though different in subject, also anticipates the present scheme in showing a pyramidal figure composition in the architectural setting, and it is tempting to suggest that Giovanni might have derived the whole scheme—if indeed it is his invention and not Antonello's—from a

---

[1] Tietze, H. and Tietze-Conrat, E. 1944, no. 324 pp. 89–90. They are favourable to the attribution to Giovanni but do not accept it as certain.

[2] In Giovanni's lost painting the point of sight lies in the base line in the water-colour copy reproduced by Fry. The Zanotto engraving shows two points, one in the base line for the foreground figures and one about the middle of the Madonna's legs for the throne and architecture. It seems likely that the water-colour is the more accurate. The point of sight in the San Cassiano altar-piece was somewhat higher, but well below the Madonna's feet. In Piero's Brera altar-piece the point of sight lies in the Madonna's mouth. Piero's altar-piece is also dis-tinguished from the 'San Giobbe' type by elements of the foreground architecture being represented on the panel itself, showing that its frame cannot have been linked to its architecture. The appearance of a similar arrangement in Fogolino's altar-piece in Amsterdam suggests the possibility that in this respect Antonello's altar-piece followed Piero's example and did not conform to the 'San Giobbe' scheme. See Meiss, M. 1966, p. 204, n. 16.     [3] Vasari, G. 1878–85, ii. 291.

sketch of Masaccio's fresco transmitted by Pietro Lombardo, whose Roselli Monument in the Santo at Padua might derive its scheme of an arched tomb canopy flanked by an order of giant pilasters and entablature, from the same source.[1]

Whatever the date of this lost altar-piece there is no doubt that the earliest surviving monumental altar-piece by Giovanni showing a group of many figures on one panel in a single space is the *Coronation of the Virgin* in Pesaro (Pl. XLVI). The dating of this picture, for which there is no documentary evidence, has been the subject of much dispute. Crowe and Cavalcaselle, followed by Berenson, dated it after Antonello's visit, but recently increasingly early dates have been advocated. Longhi has advanced an ingenious argument that it must have been executed in 1473, since that is the year in which Bartolomeo Vivarini (the steps of whose development we can follow very closely owing to his commendable habit of signing and dating most of his works) ceased to progress: the argument being that this must indicate the moment at which Giovanni Bellini, in whose wake he had been following, took a step beyond what he could compass and that if we turn to Giovanni's work we see that that step must have been the Pesaro altar.[2] Such an argument cannot be held conclusive, and even if we accepted its outline, the step in question, on Giovanni's part, might have been taken in the lost SS. Giovanni e Paolo altar-piece. More recently Pallucchini and Meiss have suggested that Zoppo's *Madonna and Saints* in Berlin, which he painted in Venice in 1471, for the church of S. Francesco in Pesaro, presupposes the existence of Giovanni's picture.[3] If we were to accept so early a date it would seem to me to involve the complete elimination of the *Vincent Ferrer* polyptych and the Carità triptychs from Giovanni's work and the backward revision of the dating of all his earlier paintings. Pallucchini's argument rests partly on general considerations of the resemblance of the two compositions, partly on the similarity of the motive of the landscape seen isolated through the wreath over the Virgin's throne to that seen through the back of the throne itself in Giovanni's picture. Meiss is more particularly concerned with the iconographical relation between the *Stigmatization of St Francis* by Zoppo in the

---

[1] Moschetti, A. 1913, p. 51 suggested that the setting of Antonio Rossellino's monument to the Cardinal of Portugal in San Miniato, Florence, was the source for the arched tomb framed with heavy entablature and pilasters. Another possible source would be the design of Brunelleschi's aisle chapels in S. Lorenzo, Florence, where the scheme may be drawn from the Arch of Titus, Rome. Another possible derivation from Masaccio in Pietro's work is the pose of St Job in the relief over the main doorway of San Giobbe, Venice, which is very close to that of the king's son in the Brancacci fresco, which, although the work of Filippino Lippi, must follow Masaccio's *sinopia* closely since the pose was copied earlier by Giovanni di Francesco in his predella of St Nicholas now in the Casa Buonarroti. See further Robertson, G. 1960, pp. 57–8.

[2] Longhi, R. 1946, p. 10.          [3] Pallucchini, R. 1959, pp. 57–8. Meiss, M. 1964, pp. 41–2.

Walters Art Gallery, Baltimore, which is plausibly supposed to have formed part of the predella of the Berlin picture, and the panel of the same subject which still forms part of the predella of Giovanni's altar (Pl. L a). There is undoubtedly a connection between the two altar-pieces. They were probably executed for the same church and not only are they of very nearly the same size and shape but it is practically certain that they were each originally surmounted by a Pietà, that in the Vatican gallery being known to have surmounted Giovanni's altar, that in the Pesaro gallery having probably performed the same function with regard to Zoppo's.

We may say with some confidence that the artist of one of these paintings was asked to make his work conform in general outline to that of the other. The most surprising feature about Zoppo's picture is the low placing of the Virgin relative to the side saints, making an effect the very opposite of that of Giovanni's lost SS. Giovanni e Paolo altar or Antonello's at S. Cassiano; and in the same way in Giovanni's picture Christ and the Virgin appear lower than the side saints. This, as Meiss has observed, is characteristic of Tuscan and not Venetian presentations of this scene[1] and we might argue that this element, introduced by Giovanni from Tuscan models, had been taken over by Zoppo. On the other hand, we can also argue that Zoppo was following a compositional form which was established in the Squarcione workshop, for exactly this arrangement is found in a drawing by Tura in the British Museum and in Mantegna's *Madonna* in the National Gallery.[2] If that is so we might think that the low centring of Zoppo's panel, in which he was following a formula acquired during his training in Padua, influenced Giovanni in adopting the low centring of Tuscan tradition for his *Coronation*. The influence with regard to the isolated section of landscape may also have been the other way about, though for some elements in Giovanni's scheme we can certainly indicate another source. With regard to the relationship of the two predella panels of the *Stigmatization* there is again a clear connection through the new presentation of the seraph, who is seen by the spectator from the back. Here it seems to me that so much more is made of the motive by Zoppo, in whose picture it forms part of a sort of arch uniting Francis and Leo, than by Giovanni, whose panel has to be scrutinized carefully before even the presence of the seraph can be observed, that it is on the balance more probable that he was the innovator. Zoppo was, after all, a painter of considerable stature who could quite well have devised an original idea of this sort.

[1] Meiss, M. 1964, p. 17.
[2] Popham, A. E. and Pouncey, P. 1950, no. 256 p. 158. Rep. pl. ccxvii. London, National Gallery, no. 274. Mantegna's painting is of course later in date than Zoppo's but may still represent the repetition of an earlier pattern.

Whether the picture shows the influence of Antonello's S. Cassiano altar-piece and was therefore presumably executed not earlier than 1475 must in the last resort remain a matter of opinion. Personally I feel that the heads in this picture, and particularly that of Christ, could not have assumed the form they have without direct and intimate knowledge of Antonello's practice, a knowledge deeper and more studied than that, perhaps deriving from an earlier visit, displayed in the Fugger portrait of 1474. I am aware that a number of distinguished scholars do not feel this but I am comforted in my view by the independent evidence of an origin for the altar-piece not earlier than the summer of 1474 which has been recently advanced by Everett P. Fahy, Jr. He has pointed out that the model fortress held by the saint in the predella, who is generally identified as *St Terentius*, (Pl. L *b*) represents the Nuova Rocca or Fortezza Costanza in Pesaro, of which the construction was not begun until 3 June 1474. The representation of this fortress on a medal struck in the following year, though not absolutely identical, is so close as to leave no doubt of the identification.[1]

Stylistically, as Longhi pointed out over fifty years ago,[2] the most important aspect of this work is the evident influence of Piero della Francesca, which makes it one of the key works not only in Giovanni's development but in the history of painting in Italy as a whole. Giovanni's early style was formed in part through the influence of the Tuscan art of Donatello, transmitted both through Mantegna and through direct observation; and in a similar way his mature style is based partly on the Tusco–Umbrian achievement of the next generation in the work of Piero, transmitted perhaps to some extent through Antonello, (who seems, while in transit from Naples to the north, to have had contacts with Piero's art which helped to mature his style), but probably mainly from direct contact with Piero's paintings.[3]

We have seen with regard to Flemish influence in Giovanni's work how much easier it is to observe the presence of an influence than to indicate its exact source, and the case is similar with Piero. It remains uncertain whether Piero ever visited Venice, since even if, as appears probable, the little *St Jerome* in the Venice Academy, which seems to have affected the treatment of this subject there, was a Venetian

[1] Fahy, E. P., Jr. 1964, pp. 216–18. The identification of the saint as Terentius can hardly be right. This is a military saint. Terentius was a civilian from Hungary of the time of Philip the Arabian who, after travelling widely to avoid persecution for his faith, was set upon and killed by highway robbers in the neighbourhood of Pesaro. (See Zacconi, L. *Compendio delle vite di tutti i santi*, Venice, 1612, p. 684. Since Zacconi was a native of Pesaro he may be presumed to give an accurate account of the local tradition of the life of this obscure saint.) He might be Alexander of Bergamo, as patron of Costanzo Sforza's father Alessandro, standing on the pagan column or altar which he overthrew.    [2] Longhi, R. 1914, pp. 244–9.    [3] Ibid., *passim*.

commission, so small a picture might have been executed elsewhere and sent. The frescoes at Ferrara seem a likely source but since they do not survive we cannot establish any certain connection. On the other hand, there is one surviving work of Piero's which can, I think, be shown to have had the most direct and significant influence on Giovanni's picture. This is the fresco in the sacristy of the Tempio at Rimini representing Sigismondo Malatesta in adoration of St Sigismund. We do not positively know whether Giovanni painted the *Coronation* on the spot in Pesaro or in Venice. Considering the dimensions of the work there would have been obvious advantages in executing it on the spot, but, on the other hand, we know from its signature that Zoppo's companion altar-piece was executed in Venice. The absence of any direct echoes of the *Coronation* in Venetian painting would perhaps point to its execution in Pesaro, and the fact that Giovanni's mother was a native of the city might have encouraged him to a period of residence there; but the strongest reason for supposing that it was executed at Pesaro lies in the echoes of Piero's Rimini fresco which it contains, since Giovanni would have had to pass through Rimini on his way from Venice to Pesaro. The view of a fortress, almost certainly the Sforza stronghold of Gradara, seen so oddly through the back of the throne in Giovanni's picture, seems to have been directly inspired by the view of the citadel of Rimini through the circular window on the right of Piero's fresco, which has even more markedly the character of an inset. The actual way in which Giovanni's landscape is framed in a rectangle of shallow marble seems to reflect the framing of the whole Rimini fresco. The treatment of the perspective of the floor is closely similar in both pictures and the rather four-square way in which Christ is sitting closely follows the pose of St Sigismund, while the highly plastic character of the heads in Giovanni's picture seem also to reflect that of Piero's saint.

The influence of Piero, however, amounts to much more than can be indicated by a mere catalogue of points of detail. The whole concept of the disposition of plastic forms in a crystalline three-dimensional space and the suffusion of form with colour—though the actual colour here with its glowing pink in the buildings in the background and the various shades of red, purple, and orange in the cherubs in the sky has nothing to do with Piero's cool gamut—reflects a penetrating understanding of Piero's achievement. We see that through Piero's integration of form, colour, and light Giovanni was enabled to achieve that monumentality of form which he had been seeking for the last decade and to achieve it without sacrifice of his sense of surface and the cohesive function of light. The contrast between

this picture and Giovanni's earlier work is striking. Such figures as those of the St Vincent Ferrer polyptych have something of the monumentality of Tuscan art as transmitted by Donatello and indirectly by Mantegna (and this is a quality in them which belongs to Giovanni even if the execution were that of an assistant), but the monumental figure of St Paul, on the left of the *Coronation*, has a grandeur of form which takes us back beyond Piero to Masaccio. He appears as the brother to the great silhouetted figure which Leonardo was to sketch a few years later on the left of his *Adoration of the Magi* in the Uffizi; and like that figure looks forward to the monumental figure of the same saint with which Raphael, in his *St Cecilia* altar-piece in Bologna, bade farewell to this classic tradition.

There is a curious discontinuity between the landscape seen framed in the back of the throne and the fragments of blue mountains seen between the shoulders of the flanking saints, and similarly between the sky and clouds within and without the throne. One is almost tempted to think of this view as a painted landscape framed in the marble or as the reflection in a mirror of the prospect behind the spectator. It can hardly be either of these: rather it must represent a window in the wall of heaven through which God watches over Gradara, symbol of the Sforza power in Pesaro.[1] He, watching over Israel, slumbers not nor sleeps. In a later work, the *Doge Agostino Barbarigo before the Virgin* of 1488 in S. Pietro Martire at Murano, Giovanni repeated in the background the motive of the three towers linked in a single wall, where it could have no relevant reference to Gradara, and while this may merely represent the use of a convenient landscape *simile* which was handy in the studio I am inclined to think that it indicates that this feature had a further significance and is to be seen as a symbol of the Trinity. Formally this view through an architectural opening in the centre of the picture looks back to that through the grilled doorway in the Chapter miniature of the Arsenal manuscript, and beyond that to Jan van Eyck's *Madonna of Chancellor Rolin*, while Meiss has drawn attention to a parallel in earlier Florentine painting.[2] The architectural forms of the throne with its figured freize in low relief go back ultimately to the architecture in the background of Mantegna's fresco of *St James led to Execution* in the Eremitani, but it is lightened both by Lombardesque contacts and perhaps also by the influence of the decorative work at the Tempio in Rimini, especially that of Sigismondo's tomb.

[1] Gradara had been seized by Sigismondo Malatesta and was recovered by Alessandro Sforza in 1463. See Fahy, E. P., Jr. 1964, p. 217.

[2] Meiss, M. 1964, p. 18.

The monumental style of the main figures is also seen in the harsh but beautiful *Pietà* now in the Vatican (Pl. xlvii *b*), which originally surmounted the altar,[1] whence its low viewing point. The conception of the scene is very different from any earlier rendering in Giovanni's work and seems designed, with its picture of earthly grief, to contrast with the calm heavenly joy of the main panel. The eight niche figures of saints decorating the frame also echo the style of these two main panels, and the *St Catherine* (Pl. xlvii *a*) and the *St Louis* of Toulouse (Pl. xlvii *c*), with their smooth geometric forms, recall the side saints of Antonello's S. Cassiano altar. In the main panel Giovanni was working within the rather narrow limits imposed by a strictly symmetrical formal composition; the seven panels of the predella gave him more freedom and in them many other elements of his art appear. In particular we see his mastery of the new medium applied to the problem that had occupied him for so long, that of the integration of the figure in the landscape. In the scenes of *St George and the Dragon* (Pl. xlviii *a*) and the *Conversion of St Paul* (Pl. xlviii *b*) we find a degree of violent physical activity with which we are unfamiliar in Giovanni's work, and for some elements he has undoubtedly turned back to his father's sketch-books; but we seem to see also a Tuscan influence, and if the sixteenth-century Ferrarese paintings in London and Baltimore have been correctly identified as indicating the character of Piero's lost frescoes at Ferrara,[2] these might have supplied suitable models. Fry thought that the accuracy of the Oriental details in the *Conversion of St Paul* indicated the use of drawings brought back by Gentile from Constantinople in 1480, but this would involve a rather late dating of the altar and other sources of accurate knowledge of the East may have been available in Venice. The relation of the figure of 'St Terentius' (Pl. l *b*) to its architectural setting is clearly connected with that of figure and architecture which we find in Antonello's *St Sebastian* in Dresden. That Antonello should have borrowed this feature from Bellini's panel, which it is doubtful if he ever saw, seems most improbable and this is an added reason for supposing that the *Coronation* was executed after 1475.

The panel of the *Nativity* (Pl. li) is of particular interest not only from the beauty of the landscape, which with its softened forms and subordination of

[1] Frizzoni, G. 1913. He reproduces a photograph showing the altar-piece surmounted by the crowning ornament to the frame, now removed, with the *Pietà* restored to the centre. Before this identification the Vatican picture had been ascribed to Bartolomeo Montagna and Puppi (1962, p. 31) has recently suggested that it does indeed show traces of Montagna's activity as an assistant in Giovanni's workshop. This, however, would involve the acceptance of a date for the altar-piece not later than the early seventies.

[2] Lauts, J. 1941 and 1953, *passim*.

detail seems to look forward to those of Giorgione and Titian at the beginning of the next century, but because of the rarity of this generally popular subject in Giovanni's surviving work. The subject is the only scene which occurs in the series of the *Carità* triptych panels, where it is squeezed uneasily into the upright panel conceived for a single standing figure. This, though admired by some, seems to me one of the weakest of the *Carità* panels and to have little or nothing to do with Giovanni. It is indeed one of the pieces which brings us nearest to the Vivarini studio. Much later Giovanni painted a picture of this subject for Isabella d'Este which is now lost,[1] but the Pesaro predella is the only fully authentic version of this theme by Giovanni that we possess. The simple figure group, with the shed and the ox very much subordinated, is confined to the right-hand side of the picture, the whole of the left and centre being given over to the still valley landscape whose calm echoes that of the figures.

It is tempting to see the lovely pen-and-ink drawing of this subject in Count Seilern's collection in London (Pl. LII *a*) as a preliminary study for this.[2] Though there is much more diffuse incident here the structure of the landscape is strikingly similar and the drawing conveys something of the same suffused atmosphere as we find in the painting. On the other hand, it contains elements which not only differ markedly from the content and even the style of the painting, but which seem surprising in the context of Giovanni's art altogether. These are elements of fancy and calligraphy particularly seen in the ox and the ass and the curious motive of the baby lying on a cushion supported by his mother's feet; and these elements, and the wattle fence, bring the drawing close to the mythological drawing from the Skippe collection now in the Lehman collection, New York, which from its thematic connection with the Schifanoia frescoes goes by the name of Cossa. We may particularly compare the drawing of the head of the bull in the sky in the Lehman drawing with that of the ox in the Nativity and the drawing of the wattle fence in both. In each case the comparisons, while showing a basic similarity of form, reveal the superior sensibility of the drawing in Count Seilern's sheet; but the similarities are such, even to the curious feature of the diamond forms on the tops of the gate-posts, that one cannot regard the drawings as altogether independent. If the drawings are by the same hand, which seems to me unlikely, then the Seilern drawing cannot be by Giovanni as it would be impossible to integrate the Lehman drawing, which though attractive and amusing is a somewhat second-rate production, into Giovanni's activity at any point. The resemblances might,

---

[1] See below, pp. 136–8.    [2] Seilern, A. 1959, no. 79 p. 21.

on the other hand, perhaps be explained in terms of common influence. The Lehman drawing would be broadly classed as Squarcionesque, and if we were to suppose that Giovanni was here basing his design on the central panel of the predella of Zoppo's altar-piece (now missing), as he seems to have borrowed the reversed Seraph in the *Stigmatization of St. Francis* from the panel now at Baltimore, the Squarcionesque elements in the Seilern drawing might be explained. But such an explanation would hardly seem to account for the detailed resemblances between the Lehman and Seilern drawing, since the Lehman drawing has, beyond its generally Squarcionesque character, no very close relation to Zoppo.

Another drawing ascribed to Giovanni which has good claims to be by the same hand as Count Seilern's and which we may consider here is the *St Mark Healing Anianus the Cobbler* in Berlin (Pl. LII *b*). This, which is very close to the Seilern drawing in technique, has some resemblance to the reliefs ascribed to Pietro Lombardo on the façade of the Scuola Grande di San Marco, but is not directly connected with the relief of this subject which is found there. The Tietzes have linked it with work on the earlier building (burnt in 1485), carried out by Antonio Rizzo in 1476, which included a relief after a design by Gentile Bellini.[1] It is possible, but hardly likely in view of its quality, that the drawing might be by Gentile. The drawing may be closer to the lost paintings in the Doge's Palace than to any surviving works of Giovanni's, none of which presents a comparable scene but there are elements which seem alien to his art, especially the decorative treatment of the string of shoes and the lamp at the top of the drawing which recalls the Squarcionesque motive of a hanging swag—a motive conspicuously absent from Giovanni's paintings occurring only in the *Lehman Madonna*. Although this and Count Seilern's drawing seem qualitatively worthy of Giovanni, I do not think that they can be unhesitatingly accepted as his.

The Pesaro *Coronation*, whatever its date, shows a full mastery of the oil medium and is perhaps the first of Giovanni's works to do so, and the suffused light and colour which distinguish it are made possible by this extension of his technical resources. The new possibilities which this advance opened to him seem to have led him to a conscious attempt to recover the exquisite detail of his earlier Mantegnesque works, such as the London *Agony*, while preserving the monumentality to which he had initially sacrificed it. I take this to be the explanation of a return to the Mantegnesque manner which is a marked feature of certain works which may be dated to the late seventies.

[1] Tietze, H. and Tietze-Conrat, E. 1944, no. 289 p. 83. The document about Rizzo's relief in Paoletti, P. 1894, pp. 15–16.

We should consider first a work which is fairly securely dated, the *Resurrection* in Berlin (Pl. LV). Although the picture is not signed and the attribution to Giovanni has often been questioned, there can be no doubt, in view of Ridolfi's description, that this is the picture which stood over the altar in the chapel to the right of the High Altar in the church of San Michele in Isola and which was assigned to Giovanni by Sansovino, who was probably relying on the lost portion of the notes of Marcantonio Michiel.[1] Such an attribution should be accepted unless strong reasons can be shown against it and it is significant that there has been no agreement on an alternative name among those who have denied Giovanni's authorship. Yet one can well understand their doubts. Of all the major works of Giovanni (and in spite of its relatively modest dimensions this must be reckoned as a major work) this is, at least in its present condition, the least satisfying. The failure of this picture arises not from any fault in execution, to be explained by the participation of assistants, but rather from a break-down in the total coherence of a work which consists of exquisite parts; parts which seem to touch Mantegna at one end of the scale and Giorgione at the other. In the London *Agony* Giovanni had gambled on securing a loosely organized composition through the cement of light and had succeeded brilliantly; here a closely similar throw had failed. The picture has suffered greatly, having been transferred from its original panel; the whole dark horizon is blistered and discoloured and it is possible that when the picture left Giovanni's hands it was considerably more coherent than we see it today, but it is hard to imagine that it was ever entirely successful. It is interesting to note that Sansovino, who seems to have had some interest in this aspect of Giovanni's activity, specifically mentions it as an oil-painting, and that it seems to be the earliest securely datable picture of his in which the technique is fully exploited— though he seems, as we have seen, to have been already experimenting with it in the Fugger portrait of 1474.[2] The execution of the *Resurrection* may be fixed between 1475, when the chapel which it adorned was granted to Marco Zorzi, and 1479, when, though dedicated to the Virgin, it is already referred to as the chapel of the Resurrection.[3]

We have seen how in his early monumental works in tempera, especially in the Vincent Ferrer polyptych (though there, as we have seen, there is the possible complication of execution by an assistant), Giovanni had sacrificed the exquisite refinement of detail of such works as the London *Agony* in order to achieve greater

[1] Sansovino, F. 1581, p. 86 *a*.    [2] See above, p. 58.
[3] Ludwig, G. and Bode, W. 1903, p. 133.

breadth and strength. Now, after his successful manipulation of the new medium in the Pesaro *Coronation*, he seems to be experimenting to see whether, by the use of the new method, he could not recover the exquisite detail without loss of monumental effect. This crisp detail to which I believe he was here seeking to return was an inheritance from Mantegna, and a renewed interest in his brother-in-law's work at this stage of his career is demonstrated by the painting of the *Descent into Limbo* in Bristol (Pl. LIV *a*), to which reference has already been made in connection with the drawing in the École des Beaux-Arts and Andrea's engraving.[1] As Byam Shaw has observed, the treatment of the rocks here indicates a date towards 1480, though we might put the picture a little earlier. As I see it this picture immediately precedes the Berlin *Resurrection* and is the source for some elements in its composition, especially the frieze-like disposition of the foreground figures in front of a rocky cliff-face pierced to the left. The Bristol picture is not, of course, an oil-painting. It is in fact a large illumination on vellum whose colour has been injured by the injudicious application of varnish, but it represents a step in the return to Mantegnism which was prompted by development of the oil technique.

In the starkness of the figure of Christ in the *Resurrection*, with his angular draperies, in the details of the landscape and in the character of the soldier in the right middle-distance there is undoubtedly an element of Flemish influence, such as we have seen earlier in many of the Mantegnesque works such as the *Blood of the Redeemer*.[2] This element is much more prominent in a work which, though dated by some authorities quite early and by others to the mid-eighties, seems to be closely related to the *Resurrection*. This is the lovely *Crucifixion* (Pl. LIII) in the Corsini collection in Florence. In the relation here of the vertical cross to the horizontal rhythm of the landscape we are reminded of Antonello's painting of the same subject in London. Another striking example of Giovanni's interest in Mantegna's work while experimenting with the oil technique is seen in the *Presentation in the Temple* in the Querini Stampalia gallery in Venice (Pl. LVI), which is a copy of Andrea's painting in Berlin expanded by the addition of a female figure on the left and a male one on the right. It is rather tempting to see this right-hand head as a self-portrait, both from the direction of the eyes and because the head on the extreme right of Mantegna's Berlin picture has a strong resemblance to the gigantic head formerly in the Eremitani which is often identified as Andrea's self-portrait. On the other hand, the resemblance to the Gambello medal, the only fully authenticated portrait of Giovanni, is not striking. The first thing we must realize about the

[1] See above, p. 25, and Byam Shaw, J. 1952, p. 157.    [2] See above, p. 33.

Querini Stampalia picture is that it is unfinished. This is most obvious in the male figures that occupy the centre and right-hand side of the picture, but I do not believe that any part of the painting has received its final surface. It seems possible that this picture was in the nature of a technical exercise undertaken by Giovanni as a preliminary to the painting of the Pesaro *Coronation* in order to try out the application of the new method to a monumental figure group; but the picture surely meant more to him than this, and it became the inspiration for a later series of compositions of the *Presentation* and the *Circumcision*, though the execution of these seems to have been mainly left to the studio.[1]

As an attempt to recapture a brilliant moment of earlier achievement the *Resurrection* must be counted a failure, but on the basis of this return to Mantegnism Giovanni was to achieve one of his supreme successes, the *St Francis* in the Frick collection in New York (Pl. LVII). This picture has often been dated as late as the mid eighties, while Meiss has recently put forward the view that it precedes the *Resurrection*.[2] It is generally conceded that it cannot be substantially earlier than the Pesaro *Coronation* and I have argued a date not earlier than 1475 for that work. In fact it seems to me that the Frick picture falls very close to, but just after, the *Resurrection*, which would date it to the end of the seventies. In dating it after the *Resurrection* I would rely partly on its superior coherence, its successfully fused atmosphere, and its chromatic richness, all of which look forward to the San Giobbe altar, but also on the painting of the head and the hands of the saint: these have a roundness and softness which show him advancing further from the Mantegnesque than any passage in the *Resurrection*. The general impression of the landscape is certainly more arid than that of the *Resurrection* and therefore in a sense more Mantegnesque, but this is due partly at least to the subject-matter of the picture which represents the saint in a desert spot, probably La Verna. We can see on examination, for instance, that the hard edges of the spurs of the hills in the background, which at first look like a rather clumsy convention, in fact represent an eroded ridge. If we compare such a detail as the tree with the bird in it on the left-hand side of the *Resurrection* with those in the *St Francis* we see how much more conventional and Mantegnesque the former remains. The silhouetted tree-trunks springing from the rock in the centre of the *St Francis* are no longer Mantegnesque at all, but look forward to Giorgione's in the *Three Philosophers* and Giovanni's own in the *Feast of the Gods*.

The extraordinarily rich meaning of this picture has been analysed by Meiss, who

---

[1] See below, p. 98.        [2] Meiss, M. 1964, p. 18.

has argued that though neither the Seraph–Crucifix nor Brother Leo are shown, it is the actual moment of the stigmatization which is represented. This is, I think, basically true. The barren setting is that of La Verna and the ass in the background is that on which the saint rode to this mountain retreat; but the artist has re-thought the incident as the climax of St Francis's life and in particular in terms of the element in it which we may be sure from the whole tenor of his art particularly appealed to Giovanni, his identification of the divine in nature. St Francis stands in the sunlight and the function of the seraph has actually been taken over by the sun itself. We see here not only the representation of the stigmatization but at the same time an illustration of the Hymn to the Sun in the Laudes Creaturarum: 'Laudato si, mi signore cum tucte le tue creature spetialmente messer lu frate sole, lu quale lu iorno allumeni per nui; e ellu è bellu e radiante cum grande splendore; de te altissimu porta significatione'—'Praised be thou, my lord, through all thy creatures especially sir brother the sun, through whom thou givest us light by day and he is lovely and radiant with great brightness, he beareth thy image, oh most high.' Similarly the donkey in the background not only represents that on which the saint rode to La Verna, but by recalling Christ's entry into Jerusalem links up with the passion symbols of the Golgotha on the desk in the saint's cell. This shows us how he has moved into the sunlight from a meditation on the Passion so deep that his self-identification with the suffering Christ must express itself in the physical marks of the stigmata. On another level the donkey represents the saint's recognition of the divine in animal creation.[1]

The painting of *St Jerome* in a landscape in the Contini collection in Florence (Pl. LVIII *a*) presents many similarities to the *St Francis*, but, though the design is fine, it lacks the magic of its execution. I think that this must be a studio version of a lost original of the late seventies, which is also reflected in the little pictures in London and Oxford, neither of which shows Giovanni's own hand. The version in Washington (formerly in the Benson collection) which is dated 1505 is further from the Contini panel in design, but the quality of the painting, at the bottom

[1] My debt to Meiss's fascinating study is obvious in the foregoing though my conclusions are not identical. In particular I am not fully convinced that the two sources of light to which Meiss draws attention allude, as he suggests is possible (pp. 25–7), to the supernatural nocturnal illumination associated with the stigmatization which is mentioned by some early biographers of St Francis. The emptiness of the landscape can be paralleled in the main section of the Pesaro *Coronation* and in the *Nativity* in its predella and I think that had Giovanni really wished to suggest a nocturnal supernatural illumination he would have given us some more positive indication. The status of the rays in the top left-hand corner of the picture is not very easy to determine. If, as I would think, they are to be conceived as emanating from the sun they are certainly not fully consistent with the fall of Francis's shadow, but we have seen similar inconsistencies of lighting in Giovanni's work before, for instance in the London *Agony*.

and on the right-hand side of the panel at least, is closer to that of the *St Francis*. One wonders whether this rather puzzling work may not have been begun by Giovanni about 1480, abandoned for some reason, and completed in 1505, with the addition by an assistant of the rock arch and the distant landscape.

We have still to consider the Madonna paintings of the seventies. Fairly closely following the *Frizzoni* and *Gardner Madonnas* comes the *Lochis Madonna* in Bergamo (Pl. LIX *b*). The use of gold hatching on the drapery reminds one of earlier works but the continuity of the modelling indicates a date in the mid seventies. The picture is exceptionally highly finished and appears very well preserved but Morelli remarked its over-painting[1] and it is difficult to avoid the suspicion that it has undergone a careful and extensive reworking in the nineteenth century. Such a hypothesis would account for the rather disagreeable sentimentality of the Child's expression as well as for the unusual colour, with the light blue in the Virgin's mantle and the hot brown of the background, and for the oleographic quality of the whole. The *Crespi Madonna*, the ruins of which are preserved in the Fogg Art Museum, at Cambridge, Mass. (Pl. LIX *a*), and which must be judged with the help of photographs taken before the disaster which overtook it on its way to America, seems to have been a very charming work closely related to the *Frizzoni* and *Gardner* pictures but a little stronger in modelling and colour and perhaps a little later in date. Two closely related *Madonnas* give a more reliable picture of Giovanni's activity at this time, that in the Madonna dell'Orto in Venice and that in Berlin (Pl. LX). The altar in the Madonna dell'Orto over which the picture there stands was set up in 1485 by Luca Navagero, who died in 1488,[2] but this picture was surely never designed for such a setting but made for private devotion. Probably it had belonged to Navagero from an earlier time. The style recalls that of the *Frizzoni* and *Gardner Madonnas* but the handling is rather heavier and the modelling more solid. In many ways these works recall the *Madonna with the Sleeping Child* in the Venice Academy, though the finish here is higher. They also have considerable resemblance to the *Pietà* at Rimini and would seem to be more or less contemporary with the lost SS. Giovanni e Paolo altar-piece and the *S. Giustina* and certainly to precede the Pesaro *Coronation*. The *Madonna with a Sleeping Child* at Verona (no. 110) (Pl. LXIV *a*) has gold hatching on her drapery and is handled much in the way of the Frizzoni and Crespi paintings, but the silhouette against the sky and the treatment of the sky itself seem to look forward to later developments and suggest a date towards the middle of the decade. Two minor

[1] Morelli, G. 1892–3, i. 261.     [2] Cicogna, E. A. 1824–53, ii. 260–1.

works, the *Madonna* formerly in the Mond collection and now in that of Sir
Kenneth Clark and the ruined picture formerly in the collection of Dan Fellows
Platt and now at Yale, reflect the style of these works in a rather cruder form and
seem to be the work of one hand, that of an assistant or follower. The resemblance
noted by Berenson[1] between the *Platt Maddona* and the Virgin of the Pesaro
*Coronation* has diminished with the removal of the repaints.

We see a clear reflection of the Pesaro *Coronation*, however, in the *Madonna in
Red* in the National Gallery, London (Pl. LXIV *b*). In design and colour this is a
very attractive picture, but it is much damaged and the execution is generally
considered only of studio quality. I am not convinced myself that, when allowance
for the condition has been made, this work is decisively below Giovanni's auto-
graph standard. In the *Madonna* with the standing Child (Pl. LXII), also in Verona
(no. 77), the quality is undoubtedly much higher. The aubergine of the Madonna's
mantle is a specially attractive feature. The composition of this picture raises
interesting problems, since it occurs in two variants, at Amsterdam and Berlin,
which are clearly related to a much earlier phase of Giovanni's activity. Neither
of these pictures seems to me of the quality to justify an attribution to Giovanni's
own hand, but they are related in style to the *Carità* altars and this probably indi-
cates that this attractive design originated with him. As with the Carità panels
the original design may have been made by Giovanni in his father's workshop. The
*Madonna* at Rovigo, with the lovely pink mantle, is very closely related to the
Verona picture.

A rather more formal character distinguishes the *Madonna* in the Brera (Pl. LXI)
which, like the *Crespi Madonna*, carries Greek inscription for the Mother and Child,
as in an icon, perhaps an indication that the pictures in question were executed for
Orthodox patrons of whom a considerable number must have been resident
in Venice. The contrast between the stiffness of the Virgin's pose, which has
itself something rather Byzantine about it, and the limpness of the rather sad-
looking Child lends this picture a peculiar pathos. A picture which passed from
Duveen to the Kress collection and so to Washington (Pl. LXIII *a*) may almost be
regarded as a variant of this one. This too is a moving work but either because of
its condition, which does not seem to be very satisfactory, or from studio inter-
vention in the execution, the quality is not so high and it does not make the same
impact as the Brera picture. The *Madonna* (no. 583) in the Venice Academy (Pl.
LXIII *b*) is in many ways close to the Brera picture, though the type of the Virgin

[1] Berenson, B. 1916 (I), p. 75.

rather recalls those in the Madonna dell'Orto and at Berlin; but the old-fashioned handling, with hatching for the highlights and the rather dull and unusual colour with its brown flesh-tones and the Child's yellow drapery, make it difficult to accept the execution as Giovanni's though the design is surely his. On the other hand, the *Madonna* with the naked Child who stands blessing (no. 594) in the same gallery (Pl. LXV) is an autograph work of the highest quality. Building on the achievement of the Pesaro *Coronation* Giovanni shows himself moving here towards the warmer tones and the greater fusion of figures and landscape which distinguishes the work of the 1480s and the more humane monumentality of the San Giobbe altar.

In the preceding chapters we have traced Giovanni's development during approximately the first fifty years of his life, and although the series of paintings which we have considered contains a number of absolute masterpieces such as the London *Agony* and the Brera *Pietà*, which rank as high as anything which he produced, the whole of this period can, in a sense, be regarded as one of apprenticeship or at least of exploration. He was seeking by a series of experiments, sometimes brilliantly successful, sometimes less so, to achieve a mastery of his means of expression which would enable him to convey his vision of the diversity and unity of nature and man in terms of light, form, and colour without the spectator being conscious of the means. Such a work as the *Agony* has still a taste of archaic sharpness, which is indeed one of its beauties but is also a limiting factor; in the Brera *Pietà* we feel a technique stretched to the very limit of its expressive possibilities, and in the Pesaro *Coronation* we are almost too conscious of the exploitation of his mastery of Tuscan linear perspective and monumental form. In the great works of the eighties, which we shall consider in the next chapter, Giovanni's mastery of his means is so complete that we are never reminded of it.

## V

*The lost paintings for the Doge's Palace and the mature work of the eighties and nineties*

T H E primacy of the Bellini family among Venetian painters and of Gentile as the head of the family was recognized in 1469 by the Emperor Frederick III when he conferred on him the order of knighthood and in 1474 by the Venetian state when they appointed him to work in the Sala del Maggior Consiglio in the Doge's Palace. The task which he was assigned was that of renewing with paintings on canvas the deteriorated frescoes of scenes from Venetian history with which Gentile da Fabriano and Pisanello had decorated this room during the first quarter of the century. In 1479 Gentile, as official painter of the state, was sent, at the sultan's request, to Constantinople. Giovanni was entrusted with the continuation of his work in the Sala del Maggior Consiglio during his absence and confirmed as his companion in the work after his return in the following year.[1]

This enormous undertaking, in which they were later joined by other painters, formed the major part of Gentile's later activity and an important part of that of Giovanni. Unhappily the whole of this decoration perished in the fire which gutted that part of the palace on 20 December 1577, leaving a gap in our knowledge of the development of Venetian painting in this period which it is impossible adequately to fill. We have some account of these paintings in Vasari and a considerably enlarged one in Sansovino's *Venetia . . . descritta* published in 1581, four years after

---

[1] Lorenzi, G. B. 1868, doc. 189 p. 86, doc. 192 p. 88, doc. 195 p. 91. Domenico Malipiero in his *Annali veneti* (1843–4, ii. 663) registers Giovanni and Gentile as commissioned together to undertake the restoration in 1474, but the documents do not mention Giovanni before 1479. Malipiero's *Annali*, which were reduced in the sixteenth century to the abridged form in which they have come down to us, are not a day-to-day record like Sanuto's *Diarii* since they often mention in a single passage events covering a considerable period of time, so that they cannot claim the authority of an exactly contemporary testimony against the record of the official documents.

the disaster, but expanding a briefer account which he had published while the pictures were still to be seen. One fuller still, but only published seventy-one years after the fire, and conflating the accounts of Vasari and Sansovino, is to be found in Ridolfi's *Meraviglie dell'arte*.[1] These authorities are not unanimous as to exactly how much or what Giovanni executed here, and the documents, while they tell us that Giovanni continued to work in the Sala until his death, do not supply any details. It seems plain, however, that at least two canvases, that showing the *Discovery of Pope Alexander III at the Carità* and that showing the *Pope handing over eight standards and silver trumpets to the Doge at Rome*, were entirely his work, while one of the most celebrated paintings in the series, that showing the *Naval battle between Otto, the son of Barbarossa, and the Venetians* may have been begun by Gentile and finished by Giovanni; and he seems also to have finished the canvas of *Otto received by his father*, which had been begun by Alvise Vivarini. Vasari also mentions a scene of which he does not specify the exact subject, but which is described as representing a solemn Mass in St Mark's, and a picture of *Barbarossa doing homage to Pope Alexander III* outside St Mark's begun by Giovanni but finished and largely repainted by Titian.

We can infer the general character of this decoration from the paintings of somewhat similar subject-matter—historical events in a localized setting, in this case miracles wrought in Venice by a relic of the true cross—with which Gentile Bellini and other painters adorned the Scuola Grande di San Giovanni Evangelista at the end of the century and which are now preserved in the Venice Academy. But when we remember how far below the standard of Giovanni's achievement Gentile's work falls in the departments where the surviving material allows of direct comparison (such as those of Madonna pictures and portraits), we see that these pictures do little more than indicate the sort of picture which Giovanni was painting, even though we may admit that in such pictures as the *Procession in the Piazza* and the *Miracle of Ponte San Lorenzo* Gentile shows himself at his best and it is possible that this style of painting was not Giovanni's forte. What we particularly miss in Gentile's canvases is the sense of luminosity which we find in Giovanni's work; and it is significant that it is precisely in the sense of the suffusion of the canvas with light that we find the *St Mark preaching in Alexandria* (Pl. CVIII *a*) in the Brera, a work left unfinished by Gentile at his death in 1507 and completed

---

[1] Sansovino, F. 1581, pp. 123 *b*–133 *a*. The accounts of this decoration in Vasari and Ridolfi are scattered through the lives of the artists to whom they ascribed the respective paintings, but can easily be traced through the indexes of Milanesi's and von Hadeln's editions respectively. Sansovino's first account is in the pseudonymous dialogue *Tutte le cose notabili e belle che sono in Venetia, dialogo di M. Anselmo Guisconi*, Venice, 1556.

by Giovanni, superior to the *Miracles of the Cross*. Similarly, in spite of its poor state and its mean detail, it is in the splendid effect of light and shadow that the *Martyrdom of St Mark* (Pl. CIX) in Venice, commissioned from Giovanni the year before his death, shows something of the master through the execution of his follower, Vittorio Belliniano. Some other pictures in Giovanni's surviving *œuvre* may help us to an understanding of his lost achievement. First among these is the *Doge Agostino Barbarigo before the Virgin* of 1488 in S. Pietro Martire, Murano (Pl. LXX). This picture, a large canvas originally executed for a room in the Barbarigo Palace, is the nearest in function of Giovanni's surviving works to the lost histories and surely its sunny solemnity echoes something of their character. The *Annunciation*, from the organ-shutters of Santa Maria dei Miracoli (Pl. LXXX), even if we suppose a considerable measure of studio intervention in the execution, emphasizes the brilliant luminosity of his large-scale work upon canvas. But when we read of the pictures in the words of those who had actually seen them, Vasari and Sansovino, especially when we read of the scene of the gift of the eight standards and the silver trumpets, it is of the fairy-tale pageantry of Carpaccio's *St Ursula* paintings that we think; and one may well imagine that the particular quality which distinguishes these canvases above all the rest of Carpaccio's work is due to their vivid reflexion of Giovanni's achievement in the Doge's Palace. Their wonderful perspective and atmospheric structure and the harmony of colour, form, and light which they present recall the art of Piero della Francesca, and if we cast our minds back to Giovanni's Pesaro *Coronation* we may perhaps infer in the lost paintings a further achievement in the following of Piero which is not fully revealed to us in his surviving work.

Unfortunately such a hypothesis can never be more than a conjecture, but there are certain features in Giovanni's development in the eighties which can be directly linked with his new activity as a painter of large-scale works in oil on canvas, and certain problems which cannot be properly understood unless we bear this now almost unrepresented activity constantly in mind. Foremost among these problems is that of the dating of the San Giobbe altar-piece, his major surviving work from the decade. The difficulty of dating this work is due to a conflict between what is suggested by a stylistic comparison with certain dated works of the second half of the decade and the implications of the statement of a contemporary writer which indicates an earlier date. There is no doubt of the fairly close relationship of the San Giobbe picture to the *Madonna degli alberetti* dated 1487 and the Frari *triptych* and *Agostino Barbarigo before the Virgin*, both dated 1488. Fry, confining

himself to stylistic considerations, thought the Frari triptych, in spite of its inscribed date, substantially painted in 1485 and the San Giobbe picture in 1486 or 1487,[1] and Paoletti roundly asserted as a fact that it was finished in the latter year. This statement of Paoletti's is sometimes accorded documentary value, as Paoletti was a great student of documents, but since, if he knew a document, he failed to cite it, his statement should not rate above a conjecture.[2]

The contemporary reputation of the San Giobbe altar-piece is attested not only by its mention in Marin Sanuto's *Cronica* of 1493[3] (a proof, if any were needed, that it was already *in situ* by that year) but by Marco Sabellico in his *De Venetae urbis situ*, and it is the form of Sabellico's reference which suggests that the picture should be assigned an earlier date. Unfortunately the first edition of this work is undated but the printer, Damiano da Milano (or da Gorgonzola) was active in Venice between 1493 and 1495 and it is unlikely that the actual printing of the book falls outside these dates[4] though it might have been composed earlier. The reference to the burning of the Scuola Grande di San Marco as occurring 'hoc quadrennio' would seem to imply that that passage was written in 1489 since the fire was in 1485, but in another passage the founding of the church of San Rocco in 1489 is referred to as taking place 'hoc biennio' which would give us 1491.[5] We cannot be certain that this mention by Sabellico really antedates Sanuto's of 1493, but whatever its exact date the form of the reference does seem to indicate an earlier dating than the late eighties for the execution of the picture. What Sabellico, in describing the church of San Giobbe, says is 'Visitur in parte aedis Joannis Bellini tabula insignis quam ille inter prima artis suae rudimenta in apertum retulit'[6] —'In part of the church is seen the famous picture by Giovanni Bellini which he exhibited among the rudiments of his art.' On the face of it Sabellico would seem to be telling us that this was one of Giovanni's earliest works, in which case we could just say that he was plainly wrong and leave it at that, but it does not seem likely that he would have made such a mistake and it is probable that he meant

[1] Fry, R. E. 1900, pp. 33–6.                                      [2] Paoletti, P. 1929, p. 149.

[3] Manuscript *Cronica* of 1493, Venice Museo Civico Correr, MS. Cicogna, 1920, c. 25. Cited in Paoletti, P. 1893, ii. 185 n. 1.

[4] For the dates of Damiano's activity in Venice see *Catalogue of books printed in the XVth century now in the British Museum*, Part V, *Venice*, London, 1924, pp. l and 543–4.

[5] The second edition, of 1502, has a reference added to the Colleoni monument which is described as being erected 'cum haec proderemus'. The erection took place in 1496.

[6] Sabellico, M. A. (n.d.), lib. ii. It is interesting to note that the only other painted altar-piece to which Sabellico refers is Antonello's in San Cassiano. Colazio (1486, leaf d. 1) writing in 1476–7 also mentions Antonello's altar-piece. He does not specifically refer to Giovanni's although he mentions the work of the Bellini in general terms.

something different. Sansovino in his *Venetia . . . descritta* of 1581 writes, in a passage which looks as though it was based on Sabellico, 'e fu la prima tavola fatta a olio ch'egli mettesse fuori'[1]—'and it was the first picture painted in oil which he exhibited'. When we remember that the *Coronation* was probably executed in Pesaro and even if painted in Venice would not have been seen outside the painter's studio, and recall the small scale and suburban location of the *Resurrection* now in Berlin, such a statement assumes a reasonable meaning; and we see that what Sabellico understood by 'ars Johannis Bellini' was not his activity as an artist in general but specifically his activity as an oil painter—was indeed equivalent to the 'secret of the van Eycks'. We might infer that the Bellini brothers were credited with a particular know-how from the terms of the appeal made to the Signoria in 1488 by Alvise Vivarini for employment in the Sala del Maggior Consiglio, where he says he will work with the same method as the Bellinis;[2] and this again suggests that what Sabellico may have meant by the 'artis suae rudimenta' were precisely Giovanni's earlier works in the Sala del Maggior Consiglio, with which he wished to suggest that the San Giobbe picture was contemporary. Giovanni's activity there began as we have seen in 1479, but we know that the work proceeded slowly and we might reasonably suppose that Sabellico's phrase really indicates a date in the first half of the eighties. It hardly seems likely that he would have used such a phrase to indicate a time any nearer that at which he wrote, and I think we ought to accept the bracket 1480–5 for the production of the picture. The extreme freedom of the execution does make such an early dating a little surprising, particularly if we compare it with the tight finish of the Frari triptych, but special reasons can be suggested for the character of that picture; and it is by reference to the liberating effect of his large-scale activity in the Doge's Palace that we can best explain the contemporary freedom of this, the largest of his surviving works.

The picture (Pls. LXVI and LXVII) is preserved in the Venice Academy and, apart from a slight mutilation at the top, is in reasonably good condition, but its effect is gravely injured by its separation from its original frame. This still survives in the church of San Giobbe in its original position over the second altar to the right and is a particularly fine example of Lombardesque workmanship. Giovanni has here, as we know he had done earlier in the SS. Giovanni e Paolo altar-piece and as he was to do again, though not quite so exactly, in that of San Zaccaria, reproduced the architecture of the frame in the painted architecture of the picture. The plate, with all the faults of a *montage*, does do something to indicate how much we have

---

[1] Sansovino, F. 1581, p. 57 a.     [2] Lorenzi, G. B. 1869, doc. 221 p. 102.

lost in the divorce of the picture from its frame. The criticism made by Fry that 'the deep frieze with its heavy mouldings, and the thick ornate pilasters deprive it somewhat of the effect of space which the lost altar-piece must have had'[1] is a perfectly just one of the picture as we see it today in the Academy gallery with its mean gilt surround, but in the setting of the original frame the deep frieze and the thick pilasters fall into place, and the light flooding in at the right-hand side of the picture and illuminating the barrel vault brings the whole picture alive as we see the figure group in the brightly lit cube bounded by four pilasters, two painted and two real. It is much to be hoped either that the altar-piece should be returned to the church, as was done to everyone's benefit with Titian's *Assunta* in the Frari, or that the gallery should obtain a cast of the frame in which to exhibit the picture.

In its general arrangement the picture follows closely the lines established in Giovanni's lost altar-piece from SS. Giovanni e Paolo and Antonello's from S. Cassiano. In placing the viewing point in the base-line of the picture, so that the floor is not seen, Giovanni follows his earlier altar-piece—that in Antonello's lay somewhat higher. The base-line in its original setting lay approximately at spectators' eye-level and this must have powerfully increased the illusionist effect of the perspective, which reminds one even more forcibly than the lost altar-piece of Masaccio's S. Maria Novella *Trinity*. Such an arrangement appears to crowd the figures into the front plane of the picture and this is accentuated by the loss of the framing pilasters. Thus the space structure appears somewhat less rigidly logical than that in the Pesaro *Coronation*. In making further comparison with that work we are struck by the broader handling and the less brilliant and intense colour. This less-varied colouristic effect is partly due to the greater suffusion of the whole with light, partly to the predominance of gold mosaic and warm-toned marble in the background—in contrast to the brilliantly white marble and blue sky of the earlier picture—and partly to there being less colour in the figure group, since two of the saints, Job and Sebastian, are shown in the nude. The free and warm painting of the flesh in these figures is one of the most advanced features of the picture and looks forward to Giorgione and Titian. The development from the *Pietàs* of the previous decade, which is the context in which we have principally met the nude in Giovanni's work, is striking. We may perhaps recognize an intermediate stage in the beautiful little painting of *St Sebastian* in the mouth of a cave loaned by the Petrarchan Academy to the gallery at Arezzo (Pl. LIV *b*). The Mantegnesque character of the unfinished setting of this figure is very interesting:

[1] Fry, R. E. 1900, p. 35.

it links the Berlin *Resurrection* or the Frick *St Francis* to such works as the San Giobbe altar-piece. The contrasting arrangement of the two clothed and one nude figure on each side of the San Giobbe picture is particularly fascinating. The eloquent gesture of Francis's right hand looks forward to that of Christ in Leonardo's *Last Supper* and the Virgin in Michelangelo's *Pietà* in St Peters. In contrast to Giovanni's domestic Madonna pictures the Virgin is shown here without intimate feeling for her child. She raises her hand in a gesture more reminiscent of an Annunciate Virgin than the enthroned Mother of God, and this emphasis on her virginity rather than her maternity is taken up in the Latin hexameter inscribed in the mosaic of the apse: AVE VIRGINEI FLOS INTEMERATE PVDORIS 'Hail undefiled flower of virgin modesty', and in the inscriptions AVE GRATIA PLENA on the five mosaic cherubim. One would think the reference to the Annunciation to be deliberate, making the picture peculiarly a celebration of the incarnation and thus relating its subject to that of the *Sacred Allegory* in the Uffizi.

Beautiful masterpiece as the San Giobbe altar-piece is, especially if we try to eliminate the disadvantages of the loss of the frame, the faint uneasiness voiced by Fry still finds a sympathetic echo, and perhaps in contrasting the heaviness of the closed setting here with the lightness of the loggia in the lost altar-piece he correctly indicated its source, for this is the only completely closed interior among Giovanni's major work. The eye does indeed pass out between the side pilasters into further space, but it is interior space. The similar oblique views at the sides of the Frari triptych and the San Zaccaria altar-piece show us the narrowest but most exquisite strips of landscape, establishing a continuity with nature which Giovanni has here unusually chosen to deny himself. One almost has the impression that the effect he was aiming at was not of a chapel opening off the side of the church but of the whole structure fronted by the marble frame projecting into the church, so that the Virgin and her attendant saint and angels are gathered under a sort of Baldacchino in the body of the church itself.

There is much in common between the San Giobbe *Madonna* and the Frari *triptych* (Pl. LXVIII). I have already referred to Fry's view that the latter could not have been executed in the same year as the Barbarigo picture though both are dated 1488, and that it must be earlier than the San Giobbe altar, and his suggestion that it must have been substantially executed about 1485. Superficially there seems to be much to recommend such a view, which has received the qualified blessing of Davies.[1] On the other hand, if the picture really shows the style of 1485, why—

[1] Davies, M. 1961, p. 54.

since the elements which are supposed to show this are those of finish, which must necessarily belong to the final stages of its production—should it be dated 1488? Compared to the San Giobbe and Barbarigo pictures and even to the *Madonna degli alberetti* this work does indeed show a certain tightness of finish, and if we are to regard an artist's development, as Fry was certainly inclined to do, as a wholly autonomous process, it might seem that this work was inevitably earlier. Such a conclusion would neglect the context in which the work was produced. First of all we must not forget its scale. Its central panel is less than two metres high as opposed to an original height of about five metres for the San Giobbe altar. This brings it into relation with the series of Giovanni's domestic *Madonnas* which never approach the San Giobbe *Madonna* in freedom of handling.[1] Again the triptych form was decidedly old-fashioned by 1488 and its choice seems to indicate an old-fashioned patron, who may well have dictated a degree of finish greater than Giovanni left to himself would have favoured. Not that we feel this to be a hampered work, either in form or finish. If these were imposed restrictions Giovanni has known exactly how to turn them to the best account and has produced here not only one of his most popular works but one of his loveliest. Antonio Vivarini and Giovanni d'Alemagna in their triptych in the Scuola della Carità of 1446 and Mantegna in his San Zeno altar had anticipated the centralized altar-piece of the San Cassiano and San Giobbe type by uniting the three panels of a triptych in a single spatial scheme. Faced with the problem of a return to this rather outmoded system Giovanni has turned to these earlier solutions and in particular to that of Mantegna. But in his work the relation between the frame, the three panels and the imagined space is much more complex. Mantegna had imagined a simple rectangular space surrounded by a colonnade of rectangular pillars, with the front ones masked by the carved pilasters of the real frame. The three panels do not reflect any further articulation of the space. Giovanni, by raising the height of his central panel so that it terminates in a barrel vault closed by an apse, recreates the spatial unit of the San Giobbe altar on a reduced scale. The side panels can now take the form of 'side aisles' to this central 'choir' and the architecture of the frame, whose form closely anticipates that of the so-called 'Venetian Window' of the sixteenth century, becomes an integrated façade expressing the structure of the space behind. The relation between the painted architecture and the frame is not, in detail, quite as close as in the San Giobbe picture, for the painted pilasters do not bear the relief decoration of those of the frame, but the effect is one of complete harmony.

[1] Cf. the contrast between the *Madonna with the sleeping Child* and the *Frizzoni Madonna*.

The general effect of the colour is very similar to that of the San Giobbe picture but rather richer and more glowing—a beautiful combination of red, green, and white in the left-hand bishop, warm red in the Virgin's robe and in the brocade behind her, blue in her mantle, and a predominance of black in the right-hand panel. Finally the perfection of Giovanni's vision is seen in the minute strip of landscape, with its absolutely just recession, to which we look at the extreme edge of the picture on each side. Whereas at San Giobbe he had given us adult, or at least adolescent angel musicians, here he returns in the absurd figures of the delightful piper and lute-player below the Virgin's throne to the type of the lost SS. Giovanni e Paolo altar-piece, though here there is a more direct reminiscence of Donatello's angel reliefs from the Santo altar. One may, in passing, speculate as to whether the form of the frame here, with its arched centre, does not more closely reflect the architecture of Donatello's altar than current reconstructions would suggest. As with the San Giobbe altar-piece there is a hexameter inscription on the gold mosaic of the apse. It runs:

IANVA CERTA POLI DVC MENTEM DIRIGE VITAM

QVAE PERAGAM COMMISSA TVAE SINT OMNIA CVRAE

'Sure gate of Heaven, lead my mind, direct my life, may all

that I do be committed to thy care.'

Probably this inscription is of the donor rather than the painter, but it might stand not unfittingly as a motto of Giovanni's life and work.

The two panels of *Saint Augustine* and *St Benedict* at Zagreb (Pl. LXIX *a* and *c*) are fairly closely related to the side figures of the Frari triptych, but although their quality is by no means bad, one does feel that the studio assistants may have had a considerable share in the execution. This is an element which becomes increasingly important in the consideration of Giovanni's work from this time on. The hypothesis that these figures originally flanked the signed panel of *St Peter Martyr* from Monopoli, now at Bari (Pl. LXIX *b*), is tempting, but is contradicted by the dimensions of the panels, the absence of a parapet behind the Zagreb figures such as is found behind the one at Bari, and the different treatment of the sky and clouds. They must, however, be close in date, perhaps a little earlier than the Frari picture. We may usefully pause to mark twenty years of Giovanni's progress by comparing the *St Peter Martyr* with the figure of *St Vincent Ferrer* in the SS. Giovanni e Paolo polyptych, with due allowance for the possibility that an assistant executed that picture, noting especially how the mastery of the oil technique has enabled Giovanni to increase the sense of volume in the figure.

The picture of *Doge Agostino Barbarigo in adoration of the Virgin*, now in the church of San Pietro Martire, Murano, (Pl. LXX) is also dated 1488. A great deal has been written about its bad condition and it is indeed not strikingly well preserved, but to speak as Hendy does[1] of the Doge's superb cloth of gold as the only thing intact is much exaggerated—one cannot indeed see any special superiority in this passage. The suggestion that the picture has been transferred from panel to canvas is most improbable. As it was originally executed for the Barbarigo palace at S. Polo one would expect Giovanni to use the same technique of oil on canvas that he was currently employing in the Doge's Palace. The general design and many of the details, such as the delicate shadows of the ermine tails on the Doge's collar, show the felicities not only of Giovanni's invention, but of his hand and show them relatively unobscured. The red curtain hanging behind the Madonna, which forms such an important element in the design of the picture, recalls the predominance of red in the centre panel of the Frari triptych.

It is particularly interesting to compare this picture with the Pesaro *Coronation*. Both pictures show the figures set on a marble platform in the open air. In general effect the Murano picture is markedly less formal than that at Pesaro. This is inherent in the nature of the subject, where the introduction of the earthly donor, even of so high a prince, lowers the tension of the scene. Formally it is emphasized by the substitution of the slung curtain behind the Virgin for the marble architecture of the throne at Pesaro, while the presence of the donor introduces an element of asymmetry. We are on the way here to the lovely ordered informality of the *Sacred Allegory* of the Uffizi. In contrast to the Pesaro picture. with its curiously isolated central landscape, the view here, visible in fairly wide sections at each side of the picture, gives a sense of continuity to the picture as a whole. I have already remarked on the re-use here of the view of the three towers linked in the one wall from the Pesaro background, where it is to be explained as the view of the fortress of Gradara, and suggested its possible significance as a symbol of the Trinity. The four trios of cherubs' heads here may express the same idea. In comparing this work with that at Pesaro we are struck by its greater mellowness. The austerity of the earlier picture has given place to something warmer and more human. It is above all for the sunny irradiation of light that we remember this picture, glowing in the dark church where it hangs. I have suggested that this is probably in many ways the nearest among Giovanni's surviving works to the lost pictures in the Doge's Palace and I have also suggested that something of

[1] Hendy, P. and Goldscheider, L. 1945, p. 28.

their character may be reflected in Carpaccio's *St Ursula* series. It is interesting in this connection to note how much a work of Carpaccio's contemporary with the *St Ursula* pictures, the *Blood of the Redeemer* at Udine, owes to Giovanni's Murano picture.

Beautiful landscapes occur also, as we shall see, in the backgrounds of some of the Madonnas of the eighties, but the most important landscape of the decade is in the *Transfiguration* in Naples (Pl. LXXI). This picture has often been considered as approximately contemporary with the *St Francis* of the Frick collection, but Meiss has recently emphasized the period of time which must divide them and it must indeed be substantial.[1] If we accept, as I have suggested we should, a date at the end of the seventies for the Frick picture, the *Transfiguration* might be placed about the mid-eighties, which would seem to accord well with the relation of its landscape to that of the Barbarigo altar of 1488. In the Pesaro altar we have the unusual scheme of a view framed not only by the architecture but by the figure group. In this painting, which has no architecture, we have the feeling of the figure group being, as it were, framed by the view. This represents an important forward step in the concept of the setting of the figure in rather than against the landscape. In this it develops some elements of the predella panels of the Pesaro altar and indeed in some ways looks back to the early London *Agony*, but it also looks forward to the union and balance of figure and landscape which was the achievement of Giorgione. There is a wonderful mellowness in this work, though the golden tone of the landscape which led Fry to characterize the time as a late autumn afternoon may partly be due to the change in value of the green pigment. One would imagine the supposed date to be rather the sixth of August, the date of the feast of the Transfiguration. The figure of Christ is of course in white, and the lights and shadows in his garments reflect those in the clouds, so that the heavens seem funnelled down to earth through his figure; while the prophets with their warm colours, brown, pink, pale vermilion, and pale purple, mediate between this brightness and the russet hues of the landscape, which are more closely echoed in the stronger tones of the apostles, green, blue, brown, and pink. A little while ago we measured the distance travelled from the late sixies in contrasting the *St Peter Martyr* at Bari with the *St. Vincent Ferrer* polyptych; an even longer journey divides this version of the *Transfiguration* from that in the Correr and it is fascinating to see how the formal structure of the landscape has been loosened. The figures are brought down from the scriptural mountain in such a way that their nearness to us and to the

[1] Meiss, M. 1964, pp. 18–19.

unknowing herdsman and others in the background only increases the impression of transcendance. In this comparison we are reminded of Zanetti's characterization of Giovanni's achievement: 'A lui si dee l'onore sopra gli altri di aver abbellite di carattere più grande le forme delle figure, già meschine e ristrette: d'averne riscaldate saporitamente le tinte languide e smorte: e d'aver fatto conoscere lo studio dell'ombre e dei lumi, come necessario per rendere ogni oggetto rotondo agli occhi, e farlo comparire lontano e vicino, secondo la situazione; onde ne comminciò a nascere la dolcissima armonia.'[1] The beautiful fragments with the head of Christ and a cartellino with Giovanni's signature, in the Venice Academy (Pl. LXXIX *a*) must come from a third version of this subject executed some ten years later.

We may best begin the consideration of the *Madonna* pictures of the eighties with the one dated example, the *Madonna degli alberetti*, painted in 1487 (Pl. LXXIII), the year before the Frari triptych and the Barbarigo picture. Here the Virgin is shown behind a parapet on which the Child stands, clasped by her hands, his left hand playing with her finger. A pale green cloth of honour behind the figures leaves a narrow strip of landscape at each side similar to the strips which appear at the extreme edges of the Frari triptych but here occupied, perhaps following an earlier iconographic tradition and symbolizing the Old and New Testaments, by the two tall trees, one on each side, from which the picture takes its name.[2] Much has been written about the bad state of this picture, which was the object of a controversial cleaning operation in 1902, and the condition is certainly not everywhere satisfactory. It still contains, however, passages of exquisite finish, such as the Virgin's white veil under the light blue mantle drawn up over her head; and the damage is not such as to destroy the great beauty of this work, which is warmer and more human than the *Madonna*s of the seventies. The rather light tone of this picture anticipates a development of Giovanni's style in the first decade of the next century.

The *Madonna of the Pear* in Bergamo (Pl. LXXII), which formerly belonged to Giovanni Morelli, is closely linked to the *Madonna degli alberetti* not only by the identity of the model for the Child, clearly drawn from the same baby at the same stage of his development, but by a closely related handling. This picture still remains the best-preserved of any of Giovanni's *Madonna*s in spite of the recent deterioration of the Virgin's blue robe, which has acquired a disagreeable chalky quality, and the texture of the painting of the flesh helps us to estimate the consider-

---

[1] Zanetti, A. M. 1771, p. 46.

[2] See Molmenti, P. and Ludwig, G. 1904 for a study of the iconography of this picture as well as for a defence of the cleaning of 1902.

able extent of the damage in the flesh parts of the *Madonna degli alberetti*. The colour is, and probably always was, richer than in that work and there is notable warmth in the flesh-tints. The cloth of honour is a warm gold. The strips of landscape are wider, showing a peopled view of almost Eyckian intensity. It is certainly a little later than the *Madonna degli alberetti* but surely not so much so as Morelli's dating of 1496–8 would imply;[1] it must, I think, lie before rather than after 1490. A less attractive, though fully authentic, work which seems to lead up to these two is the *Madonna with the 'Pomegranate'* (no. 280) in the National Gallery, London (Pl. LXXV *a*). There are external reasons for dating this picture before 1489, since its design was adapted and clumsily expanded to a full-length by Francesco Tacconi in a picture signed and dated in that year also in the London gallery (Pl. LXXV *b*).[2] In fact it would seem to be substantially earlier than this date. Its cold dark shadows and heavy strength of colour indicate a period when Giovanni was still experimenting, not always with success, with the possibilities of the oil medium, and the picture would seem to fall in the early eighties. The green of the cloth of honour, suspended from vermilion ribbons, the red of the Virgin's robe, and the blue of her mantle are all exceptionally strong and the whole effect is striking rather than harmonious. In the landscape we find again, on the left-hand side, the 'Gradara' motive of the three towers linked in a single wall, and its further use would tend to confirm its symbolic significance.[3] Apart from the landscape which looks a little rubbed the condition of this picture is good. Though the finish is higher there are elements here, especially in the colour, which recall the Madonna and Child from the San Giobbe altar-piece, with which this picture is probably approximately contemporary.

A much more attractive picture which I would also date substantially before the *Madonna degli alberetti*, although it is often dated later, is the *Madonna with the Red Cherubim* also in the Venice Academy (Pl. LXXIV). This is certainly later than the *Madonna with the Standing Child*, (no. 594) in the same gallery, but it still has a

---

[1] Morelli, G. 1892–3, i. 260, n.

[2] For Tacconi's picture see Davies, M. 1961, p. 56 and Berenson, B. 1916 (1), pp. 113–15. Berenson suggested that Tacconi's composition must derive from a full-length by Giovanni from which Giovanni's half-length and the studio half-length then in the Nemes collection, now in New York, also derive, on the grounds that the raised right knee of the Virgin is explained by her foot resting on a foot-stool in Tacconi's picture; and Davies, while not drawing Berenson's conclusion about the date of Giovanni's picture in the National Gallery, is inclined to accept this. The reverse is surely the case. The raised knee requires no more explanation here than in other half-length *Madonnas* in which it occurs, such as the *Madonna of the Pear*, and Tacconi's jejune and clumsy device of the foot-stool is the attempt of a plodding second-rater to explain the raised knee when expanding Giovanni's half-length model to a full length. Since there is no need to suppose any other model by Giovanni than the National Gallery picture it is reasonable to infer that it was in existence by 1489 when Tacconi copied and expanded it.

[3] See above, p. 70.

good deal that reminds one of the Pesaro *Coronation*, from which the idea of the
red cherubim perhaps derives, and this is particularly true of the landscape. The
warm cloud of the cherubim in the background lends this picture a peculiar rich-
ness. Two somewhat damaged pictures which seem to belong also to the first
half of the eighties are the *Booth Madonna* in Washington and the *Mond Madonna*
in London.

A new type of Madonna composition seems to have been introduced by Gio-
vanni around 1490, in which the field is a horizontal oblong and the Virgin is
flanked by a half-length saint at each side. This was to remain a favourite type of
composition for Venetian painters during the next thirty years or so. I think the
earliest appearance of this type of composition in Venetian painting is in Giovanni's
*Madonna and Child with Two Female Saints*, (no. 613) in the Venice Academy
(Pl. LXXVI). This is an extremely beautiful picture, in which the experiments of depth
of tone in the rendering of light and shadow which distinguish the San Giobbe altar-
piece and the Frari triptych are pushed further and refined, the effect of tonal depth
being accentuated by the placing of the figures against a pool of darkness. Giovanni
had employed a dark background earlier, in the Rimini *Pietà*, but there its function
was rather to emphasize a linear, relief-like pattern than to suggest recession, depth,
and volume. His use of it in the adaptation of Mantegna's *Presentation* in the Querini
Stampalia gallery is closer to what he is attempting here. This preoccupation with
extreme subtleties of chiaroscuro modelling and with the effect of bodies emerging
from darkness into light recalls not only the precept but forcibly also the practice of
Leonardo, and suggests that Giovanni had possibly had some direct contact with
Leonardo's work. We know of course that Leonardo was in Venice in 1500 but
we do not know that he executed any paintings there and it would not be easy to
integrate this picture into Giovanni's *œuvre* at so late a date. If there is any direct
connection, it seems more likely that it came from Giovanni having seen some work
of Leonardo's which had been brought to Venice, or possibly from his having
himself visited Milan. Vasari alleges Leonardo's example as the inspiration of
Giorgione[1] and there is much in this 'Leonardesque' work of Giovanni's that
points to avenues to be explored in the work of that painter.

In subtlety of modelling this picture represents a unique achievement in Giovanni's
work, and this makes it difficult to date, but it seems to represent a deeper and more
refined study of problems already approached in the San Giobbe *Madonna* and the
Frari triptych, and the picture must be later than the latter though perhaps not by

[1] Vasari, G. 1878–85, iv. 92.

very much. The arrangement of the mantle, drawn up over the Virgin's head, is one which is general in Giovanni's work through the eighties and nineties and which gives way to a heavier white veil or head-cloth in the works after about 1500. This seems first to appear in another composition of the same shape, the *Madonna with St Paul and St George*, also in the Venice Academy (Pl. LXXVII). The effect of the picture here depends to a great degree on its colour, with the warm red curtain and St Paul's red mantle contrasting with the blue of the Virgin's mantle and the dark sheen of St George's armour. It is interesting to make another comparison with an earlier work, that of the head of St Paul here with the same saint in the Pesaro *Coronation*. We see here steady development rather than contrast. The linear elements, still strong in the head at Pesaro, have been softened and the whole modelling is softer too, but the later achievement seems to be implicit in the earlier version. The pose of the Virgin and Child is taken from that of the *Madonna degli alberetti*, but the direction of the Virgin's eyes is changed, as is the type of the Child who has much less individuality and charm. Altogether, comparing the two, the actual execution here seems a little heavy, and one wonders if there has not been some intervention by the studio.

I have referred earlier in general terms to the problem presented by studio activity in the latter part of Giovanni's career. This problem, which has recently been greatly illuminated by Gibbons in a series of articles,[1] is one with which I do not intend to concern myself very deeply in this book. My object is to give as clear an outline as possible of Giovanni's artistic personality and of its development, and this can be largely done by relying on autograph works. But it will be necessary to refer to some compositions which are only known in studio versions and to some works which, like the *Madonna with St Paul and St George* which we have just been considering, may, while to a great extent autograph, betray a greater or lesser degree of studio intervention. Gibbons associates the great increase in studio activity later in Giovanni's career with the drive to step up the rate of work in the Sala del Maggior Consiglio after 1492, when Gentile and Giovanni were set at the head of a team including Alvise Vivarini, Carpaccio, and other artists. An interesting point which Gibbons makes is that the designs which were multiplied in the shop tended not to be those of Giovanni's finest autograph works but ones which, while no doubt put together under Giovanni's direction, do not seem to have been honoured with a fully autograph version. He has also observed the

---

[1] For his views on the general organization of the Bellini studio see Gibbons, F. 1965, *passim*; for the role of Rocco Marconi, Gibbons, F. 1962 (1), and for that of Marco Bello, Gibbons, F. 1962 (2).

extent to which particular designs were assigned for reproduction to particular assistants—a shop practice which survived at least till the time of Watteau and his *St Nicholas*. Among Madonna compositions from the nineties which seem to show much of Giovanni's invention but a degree of studio participation in the execution are the *Virgin with a Standing Child and a Male Donor* in Lord Harewood's collection, the *Virgin with a Standing Child* at Castle Ashby, the *Virgin and Child with St Peter and St Sebastian*, no. 1158 in the Louvre (Pl. LXXVIII *b*), where an uncomfortably crowded composition is redeemed by great beauty of colour, especially in the yellow mantle of the Virgin, and the *Madonna* in the Burrell collection in Glasgow, formerly in the Barberini Collection (Pl. LXXVIII *a*). This last is generally reckoned a fine autograph work, and the motive of the standing Child playing with the flower hanging on a thread is certainly attractive, but the whole drawing of the Child is weak and the Virgin's face has the uncomfortable appearance of a mask surrounded by drapery which does not contain any solid head, so that I would reckon this as essentially a studio product.

The *Madonna* in New York (Pl. LXXIX *b*) which shows the Virgin behind a marble parapet seems to me to be of sensibly higher quality and the treatment of light is particularly beautiful. As in the Barbarigo altar and the *Madonna with St George and St Paul* the curtain is red. The landscape, with its rather large building, looks forward to such works of the next decade as the Giovanelli *Sacra conversazione* in the Venice Academy. On the other hand, the inlaid marble parapet recalls the interior of the church of Santa Maria dei Miracoli which had been completed in 1489, and the whole painting is linked with the *Annunciation* in the Venice Academy, which formed the outside of the organ shutters of that church (Pl. LXXX). Reference has already been made to this picture as one of Giovanni's surviving large-scale canvases from which we may infer something of the character of the lost paintings in the Sala del Maggior Consiglio, and perhaps if we had these the *Annunciation* would not appear as surprising as it does. The imposing figure of the angel, entering from the left, with his restless papery draperies, is very unlike anything else in Giovanni's work—for instance to take a nearly contemporary parallel the sober musician angels of the Barbarigo picture—and suggests at first sight a different authorship. We should remember too that this picture is attached to Giovanni's name neither by documentation nor old tradition. On the other hand, the effectiveness of the angel's figure is not in doubt nor is the generally Bellinesque character of the picture; and one does not readily recognize in it any of the known personalities of Giovanni's studio or entourage at this period, certainly not Pennacchi to

whom Boschini ascribed it.[1] We may see in its peculiar character not only the possible development of unknown elements from the work in the Doge's Palace, but a calculated attempt to create something that would be immediately impressive in the dazzling setting of the interior of the Miracoli. The effect of the fall of light and shadow on the marble walls, whose panelling is closely copied from that of the church (somewhat as the architecture of the SS. Giovanni e Paolo and SS. Giobbe altar-pieces echoed the decoration of their frames), is particularly subtle and one is reminded of Carpaccio's St Ursula paintings, especially the *Dream*. Through a doorway in the back we look out, beyond a shadowed loggia (this part of the picture, lying at the right-hand edge of the canvas with the Virgin, is unfortunately much damaged), to a characteristic landscape. This arrangement of a central landscape is somewhat reminiscent of the Pesaro *Coronation*; though here the landscape, while central to the architecture, is displaced to the right by the viewing-point lying a little outside the right-hand edge of the picture. Even if some of the peculiarities of this picture are due to studio assistance, this remains a wonderfully lively work, and an example of Giovanni's inventiveness and the freshness of his solutions. The *St Peter*, in a niche, which formed the interior of the shutter which had the angel on its outside (the corresponding *St Paul* from the back of the Virgin's shutter is lost) looks at first sight later, recalling the San Zaccaria altar of 1505; but closer examination suggests that it is in fact, as one would certainly expect, contemporary with the *Annunciation*.

The *Annunciation* may be dated with some confidence to the time of the dedication of the church. In 1490 Giovanni painted a picture of the supper at *Emmaus*, which was unfortunately burnt in the eighteenth century but which is known to us from copies and an engraving (Pl. LXXXI *b*), and this picture had a setting of panelled marble closely related to that of the *Annunciation*. Now since the setting in the *Annunciation* is clearly determined by the decoration of the church it is reasonable to assume that it was taken over for the *Emmaus* later and therefore that the *Annunciation* was in existence by 1490. This *Emmaus* picture was a popular composition. In addition to a number of direct copies we have a fine variant version, probably dating from the end of the decade (Pl. LXXXI *a*): this is certainly from Giovanni's studio, and even if he did not actually paint any of it we certainly see his mind in the impressive pillared setting. This painting hangs in a poor light in the left-hand transept of the church of the San Salvatore in Venice. Some thirty years after the production of the original version it was imitated twice by

[1] Boschini, M. 1664, p. 414.

Vincenzo Catena, and the composition was expanded into a *Last Supper* by a follower of Giovanni's in an interesting drawing in the Pierpont Morgan Library in New York. The head of Christ in this picture seems to have been the prototype of a number of busts of the Saviour, of which the best is perhaps the one in the Academia San Fernando at Madrid.

A number of compositions of the *Pietà* seem also to have originated in the nineties. The finest design is the simple one with Christ between Mary and St John, of which the best version is in Berlin (Pl. xciv *b*). This is in a sense a revision of the Brera *Pietà* in contemporary terms and though it is by no means so supreme an achievement it is a design of great subtlety and beauty. Unfortunately the execution, even of the Berlin version, is timid and indecisive and lets the picture down. This design was particularly popular with the *madonneri* who worked in Venice in the manner of icon painters for the Greek and Dalmatian market and translates indeed surprisingly well into their austere technique. This makes one wonder whether the design was not originally made for the Greek community in Venice.[1] In the more crowded compositions of the subject, at Stuttgart and in the cathedral of Toledo, Spain, one has the impression that it is not only the execution but the designs that have been left to assistants; the designs themselves appear to have been built up in the studio from authentic material, but not under the close supervision of the master. The grisaille in the Uffizi, which is often dated to this period, belongs, I think, to a later phase of Giovanni's activity and will be considered in due course.[2] Two other popular religious themes of this period are the *Circumcision* and the *Presentation*, for which a pair of closely related oblong compositions was devised. For the general scheme of these, though not their detail, Giovanni went back to the enlarged copy he had made many years before from Mantegna's *Presentation* in Berlin and which is now in the Querini Stampalia gallery. What is generally held to be the best version of the *Circumcision*, the one from Castle Howard in the National Gallery, London (Pl. lxxxii *a*), retains the dark ground of Mantegna's composition, which Giovanni had intermediately exploited with such effect in the *Madonna with Two Female Saints* in Venice. The London version, though of fair quality, shows little if any sign of Giovanni's execution; but the compact and coherent design would seem to be his own creation.

[1] For the Madonneri see Marle, R. van, 1923–38, xviii. 544–51. To the two Madonneri copies of the Berlin composition to which van Marle refers we may add one in the Byzantine Museum, Athens, one which passed through a London sale-room shortly before the war, and one in the writer's possession, acquired in Vienna in 1937.
[2] See below, p. 117.

The rather more disjointed design of the parallel series of *Presentation* pictures, which I illustrate from the version at Verona (Pl. LXXXII *b*), is less satisfactory—some of the background heads seem ill co-ordinated with the main composition and one has the impression, as in the Stuttgart and Toledo *Pietàs*, of a poorly integrated cento of studio material.

From these rather generic examples of Giovanni's activity we may turn with relief to a work which is certainly wholly autograph and one of the most individual and fascinating of his achievements, the *Sacred Allegory* of the Uffizi (Pl. LXXXIII). Though it was traditionally assigned to Giorgione no one would now question Giovanni's authorship, but little else about the picture commands general assent. Proposed datings have varied from one approximately contemporary with the San Giobbe altar to one in the early years of the sixteenth century. Although Ludwig's interpretation of the subject as an illustration of the fourteenth-century poem of Guillaume de Deguilleville, *Le Pèlerinage de l'âme*, was accepted for over forty years[1] it has been decisively challenged by Rasmo,[2] and new and differing interpretations have been offered by Verdier[3] and Braunfels.[4] With regard to the date a *terminus post quem* is provided by the San Giobbe altar, since the figures of Job and Sebastian are plainly borrowed from those in that picture and not vice-versa. Braunfels has suggested that a date before 1488 can be established by reference to the signed picture of the *Dormition and Assumption of the Virgin* by Gerolamo da Vicenza in the National Gallery, London, which is dated that year and which he thinks borrowed from the Uffizi picture the motive of the marble balustrade with the open door and the figures leaning over it. I have already suggested that Gerolamo da Vicenza may have modelled his picture on Giovanni's lost *S. Giovanni Evangelista* altar-piece in the Carità[5] and this or some other borrowing from a common source might well account for the undoubted resemblance to which Braunfels has drawn attention. The late dating is proposed on stylistic grounds. Personally I think that the style suggests a date substantially before such works of the opening of the new century as the *Baptism* at Vicenza and I should suppose that the picture dated from the mid-nineties. Allowing for the indifferent condition of both pictures and the differences of scale, technique, and intention, the landscape seems to agree well

[1] Ludwig, G. 1902.

[2] Rasmo, N. 1946. It is unfortunate that Rasmo's important article is so inaccessible. *Carro minore*, a cultural review published at Trento, is not available in any British library and in the U.S.A. only at Harvard.

[3] Verdier, P. 1953. For his identification of the crowned female as *Maria Aeterna* see, in addition to the literature which he cites, Einem, H. von, 1956.

[4] Braunfels, W. 1956.                                    [5] See above, p. 54.

enough with that in the background of the *Annunciation* of the Miracoli organ doors. The Uffizi picture is disfigured by a perished and yellow varnish and has evidently been a good deal rubbed in places, but it does not seem to have been much retouched, and I see no reason at all to accept Longhi's suggestion that the trees and bushes seen against the sky are an addition of the sixteenth century[1]—on the contrary the picture in its present state seems to me completely coherent.

Ludwig's attempt to explain the subject simply in terms of Deguilleville's poem is plainly inadequate and his failure to recognize the clothed child seated on the cushion, towards whom the gaze and prayers of the saints are directed, as the infant Christ, shows a fatal misunderstanding of the basic meaning of the picture. On the other hand, it is equally unsatisfactory to dismiss the interpretation of the subject as a matter of private fantasy as Rasmo does. Verdier has shown that though Ludwig's detailed interpretation is unacceptable it pointed in the right direction, that of medieval Christian allegory, and he has proposed a detailed explanation of the picture in these terms. He sees the picture as an illustration of the debate between the four daughters of God, Mercy, Truth, Justice, and Peace, over the salvation of mankind by the Incarnation. The idea of this debate derives from St Bernard's interpretation of verses 10–12 of Psalm 84 as foreshadowing the Annunciation. It is not possible to repeat the whole of Verdier's argument here, but the final interpretation of the main elements of the picture which he proposes are as follows. The figure seated on the marble throne to the left is *Maria Theotokos*, Mary the mother of Christ incarnate for the salvation of man; the throne is the *Sedes Salomonis* and she is representing the Father as judge in the debate. The disputants are Mercy (also representing Peace), who is the crowned figure on her left, and Truth (also representing Justice), who is the standing figure on her right, but Mercy also represents another aspect of Mary, the *Maria Aeterna* who was from the beginning. For the representation of the two Maries in the same panel he cites the parallel of Grünewald's Isenheim altar. Of the two male figures behind the balustrade the one with the sword is Simeon, who foretold to Mary the suffering of the Passion, the other Isaiah. Job and Sebastian represent the implacability of Justice. The naked putti playing with the infant Christ are angels. The three zones into which the picture is divided, the marble terrace, the meadow between the terrace and the lake, and the land beyond the lake are the world, *sub gratia*, *sub lege*, and *ante legem*. Rasmo stated that the standing figure to the right of the Virgin's throne is without feet and

[1] Cited by Pallucchini, R. 1959, p. 145. I cannot find this statement in Longhi's *Viatico* to which Pallucchini refers.

suggested that the picture might be unfinished. Verdier accepts the fact and explains it as an illustration of the verse in Psalm 84 'Veritas de terra orta est'.

Braunfels has criticized Verdier's interpretation as too complex; he does not believe that an elaborate allegory of this type is a possibility at this date and he seeks to explain the picture as a traditional 'Paradise Picture', citing as parallels the painting by Stefano da Zevio in Verona, that by the Master of the Virgo inter Virgines in Amsterdam, and that by the Master of the St Ursula Legend in Cologne. The material which he has collected certainly seems to indicate that this tradition contributed to the form which Bellini's picture took, but it leaves so many features of it unexplained that one is forced at the end to deny his initial premise and to recognize the essential validity of Verdier's interpretation, although one may question some details. Braunfels denies that the standing female figure is without feet. The passage in the picture is obscure but I think myself that she was intended to have them.[1] I do not believe that Giovanni would have introduced such a piece of naïve transcendentalism into a painting in which a transcendental subject is otherwise rendered with such strict rationality. This might open the way for a transposition of roles so that we would see the crowned figure, as Ludwig did, as Justice, abandoning the identification with *Maria Aeterna* altogether, and the nearer one as Mercy. With regard to the naked putti I am tempted still to see them as Ludwig did, as human souls, put here as redeemed souls to indicate the purpose of the Incarnation. The picture which seems to come nearest to this in conception, with a different but related subject-matter, is Carpaccio's *Meditation on the Passion* in New York, and I think *A Meditation on the Incarnation* would be a good title for the Uffizi picture. One wonders whether two such pictures, of similar scale and mood, might not have been executed for a single patron, who perhaps had a particular veneration for St Job, who figures in both.[2] I have already drawn attention to the emphasis on the Incarnation which distinguishes the San Giobbe

[1] I have not been able to examine the picture in the original since I became seized of this problem. The photographs I have examined (Alinari's detail no. 48007 and a detail taken by AFI at the time of the 1949 exhibition) certainly seem to show that no feet are now visible and that she appears to float, but examination of Alinari 48009, a detail showing Job and Sebastian, shows clearly that the figures are painted in not only over the drawing but the painting of the pavement and Jerome's right foot is already beginning to disappear through rubbing. I think in the case of the 'floating woman' the process has gone further. I believe that if Giovanni had intended to represent a floating figure he would have shown her with feet above the pavement and not truncated as she appears at present. It is perhaps more usual at this period to show female figures with their robes resting on the ground and covering the feet, but a parallel to what I consider to have been the original form of this figure, a woman with the hem of her robe hanging clear of the ground and showing her feet, is provided by the Magdalene in the Gulbenkian (ex Brownlow) Cima. Mr. Hugh MacAndrew, of the Ashmolean Museum, Oxford, who kindly examined the picture for me, thinks that the figure was probably intended to have feet, but retains a residual doubt.     [2] For the interpretation of Carpaccio's picture see Hartt, F. 1940.

altar-piece and one is tempted to think of the same patron as responsible for that commission also.

It is clear that whatever the exact intended meaning of the picture Giovanni entered fully into it and has produced a work expressive far beyond the direct reading of iconographical detail. There is a wonderful stillness here and a perfect balance of formality and informality. The means by which this is achieved deserve some analysis. In Giovanni's formal altar-pieces there is always a symmetrical architectural scheme which is viewed from a central point, whereas, as we have just seen, in the *Annunciation* from the Miracoli, which is a dramatic narrative picture, the viewing point lies actually outside the field of the picture altogether. The balance of formality and informality in the Uffizi picture depends to a great extent on the interplay between the formally symmetrical architectural setting of the paved terrace, with the vase with the Tree of Life at its centre, and the asymmetry introduced by shifting the viewing point to the right, so that it lies exactly two-thirds of the picture's width from the left-hand edge and one-third from the right, above the hermit in the cave and exactly at the height of the cross beam of the cross in the background above St Job. The sense of quiet depends partly on soft even light but perhaps even more on the still sheet of the waters of the lake, of which the high viewing point gives us an extended view. We have noted the significance of water in Giovanni's pictures from the beginning, and its value for him is nowhere perhaps so fully realized as here. The slightly blurred reflections are particularly beautifully observed and rendered. The colour is rather subdued and extremely subtle—especially the effect of the grey-violet robe of the oriental figure turning away on the extreme left seen against the water of the lake. This figure seems to symbolize the rejection of Grace.

Many elements here recall the early *Blood of the Redeemer* in London, and a comparison of the two pictures is instructive. In both the figure composition is set on a paved marble terrace bounded by a parapet and opening on to a landscape, though in the later picture it is an open balustrade and in the earlier is solid and adorned with reliefs. A relief in similar style, representing two satyrs or a satyr and a sea-monster with a vase between them, beneath a tree on which panpipes are hanging, adorns the Virgin's throne in the Uffizi picture.[1] Apart from the great differences in the relative scale of the parts, what strikes one most as differentiating the two pictures

---

[1] None of those who have attempted the iconographical interpretation of this picture has, I think, referred to this relief which may possibly refer to the story of Marsyas as a parallel to the Passion. In connection with Verdier's interpretation of the throne as the *Sedes Salomonis* we may note the absence of the imagery of lions specified in the Biblical source and generally found in medieval representations.

is the elimination of outline and the suffusion of the atmosphere in the later work. Christ's figure in the *Blood of the Redeemer* is bounded by an emphasized contour, beautiful in itself but disrupting the atmospheric continuity of the picture. The figures in the Uffizi panel have no hard outlines and merge into the surrounding space giving the effect of a positive atmospheric envelope, an effect which is partly achieved by their being painted into a setting already realized. This can be seen very clearly by a careful examination of the figures of St Job and St Sebastian: not only the drawing of the pavement but its colouring can be seen to continue under their legs, so that the way in which the setting seems to embrace the figures corresponds to a physical fact about the pigment. This practice of painting figures into a realized setting is something that becomes general in the work of Giorgione and Titian. This picture was, as I have said, traditionally ascribed to Giorgione, and in the relative importance of its landscape and to some extent the softness of its rendering it does look forward to his practice; but nature is still seen through the rational grid of fifteenth-century perspective construction, as it is no longer in the more improvised structures of the younger master. In spite of its small scale we may perhaps regard this picture as reflecting, in the layout of the foreground, background, and figure group, something of the compositions for the Sala del Maggior Consiglio. The extent to which the landscape reflects the mood of the figures is a further step in the realization of the immanence of the Divine in nature which finds another expression in the *Feast of the Gods*.

The five little paintings of allegorical subjects in the Venice Academy (Pls. LXXXIV, LXXXV, LXXXVI *a*) are generally associated with the Uffizi panel, but perhaps more from a parallel obscurity of subject than from any intimate connection of style. The *Sacred Allegory*, in spite of its many unique features, is very closely related in various ways to other paintings by Giovanni; the *Allegories* in Venice, although their poetry and their feeling for light might lead us to Giovanni as the artist even if one of them were not signed with his name, are nevertheless strikingly different from any of his other surviving works, though they are to some extent paralleled in some of his father's drawings.[1] In particular there is, in the drapery of the woman in the boat and in that of the armed man next the Bacchus, a conscious classicism such as we find nowhere else and which finds its closest parallel in Venice in contemporary sculpture, especially the reliefs of the Lombardi.[2] This stylization

[1] Louvre sketch-book, folios 36ʳ and 39ʳ. Rep. Ricci, C. 1908, pls. 40 and 41, and Goloubew, V. 1912, pls. XXXV and XXXVIII.

[2] Cf. particularly the reliefs on the base of the Vendramin Monument in SS Giovanni e Paolo, by Tullio and Antonio Lombardo.

makes the dating of the panels extremely difficult as there are so few points of formal contact with other works. In many ways the landscapes, especially that of the woman in the boat, look back to the predellas of the Pesaro *Coronation*, but that behind Bacchus and the Warrior, on the other hand, finds its closest parallel in such works of the sixteenth century as the *Portrait of a Man* at Hampton Court. The putti round the base of the nude with the mirror may reflect those on the Frari triptych, but this is not demonstrable. To discuss these pictures at this point is not to make a firm judgement as to their dating, which I find it impossible to reach. I do not suppose that they originated before about 1480 and I am inclined to think that they may even belong to the opening years of the sixteenth century. Bearing in mind the possibility of a late dating one may speculate as to whether the unusual classicism here betrays the participation of one of the painters of the younger generation working in Giovanni's studio, and in the light of later performance one might in this connection think of Sebastiano del Piombo. Part of the difficulty in dealing with these pictures arises from the fact that they are furniture pieces for which a rougher standard of finish was acceptable than for portraits or religious paintings. The piece of furniture which they originally adorned has been usually identified with that mentioned by the painter Vincenzo Catena in his will of 1518 and more fully described in the following terms, in that of 1525: ' . . . mio restolo di nogera con zerte fegurete dentro depinte de mano di miser zuan Belino.' Though one should admit the formal possibility that this was not the only work of this sort which Giovanni executed, the probability of the identification is strong.

Ludwig has shown that the 'restolo' or 'restello' was a sort of rack for toilet articles which also included a mirror and he has offered a rather fancy reconstruction of Catena's.[1] He inferred from a slight discrepancy in the size of the Bacchus panel that a sixth panel, of the same size, was missing, and its place is artfully concealed by a hanging curtain in his plate. His arrangement of the panels in relation to one another is not convincing. The design of the individual panels really leaves little doubt as to their original relationship and the reconstruction offered by Wind is surely right.[2] This places the panel with the man emerging from the shell, which bears Giovanni's signature, at the bottom right, with the Bacchus pairing with it on the left; above the Bacchus on the left will come the woman in the boat and corresponding to her on the right, above the man in the shell, the nude with a mirror, while the 'Harpy' will go in the centre, below or

[1] Ludwig, G. and Rintelen, F. 1906, pp. 187 ff. Robertson, G. 1954, p. 9.
[2] Wind, E. 1948, p. 48 n. 14 and pl. 52.

more probably above the central mirror. Ludwig explained the woman in the boat as *Inconstancy*, the nude with the mirror as *Prudence*, the 'Bacchus and Mars' as *Perseverance*, the man emerging from the shell as *Calumny* and the 'Harpy' as *Summa Virtus* with the bandaged eyes for *Justice*,[1] the jugs for *Temperance*, the claws for *Fortitude*. The hypothetical sixth panel was to have represented the crowning of the 'Tugendhelder'. Wind suggests *Fortuna Amoris* for the woman in the boat, pairing with *Vana Gloria*, the nude with the mirror, the pair symbolizing woman's good fortune and her ill fame; *Comes Virtutis* for the Bacchus paired with *Servitudo Acediae*, the man in the shell, the pair showing Man's good fortune and his ill fame; the whole surmounted by Nemesis, the Goddess of Chance, Retribution, and Temperance. Hartlaub[2] has more recently proposed another series of identifications, but his interpretation is marred by starting off from Ludwig's faulty reconstruction. For him the woman in the boat is *Vanity*, the figure with the mirror *Truth* (showing a highly unflattering reflection), 'Bacchus and Mars' *Abstemiousness*, the man in the shell *Illusion* or *False-prophecy* and the 'Harpy' *Fortune*, the hypothetical missing sixth panel representing *Truth* and *Self-knowledge*.

Wind's interpretations seem the most acceptable but the variety offered shows the difficulty of achieving any certainty. The general moralistic intention of the images cannot be in doubt and their exact interpretation seems less important than that of the Uffizi *Allegory* in so far as Giovanni appears here as less personally committed. It has been observed that in spite of the classicism of the draperies, to which I have referred, Giovanni has given the nude with the mirror a northern rather than classical proportion of body very reminiscent of Rizzo's *Eve* in the Doge's Palace. One is tempted to wonder whether this portrayal of a nude woman with a mirror in an interior setting does not reflect a knowledge on Giovanni's part of a painting by Jan van Eyck of the type known to us from van Haecht's picture of Cornelius van der Geest's gallery.[3] As one might expect with furniture pictures the execution is somewhat summary, but the effect is lively and, especially in the panel with the woman in the boat, with its swiftly flowing water, bare hills, and swimming children, extremely beautiful. The panel with the 'Harpy' is slightly smaller than the others and the type of landscape with its romantic valley scene rather different from the rest. This has led Longhi to separate it from the others and to deny Giovanni's authorship;[4] but it has considerable resemblances to the other panels as well as differences from them and it seems more probably to

---

[1] Panofsky, E. 1939, p. 109 n. 48. indicates that this symbolism for Justice is not found before about 1530.
[2] Hartlaub, G. F., 1942.     [3] Baldass, L. 1952, cat. no. 36 p. 284.     [4] Longhi, R. 1946, p. 13.

be an exercise by Giovanni in a rather different manner, perhaps not uninfluenced by Leonardo.

We must now turn to consider Giovanni's activity as a portrait painter. The *Jörg Fugger* of 1474 which we have already discussed introduces a series which continues without any very fundamental change of style until the end of the century. Unfortunately none of these portraits is dated nor can dates be inferred for any of them from outside circumstances, so that although it is possible to arrange them in what may seem a plausible chronological order we cannot hope for any exact dating. The lovely though sadly ruined *Portrait of a Boy*, formerly in the Holford collection and later in that of Mrs. Benson and now in the Barber Institute in Birmingham (Pl. LXXXVI *b*) would seem to lie very close to the *Fugger* portrait in date, and is close also to the Rimini *Pietà* for which I have argued a dating in the middle of the eighth decade. It has been suggested that the rather unusual form of the signature OPVS BELLINI—IOANNIS VENETI indicates that it was painted outside Venice, possibly at Rimini or at Pesaro.[1] The boy is shown behind a parapet in a beautiful *contraposto* with his body turned slightly to the left and his head to the right which introduces great liveliness into the design. The background of a very dark blue acts much like the black background of the Rimini *Pietà*. The boy wears an aubergine doublet over a pink shirt with a narrow white collar; his hair is light brown. Unfortunately the hair (which is very like that of the putti in the Rimini *Pietà*) is the only part of the picture surface which is tolerably preserved. The flesh has been scraped to a point where it has lost almost all its colour and modelling and there is considerable repainting along two vertical cracks to the left. On the right, where the main features are, there is scraping and uneven cleaning, but not, I believe, much repaint. The only passage which gives us an idea of the original surface and colour of the flesh parts is the little isolated area of forehead above the curl over his right eye. Ruin though it be this remains a striking and a moving picture and I do not think its injuries mislead us as to its original impact. At least the imaginative design and silhouette and the set of the head are unimpaired.[2] We must not allow the poor condition of this work to blind us to the great significance of its design. Meiss has pointed out the resemblance between the parapet here and in the portrait of Marcello in the Arsenal MS., and of both to Jan van Eyck's

[1] See Gamba, C. 1937, p. 71 and Pallucchini, R. 1949, p. 126.

[2] Below the blank cartellino is the inscription NONALITER. Though written as one word it seems it must be read as two, being either an authentication of the picture as really by Giovanni or of the portrait as a true likeness of the boy. As a single word it would mean 'in a manner pertaining to the Nones' which gives poor sense. Possibly NON ALITER might have been an *impresa* in the boy's family.

'Leal Souvenir portrait in London.[1] It should be noted that, in contrast to those two examples, the inscriptions on the Barber portrait are painted flat on the parapet and are not intended to give the illusion of incised letters. The treatment of the head, in my view, owes much to Antonello, but the liveliness of the pose, with the turned head, is not found in his work. Curiously enough, as in certain features of the Rimini *Pietà*, here too we are reminded of Botticelli.

Another portrait ascribed to Giovanni may also be compared to the Rimini *Pietà*. This is the *Bust of a Man with a Wreath* generally termed a humanist or a poet, from the Trivulzio collection, in the Castello at Milan. The fall of the drapery and the hair strongly recall the right-hand putto at Rimini but the comparison is not really favourable to the attribution of the portrait to Giovanni. It is difficult to see how the subtlety and movement of the Rimini figure, which is found in portraiture in the *Birmingham Boy*, could have been translated by the same painter into the flat lay-figure of the Trivulzio portrait's bust, nor is it easy to see Giovanni's hand in the rather brassy surface. An analagous but rather different metallic effect distinguishes the *Portrait of a Young Man* from the Bache collection in the Metropolitan Museum, New York, and this picture too, though widely accepted as Giovanni's, does not seem to me to be his work. Another attribution which must be rejected is that of the so-called *Colleoni* once in Lord Brownlow's collection and now in Washington. Even allowing for the very unsatisfactory state of this picture it is impossible to see either the hand or the mind of Giovanni here. This picture has a curious mixture of plastic and linear values which make one wonder whether it is not a Venetian copy of a Paduan original from the circle of Mantegna.

Although no portrait before the London *Loredan* of the opening of the new century reaches the level of the *Birmingham Boy* there are a number of very respectable male busts which follow up the line opened by the *Fugger* portrait. The *Young Man in Red* in Washington (Pl. LXXXVIII *a*) would seem to represent Giovanni's activity contemporary with or a little later than the Pesaro *Coronation* and in some ways recalls the *Madonna in Red* in the London National Gallery. A somewhat similar portrait of a young man also in red in Padua, which is in worse condition, was perhaps never more than the work of a follower. On the other hand, the portraits of the *Young Man* in the Louvre (Pl. LXXXVIII *b*), in the Capitoline Gallery in Rome (Pl. LXXXVII *a*) and in Washington (Pl. LXXXVII *b*) would seem to be fine originals of the eighties or nineties. These last works are signed, but not all signed portraits seem to show Giovanni's own hand, and in this department too the

[1] Meiss, M. 1957, pp. 27–9.

assistants were called in to help. We may instance the well-known *Portrait of a Man* in the Uffizi, where a good design is weakly executed and, from a slightly later date, the little portrait in Liverpool. The general pattern of these portraits remains pretty constant: it is the Antonellesque formula of a head and shoulders behind a parapet almost always turned to the left, and in the case where we do not find a parapet we may suspect a mutilation. But in one instance, the *Senator*, formerly in the collection of Mrs. Derek Fitzgerald (Pl. xc *b*), which probably dates from near 1500, the sitter is shown down to the waist and turned the other way, in a manner which looks forward to the development of the portrait in Venice in the next decade. Unfortunately the surface state of this fine picture does not seem very satisfactory.

# VI

*The works of the first decade of the sixteenth century.* 1500's *Contact with Albrecht Dürer*

ON 2 October 1501 Leonardo Loredan was elected Doge, to guide the Signory through the next twenty years and through the worst military and diplomatic crisis of her history. He was already over sixty and it seems likely that the portrait which Giovanni executed of him as official painter to the State was painted soon after his election. With this splendid picture, which is now in the National Gallery, London (Pl. LXXXIX), we may begin our consideration of Giovanni's activity through the sixteen years during which his life was prolonged into the new century. The basic scheme here is that of the portraits which we have been considering, a bust and head in three-quarter face behind a parapet with a cartellino bearing the signature. Indeed compared to Mrs. Fitzgerald's portrait the scheme is slightly archaic. But subtle differences in scale and presentation determine this portrait as belonging to a new age. Compared to such a work, for instance, as the Capitoline portrait the extent of the bust shown above the parapet is greatly increased while the scale of the head in the field of the picture as a whole is correspondingly reduced. This gives a sense of the existence of the whole person within the picture such as the earlier examples do not. We are already on the verge of the portrait type of the painters of the younger generation, where the line of the parapet is broken and hands and arms freely appear, as in Giorgione's *Young Man* in Berlin and Titian's *'Ariosto'* in London. This painting exemplifies particularly well the aged Giovanni's capacity to keep level with new trends while remaining within the framework of his inherited tradition, and this is the great achievement of his last years. His art, like Titian's, and, in a briefer compass, Rembrandt's is evergreen and shows a continuous development. In this picture the undistracting simplicity of the design leaves us free to concentrate on the sureness of the drawing, the subtlety of the modelling, and the convincing presentation of the sitter's character. I have said

that this picture looks forward to the work of Giorgione and Titian; it may also be viewed as the last monument of the tradition of portraiture inaugurated about the time of Giovanni's birth by Jan van Eyck.

The Tietzes, by a comparison with the Loredan portrait, have tentatively identified as Giovanni's the portrait drawing in Berlin usually regarded as a self-portrait by his brother Gentile (Pl. xc a) and used by him in his *Procession in the Piazza* of 1496, supposing plausibly enough that Gentile got his brother to draw him when he wished to include his own portrait.[1] In the absence of any authenticated portrait drawings by Giovanni for comparison the attribution must remain somewhat speculative but it is very plausible, especially in view of the superior quality of this head when compared to another drawing, also in Berlin, for another head in the same picture, which would seem to show Gentile's limitations. Gibbons has linked this drawing with the double portrait formerly in Lord Kinnaird's collection and now in private possession in England, in which he recognizes the older man as another portrait of Gentile and for which he accepts Berenson's attribution to Giovanni.[2] I do not myself find the identification acceptable, since the man portrayed in the painting appears many years younger than the man in the drawing while the painting must be later than the drawing in date. Nor do I think that this lively but clumsily executed painting can possibly be by Giovanni. A case could be argued for an attribution to Vincenzo Catena, in which case its date would have to be put forward into the second decade. The irrelevance of the Kinnaird picture to Giovanni's personal achievement is confirmed by the very different quality of a picture which is probably some five years later in date than the *Loredan*, the *Portrait of a Man* at Hampton Court (Pl. xci). This portrait has been identified as that of Pietro Bembo and the identification is attractive and plausible, but the evidence as to Bembo's appearance during the first decade of the century is not adequate to make it a certainty.[3] Giovanni's approach is naturally more informal here than in the official portrait of the Doge but we see the same development of a new sense of scale and freedom of handling within the framework of the traditional bust portrait. The new qualities are particularly to be seen in the fused modelling and in the freely painted, atmospheric, and relatively empty landscape which is close to that in the background of Giovanni's *Madonna with Saints and a Donor* in the church of San Francesco della Vigna (Pl. cvi a). This

[1] Tietze, H. and Tietze-Conrat, E. 1944, no. A. 261 p. 68.
[2] Gibbons, F. 1963, p. 56. The picture is reproduced in Berenson, B. 1957, i. fig. 254.
[3] See below, pp. 141–2.

painting, which is signed and dated 1507, gives us an approximate dating for the portrait.

Such an increased atmospheric saturation and subordination of detail in the landscape had been foreshadowed in the Naples *Transfiguration* and the Uffizi *Allegory* and already predominates in the great altar-piece of the *Baptism of Christ* in the church of Santa Corona at Vicenza (Pl. xciii). The altar was under construction between 1500 and 1502 and this should give us the approximate date of the picture.[1] The glowing colour of the Pesaro *Coronation* is fused here into a richer harmony, just as its austerity of contour and geometry of modelling is softened. The landscape, which there was as it were segregated from the figures, here follows the direction indicated in the Naples *Transfiguration* and enfolds them. The brilliant colours of the grouped pairs of cherubs' heads are particularly reminiscent of Pesaro, the upper quartette dark blue, the middle ones vermilion and the lower ones orange. The Father, in the sky, has a blue mantle over a red robe, the Baptist dark flesh, a grey-blue shirt, and a dark green mantle. The angel nearest the frame has a lovely yellow dress, the middle one a blue-grey dress and blue mantle, the one furthest into the picture a dark-green dress and red-pink mantle. It is perhaps a reflection from this mantle that gives a pink light to the shadow on Christ's loin-cloth. A parrot with grey-blue wings and brilliant red bill perches in the right foreground. In this picture the new sort of pictorial organization which Giovanni had unsuccessfully attempted in the Berlin *Resurrection*, and which he had achieved on a smaller scale in the Naples *Transfiguration*, finds its full monumental expression. The suppression of detail in the background does not make it bare or barren, but, as in Giorgione's work, we sense a richness we do not in detail see. One may speculate as to whether there is not in this landscape a direct reference to the landscape of the Holy Land, from which the donor of the picture had just returned. The detail of the foreground looks back to the Frick *St Francis* and forward to the *Feast of the Gods*. The Hermitage in the middle distance somewhat recalls features in the background of the Uffizi *Allegory*, but consideration of the landscape as a whole will show the difficulty of accepting the later dating proposed by Rasmo for the Uffizi picture.

Arslan would indeed favour a later dating for the Vicenza picture on account of its Giorgionesque quality and even see in it the collaboration of the younger master, but a date not substantially later than 1501 is indicated by the very close links between this picture and the little half-length of *St Dominic* in the Hickox collection,

---

[1] Bortolan, D. 1889, p. 263; cited after Gronau, G. 1930, p. 213.

New York (Pl. xcii), which is almost certainly identical with a panel painted for Alfonso d'Este in that year.[1] The Hickox picture is an autograph work of the highest quality and is particularly valuable as giving us a firm point in Giovanni's chronology in this period, though, being modest in scale and simple in treatment, it does not greatly enlarge our concept of Giovanni's activity. I cannot follow Arslan in clearly distinguishing two manners in the Vicenza picture, one in the figures of Christ and the Baptist, the other in the three angels. The painting seems to me completely unified and the difference between the two groups no more than one would expect between older figures mainly nude and youthful ones heavily draped. The drapery of the angels seems to me characteristic of Giovanni. On the other hand, no one could deny that the style of the picture does in some respects approximate to Giorgione's. We do not really know enough of Giorgione's work, of which so much must have perished, or of the chronology of what has survived, to hope to be able to give a clear answer to the question of the exact nature of the relation of Giovanni's work at this period to that of the younger master. But in view of the extent to which his style here develops coherently from his earlier achievement, especially from the Naples *Transfiguration*, one may perhaps think in terms of Giovanni giving as well as receiving. In discussing the Naples picture I remarked how the brilliant white figure of Christ seemed to funnel the heavens down to earth. Here there is a somewhat similar vertical connection, the ray with the dove descending and meeting the Baptist's bowl and continued as the stream of sanctifying water. The outspread hands of the Father recall, perhaps deliberately, a Trinity composition in which Christ is raised on the cross before him. In the beautiful head of Christ we are reminded of Flemish models such as must have lain behind some of his earlier achievements like the *Christ Blessing* in the Louvre. It is interesting to compare Giovanni's picture with that executed by Cima between 1492 and 1495 for the church of San Giovanni in Bragora in Venice. It may be noted that Cima's composition is less hieratic, lacking the bust of the Father and with Christ turned slightly to the left, while the landscape is rather more open and considerably more detailed, with the view of Conegliano on the left. The very much lower horizon in Cima's picture may perhaps be due to the high position which it was painted to occupy, and still occupies, in its beautiful Lombardesque frame over the high altar of the church. Giovanni's picture is also in its original setting but the elaborate structure of columns and coloured marbles betrays

[1] Arslan, E. 1956, p. 67. For the documentation of the Hickox *St Dominic* see Venturi, A. 1926, p. 70, and Luzio, A. 1880, p. 278.

a vulgar provincial taste in Vicenza (making the later achievement of Palladio appear all the more remarkable) which sadly oppresses the delicacies of Giovanni's painting.

The bust of the Father from the top of this altar is repeated in a very beautiful and freely painted version in the gallery at Pesaro (Pl. XCIV *a*). Gibbons has made the interesting suggestion that this is a painted *simile* made by Giovanni for use in the workshop and that not only such inferior versions as that above Fra Negroponte's *Madonna* in S. Francesco della Vigna or Bissolo's *Crowning with Thorns* in the Venice Academy, but the figure in the Vicenza picture itself depend upon it.[1] If it were such a *simile* of a part of a composition it would be a unique survival from this period and it seems to me unlikely that the sky would be so highly finished. I would see it rather as a fragment of a lost composition, probably another *Baptism*, perhaps rather later in date than the Vicenza picture. Its superior quality forbids the hypothesis that it once formed the top of the studio version of this subject in S. Giovanni degli Cavalieri in Venice.[2] Another studio derivation from the Vicenza picture is the *Christ Blessing* published by Morassi, which he claims as an important original, antedating the Vicenza picture by more than five years. The harder handling on which he grounds his dating seems to me a sign of studio execution rather than earlier date and the whole a typical assistant's compilation of motives current in the studio, though one of high quality. I do not think it likely that this is the picture which Ridolfi says Giovanni gave the fathers of S. Stefano. His description of 'la diligenza usatavi, annoverandosi ogni minuto pelo ed esprimendovi ogni particolare sentimento del volto' is much more suggestive of a work of Giovanni's early period and in fact fits the early picture in the Louvre, as was proposed by Borenius, much better than this.[3]

A work of higher quality, which stands in close relation to the *Baptism*, is the *Christ in the Tomb* at Stockholm (Pl. XCV *b*). In spite of its bad condition the distinction of this work is still apparent in its design and in certain passages of the execution, especially in the background, and it is worthy to be, as Gamba suggested,[4] the picture of this subject which Vasari tells us was extorted from the fathers of S. Francesco della Vigna by Louis XII.[5] It seems likely that so substantial a panel as

---

[1] Gibbons, F. 1965, p. 151.

[2] This picture, which is difficult to see as the church is generally shut, is of secondary quality.

[3] Morassi, A. 1958, p. 50. For the S. Stefano picture, Ridolfi, C. 1914–24, i. 71, and Borenius, T. 1915, p. 205.

[4] Gamba, C. 1937, p. 161.

[5] Vasari, G. 1878–85, iii. 163. Vasari says 'Ludovico Undecimo' and it is chronologically possible that Louis XI might have obtained an earlier work of Giovanni's but, with his known Italian preoccupations, it is much more likely that Louis XII was meant.

the *Baptism* was executed on the spot in Vicenza and it has been thought that the beautiful *Pietà* which passed in 1934 from the Donà delle Rose collection to the Venice Academy (Pl. xcvii), which contains views of several monuments of Vicenza in its background, may have been executed there on the same occasion; the more so since this northern type of composition, with the dead Christ stretched over his Mother's knees, which does not occur earlier in Giovanni's work, might have been adopted in imitation of some sculptured northern examples or local painted derivatives which are still to be seen in the Sanctuary of Monte Berico at Vicenza.[1] When Michelangelo had executed his version of the same type of composition some years earlier we are told that it was criticized for the youthful features he had given Mary and the artist's ingenious defence of his idealization is recorded for us by Condivi.[2] Giovanni, less idealistic, has, like Donatello in his relief of the Ascension in the Victoria and Albert Museum, made his Virgin a moving picture of worn old age. In this picture, as in some other later works, we find that not only is the landscape given as much attention as the figures, but that, while one may suspect some studio assistance in the execution of the figure group, the landscape seems to be wholly autograph. We may also suspect a similar distribution of parts in the actual painting in the *Madonna of the Meadow* in London, where Giovanni recalls this northern *Pietà* type in a *Madonna of Humility*.

The beautiful detail of plant life in the setting here, which takes us back to the Frick *St Francis*, is found in another work for which a date in the early years of the new century is suggested on other grounds, the *Crucifixion* in the collection of Count Niccolini da Camugliano in Florence (Pl. xcv *a*). According to Pallucchini the Hebrew inscriptions on the tombstones in the background bear dates corresponding to 1501 and 1502 or 1503 respectively.[3] The townscape in the background, which is very similar to that of the *Pietà* in its general character, contains a view of a Gothic church which seems to be that of St Syriac at Ancona. A slightly different view of the same church occurs in the background of the *Martyrdom of St Mark*, begun by Giovanni at the end of his life and finished by Vittorio Belliniano.[4] Though a visit to Ancona at this period is quite possible we need not necessarily infer it, since the studies could have been made on an earlier occasion, perhaps at the time Giovanni was in Pesaro in connection with the *Coronation*. Another link

---

[1] See Arslan, E. 1956, no. 1271 p. 180 and pl. c. It seems equally likely that Giovanni may have made contact with such northern models in Venice itself; for another Venetian derivative of this type see the sculptured central group of Bartolommeo Vivarini's polyptych of 1485 in Boston rep. Pallucchini, R. (n.d.), pl. 201.

[2] Condivi, A. *Vita di Michelagnolo Buonarroti*, Rome, 1553, chap xx.

[3] Pallucchini, R. 1959, p. 151.                                    [4] See below, p. 125.

between the work of this period and the Frick picture is provided by the little *St Jerome* in a landscape formerly in the Benson collection and now in Washington (Pl. LVIII *b*). This work, to which reference has already been made,[1] bears the date MCCCCCV incsribed on a stone in the foreground, without any artist's name. There is a curious disparity between the foreground and the distant view which might suggest that this is actually a work begun much earlier but only now completed. It is perhaps more reasonable, however, to regard it as something which originated at this time—when, as the *Donà delle Rose Pietà* and the *Niccolini Crucifixion* show, Giovanni was again occupied with natural detail somewhat as he had been in the late seventies—and to attribute the disparity and the evident inferiority of the distant view to studio participation. The two rabbits in the background are also found in the *Christ Blessing* which we have just considered and a related motive occurs earlier in the Berlin *Resurrection*. We should not forget that the dating of the Frick *St Francis* is entirely a matter of style—we have no independent evidence as to its date—and that it would be formally possible to build up an argument that it is itself a work of this period; but a careful comparison between it and the works which we have just considered, both in respect of the actual handling of detail and of the structure of the landscape as a whole, seems effectively to rule out this possibility.

The *Madonna with the Baptist and a Female Saint* (Pl. XCVI), which passed in 1925 from the Giovanelli collection to the Venice Academy, shows a development from the Vicenza *Baptism* in another direction, echoing its glowing colour and painterly execution. One would be tempted, as Gronau has remarked,[2] to date this picture to the very end of Giovanni's career, and one can point to striking resemblances between the Virgin and the female Saint here and the nymphs in the *Feast of the Gods*. But as Gronau also points out, the composition and in particular the figure of the Baptist seem to have inspired a painting by Previtali in London which is dated 1504, which argues that Giovanni's picture was in existence by that year. We might perhaps see this work with its soft modelling and chromatic brilliance as a direct reaction to the work of Giorgione as we see it in the Castelfranco *Madonna*. A picture which, in the open-air setting, has something in common with this work, as well as with the Vicenza *Baptism* and the *Hickox St Dominic*, is the charming little altar-piece with a male donor presented to the Virgin by a male saint with another male saint at the other side, formerly at Cornbury Park, which bears the date 1505 (Pl. XCIX *a*). Though this is often rated as a studio production I see little

---

[1] See above, pp. 77–8.    [2] Gronau, G. 1928, p. 18.

sign of assistance. It may have been cut a little at the left, but part of its charm must always have depended on a very slight asymmetry carried through the whole picture, by which the viewing point lies a little to the left of the centre of the throne while the *cartellino* is displaced slightly to the right. A number of other *Madonna* pictures are more or less closely related to the type found here. Some seem to be considerably later in date, but the one in the Borghese Gallery in Rome, which is, however, only of studio quality, may be approximately contemporary.

Giovanni's great achievement of 1505 was the enthroned *Madonna* in S. Zaccaria (Frontispiece and Pl. xcviii), of which I spoke at the beginning of the book. We can now approach this painting with more understanding and see more clearly the foundations of Giovanni's achievement. If we compare this altar-piece to that at S. Giobbe we are particularly struck by its greater sense of spaciousness. This is partly a question of the treatment of light, but it owes much to the choice of a higher viewing point and the reduction of the flanking saints from six to four and the angel musicians from three to one. The result of these changes, especially the raising of the viewing point, is to substitute for the assertive realism of the earlier Renaissance—and something of Castagno was still to be seen in the S. Giobbe picture—the ordered and spacious eloquence of the High Renaissance as Leonardo had displayed it in the refectory of S. Maria delle Grazie in Milan and as Raphael was developing it in Florence. The new spirit is also seen in the more architecturally complex and less decoratively ornate character of the frame, which reflects the developed forms of Coducci's church. In colour the picture has much the same richness as the Vicenza *Baptism*. Mary has a white veil, a red-pink robe, and a rather light-blue mantle, the little angel below her a green robe and pink mantle, the female saint to the left has a red robe and green mantle and the one to the right a blue-grey robe brocaded with yellow and a green-orange mantle with a grey-blue lining. St Peter has a grey-blue robe and a brown-orange mantle, while St Jerome's red mantle has a white lining. The floor is paved with red and white marble. The capitals of the columns are gilded, the architrave of dark marble, the curved wall of the apse of dull yellow. The decoration of the apse vault is the representation of a scroll-work mosaic on a gold ground. Not only is the viewing point in the picture placed relatively high, at a point level with the Madonna's feet, but the base of the picture itself lies higher than at S. Giobbe, rather above the eye level of a spectator standing in the body of the church. This picture was painted the year after the supposed date of Giorgione's Castelfranco *Madonna*. We may well see the influence of the younger master in the modelling, especially in

the head of St Jerome, and the picture as a whole shows Giovanni's sensibility to new trends. If we compare the two pictures we are also struck by the great loss implicit in Giorgione's abandonment of a rational architectural setting in favour of *ad hoc* contrivances for pictorial effect, which rather remind one of the properties of an old-fashioned photographer's studio. Berenson at one time suggested that the *Three Ages* in the Pitti might be a very late work of Giovanni's, though he later veered towards the view that it was a Giorgione.[1] In some ways this picture comes closer to the heads of the female saints in the S. Zaccaria picture than anything else in Giovanni's work. Nevertheless, the hypothesis of common authorship, while attractive, does not seem convincing.

When Dürer came to Venice in 1506 he was, as we have seen, favoured with Giovanni's friendship and he tells us that Giovanni wished to have a work of his. It has been suggested that this was satisfied with the *Christ in the Temple*, 'opus quinque dierum', which passed from the Barberini collection in Rome to the Thyssen collection in Lugano.[2] Much has been written of the influence of Italian art on Dürer, less of his possible influence on Giovanni. Vasari invoked the example of the *Madonna of the Rose Garlands* to explain 'un certo che di tagliente' which struck him in the *Feast of the Gods*,[3] and there are works dating from this time or a little later, such as the triptych formerly in Berlin,[4] in which we are conscious of an increased sharpness of drapery which might derive from this source. I should like to connect with Giovanni's contact with Dürer a puzzling work which is generally assigned to a considerably earlier date. This is the grisaille *Pietà* in the Uffizi (Pl. c). As with Jan van Eyck's *St Barbara* there has been much discussion as to whether this is a finished work or the preparatory underdrawing for a painting. Paolo Pino, in his *Dialogo della pittura* published in Venice in 1548,[5] advises students against following Giovanni Bellini's example and making an elaborate under-drawing including the whole of the chiaroscuro modelling, as this is wasted labour, all having to be covered with colour, and this would on the face of it be strong evidence that what we have here is the preparatory stage of a fully coloured picture. On the other hand, it is possible that Pino was basing himself on a knowledge of this particular work, which he assumed, perhaps wrongly, to be the preparation

[1] Berenson, B. 1932, p. 349, and 1957, i. 84.

[2] Waetzoldt, W. 1950, p. 110. For Venetian elements in Dürer's panel see Białostocki, J., ' "Opus Quinque Dierum": Dürer's "Christ among the Doctors" and its sources', *Journal of the Warburg and Courtauld Institutes*, xxii, 1959, pp. 17–34. For the recent suggestion that the picture was executed not in Venice but in Rome see Winzinger, F., 'Dürer in Rom', *Pantheon*, xxiv. Jahrgang, Sept./Okt. 1966, pp. 283–7.

[3] Vasari, G. 1878–85, vii. 433.     [4] See below, p. 120.     [5] Pino, P. 1946, p. 106.

for a coloured picture; and this would rob his statement of its authority, though it would still have value as showing that this was how the picture struck an artist of the next generation. That this was not the universal practice of Giovanni's contemporaries in Venice is shown by the unfinished Cima in Edinburgh, where the whole process of building up the colour on a much more summary basis of drawing may be observed, and some paintings of Giovanni's where the paint has worn rather thin seem to indicate a similarly rough drawing underneath. Yet there is something very unsatisfactory about the Uffizi panel regarded as a finished work of art. From a distance it is remarkably ineffective and one would think that if for any purpose he had wished to produce a finished painting in grisaille, for instance for a lenten altar-piece, he would have executed a grisaille painting, like the *Continence of Scipio* in Washington. In answer to the argument that no one would make so highly finished a drawing to cover it with pigment we may cite a very relevant example, the *Salvator Mundi* in the Metropolitan Museum, New York, which Dürer probably abandoned unfinished when he set out for Venice in 1505 (Pl. CI *a*). Here we can actually see a delicate and carefully shaded preliminary drawing, closely similar in character to the Uffizi picture, in the process of being obliterated by surface colouring. I believe that this picture explains the nature of Giovanni's. It is the underdrawing for a painting made by Giovanni in 1506 in imitation of Dürer's method. The reason for its remaining uncoloured may of course be that Giovanni or a patron thought that it was too good in this state to risk spoiling it by the application of colour, although this had been the original intention.

The hypothesis of Dürer's influence is also helpful in considering the work from a stylistic point of view. A certain dissatisfaction with the work has shown itself in the doubts of Giovanni's personal authorship expressed by Düssler, the Tietzes, and Ricci,[1] but this is one of those paradoxical cases in which the hypothesis of studio assistance is not helpful. While there is no question as to the sensitive and accomplished quality of the execution, doubts are raised by the somewhat confused and crowded nature of the design, the harshness of type and attitude of the figure of St John and the curious pose of the Virgin with her extended left leg. The crowded composition is distinctly reminiscent of the Thyssen *Christ among the Doctors* and the type of St John is decidedly German, so that some at least of these awkward features might be ascribed to an experimental following of Dürer's

[1] Düssler, L. 1935, p. 142, doubted the attribution but 1949, p. 38, accepts it without reservation. He notes possible connection with northern examples but does not date the picture late enough to associate it with Dürer's visit of 1506. Tietze, H. and Tietze-Conrat, E. 1944, p. 85, express doubts as to the attribution citing an earlier query by Ricci.

example. One can well understand why an earlier date has usually been assumed for this work, since it has a sharpness which we associate with Giovanni's work substantially before 1500, but such criteria are not satisfactory when comparing what is in effect a drawing with finished paintings. Once we have begun to think of it as originating after the middle of the first decade of the new century we can appreciate its close relationship to a rather later work, the *Drunkenness of Noah* at Besançon (Pl. cxiv), where the harshness of feature and attitude of the St John is repeated in the figures of Noah's sons—though the resemblance is disguised by the softness of handling in the painting, an effect probably exaggerated by the poor condition of the picture. The independent drawing of the head of a bearded man which occurs in the left background of the *Pietà*, also in the Uffizi (Pl. ci *b*), is generally regarded as a preliminary study made for the Uffizi painting or a *simile* used in it. However it seems to me a studio copy from the painting, both because of its mechanical quality and from the fact that it fails in any way to indicate the man's right shoulder which is, in the painting, covered by the Magdalene's hair.

Whether or not Giovanni deliberately refrained from colouring the Uffizi *Pietà* there is one work at least to be dated to the same period which he seems to have begun in the same way and carried to completion. This is the *Madonna of the Meadow* in the National Gallery, London (Pl. cii), one of the masterpieces of the time. When it became unhappily necessary after the war to transfer this painting to a new support and the under surface of the painting became thus exposed, Professor Wind, who saw it at that time, was able to observe traces of an elaborate hatched modelling in the figure group closely similar to that of the Uffizi *Pietà*; and this, though not immediately obvious, can be clearly seen on careful examination of the photograph taken in the gallery at the time (Pl. ciii).[1] This photograph is interesting in other ways too. It brings out the way in which the shape of the tower-crowned hill in the background repeats the shape of the figure group in flattened form and shows how it was originally intended to repeat this form, still more flattened, in the clouds. By isolating the figure group it makes its monumental character even more apparent and it also shows how much of the detail of the background was added, and was always intended to be added, at a late stage in the painting. This is a feature that we shall have to bear constantly in mind when considering the X-rays of the *Feast of the Gods*.

This picture remains, in spite of serious damage, one of the most perfect of all Giovanni's creations. He had already used the motive of the Virgin adoring the

[1] I have to thank Professor Wind for drawing my attention to his observation.

sleeping Child in the early *Davis Madonna* in New York, where the child lies on a parapet, and in the full-length *Madonna* in the Venice Academy where he lies across her knees. Already in these earlier examples there is as I have said a reference to the *Pietà*—the Virgin adores the sleeping child as she will mourn over his body— but here, combined as it is with the motive of the *Madonna of Humility* in a landscape, the reference is much more specific and we are reminded of the *Donà delle Rose Pietà*, probably painted a few years earlier.[1] In the union of figure and landscape this picture builds on and surpasses the achievement of the Vicenza *Baptism*, and the sunny landscape is one of the loveliest which Giovanni ever executed. The season is early spring, the time indeed of the Passion, to which the classical altar in the right background may obliquely refer, and this is indicated not only by the vegetation but very specifically by a detail in the background on the left where a bird is seen fighting a snake. Professor Wind has suggested that this is a direct quotation from Vergil's second Georgic where spring is characterized as the season when the white bird arrives, the enemy of the long snakes.[2] The rustic figures in the background would also seem to betray a preoccupation with the Georgics and to speak to us in the context of the picture of the cycle of the seasons and the renewal of spring. We feel in these later works of Giovanni's a growing sense of the permeation of nature by the divine which brings him into close sympathy with Vergil and which finds its final expression in the *Feast of the Gods.*

The sharpness in the rendering of drapery which Vasari noticed as a sign of Dürer's influence in the *Feast of the Gods* is a striking feature of the *Madonna of the Meadow*, and has led to a tendency to date it at about the beginning of the century. A similar sharpness was found in the triptych formerly in Berlin, which was destroyed in 1945, showing *The Baptist between Jeremiah and St Francis* (Pl. CIV). Though not quite equalling the *Madonna of the Meadow* this was a work of high quality and very close to it in style and feeling and certainly also in date. I think the three main panels were substantially autograph works. The lunette with St Helena and St Veronica flanking the Virgin, which though clearly contemporary did not perhaps belong to the other panels since it had been plainly enlarged at a later date, perhaps betrayed more of the hand of the studio. The two drawings in the Louvre in brush and wash, which relate to the figures of St Francis and *Jeremiah*

---

[1] For the relation of the theme of the *Madonna of Humility* to that of the *Pietà* see Meiss, M. 1951, pp. 145 ff.

[2] Wind, E. 1950, p. 350. Vergil, *Georgics*, ii. 319–20. Wittkower, R. 1939, p. 322, had earlier interpreted this passage in the painting as an adaptation of the theme of the struggle of the Eagle and the Snake to that of the Pelican and the Serpent in reference to the Passion. It seems likely that Giovanni has here conflated this idea with the reference to Vergil.

seem to derive from the painting rather than prepare for it.[1] It is interesting to compare this altar-piece, with its rather old-fashioned division into three panels, with the Carità altars where the same scheme was employed.[2] One is struck by the extent to which the later work represents a bringing up to date of the earlier scheme rather than its complete renewal. Such a comparison also emphasizes the difficulties presented by Arslan's theory of a date near 1500 for the Carità panels themselves. The sharpness of rendering of drapery and feature here agrees well with that in the Uffizi *Pietà*.

In contrast to these works whose character I have sought to explain by reference to a direct influence from Dürer we have others, which must date from the second half of the first decade, which show more of the broader elements distinguishing the Vicenza *Baptism* and the S. Zaccaria *Madonna*. The most imposing of these is the picture generally described as the *Assumption of the Virgin*, but more probably representing the *Immaculate Conception*,[3] in the church of S. Pietro Martire at Murano (Pl. cv). The design is basically fine and the landscape, the sky with its lovely contrast of deep blue with scarlet cherubim, and the figure of the Virgin herself, are worthy of it. The lower semicircle of figures, however, especially those on the spectator's left, are somewhat mechanical in execution and mesquin in form, and Gibbons is probably right in seeing in them the hand of Rocco Marconi, the leading studio assistant of Giovanni's later period.[4] The Virgin is in many ways close to the one in the S. Zaccaria altar-piece, but the picture would seem to be slightly later, though it cannot be by much since the whole design was adapted by Lotto for his simpler altar-piece at Asolo which is dated 1506. The fine brush drawing in the Uffizi (Pl. xcix *b*) of two saints, while not identical with any figures in the existing painting, is closely related to its general scheme and might well be a preliminary study for it, and the sheet may give us a clue to Giovanni's late graphic style.[5]

[1] Tietze, H. and Tietze-Conrat, E. 1944, nos. 348 and 349, p. 93. A red chalk drawing in the Lehman collection, New York (perhaps identical with the Tietzes' no. 345) seems also to be after the painting rather than preparatory to it. Puppi, L. 1962, p. 151, ascribes the Louvre drawings to Montagna, but the St Francis is no closer to the figures which he cites in Montagna's paintings than to that in Giovanni's and the drawing is not strikingly close in style to others which he ascribes to Montagna. The Jeremiah does seem closer to Montagna.

[2] The evident widening of the lunette over the three figures in the Berlin picture suggests that the three standing saints below may originally have formed one narrower panel, but since the original is destroyed this cannot be verified. They were in three panels as early as 1664, see Boschini, M. 1664, p. 523.

[3] For the identification of the subject of this picture as the *Immaculate Conception* see Einem, H. von, 1956, p. 163 n. 64.

[4] Gibbons, F. 1962 (1), p. 130.

[5] Tietze, H. and Tietze-Conrat, E. 1944, no. 298 p. 85.

The half-length picture of the *Madonna with St Francis, St Jerome and St Sebastian and a male donor* in the church of S. Francesco della Vigna, Venice (Pl. CVI *a*), which is dated 1507, has some resemblance in its general softness to the Murano *Immaculate Conception* but it is not easy to judge in its present condition. It appeared to be much damaged when it was possible, at the 1949 exhibition, to examine it under conditions more favourable than those which obtain in the church. The donor has evidently been repainted about the middle of the century. It seems originally to have been a work which exploited on a smaller scale the ideas of the union of figure and landscape which we have seen in large in the Vicenza *Baptism*. The main group is derived directly from the Barbarigo picture of 1488. The critical study of this picture has been confused by its supposed identity with one which Vasari says was suspected to have been largely the work of Giovanni's pupil Girolamo Mocetto;[1] but Vasari speaks of the latter as a substitute for a *Dead Christ* begged from the fathers by Louis XI (he probably meant XII) of France[2]—and it seems much more likely that he was speaking of another *Dead Christ* which has not survived, especially as it is impossible to recognize any stylistic relation between the existing picture and the signed works of Mocetto. In view of the condition of the picture it is impossible to say how much it may be a work of studio participation, but it is of importance as a dated work and as marking an approximation on Giovanni's part to the sort of picture that was probably already being produced by such painters of the younger generation as Palma Vecchio.

In 1509 Giovanni signed and dated the *Madonna* now at Detroit (Pl. CVI *b*). This is generally considered an autograph work but it seems to me to be very largely of the studio. The landscape in particular, though it contains Bellinesque incidents, like the two rabbits, is handled with a freedom itself attractive enough, but not to be paralleled in Giovanni's authentic work, and which would seem to show the hand of one of the livelier younger assistants. There is no very coherent relation between the Madonna and the landscape. This evaluation of the Detroit picture seems to me imposed by the outstanding quality of the *Madonna* in the Brera which Giovanni signed and dated in the following year (Pl. CVII). This is a singularly perfect picture and one in which the consistent qualities of design and execution bring forcibly before one the extent of studio participation in so much of the work of the later years. The oblong shape of the picture and the disposition of the landscape recall the *Madonna of the Meadow*; but the design of the seated *Madonna*, backed by the cloth of honour and holding the standing, blessing Child

---

[1] Vasari, G. 1878–85, iii. 163.          [2] See above, p. 113.

on her knee, goes back to the upright *Madonna* pictures of the eighties and nineties, though this picture has not and surely never had a parapet in front. To the left a classical altar, similar to that in the right background of the *Madonna of the Meadow*, bears the signature and date, while on it sits a little monkey which perhaps, as the *Scimia Naturae*, symbolizes the holy and acceptable sacrifice which Giovanni has made of his art, though in that case it would be an early example of this use of the ape symbol.[1] Perhaps the tree on the right, with its limed streamers and its tragically tethered decoy-bird, bears the same symbolism as the *Muscipula Diaboli*, the trap for the Devil baited with the flesh of Christ, and so refers obliquely to the Passion. The bright cold clarity of the *Madonna of the Meadow* where 'a hot sun, on a March day, kisses the cold ground',[2] has given way here to the weight of high summer and the whole picture has the richness of a ripening fruit, and all the tones, including those of the flesh, are warmer. The Virgin's veil is white, her dress pink, and her mantle dark blue with a golden-brown lining. The cloth of honour is of a particularly beautiful light green with a narrow pink stripe at the edge. The enormous impression which this picture makes is due as much as anything to its absolute simplicity and lack of pretension and the quiet interplay of verticals and horizontals.

The date 1510 also occurs on the early nineteenth-century engraving of the small altar-piece of the *Virgin enthroned between St Peter and St Mark*, with three Venetian magistrates in adoration, which is now in the Walters Art Gallery, Baltimore. The authority of the engraving appears somewhat doubtful, since the part of the picture in which the *cartellino* occurs has been entirely renewed and it seems likely that this mutilation took place before the engraving was made, but the year itself seems not improbable.[3] The picture has been very much damaged: not only have the lower steps of the throne been cut away but the same has happened to the upper parts of the sides so that the carved capitals seen in the reproductions are found to be entirely modern. It also seems likely, in view of the curious truncated presentation of the donors, that more is missing along the whole lower edge of the picture. Presumably these mutilations were made to adapt it to some changed position in the Doge's Palace, where it is recorded from the time of Ridolfi and for which it was presumably painted.[4] The painting is on a fine canvas

---

[1] See Janson, H. W. 1952, pp. 287 ff.     [2] Fredegond Shove, *The New Ghost*.

[3] The engraving is reproduced in Gronau, G. 1928, pl. 22. The panel has been cut vertically on each side between the Virgin and the donors, the central section curtailed at the bottom and the side sections at the top. These sections, including the steps of the Virgin's throne and the capitals of the columns flanking the niche have been later renewed. I must thank the authorities of the Walters Art Gallery and in particular Miss Elizabeth Packard for allowing me to see the picture in the restoration studio.     [4] Ridolfi, C. 1914–24, i. 71.

glued to panel and the surface is a good deal damaged, but even when every allow-
ance has been made for its condition, this work, when we compare it to the Brera
*Madonna*, still presents us in the most unambiguous terms with the question of
studio participation in Giovanni's later works. One would expect, *a priori*, that a
picture ordered for the Doge's Palace would show at least some of the master's
handiwork.[1] At least the fine design of the Virgin and donors may be credited to
Giovanni, but how far do we see his hand anywhere in the painting? Gibbons
thinks that the whole of the execution is due to Rocco Marconi, who had become
by this time a sort of foreman in the shop,[2] but technically the side saints are
distinguished from the other figures by being executed direct with no under-
painting and there is a certain weakness in these figures in contrast to the rest.
Perhaps the central group of Virgin and donors was laid in by Giovanni and the
side saints added and the whole finished by Rocco. There are certainly no passages
of finished surface that nearly approach the quality of the Brera painting. Very
much the same considerations would seem to apply to the triptych with the
*Madonna enthroned with Four Saints and a Donor* from the church of S. Michele in
Isola, now in Düsseldorf.

The *Christ Bearing the Cross* in Toledo, Ohio, (Pl. CXII *a*) would seem to be a
substantially autograph work of the end of the first decade. In some respects it
recalls the grisaille *Pietà* of the Uffizi and in others looks forward to the *Drunken-
ness of Noah* at Besançon. The painting of the drapery is particularly beautiful, but
there is a conventional element in the head which suggests that it was an image by
which Giovanni was not himself deeply moved, and which has led Gibbons to
suggest that it was never more than a studio pattern. The composition exists in a
number of versions, of which only that at Toledo can claim to be autograph; but
some of these, including that ascribed to Giorgione at Fenway Court, may be
earlier than the Toledo version and it is possible that another earlier autograph
version, perhaps dating from the 1490s, may have existed.

Gentile Bellini died in February 1507 and by his will desired that his 'very
dear brother' Giovanni should complete the painting of *St Mark Preaching at
Alexandria* which he had begun two years earlier for the Scuola di San Marco. As
recompense Giovanni was to receive an album of drawings by their father Jacopo,
presumably the one now in the British Museum.[3] Later in the same year he under-

---

[1] But cf. the earlier *Pietà*—see p. 46 above.
[2] Gibbons, F. 1962 (1), p. 129.
[3] For the text of Gentile's will see Crowe, A. J. and Cavalcaselle, G. B. 1912, i. 137 n. 1.

took to finish three further canvases in the Sala del Maggior Consiglio, which had been left incomplete by Alvise Vivarini at his death. Whatever he achieved in the Doge's Palace is lost but the *Preaching of St Mark at Alexandria* survives in the Brera (Pl. cvɪɪɪ *a*), and we may reasonably ascribe the luminosity which distinguishes it from Gentile's canvases for the Scuola di San Giovanni Evangelista to Giovanni's intervention. Giovanni was further commissioned to execute a companion picture for the Scuola, the *Martyrdom of St Mark*, the year before his death. This picture, the property of the Venice Academy, is now exhibited in its original position in the Albergo of the Scuola, now the Ospedale Civile (Pl. cɪx). It was completed and signed by Giovanni's pupil Vittorio Belliniano in 1526 and it is obviously questionable how far it is relevant to the study of Giovanni's achievement. Considering the well-documented difficulties which numerous patrons experienced in getting their commissions executed even after many years, it would seem surprising if Giovanni had in fact done much before his death in 1516 on a picture only ordered in the previous year. On the other hand, when allowance has been made for the awkward shape of the space to be filled, with a door just off centre, and the poor condition of the work, it does seem to present qualities which we would hardly expect from Vittorio unaided. There is something really impressive in the sense of space and the broad fall of light and shadow. One cannot escape the conclusion that Giovanni had in fact laid in the design before his death. Since both the brothers had offered to work for the Scuola in 1496 and Gentile had provided a drawing for the *Martyrdom of St Mark* in 1505, it has been suggested that Giovanni's picture may in fact have been begun before 1515, but the documents hardly bear such an interpretation.[1]

One of the most puzzling problems concerning the relation of Giovanni's autograph work to that of his assistants and followers in the late period is presented by the two versions of the *Death of St Peter Martyr*, both in London, one in the National Gallery, the other in the Lee of Fareham collection at the Courtauld Institute. The National Gallery version (Pl. cx) is a long oblong and was perhaps originally, to judge from the truncated cow at the left-hand edge, even a little longer. In it the figure groups of the saint and his companions, each with his attacker, are spread out before a screen of woodland where light is seen between the trunks and woodmen are busy cutting trees. Near the left-hand edge of the picture the wood terminates rather abruptly leaving an open view across flat meadows to a river with a bridge which leads to a town with rising hills beyond. The Courtauld

[1] Documents printed in Paoletti, P. 1894, pp. 14–15.

version (Pl. CXI *a*) is more nearly square in shape and the main figures, which are virtually identical with those in the National Gallery version, are much larger in scale, and set closer together; while the background wood is shown as more distant and extending out of the picture at both sides, but with a clearing through it right of the centre giving a prospect similar to that at the left of the National Gallery version.

There can be little doubt, both because of pentiments revealed by X-rays and on more general grounds, that the National Gallery version represents the earlier form of the composition, but this does not determine the relation of either to Giovanni. Giovanni's signature on the cartellino in the National Gallery version is not held to be authentic and the similar cartellino in the Courtauld version is now blank.[1] Although the present signature is not authentic it would be difficult to think of the National Gallery version as originating anywhere else than in Giovanni's studio, and, in spite of the disfavour with which it has sometimes been viewed, it would seem to me that the design and even in large part the execution was authentically his. The landscape to the left is admittedly much inferior, in its present state at least, to those of the *Madonna of the Meadow* or the Brera *Madonna*, but its surface condition is poor and the actual design, with the road winding to the bridge and the heavily laden cows returning to the milking shed, is in touching contrast to the scene of horror in the foreground. Similarly the rendering of the wood is tender and beautiful and the way in which its surface forms a decorative screen and yet allows the eye to wander into and through it is very effective, while the way the gestures of the woodmen echo those of the assassins is highly imaginative and moving. Both the decorative treatment of the foliage, and the classicism of the figures of the woodmen (which might favour a sixteenth-century dating for the Allegories in the Venice Academy) are strangely reminiscent of Burne-Jones. Here Giovanni is again setting his figures in the context of nature and the sum of human activity. Giovanni's art depends, as we have seen, on a balance infinitely subtle and where this is not achieved the picture tends to disintegrate. We have seen this in the Berlin *Resurrection* and to some extent—although this picture is a moving and beautiful creation—we see it here again. The second version seems to me a recognition of this. The figures are enlarged and the groups knit more closely together, while the subtle links between figures and setting which are really the essential point of the National Gallery version are sacrificed altogether. Though certainly the work of a fairly close follower the Courtauld version suppresses all

[1] Davies, M. 1961, pp. 65–6.

that is most characteristic of Giovanni in the National Gallery picture and I should doubt if it were even produced in the studio. I think it is the work of Andrea Previtali, who signed himself 'Iohannis Bellini Discipulus' but did not so far as we know ever work in the studio.[1] As to the date of these pictures, the Courtauld version is said to have once born the date of 1509 on the back and such a date is very plausible. The National Gallery version seems to have been in existence by about 1505 since Lorenzo Lotto, in his Bridgewater House *Madonna*, which though undated can hardly have been painted later than that year, seems to have been inspired in the background by the background of Bellini's picture; but it does not seem likely to be very much earlier, certainly not before 1500.

The *Portrait of a Dominican*, also in the National Gallery, London (Pl. cxii *b*) probably dates from about the middle of the first decade. This picture has not been improved by the later addition of sword, palm, knife, and halo to make it also commemorative of St Peter Martyr, and its generally poor condition makes it difficult to appreciate. X-rays have revealed a scroll beneath the palm and if we try to visualize the original aspect of the picture without the saintly attributes we can see its importance as marking a further stage in Giovanni's development, already foreshadowed in Mrs. Fitzgerald's portrait and in the London *Loredan*, from the simple Antonellesque type of portrait bust towards the fuller forms of the sixteenth century. Perhaps we see here Giovanni's reaction to such works as Giorgione's *Young Man* in Berlin, Titian's *'Ariosto'* in London, or his *Portrait of a Man* formerly in the Doetsch and Goldman collections and now in Washington.

[1] Not very much is known for certain of the earlier career of Previtali, who came from Bergamo, but his hand does not seem to be recognizable in the actual productions of the Bellini shop.

# VII

*The latest works.*
*The problems presented by the*
Feast of the Gods. *Conclusion*

THE last of Giovanni's formal altar-pieces is the beautiful painting in the chapel on the right of the nave of the church of S. Giovanni Crisostomo in Venice, itself one of the loveliest of the smaller Renaissance churches in the city, built in the last years of the fifteenth century. The altar-piece (Pl. CXIII) bears Giovanni's signature and the date 1513, but we know that the chapel was constructed under the will, made in 1494, of Giorgio Diletti, who died in 1503, so that it might have been begun as much as ten years earlier.[1] The design of this altar-piece is something quite new in Giovanni's work. We look through a relatively shallow archway with marble pillars capped with heavy mouldings. The lower part of this archway is closed at the back by a parapet panelled in dark marble with a white marble cornice and divided down the centre by a white marble pilaster with Lombardesque relief decoration. In the narrow space in front of this parapet stand to the spectator's left St Christopher, with the Christ Child on his shoulder, and to the right the figure of a youthful bishop, holding in his right hand a crozier and in his left a leather-bound volume whose cover (it is in fact the back cover) bears a vellum tab inscribed DE.CIVITA/TE.DEI. Beyond the parapet rises a steep rock-face, studded with plants which are observed and rendered with a Leonardesque precision and tenderness. On top of this sits the bearded figure of an anchorite, reading in a folio supported on the bent trunk of a fig-tree, whose great leaves are silhouetted against the sky, while two other volumes lie beside him. Behind is a bare mountainous landscape with a single building, rising to an evening sky banded with clouds.

The identification of the St Christopher is not in doubt, but there has been some

[1] Paoletti, P. 1893, i. 110. In his descriptive text, p. 179, he gives the donor's Christian name as Giovanni, but it appears as Giorgio in the document and again in Paoletti, P. 1929, p. 151.

confusion with regard to the other two saints. Giorgio Diletti's will, as printed by Paoletti, says that the chapel should be 'sub titulo Sancti Hyeronomi Sancti Ludovici et Sancti Chrisostomi; but Dr Felton Gibbons, who has checked the original document, tells me that 'Chrisostomi' is a mistranscription for 'Christophori'. This would confirm the usual and plausible identification of the hermit saint as Jerome, as against Gamba's suggestion of St John the Evangelist and Fry's of St John Chrysostom.[1] We may certainly dismiss St John the Evangelist but a slight argument in favour of the identification as St John Chrysostom might be drawn from the inscription in beautiful Greek capitals in the soffit of the arch. ΚΥΡΙΟΣ ΕΚ ΤΟΥ ΟΥΡΑΝΟΥ ΔΙΕΚΥΨΕΝ ΥΠΕΡ ΤΟΥΣ ΤΩΝ ΑΝΘΡΩΠΩΝ / ΤΟΥ ΙΔΕΙΝ ΕΙ ΕΣΤΙ ΣΙΝΙΩΝ Η ΕΚΖΗΤΩΝ ΤΟΝ ΘΕΟΝ—'God looked down from Heaven upon the children of men to see if there were any that did understand and seek God.' This is the second verse of Psalm 13 (14 in the Authorized Version) and does not seem to have any obvious connection with St Jerome, in whose honour in any case one might expect a quotation from the Bible to be made in his Latin rather than in the Greek. This quotation would, on the other hand, not be inappropriate to St John Chrysostom since his commentative homilies on the psalms were among his best-known works, and although no genuine homily by him on Psalm 13 survives, a spurious one was current under his name.[2] It is possible that even if he was originally intended as St Jerome, according to Diletti's will, there may have been a change of plan since precisely the same thing seems to have happened in the case of the third saint. It is very difficult to think that this youthful figure, who is closely related to one always identified as St Louis in the Murano *Immaculate Conception*, was not originally intended for this saint as specified in the will, but it is also difficult to suppose that by making him hold the *City of God* it was not intended to indicate him as St Augustine. Perhaps therefore we have a picture originally designed to present St Jerome between St Christopher and St Louis of Toulouse changed, undoubtedly while still in Giovanni's hands, to one presenting St John Chrysostom between St Christopher and St Augustine. In any case the design of the figure of the hermit saint derives from that of Giovanni's earlier representations of St Jerome, being specially close to, though not identical with, that in the little picture of 1505 from the Benson collection now in Washington.

The altar-piece is distinguished by a warmth of colour and richness of painting even greater than that in the Vicenza *Baptism*. The clouds against the blue sky are

---

[1] Gamba, C. 1937, p. 167. Fry, R. 1900, p. 46.
[2] Migne, J.-P., *Patrologia Graeca*, lv, Paris 1859, p. 550.

warm grey-brown, yellow and orange, St John or Jerome wears a grey-white shift and an orange mantle, St Augustine or Louis has a green cope brocaded in red and gold and there is a deep red panel set into the skirt of his white robe, St Christopher has a white shirt, pink tunic, and brown mantle. The whole glows quietly with light and colour from the wide landscape. God and nature flow into the church. The actual painting shows an increasing richness from the figure of the hermit saint through that of the bishop to a culmination in those of St Christopher and the Christ Child. The extremely advanced painting of these last led van Marle to suspect the collaboration of Titian,[1] but this is to misunderstand the situation. The consistency of the picture is at least as striking as its diversity and the differences reflect rather Giovanni's own development during the considerable time that the picture must have been on the easel. The evident change of plan with regard to its frame indicates that it really was executed over a period. It was clearly originally intended that it should have an arched frame of the type familiar in Giovanni's earlier altar-pieces, though evidently, as is shown by the painted mouldings, of a heavier, more sixteenth-century form. For this reason we find the mouldings of the pillars of the arch cut in sharp silhouette on the picture surface, where they must have been intended originally to meet those of the marble frame in which they would have been continued. In conformity with changing fashion the frame was finally constructed as a simple rectangle with flanking pilasters and straight architrave, so that no illusionist relation between real and painted architecture is attempted. We may note here that the viewing-point lies about one-quarter the way up the dividing pilaster of the parapet. Perhaps the earliest example of a square-headed altar panel of this type is Giorgione's Castelfranco *Madonna*, and it is possible that the relation of the three main figures here reflects the influence of Giorgione's work.[2] The three figures form a sort of arch within the arch, St Christopher's staff and the bishop's crozier, the line of the latter continued in the curve of the hermit's back, frame a sort of empty space filled by the parapet and rock-face where art and nature are exquisitely contrasted. This iconographic gap in the middle of the picture prompted an eighteenth-century incumbent of the church to attach a statue of St Anne to this part of the panel. He was very properly made to detach the statue and repair the damage by the Scuola di San Marco, the patrons of the chapel under Diletti's will.[3] The treatment of the rock-

[1] Marle, R. van, 1923–37, xvii. 334.

[2] But we must not think of the present setting of Giorgione's altar-piece as having influenced that of Giovanni's, since the reverse is the case: the setting of Giorgione's picture was constructed about thirty years ago in imitation of that of Giovanni's.          [3] Paoletti, P. 1893, i. 111.

face, with the little plants and the bent trunk of the fig-tree above, recalls the decoration recently uncovered on the walls of the *Sala delle Asse* in the Castello at Milan, and this again raises the question of whether Giovanni had first-hand knowledge of the work of Leonardo in Milan. The silhouetted fig leaves, which were imitated later by Titian in his altar-piece at Ancona, have an extraordinary emotive value, similar to that of the wing of the pheasant cutting the landscape in Delacroix's *Still Life with a Game Bag* in the Louvre. Though, as we shall see, this is probably not the last great altar-piece which Giovanni designed it is the last which he lived to paint and it forms no unfitting climax to his career, firmly linked as it is to his earlier performance and yet sensitive to new developments and still looking forward. We may again measure the length of the road which Giovanni travelled by a comparison of the St Christopher figure here with that executed more than forty years earlier by Giovanni or by an assistant under his direction in the polyptych of *St. Vincent Ferrer*.

The frieze-like elements in the background of the *Death of St Peter Martyr* in the London National Gallery are echoed in the pattern of vine leaves, recalling an architectural scroll, which forms the background of the curious but beautiful painting of the *Drunkenness of Noah* in Besançon (Pl. cxiv). The execution of this picture, however, as far as its poor condition allows one to judge, would seem to put it no earlier than the later parts of the San Giovanni Crisostomo altar and therefore in the last years of Giovanni's activity, and indeed it has many points in common with the *Feast of the Gods*. Vasari, as we have seen, referred elements in that picture to the influence of Dürer, and I have suggested in connection with the Uffizi *Pietà* that the same influence may be at work here. The cramped attitude of the left-hand of Noah's sons, with his hand on his knee, is very close to that of St John in the Uffizi picture and both seem to reflect the influence of an artist trained in a manner less inhibited by a tradition of decorum than that in which Giovanni had grown up. I have compared the background to an architectural vine scroll: the type of the beautiful figure of the patriarch looks back even more surely to a model from architectural sculpture, the lovely group of the same subject on the corner of the Doge's Palace over against the Carceri, though the position of the figure is of course radically different.

If we consider the period during which Giovanni worked and the extent to which his activity was bound up with the development of the Renaissance in Venetian art, it may seem strange that, with the exception of the five little Allegories in the Venice Academy, the subjects which we have so far encountered

have been confined to religion, portraiture, and history. But it is perhaps even more surprising, in view of the consistency of the picture of his work as it has hitherto been presented to us, that he should suddenly, in the last years of an activity stretching over at least six decades, have given us two masterpieces of pagan or secular subject matter—the *Feast of the Gods* in Washington, signed and dated 1514, and the *Venus* or *Lady at her Toilet* in Vienna of the following year. Before embarking on the discussion of the difficult problems posed by the first of these paintings we should consider another picture of classical subject-matter which is often ascribed to Giovanni. This is the frieze-like grisaille from the Cook collection now in Washington showing an incident from the life of Publius Cornelius Scipio (Pl. cviii *b*).[1] Nothing seems to be known of the earlier history of the canvas, but it must clearly have had some connection with Mantegna's *Reception of the Worship of Cybele in Rome*, now in London, which had been commissioned from him by the Cornaro family—who believed themselves to be descended from the *Gens Cornelia*—for their palace at San Polo. This picture was still in Mantegna's studio at the time of his death in 1506 and passed immediately not into the hands of the Cornaros but of Cardinal Francesco Gonzaga, though it appears that at some stage the Cornaros recovered it. It seems likely that the picture in Washington may have been commissioned after Mantegna's death as a present substitute for and future pair to the London picture. Giovanni Bellini would be a natural person to whom to give such a commission both from his relationship to Mantegna and his general eminence, even if he had no particular reputation for work of the type, and I think that we need not doubt that the picture was commissioned from him and produced in his studio. It is not easy to find relevant matter for comparison in his authenticated work, owing to the different subject-matter, but the female figure to the left of the centre may be reasonably compared, on the one hand, to the angels of the Vicenza *Baptism* and, on the other, to the nymphs in the *Feast of the Gods*. One may also wonder whether the presence of the greyhound on the steps of Scipio's throne is not a reminiscence of Piero della Francesca's *St Sigismund* at Rimini, which Giovanni had studied years before on his road to Pesaro. The whole design may reasonably be ascribed to Giovanni, but it is difficult, now at least, to see his hand in the execution. There is a sort of bluntness in the painting which recalls painters of the younger generation like Palma Vecchio, but the

---

[1] The subject of the picture seems probably to be the *Continence of Scipio* (Livy, xxvi, 50; Valerius Maximus iv, 3, 1). The inscription on the tablet in the background TVRPIVS / IMPER / VENERE / Q.A. / MIS AL is somewhat retouched and does not seem to yield intelligible sense in the present form.

condition of the picture seems far from satisfactory and this idiosyncrasy may be that of the restorer rather than the original painter. To appreciate fully just how ill adapted Giovanni's art was to this sort of classicism we have only to compare his composition, timid in drawing and confused in grouping, with the superb drama and lucid structure of Mantegna's London picture, which is one of his richest and, in a curious way in spite of the sculptural implications of the grisaille, one of the most painterly of his creations. Giovanni's relative failure here is particularly interesting in comparison with his success in the *Feast of the Gods*: there he has transposed a classical subject into a key in which he can show his mastery, whereas here he had been bound by the rules which the austere nature of Andrea found fitting to his genius. The fine black-chalk drawing of heads in the British Museum, tentatively assigned to Giovanni by Popham and Pouncey, is rather (Pl. cxi *b*) close to the picture. The attribution is attractive but cannot be considered certain.[1]

In the earlier literature on Giovanni the *Feast of the Gods* (Pls. cxv, cxvi) has been very inadequately handled. This is partly no doubt due to the disturbing effect that the recognition of its importance has on the tidy image of Giovanni, the pious painter of the Madonna, the serious portraitist and historian; partly because a large portion of it has always been known to be the work not of Giovanni but of Titian, which has made its evaluation as a work of Giovanni's difficult; and partly because until it passed to the National Gallery at Washington some twenty years ago it had been for nearly a century relatively inaccessible, first in the Duke of Northumberland's collection at Alnwick Castle and then in Mr. Widener's at Philadelphia. Since it passed to Washington this neglect has been handsomely remedied by two monographs, Professor Wind's *Bellini's Feast of the Gods*, of 1948, and Mr. Walker's *Bellini and Titian at Ferrara* of 1956. Wind's study is primarily concerned with iconography and with an attempt to reconstruct the history of the commission from iconographic evidence, and it extends far beyond the study of Bellini's picture to that of Mantegna, Costa, and Correggio's work for Isabella d'Este, on the one hand, and Titian's for Alfonso d'Este, on the other. Walker's book, which has revolutionized our understanding of the picture, starts from the publication of the splendid X-ray photographs of the picture taken since it arrived in Washington, which enable us for the first time to appreciate to some extent Giovanni's original intentions. Working from these and a perhaps over-subtle analysis of Vasari's account of the origin of the picture he seeks to show the progress of the commission and the stages by which it reached its present

[1] Popham, A. E. and Pouncey, P. 1950, no. 14 p. 9.

appearance. It will be impossible to discuss this picture without frequent reference to both these books, and since I do not fully agree with the conclusions of either author it will involve some criticism: but such criticism is made in the full recognition of the value of both books in focusing attention on the enormous importance of this surprising outbreak of Giovanni's old age and in directing attention to the nature of the problems with which it presents us.

Alfonso d'Este was decorating the 'camerini d'alabastro' in the castle at Ferrara from which Bellini's picture is known to have come as early as 1508, which is the date of the pieces of sculptured relief, probably by Antonio Lombardo, now in Leningrad, which certainly come from this source.[1] In 1511 Mario Equicola, Isabella d'Este's Latin tutor and later her secretary, who was also in close relations with Alfonso, devised a programme of six 'fabule overo historie' for 'la pictura di una camera' at Ferrara, though we do not know whether this was connected with the 'camerini' or with Bellini's picture.[2] The painting itself is signed 'joannes bellinus venetus / M.D.xiiii' on a *cartellino* on the wine-tub in the right-hand bottom corner of the picture, and the Este archives at Modena contain the record of the authorization of a payment to Giovanni Bellini of eighty-five ducats on 14 November 1514, being the balance due for a picture executed 'instante praefato Domino nostro'.[3] Apart from the account in Vasari's second edition of 1568, which I shall discuss in a moment, that is all the documentation we have for the Washington picture. We have, on the other hand, considerable documentation of two earlier unsuccessful attempts by Alfonso's sister, Isabella Marchioness of Mantua, to get a similar picture from Giovanni for her Camerino in the Corte Vecchia at Mantua. How Alfonso, who seems to have been a less-exacting patron than his sister, succeeded where she failed remains uncertain, though I shall later suggest an explanation. Wind thinks that the picture now in Washington was in fact begun by Giovanni for Isabella and then left on his hands and ultimately finished for her brother, but we must realize that this remains only an hypothesis, in spite of the brilliant display of argument with which Wind supports it; indeed

[1] Planiscig, L. 1921, pp. 222–5.

[2] Luzio, A. and Renier, R. 1899, p. 8 n. 1. This letter of 9th October 1511, from Equicole in Ferrara to Isabella in Mantua, does not appear to have been cited earlier in connection with the decoration of the Camerino, and it may refer to some different project which was never executed or has not survived, but it should be considered in this connection. We may note that it mentions 'six histories' and that what Vasari describes (1878–85, vii. 433) is a six-subject decoration—three Dossos, one Bellini, and two Titians. We know that in fact there were three Titians and perhaps only one Dosso, but Vasari's confused account might record a tradition of an original six-subject scheme, though it is more likely that he was confusing the main pictures and some of the panels in Dosso's decorative frieze which contained subjects from the *Aeneid*. See Mezzetti, A. 1966, *passim*.

[3] Campori, G. 1874, p. 582.

the case when closely examined does not appear as strong as he would have it. Nevertheless a knowledge of these earlier attempts to get Giovanni to paint a picture of this sort is necessary in order to understand the Washington picture and its relation to the rest of his work.

Nineteen letters which Isabella exchanged with her agents in Venice, Michele Vianello and Lorenzo da Pavia, were published by Braghirolli in 1877[1] and give the outline of the first attempt. It is clear that a wider selection of documents underlies Yriarte's article of 1896[2], but he prints no texts *in extenso*, only summaries and snippets of translation, and where he seems to be covering the same ground as Braghirolli he is often demonstrably inaccurate. One has the impression that he was working only from rough notes and a capacious but fallible memory, and alleged facts which rely on his unsupported testimony must be received with great caution.

The commission for a picture for the Camerino had been given verbally to Giovanni by the Marquis Gianfrancesco, Isabella's husband, on a visit to Venice in 1496,[3] that is to say early in the planning of the decoration; but this must have been in the nature of a preliminary inquiry as to whether Giovanni would undertake such a commission, as when the published correspondence starts, in March 1501, detailed negotiations were still clearly in an early stage. By April Vianello was able to report that Giovanni had agreed to do a picture for a hundred ducats in a year—at least he hopes it will not take much longer. In June Isabella sent an advance payment of twenty-five ducats. As soon as he had secured this advance Giovanni began, through Vianello, to try and get the terms of the commission altered, complaining that he could not show himself to advantage in this kind of work and that he did not wish his work to be judged beside Mantegna's. We do not know what the subject here proposed to Giovanni was. It was almost certainly devised by Isabella's humanist adviser Paride da Ceresara[4] and may have been the *Feast of Comus*, later commissioned from Mantegna and finished after his death by Costa. Certainly to judge from the programme for Perugino's *Battle of Love and Chastity*, which is known to have been devised by Paride and which has been preserved, it will have been dry, precise, and detailed. Isabella, who was evidently really anxious to secure a work from Giovanni for the Camerino, gave way and professed herself willing to leave it to Giovanni's judgement so long as he painted

[1] Braghirolli, W. 1877.    [2] Yriarte, C. 1896.    [3] Luzio, A. 1880, p. 277.
[4] For Paride da Ceresara see Wind, 1948, pp. 15 ff. There is no direct documentation of the 'invention' sent to Giovanni in the published correspondence, but Isabella's letter to Paride of 1504 quoted by Cartwright (1903, i, 372) seems to imply that he had supplied it.

'Qualche Historia o fabula antiqua aut de sua inventione ne finga una che rapresenti cosa antiqua et de bello significato'—'some subject-picture or ancient tale or of his own invention makes one which represents something ancient and of a pretty meaning'—by which, presumably, is meant capable of ingenious allegorical interpretation.

On 20 December 1501 Isabella, having evidently heard no more, asked Vianello to go and see how the picture was getting on, since as it was to be finished within a year it ought to be well advanced. If (as she evidently suspected) Giovanni had not started the picture and did not seem able or willing to keep his promise, he was to see about recovering the advance payment so that she could make other arrangements, as she was anxious to see the Camerino completed. Vianello replied that Giovanni had been ill and asked her to wait for her picture till the end of September, to which she unwillingly agreed. As this term approached Isabella sought the help of Lorenzo da Pavia, a famous maker of musical instruments who had formerly been in the service of Lodovico il Moro at Milan where he had enjoyed the friendship of Leonardo da Vinci, and who had long been among her devoted servants. The first letter of his printed by Braghirolli is of 10 September 1502. Yriarte cites one of 27 August 1501 but his dates are often demonstrably unreliable and I think this is a mistake; he also cites an interesting letter, under the date 30 August 1502, in which Lorenzo says that in spite of much prodding by Vianello and himself nothing had yet been done, that he has got a poet friend of his to devise an easy subject (which he encloses), but that as Giovanni does not want to do it Vianello is seeing about getting the money back. One would particularly like to see the original text of this letter. The letter of 10 September printed by Braghirolli refers to the difficulty of getting the money back and says Giovanni still says he will do the picture 'e farà una fantasia a suo modo'.

At this point the exasperated Isabella gave up the attempt to get a picture for her Camerino and turned her attention to trying to get something else out of Giovanni for her twenty-five ducats, which it was clearly going to be very difficult to recover in cash. On 15 September she wrote to Vianello to say that she had already notified Giovanni that she did not want the picture for the Camerino, but wanted the money back, and that she did not believe him when he still said he would do it, but she told Vianello that if Giovanni was willing to do a 'presepio' he might keep the twenty-five ducats meantime and the final price could be adjusted according to Vianello's judgement. This is the first mention of the 'presepio' in the correspondence published by Braghirolli and it looks as though the suggestion came from her.

Yriarte states that the proposal to paint a 'presepio' or a 'circumcision' originated with Giovanni in October. The date at least must be wrong as we have seen that the suggestion appeared in Isabella's letter the month before.

To cut the story short, after many further delays and even more serious threats of legal action to recover the twenty-five ducats, which elicited a grovelling apology from Giovanni, the 'presepio' was finally delivered and graciously received by Isabella in the summer of 1504, and a further payment of twenty-five ducats was made. By a 'presepio' we must understand a *Nativity* or *Adoration of the Shepherds*. This is clear not only because it is the meaning of the word, but from her description of what she wanted in her letter of 15 September 1502: 'Questo presepio desiderammo l'habbi presso la Ma el nostro Sre Dio, S. Isep. con Sto Joanne Baptista et le bestie'—'We want this presepio to have near the Madonna Our Lord God, St Joseph and St John the Baptist with the beasts.' Although Giovanni, who did not think that the Baptist, nor for that matter St Jerome, whom Isabella suggested in another letter, could properly be introduced into such a scene, seems to have contemplated various alternative subjects—possibly at one time an *Infant Jesus and John the Baptist in a Landscape* and at another an ordinary *Sacra conversazione*—the picture which was delivered is consistently referred to as a 'presepio' and must represent a return to the original idea. Curiously enough no *Nativity* by Giovanni appears in any of the Mantuan inventories and it is one of the rarest subjects in his work, no version from his later years being known. It seems rather unlikely that, as Yriarte tells us, the proposal for 'presepio' originated with Giovanni since one would expect him to offer something for which models were handy in the studio, as in the case of the alternative of a 'circumcision'. In any case we must accept that Giovanni did paint a 'presepio' for Isabella between 1502 and 1504 which appears to be lost.[1] The Tietzes produced an ingenious theory that the missing picture was in fact the *Allendale Nativity* in Washington but this seems to me to break down because of the very limited extent to which the Allendale picture can be described as Bellinesque.[2] We really know a good deal about the style of Giovanni and his studio in the early years of the new century and I think we can say with confidence that wherever the Allendale picture was produced it was not there. On the other hand, it seems possible, even quite probable, that the common denominator which unites the Allendale picture, the drawing on blue paper at Windsor,[3] and the Cima in the Carmine at Venice is this missing composition of

[1] Perhaps sabella gave the picture away as she did two by Francia. See below p. 139 n. 1.
[2] Tietze, H. and Tietze-Conrat, E. 1949.     [3] Id. 1944, no. A. 719 pp. 175-6.

Giovanni's. Lorenzo da Pavia's criticism that the figures in Giovanni's 'presepio' were too small would accord well with a composition in which the balance of figures to landscape resembled that of the Allendale picture.

We see thus that Isabella admitted defeat in her first attempt to get a mythological subject from Giovanni, and there the matter might have rested had not Pietro Bembo visited her in Mantua in June 1506 and undertaken, on his return to Venice, to try if he could not be more successful in persuading Giovanni. The major part of the relevant correspondence was printed by Gaye[1] and reprinted by d'Arco[2] but two interesting items were added by Cian;[3] fortunately there are no documents for which we have to rely on Yriarte and that part of his article may be ignored. The correspondence begins with a letter from Bembo in Venice to Isabella in Mantua of 27 August 1505, in which he reports that with the help of a mutual friend Paolo Zoppo he has almost won Giovanni over and that the fortress is about to surrender—would she write to Giovanni direct. This she did, through her secretary, on 19 October, having been delayed through illness, and it is interesting that in this letter she again refers to the earlier painting as a 'presepio'. It is clear from a second letter, of 6 November 1505, also from her secretary Capilupo, that Giovanni had replied formally accepting the commission. In January 1506 follows the well-known letter from Bembo to Isabella in which he speaks of Giovanni's attitude to his subject-matter. 'La invenzione che mi scrive V.S. che io truovi al disegno bisognerà che l'accomodi alla fantasia di lui che l'ha a fare; il quale ha piacere che molto segnati termini non si dieno al suo stile, uso come dice di sempre vagare a sua voglia nelle pitture, che quanto è in lui possano soddisfare a chi le mira'—'The subject which your Excellency writes to me that I should devise for the design must be suited to the fancy of the person who has to execute it; whose pleasure is that sharply defined limits should not be set to his style, being wont as he says to wander at his will in paintings, that they may satisfy the beholders to the best of his power.' There is perhaps a deliberate mockery of Bellini's pretensions in the almost regal terms in which his requirements are retailed.[4]

We learn from the beginning of this letter that the measurements had not yet

[1] Gaye, G. 1839–40, ii. nos. xxii xxiv, xxvi, xxviii, pp. 71–82.

[2] D'Arco, C. 1857, ii. nos. 68, 72, 73, 74, 78, pp. 57–64.

[3] Cian, V. 1887, pp. 105–6 and 108.

[4] Ibid., p. 106. He has shown conclusively on the internal evidence of other parts of this letter that the correct date is January 1506 and not 1505 as printed by Gaye and d'Arco and that it forms an integral part of the story of the second approach to Giovanni for a mythology for the Camerino. Verdier's suggestion (1956, p. 115) that it might refer to the Uffizi *Sacred Allegory*, which he inclines on rather inadequate grounds to associate with Isabella, therefore falls to the ground.

been sent and further delay followed owing to the outbreak of plague in Mantua which sent Isabella for a long spell to one of her country villas. When Isabella wrote to Bembo on 11 May 1506 the measurements had still not been sent nor had the advance payment and it seems that the subject had not yet been devised. 'La M.V. non resterà di tener ben disposto il Bellino, et di componere la poesia ad sua satisfactione perchè quamplurimum [*sic*: should be quamprimum] darà volta la peste mandarimo le misure dil quadro et le figure et l'ara'—'Your Magnificence will persist in keeping Bellini well disposed, and devising the *poesia* to his satisfaction, for as soon as we are free of the plague we shall send the measurements of the picture and the figures and the advance payment.' The measurements of the figures were to ensure that they agreed in scale with those in Mantegna's pictures. In replying on 13 May Bembo only says on this subject, 'quanto al Bellino non rimarro ubbidir a V.S.'—'as regards Bellini I will not fail to obey your Highness', which seems to imply that the subject was still not devised. This is the last we hear of the whole matter. When Lorenzo da Pavia excused himself in January 1507 for his delays by saying he must have caught 'Master Giovanni Bellini's disease' he may, as Wind thinks, have been referring to further delays in these negotiations; but he may equally well have been referring back to those of the 1502–4 in which we know him to have been intimately involved.

Wind argues, as I have said, that though we hear no more of the negotiations they must have continued and that a picture was actually begun; this was not finally wanted by Isabella because she had come so much under the domination of Lorenzo Costa, who was appointed to succeed Mantegna as court painter in Mantua in December 1506.[1] He bases this theory primarily on the hypothesis that

---

[1] Wind, E. 1948, p. 24. In support of this view Wind cites the case of Francia, from whom Isabella was trying to get a picture in 1505 and who reopened negotiations unsuccessfully in 1511. All we actually know of this is that Francia wrote in 1511 to Isabella that he had heard from Girolamo Casio that she wanted the picture which had been ordered for her Camerino in former years, which would imply that the initiative had come from her. Why this proposal produced no result we do not know. The letter from Isabella to her half-sister, Lucrezia d'Este, in Bologna, on which Wind relies to prove Isabella's 'decisive rejection' of Francia's offer, has no reference to the question of a painting for the Camerino: it refers to the proposal that Francia, who had painted a portrait of Isabella from a drawing which was admired as a picture but not considered a good likeness, should come to Mantua in person to paint her from the life. This proposal she rejected on two grounds, (*a*) that she much disliked sitting for her portrait and (*b*) that she did not know how she would manage with both Francia and Costa on the spot in Mantua. The proposal that Francia should paint a picture for the Camerino did not involve his presence in Mantua so that this objection would not apply. On the other hand, Costa no doubt did his best to keep the commissions to himself and the convenience of being able to control him on the spot probably contributed to Isabella's willingness to dispense with the help of artists from outside. For the correspondence dealing with this matter see Cartwright, J. 1903, i. 378–9 and 383, and Luzio, A. 1900, pp. 427–30. The fact that Isabella soon parted with the portrait of herself and that painted earlier by Francia of her son does suggest that she had tired of his work and this may reflect Costa's influence.

the nature of the subject and its treatment in the Washington picture show unmistakable signs of Bembo's authorship, and that the painting contains portraits not only of Bembo himself but of Alfonso d'Este, his wife Lucrezia Borgia, his brother Cardinal Ippolito, and possibly Giovanni Bellini as well. Things might have happened thus but I do not think the documents lend these views very much support. We know for certain, and this is the last thing in this story we do know for certain, that not only had no picture been begun by May 1506 but that the measurements and advance payment had not been sent and that the subject had not been finally agreed. I do not myself think that Giovanni would have begun a picture without an advance payment or that, had one been made, Isabella would have failed either to get it back or to get her money's worth. Wind, as I have said, ascribes the dropping of the project to Costa's influence, and because he was available Isabella may well have been reconciled to Giovanni not producing a picture. But a more likely reason for the apparent (and as I would think real) breakdown of the negotiations was suggested by Cian[1]—Bembo's departure from Venice for Urbino in the course of the summer of 1506.[2]

The argument that Bembo must have devised the subject of the *Feast of the Gods* is bound to be somewhat subjective. Wind shows that both Bembo and his father had taken an interest in the ancient collections of epigrams in honour of Priapus and that Bembo himself had written a poem entitled *Priapus*, and also that the *Feast* is an illustration of a story about Priapus. But this story does not come from the *Priapeia* nor has it any connection with Bembo's poem. It is from the *Fasti* of Ovid which cannot be considered an obscure source; it is mentioned in such a popular handbook as Boccaccio's *Genealogia Deorum Gentilium*,[3] and had indeed already furnished material for an illustration of the Venice translation of Ovid's *Metamorphoses* of 1497,[4] although the story itself does not occur in this form in that poem. It seems to me that there is nothing against the supposition that the

[1] Cian, V. 1887, p. 108.

[2] The inaccurate dating of Bembo's earlier letters in the printed editions makes it difficult to determine his movements precisely. We know that he was still in Venice on 25 May when he wrote to L. da Porto, since the original letter exists, and if the date given in the edition of his Latin works published in Venice in 1729 (iv. 194) for his letter to Cardinal S. Croce is correct he was still there on 5 June. A letter to Paolo Canale printed in the same volume (p. 195) is dated from Urbino, 26 September, and his presence there by this date is confirmed by Castiglione's inclusion of him among the interlocutors of the *Cortegiano*, laid during the Pope's visit to Urbino which began on 25 September. A letter (Milan ed. 1809, vi. 24–5) to his brother Bartolomeo in Venice from Forli, which implies that he had come there from Urbino, is dated 2 September, but this is clearly wrong as it refers to something as having happened on the tenth of the month. Dr. C. H. Clough, whom I have to thank warmly for his kindness in clarifying the situation for me, has suggested that he may have spent part of the summer in Mantua, which would account for the rather abrupt breaking off of the correspondence with Isabella.

[3] Lib. viii, cap. 3.                        [4] Krause, E. 1926, pp. 57–8.

subject was of Bembo's devising but not much positive evidence in its favour. It is such a theme as might have occurred to any scholar of reasonable education, and I am tempted to associate the origin of this subject with the letter of Mario Equicola, to which I have already referred, and to suppose that this is one of the six 'fabule overo istorie' which he had found for Alfonso in 1511,[1] but this of course is quite conjectural.

Although Hourtiqu had directed attention to the relevant texts for the elucidation of the subject of the picture[2] he had done so a rather muddled way and it was first fully and systematically explained by Wind. Two passages in Ovid's *Fasti*, i. 391 ff. and vi. 319 ff., tell an almost identical story, in the one case to explain the reason for sacrificing an ass to Priapus, the other to explain the custom of hanging necklaces of loaves on donkeys in honour of Vesta.[3] The first passage tells of a biennial festival of Bacchus in Greece, attended by all the gods who wait on Bacchus, satyrs, pans, and Silenus on his ass: when all were drowsy with wine, Priapus was about to assault the sleeping nymph Lotis but she was awakened by the braying of the ass of Silenus and escaped him. The second tells how at a feast of Cybele on the slopes of Mount Ida, to which the eternal gods were bidden, as were satyrs and nymphs, and which Silenus attended uninvited, Priapus (whether present as a guest or, like Silenus, a gate-crasher is not quite clear) made the same attempt on Vesta (unaware, as he said, of her identity) and was similarly frustrated. The likeness of the two stories is such that it has led editors to think that they were intended as alternative drafts and that one of them would have been suppressed in the final revision of the poem.[4] The question of which of these versions the Washington picture is intended to illustrate, or whether it represents a conflation of the two, is best left for consideration in connection with the evidence of the X-rays for changes introduced into the painting in the course of its execution.

As to the identification of portraits in the picture I do not myself find Wind's identification of Silenus as a portrait of Bembo acceptable. Of the three portraits which he reproduces for comparison the two which date from the sixteenth century, Valerio Belli's medal and the mosaic after Titian by Francesco and Valerio Zuccato, agree in presenting a clearly recognizable individual with a high straight forehead and a long sensitive nose and these features seem to me conspicuously absent from the head of Silenus. The third portrait reproduced by Wind is certainly much more like the Silenus head, but it is an engraving of the eighteenth century and

[1] See above, p. 134.                    [2] Hourticq, L. 1919, pp. 256 ff.
[3] The textual sources are most conveniently accessible in Walker, J. 1956, pp. 122–3.
[4] Frazer, J. G., *The Fasti of Ovid*, 1929, iv. 231.

though it may be based on a lost portrait by Titian, as Wind supposes, there is no evidence of this; and even if it was so its total disagreement with the two authentic sixteenth-century examples would lead us to suppose that it must have completely traduced its model. Thus I do not think that this argument adds any support to the view that the Washington picture was begun for Isabella, on Bembo's 'invention', in 1506. Wind's further suggestion that the picture contains portraits of Alfonso d'Este, his wife Lucrezia Borgia, and his brother Cardinal Ippolito, and that it was painted to celebrate the wedding of Alfonso and Lucrezia is, in point of portrait identification, rather more plausible. The head of the central goddess (Gaia?) is certainly not at all unlike that of Lucrezia on her medal, though it is surprising that if her portrait was really intended the painter should not have given more emphasis to the blonde hair and fair skin on which, to judge from contemporary accounts, her claim to beauty seems to have rested; and the rather conventional features of Ippolito on his medal seem to agree well enough with those of Mercury in the painting. With regard to Alfonso himself there is as Wind points out so little agreement between the face we see on his medal as a long-haired youth and that in the portrait painted by Titian in his middle age that it is difficult to know to what the head of Neptune should best be compared; but it is not altogether easy to reconcile the shape of the Neptune's nose with those in either authentic representation. It seems to me that these identifications might be acceptable if we had independent evidence that the picture was intended to contain such portraits, but without such evidence we cannot say that the heads are portraits of these persons, or even that they are portraits at all.

At the basis of these identifications lies Wind's solid observation that the picture contains another element besides the illustration of the story from Ovid. Among the gods, ranged facing towards the group of Priapus and his victim on the right, another drama is being enacted, symbolized by the fruit which Gaia holds in her hand. This fruit can hardly be other than a quince, and as such must be intended to symbolize Matrimony.[1] This, taken in conjunction with the supposed portrait identifications, does indicate the possibility that we have here a picture intended to celebrate Alfonso and Lucrezia's wedding. It seems to me that this part of Wind's theory would be more plausible if it could be separated from the hypothesis that the picture was begun for Isabella. In spite of the arguments brought forward by

---

[1] Wind, E. 1948, p. 37. Cf. Panofsky, E. 1939, p. 163, and Ripa, C. *Iconologia* s.v. 'Matrimonio'. E. Tietze-Conrat's suggestion in a letter to the *Art Bulletin*, xxxiii, pp. 71–2, that the reference is to the properties of the quince as a protection against drunkenness, mentioned by Athenaeus, is not convincing.

Wind I think it is most improbable that she would have wanted this event cele-
brated in the decorations of her Camerino,[1] and it would be a somewhat curious
coincidence if a picture begun for Isabella and taken over by Alfonso should from
the beginning have been linked to him so intimately. The question remains whether
it is really plausible to suppose that Alfonso and Lucrezia would have wanted their
married bliss displayed in the context of such a story and with an intimacy verging
on coarseness. Whenever it may have been begun we know that the picture was
not finished until 1514 and that consequently its treatment must be one that they
would have considered suitable at that time. One may reasonably doubt whether
Lucrezia at least would have favoured such a presentation at this date. One may
feel a more general doubt in accepting such a presentation of the members of a
ruling house as possible. This is a very difficult question. Wind, who has obvious
authority in such a matter, is satisfied that Alfonso and Lucrezia not only could
be so represented but were so, though his view has not gone unchallenged.[2] I
must confess that on the balance I consider it improbable. On the other hand, if
we are to reject Wind's theory we must find some alternative explanation of the
quince and the emphasis on what we may call the sub-plot which is being enacted
in the centre of the picture. This is I think slightly more complex than might at
first appear, in so far as Neptune appears not only to be asserting his conjugal
rights with a rather open gesture of his right hand but simultaneously with his
left pinching the bottom of Ceres, as seems clearly indicated by the horizontal
line taken by his red cloak as it disappears behind her. I think it possible that the
symbolism of the quince is not intended to indicate a specific marriage or wedding
but to refer to the state of matrimony in the abstract. The meaning of this element
of the picture will then be to emphasize the contrast between the pleasures, and
even the licence, of the married state and the frustrations of fornication, as demon-
strated by the misfortune of Priapus. If it is felt that a more specific reference to a
contemporary wedding must have been intended I would tentatively suggest an
alternative interpretation. The figure of Neptune, with his large head and shrunken-
looking shoulder (and this is not a passage where the X-ray reveals any alteration)
has a curious look of deformity, and I think it is not impossible that we have here

[1] The fact that since she felt she had to attend the wedding she attempted to dominate the proceedings and
outshine the bride hardly justifies the supposition that she would have wanted to commemorate it in this way,
especially since Wind does not suggest that her part in the proceedings is in any way commemorated. For her
initial dislike of the marriage see Cartwright, J. 1903, i. 190.

[2] See particularly C. Dionisotti's review in *Art Bulletin*, xxxii, 1950, pp. 237–9, with Wind's reply and further
comments from Dionisotti, xxxiii, 1951, pp. 70–1.

the record, under a burlesque classical theme, of a burlesque wedding among the buffoons of the Este household.[1]

It has always been known that the beautiful but not entirely appropriate landscape which occupies the upper left-hand portion of the picture was the work not of Bellini but of Titian. Following what was believed to have been Vasari's statement, it has been generally supposed that Giovanni had been unable to finish the picture because of his old age and that Titian had been called in to complete it, though it must have always seemed odd that Giovanni should have signed and dated an unfinished picture when he still had two years of active work ahead of him. The X-rays taken since the picture went to Washington (Pl. CXVI), for the publication of which we are so much indebted to Walker, show that in this part of the picture at least Titian was not completing a passage left undone by Giovanni but altering a completed landscape We see clearly that the screen of trees was originally carried right across the picture, but we also see rather obscure indications of an intermediate landscape on the left and a considerable amount of pentiment in the figure group. The correct interpretation of X-rays is notoriously difficult and though these speak more clearly than some there is room for considerable difference of opinion as to exactly what they tell us. Walker has based his interpretation on the premiss that any alteration revealed will show a change by a later artist of Giovanni's final intention. This seems to me basically unlikely. The amount of authentic pentiment in the work of Giorgione and Titian is well documented by published X-rays, and though we have not this advantage in the case of Giovanni, it is very likely that he would have made alterations of the same kind in a work of this period. Beside this we can see from the photograph of the back of the paint film of the *Madonna of the Meadow* (Pl. CIII) how much of the detail at least in his later work was always intended to be added on the surface.[2] I think we should start our examination of the X-rays with the assumption that any change or addition may equally well represent a change of intention on Giovanni's part or a change by another artist, and that in the case of simple additions they may not represent any change at all but the execution, on the surface, of features which it was always intended to add there. Whether a given passage is by Giovanni or represents a later change or addition by another artist can only be determined in the last resort by the style of the surface painting and its agreement or disagreement with those passages which are undoubtedly Giovanni's unaltered work.

[1] For the importance attached to buffoons and dwarfs at the Este and Gonzaga courts see Luzio, A. and Renier, R. 1891.                    [2] See above p. 119.

Applying the criterion of the style of the surface painting there seems to me to be only one passage outside the left-hand landscape which clearly indicates Titian as its author. This is the red mantle over Jupiter's right shoulder and the right sleeve of his white tunic. Now curiously enough this is a passage where the X-rays reveal no change whatever. Walker stresses the difference of this passage from the rest of the draperies of the figure group,[1] and infers from the fact that no change is visible in the X-ray that this passage was left blank by Bellini and that here we have indeed Titian completing what Giovanni was too old to finish. But it seems likely that this is a passage where the overpainting, containing a high proportion of lead, blocks out what is underneath,[2] which in any case probably did not differ materially in form from what is now on the surface: the object of the repainting being not to alter the form but to add an accent of colour and a bolder touch of painting that would enliven Giovanni's group and bring it into greater harmony with the canvases that Titian had painted to accompany it—the *Bacchanal of the Andrians* and the *Worship of Venus* in Madrid and the *Bacchus and Ariadne* in London. Walker thinks that the bulk of the alterations shown up by the X-ray, such as the lowering of neck-line of the nymphs' dresses and the alteration to the position of Gaia's left arm (both of which make sartorial nonsense of their clothes), and the indelicate position of Neptune's right hand as well as the addition of the Olympian attributes and the pheasant in the tree, are all due to Titian. To me, however, it seems very difficult clearly to distinguish the hand here from that which painted the rest of the figure group and the right-hand part of the landscape, whereas it seem clearly different from that which painted the passage of drapery on the figure of Jupiter to which I have just referred and which Walker, rightly I think, claims for Titian.[3] Such a difference as Walker illustrates in his fig. 29 *a* and *b*, which he claims to show the difference between Bellini and Titian, seems to me quite possible in Giovanni's own work and may be paralleled in such a work as the S. Giovanni Crisostomo altar, where though some have claimed to see the hand of Titian the claim is not generally admitted nor I think rightly made.[4] In support of a single authorship we may point to the consistency of the form of the hand with

---

[1] Walker, J. 1956, p. 28. Walker's observation extends only to the sleeve but should, I think, be extended to the mantle on the shoulder as well.

[2] Cf. Walker's remarks on the interpretation of X-rays, p. 100.

[3] If this passage which is, as Walker observes (pp. 27–8), 'noticeably different from other passages of drapery' is really by Titian it is difficult to see his hand elsewhere in the figure group.

[4] See above, p. 130. It is a great pity that the painting of the *Submission of Barbarossa to the Pope* in the Sala del Maggior Consiglio, referred to by early authorities as begun by Giovanni and finished and mostly repainted by Titian, has not survived for comparison. See above, p. 82.

its crooked little finger in all figures, including the right hand of Neptune which the X-ray seems to reveal as an alteration.

We must, as I have suggested, distinguish between two classes of change revealed by the X-rays. First of all there is the addition of things which were always intended to be there but which were added on the surface, just as the figures, surely always intended, were painted over the pavement in the Uffizi *Allegory*; such are the fruit in the bowl, the cups lying on the ground, and the pheasant in the tree. I am inclined also to place the attributes of the gods in this class. Even the eagle of Jupiter does not seem to me to have the awkwardness which is sometimes alleged, and the rest are very much part of the picture, although possibly they represent a change of plan on Giovanni's part and a shift of emphasis from the first passage in the *Fasti* to the second. Winternitz's curious note on the *lira da braccio* held by Apollo[1] shows a confusion between the imperfect or inaccurate representation of an object and the accurate representation of an object only partly seen. If artists were compelled to show all objects in a picture in their most complete form pictorial composition would become very difficult. This passage seems to me one of the most vivid and beautiful in the picture. In the second place there are certain quite deliberate changes of earlier forms, such as the alteration of the position of the left arm of Gaia and the right arm of Neptune and the lowering of the neck-lines on the nymphs, and all these seem to represent an attempt to give more prominence to the erotic elements in the picture. If the actual alterations seemed to show Titian's hand, which I think they do not, this could very well be explained as representing a temperamental difference between Titian and Bellini. Alternatively they would fit very well with Wind's theory that the picture had been begun for Isabella, in which case they might represent Giovanni's adaptation of his original design to the coarser taste of her brother. These changes must be recognized as an argument in favour of Wind's hypothesis, but as I shall explain later, I do not think the picture can have been designed before about 1513 and consequently we must seek another explanation. This may be found in a conflict between the person-alities of Bellini and Alfonso. I think that Bellini attempted as far as possible to play down the erotic elements in the picture and was so successful in this as to disappoint Alfonso when he delivered the picture to Ferrara in 1514; and I believe that these alterations were made to the picture at Alfonso's wish by Giovanni, perhaps with the help of an assistant working under his general direction, in Ferrara, after its delivery. Although Crowe and Cavalcaselle were surely wrong in inter-

[1] Winternitz, E. 1946.

preting the phrase in the Modena document 'instante praefato Domino nostro' as meaning 'in the very presence of the Duke', it seems very likely that Giovanni delivered his picture in person, since we know that Titian did so later.[1]

The problem of the intermediate landscape is extremely difficult. It is not easy to visualize the appearance of the picture when it was on the surface, particularly since the X-ray gives us little indication as to how the boscage of the middle-distance was linked to the foreground figures. I think it is possible that this altera-tion was made by Giovanni himself, probably at the same time as the alterations to the figure group—the appearance that the landscape must have presented at this stage of a screen of trees opening to a distant prospect at the left-hand side would be somewhat similar to what we find in the National Gallery *Death of St Peter Martyr*. I think it is more likely, however, that this represents Titian's first attempt to adapt Giovanni's landscape. Walker inclines to reject this idea on the grounds that Titian was a painter who knew his own mind and that such fumbling would be uncharacteristic.[2] I incline myself to think such an empirical approach by Titian rather in character. Walker also suggests that the landscape might represent an intermediate intervention by Dosso Dossi. While this is possible we have no evidence that Dosso had anything to do with the picture, and it would be hazardous to ascribe the landscape, which we can see so imperfectly in the X-ray, to anyone on purely stylistic grounds.

Walker, basing himself on the interpretation of the X-rays which I have indi-cated and on a rather elaborate interpretation of the passage dealing with the *Feast* in Vasari's second edition, suggests a different sequence of events. Vasari[3] tells us that Alfonso wanted to have 'some pictures' from Giovanni's hand in his Camerino and then goes on to describe the *Feast of the Gods*, fully but inaccurately: he writes of Silenus as naked and riding on his ass, which seems to be a confusion with Titian's *Bacchus and Ariadne*, a picture which he oddly omits to mention when going on to speak of Titian's further decorations in the room. He correctly records the date and signature on Giovanni's picture and goes on: 'La quale opera non avendo potuto finire del tutto, per esser vecchio, fu mandato per Tiziano, come più eccellente di tutti gli altri, acciò che la finisse. Onde egli, essendo desideroso d'acquistare e farsi conoscere, fece con molta diligenza due storie che mancavano al detto camerino.' It is unfortunately not quite clear what Vasari is trying to say here. Does 'quale opera' refer as would seem most natural to the single picture of the *Feast*, or to the project of several pictures referred to initially, as is suggested by his immediately

[1] Campori, G. 1874, p. 584.     [2] Walker, J. 1956, p. 50.     [3] Vasari, G. 1878–85, vii. 433–4.

going on to speak of other pictures which Titian executed in the same room? If Vasari is saying that Titian worked on the *Feast* because Giovanni was too old to finish it, what was the source of his information? Walker thinks he had the information direct from Titian himself when he visited him in Venice in 1566 and that Vasari's statement here is therefore particularly authoritative. He does not here cite Titian as the source of his statement; and when on one other occasion he does so the statement he makes on Titian's authority is universally admitted to be wrong.[1] Walker suggests, in order to save Vasari's credit in this case, that what had really happened was that Titian had worked twice on the picture, once before it was finished in Giovanni's studio, because Giovanni was so old that he needed assistance, and once after Giovanni's death to bring the picture into greater harmony with those he had painted for the room.[2] This seems an unsatisfactory theory for two reasons. First, its purpose is supposed to be to justify the truth of Vasari's statement, but it seeks to do this by telling a story quite different from the one Vasari himself tells us. Secondly, since political considerations make it very difficult to suppose that Alfonso can have commissioned the picture before 1513—and in any case, if the reason for Titian's intervention was Giovanni's feeble old age we can hardly put their co-operation much earlier—it supposes that Titian was working with Giovanni in his studio in that year, that is to say at a time when he was engaged in an agitation to supplant Giovanni in his direction of the work in the Sala del Maggior Consiglio.[3] I believe myself that no such elaborate explanation is needed. It seems to me probable that Vasari got his information not from Titian but from whoever showed him the Camerino in Ferrara, which he also visited in 1566, and that the true story had already been forgotten there, since the events in question had occurred over fifty years before. Because a large part of the picture was clearly by Titian's hand it had come to be supposed that the picture had been left unfinished, and since it bore Giovanni's signature and the date 1514 and it was known that Giovanni had lived two more years, the interruption of the work was ascribed not to death but to infirmity.

Before proceeding to the central question of the place of the *Feast of the Gods* in Giovanni's work as a whole and what we can learn from it of his reaction to con-

---

[1] Vasari, G. 1878–85, vii. 430. Vasari says that Titian, according to his own account, painted the *Tobias and the Angel* in the church of S. Marziale in 1507. This picture is universally allowed by the critics to date from the 1530s or 1540s.

[2] Walker, J. 1956, pp. 26–9.

[3] Crowe, A. J. and Cavalcaselle, G. B. 1881, i. 153–61. The documents printed in Lorenzi, G. B. 1868, docs. 337–8, 341, 344–5, 352–6, pp. 159 ff.

temporary developments, we might return for a moment to the consideration of the sources and the question as to which of the two passages of Ovid Giovanni intended to represent, and the respects in which he departs from both accounts. In the present state of the picture one would rather refer it to the latter than the earlier passage, since it is only there that Ovid refers to the presence of the Olympians.[1] On the other hand, Cybele, with her turreted crown specifically mentioned by Ovid, is absent and it is possible that the Olympian emblems are a later addition, adapting a picture which began as an illustration of the first story to the second. Yet again, if this is the 'feast of ivy-berried Bacchus' of the first passage, where is the god? He is generally identified as the child drawing a jug of wine from the cask, but if so why is he represented as a child? Wind would identify him as Ercole, the son of Alfonso and Lucrezia,[2] and Erica Tietze-Conrat produced an ingenious explanation from a passage in Macrobius according to which Bacchus is shown as a child in the winter, which is the season of the feast to which Ovid refers.[3] But does the child really represent Bacchus? He is not crowned with ivy, as is the related single figure from the Benson collection also in Washington, and as he should be in this context, but with vine.[4] In my view the picture was always intended to represent the second passage, which in any case would seem the more likely choice since the assault of Priapus of Vesta lends itself to more interesting allegorical interpretation than the assault on the comparatively unknown Lotis, and had indeed already received such exposition from Boccaccio[5]. The celestial pot-boy does not, I think, represent Bacchus whose presence at the second feast is not specified, but Ganymede. It seems likely that the suppression of Cybele's symbols in the central figure followed from the adaptation of the story to convey a symbolism of marriage and since there is no sign of the turreted crown in the X-ray this would argue that the marriage symbolism formed part of the scheme from the beginning.

Beautiful as is Titian's landscape in itself one cannot but regret it for its disruption of Giovanni's classical design. This is more easily appreciated in the X-ray where we see, against the unified background of the screen of trees, an arrangement of

[1] vi. 322. 'Convocat aeternos ad sua festa deos.'

[2] Wind, E. 1948, p. 41. This seems a curious identification if the picture is supposed to represent the wedding of the parents. Wind also suggests that as the child appears to be four or five years old and as Ercole was born in 1508 this will give us about 1513 for the date at which the picture was begun again in this form. If this important figure was only added at this stage we may ask ourselves what the supposed picture begun for Isabella in 1506 can have looked like.

[3] Walker, J. 1956, p. 5 n. 10.

[4] The ex-Benson picture surely derives from the figure in the *Feast of the Gods* but is not by Giovanni's hand, nor even certainly from his studio.

[5] *Genealogia Deorum Gentilium*, viii. 3.

beautiful symmetry in which a central pyramidal group, built round the nymph with the bowl and the turned head, flanked by the pan and the satyr, is itself flanked by the more vertical groups of Silenus, his ass and a satyr on the left and Priapus and Vesta on the right. Though there is something in this symmetry that recalls the tradition of the altar-piece of the enthroned Madonna and saints it represents in many respects something quite new in Giovanni's art, which links it more closely than any other specimen to the contemporary development of the High Renaissance in Central Italy. In certain respects there is no composition quite so close to this as that of Raphael's *Parnassus*, frescoed in the Vatican between 1509 and 1511, particularly the earlier version of the design which formed the basis of Marcantonio's engraving (B. 247, Pl. cxvii *a*). As this engraving was probably made at least as early as 1513 it is quite possible that there is a direct connection between the two compositions. Such an idea is confirmed by the pose of the nymph with the bowl who turns her head to look over her shoulder, a pose characteristic of Raphael which occurs in two prominent figures in the engraving. Alfonso may himself have brought back an impression or the print from one of his visits to Rome.

If we were to accept this it would indicate what I would myself think probable from the rest of the evidence that we have examined, that the whole idea of the picture originated when Alfonso was first able to have contact with Venice again in 1513, after the wars of the League of Cambrai.[1] If this really is so we are faced with the question of how Alfonso obtained in a period of hardly over eighteen months a picture of a type which his sister had failed to obtain after years of exasperated effort. To this I think we can suggest an answer. In considering the earlier correspondence with Isabella we should not take too readily Giovanni's excuses and accept without question that the difficulty lay primarily in the uncongenial nature of the task set him. We notice that when Isabella had entirely given way about the subject, and Giovanni was painting for her a religious picture of a subject perhaps of his own choice, it was hardly easier to get delivery. Also we may note that apart from the very first move, made by her husband in 1496, Isabella operated entirely through private agents and not through official diplomatic channels, except for one moment of exasperation when she thought Giovanni meant neither to return the advance payment nor to paint a picture and she appealed to the Mantuan agent in Venice. I think that the root of the trouble was that Giovanni had chronically more work than he could get through, largely because of his

---

[1] The slow steps by which Alfonso reconciled himself with the Venetians from the autumn of 1513 may be traced in Sanuto, M. 1879–1903, vols. xv and xvi.

official commitment to work in the Sala del Maggior Consiglio, which took up all his mornings. What I would suppose is that Alfonso, in the course of negotiating his new peaceful relation with the Venetians in 1513, slipped in a request, which was granted, that Giovanni should be allowed to treat the commission for his Camerino as an official one and work on it in time he would otherwise have been spending in the Sala del Maggior Consiglio.

I have suggested that the influence of an outside artist, Raphael, may be traced in the design of the *Feast*. Some passages of the design and its execution also betray a close relation to a work of Giorgione's, the *Three Philosophers* in Vienna (Pl. cxvii *b*). Here we may think in terms of mutual influence. The pebbly foreground of both pictures—the foreground of the *Feast* is actually a crystal-clear stream—goes right back in Giovanni's work to the Frick *St Francis*, but the effective use of silhouetted tree-trunks in the one picture must surely be borrowed from the other. Since Giorgione died in 1510 and Giovanni's picture was not finished until 1514 it seems reasonable to give him the priority, though he may himself have been developing hints from Giovanni's National Gallery *Death of St Peter Martyr*. The resemblances go beyond that of the tree-trunks. The still columnar verticals of Giorgione's standing figures seem to link up directly with the two standing nymphs in Giovanni's painting. In so far as both may be counted among the last echoes of the art of Piero della Francesca we might think of Giovanni as the leader, but it may be that Giorgione developed his figures from those of the saints of Giovanni's great altar-pieces and then gave the idea back to Giovanni. Certainly the more superficial but striking resemblances of the 'surveyor' in Giorgione's picture to the Mercury in Giovanni's suggests that Giovanni actually had Giorgione's picture in mind.

Visualizing Giovanni's picture as far as we can with the aid of the X-ray without the splendid but regrettable alterations of Titian, how does this picture, of such a new type, relate to his more familiar works, and how has he managed to make of this assignment so remarkable a masterpiece? We should recognize at the outset how far, in a certain sense, this picture fails in what it ostensibly sets out to do. In spite of the subject, in spite of the increased emphasis on the erotic elements which the X-rays reveal, this remains an extraordinarily virginal picture. There is no passion here, no abandon such as Titian gave his neighbouring canvases, only a great stillness. The story is from Ovid but the spirit is that of Vergil. We do not, until our attention has been drawn to it, see the story from the *Fasti*, but rather the solemn assembly that unites at the poet's call at the opening of the Georgics. We have seen a quotation from this poem in the background of the *Madonna of the*

*Meadow*,[1] and this is the one among Giovanni's earlier paintings which most strikingly anticipates the spirit of the *Feast*. The feeling of the divine in nature had been present from his earliest work; here it is developed into a sort of pantheism which can unite even this subject with the Christian content of the main body of his work. The message of Vergil may have been reinforced by that of Sannazaro's *Arcadia* which first appeared in a pirate edition in Venice in 1502, and perhaps of the eclogues of Tebaldeo, two of which had been staged in Ferrara in 1509 (and one wonders how far such stage performances may have contributed to the un-archaeological approach to a classical theme which is such a marked feature of Giovanni's picture, giving it something of the character of a charade). This is the first great Arcadian picture and it is fitting that Nicholas Poussin, the great Arcadian, should have copied it more than a hundred years later;[2] but it is much more than just an Arcadian fantasy. By his handling Giovanni has made it an expression of the concord and harmony of classical and Christian thought, just as Raphael, whose influence I have thought to detect in the design of the picture, had done more programmatically in the frescoes of the Stanza della Segnatura; and Giovanni's picture stands with those as one of the supreme and conclusive statements of the earlier Renaissance.

This flowering into an entirely new range of subject-matter remains almost isolated in Giovanni's work, indeed it came too late in time to allow of much expansion, but in the next year he followed it up with the nude *Venus* or *Lady at her Toilet* in Vienna (Pl. cxviii). In scale and relation of figure to background the composition derives from earlier Madonna compositions—one may particularly compare the Detroit *Madonna* of 1509—but the treatment of the nude is very like that of the nymphs in the *Feast*. The spirit is the same that Giovanni instilled into the *Feast* against the letter of its subject-matter and the effect is not voluptuous, but charmingly intimate. The picture is not idealized like Giorgione's Dresden *Venus*—a goddess of love, but a real goddess—but in its lively humanity looks forward to Titian's more worldly *Venus of Urbino*. If the achievement of the *Feast of the Gods* was a task unwillingly undertaken, as the correspondence with Isabella perhaps entitles us to infer, its accomplishment had worked in Giovanni a liberation celebrated in this relaxed and charming picture, which is almost his farewell to the art he had pursued for sixty years.

[1] See above, p. 120.

[2] In the painting now at Edinburgh. Unlike the Titian *Bacchanals* which went to Madrid between 1636 and 1638 the *Feast of the Gods* remained in Rome until the nineteenth century. It is possible that Poussin's copy falls later in his career than is generally supposed.

We have one other painting dated to this year, the *Portrait of a Dominican as St Dominic* in London (Pl. CXIX *a*). The date occurs below the cartellino with the signature and is perhaps not original but may belong with the partly effaced inscription on each side of it, which runs IMAGO FRATRIS / THEODORI VRBINATIS. Since Fra Teodoro d'Urbino is recorded among the brothers of SS. Giovanni e Paolo in 1514, and since the portrait clearly does represent a Dominican brother shown as the founder of his order and as the inscription, if not original is certainly old, it seems reasonable to accept both date and sitter's name as correct. The pentiments in the picture and the stages by which it has reached its present form, which appears to be substantially what was originally intended, are interestingly analysed by Davies in the gallery catalogue.[1] The picture, which like the other *Portrait of a Dominican* in London follows the new fashion of showing the hand, but retains the parapet and cartellino, shows like the Vienna *Venus* how far Giovanni could go in the direction of the work of the painters of the younger generation, while still preserving something of the more rigid formal values of the previous century.

Two versions of a composition of the *Virgin and Child with the Baptist in a land-scape*, in the Querini Stampalia gallery in Venice and in the Museo Civico at Padua, signed and dated 1516, seem to be copies of a lost original. To judge from the figure of the Baptist in the Querini Stampalia version this would seem to have been left unfinished at Giovanni's death, in which case the signature would have to be read as a studio authentication. The copies are of indifferent quality but we can sense a rather beautiful relation of figures to landscape. In 1515 the *Serenessima* commissioned from Giovanni a painting of the Madonna and Child as a present for François I$^{er}$'s sister, the duchesse d'Alençon, and it was almost complete in January 1516.[2] It is tempting to identify this with the late *Madonna* in the Jacquemart-André Museum in Paris (Pl. CXIX *b*), which, in spite of obvious weaknesses, is a strangely impressive work with its marked verticality and its heavy forms, such as the thick rope over which the cloth of honour is hung. There is certainly studio assistance here but I believe that beneath dirt and damage we have an important document for the last phase of Giovanni's development.[3]

[1] Davies, M. 1961, pp. 61–2.     [2] Ludwig, G. 1911, p. 90.

[3] The unfinished *Madonna* from the Donà delle Rose collection now in a private collection in England, reproduced in Pallucchini, R. 1959, pl. 234, may be an authentic lay-in left in Giovanni's studio and is in some ways close to the Jacquemart-André picture. Another puzzling work which in some ways recalls it is the ample *Portrait of a Woman* at Eastnor Castle, reproduced by Gronau, 1930, pl. 154; but in spite of the Bellinesque features of the landscape, to which Gronau draws attention, and the signature, it is difficult to think that, in its present state at least, the picture bears a very close relation to any concept of Giovanni's.

The great *Deposition* of the Venice Academy (Pl. cxx) must surely have been designed and laid in by Giovanni before his death, and represents his last effort in major altar-piece design, though the execution seems to be entirely that of his pupil Rocco Marconi.[1] The relation of figures to landscape here recalls the Vicenza *Baptism*, the silhouetting of the leaves against the sky the San Giovanni Crisostomo altar-piece. If we bear these masterpieces in mind and eliminate mentally the characteristics of Rocco's style, at once sloppy and theatrical, we can see the concept as one that would have fittingly closed the series of Passion pictures which began with the *Agony in the Garden* and the *Blood of the Redeemer* in London and was carried on through the *Pietàs* in the Brera and at Rimini, revealing to us yet again his particular achievement in the permeation of the landscape by the mood of the figure-subject so that man and nature are presented as elements of a divinely illuminated whole.

On 29 November 1516 Marin Sanuto wrote in his diary: 'Se intese questa mattina esser morto Zuan Belin optimo pytor, havia anni     la cui fama è nota per il mondo, et cussi vechio come l'era, dipenzeva per excellentia. Fu sepulto a San Zane Polo in la soa arca, dove *etiam è* sepulto Zentil Belin suo fradelo *etiam* optimo pytor.'[2] 'We learned of the death this morning of Giovanni Bellini, a very good painter, he was     years old and his fame was known throughout the world and old as he was he painted with excellence. He was buried in SS. Giovanni e Paolo in his tomb where also his brother Gentile Bellini is buried, also a very good painter.'

The age so tantalizingly left blank by Sanuto must have counted more than eighty years. He was old, ten years older indeed than when Dürer had written of him, but still 'optimo pytor', 'pest im Gemoll'. Now he is an Old Master but for some of us, in spite of all the magnificent achievements of four hundred and fifty years of subsequent painting that is what he remains, for his unique combination of mathematical structure and sensitive observation, form and colour, intellect and feeling: 'optimo pytor' 'pest im Gemoll'—a very good—the best—painter.

---

[1] This was the view of Gibbons, F. 1962 (1), p. 130. A recent, and questionably judicious, cleaning has perhaps revealed something of Giovanni's lay-in in the figure of Christ.

[2] Sanuto, M. 1879–1903, xxiii. 256.

# Bibliography

ARSLAN, E., 1951. 'I trittici della Carità', *Bollettino d'arte*, serie 4, anno 36, pp. 305–23.

—— 1952. 'Il polittico di San Zanipolo', *Bollettino d'arte*, serie 4, anno 37, pp. 127–56.

—— 1956. *Catalogo delle cose d'arte e di antichità d'Italia*, Vicenza, I, Le chiese, Rome.

—— 1962. 'Studi belliniani', *Bollettino d'arte*, serie 4, anno 47, pp. 40–58.

BALDASS, L., 1952. *Jan van Eyck*, London.

BERENSON, B., 1895. *Lorenzo Lotto*, London.

—— 1916 (1). *Venetian painting in America*, London.

—— 1916 (2). *Study and criticism of Italian art*, third series, London.

—— 1932. *Italian pictures of the Renaissance*, Oxford.

—— 1938. *The drawings of the Florentine painters*, amplified edition, 3 vols., Chicago.

—— 1957. *Italian pictures of the Renaissance, the Venetian School*, London.

BIADEGO, G., 1907. *Variazioni e divagazioni a proposito di due sonetti di Giorgio Sommariva in onore di Gentile e Giovanni Bellini (per nozze Gerola–Cena)*, Verona.

BISCARO, G., 1914. 'Note di storia dell'arte e della coltura a Milano', *Archivio storico lombardo*, serie 5, i, anno xli, pp. 71–108.

BORENIUS, T., 1913. 'The probable origin of an Antonellesque composition', *Burlington magazine*, xxiii, pp. 82–4.

—— 1915. 'The provenance of Bellini's Christ in the Louvre', *Burlington magazine*, xxvii, p. 205.

BORTOLAN, D., 1889. *S. Corona, chiesa e convento dei Domenicani in Vicenza*, Vicenza.

BOSCHINI, M., 1664. *Le minere della pittura*, Venice.

BOTTARI, S., 1958. 'Antonello da Messina', *Encyclopedia of world art*, i, pp. 501–7, New York, Toronto, London.

BRAGHIROLLI, W., 1877. 'Carteggio di Isabella d'Este Gonzaga intorno ad un quadro di Giambellino', *Archivio veneto*, anno settimo, xiii, pp. 370–83.

BRAUNFELS, W., 1956. 'Giovanni Bellinis Paradiesgärtlein', *Das Münster*, 9. Jhrg. pp. 1–13.

BYAM SHAW, J., 1952. 'A Giovanni Bellini at Bristol', *Burlington magazine*, xciv, pp. 157–9. 'A further note on the Bristol Bellini', ibid., p. 237.

CAMPANA, A., 1962. 'Notizie sulla Pietà riminese di Giovanni Bellini', *Scritti di storia dell'arte in onore di Mario Salmi*, ii, pp. 406–27, Rome.

CAMPORI, G., 1874. 'Tiziano e gli Estensi', *Nuova antologia di scienze, lettere ed arti*, xxvii, pp. 581–620.

CARTWRIGHT, J., (Mrs. Ady), 1903. *Isabella d'Este*, 2 vols., London.

CECCHETTI, B., 1887. 'Saggio di cognomini ed autografi di artisti in Venezia, secoli XIV–XVII', *Archivio veneto*, xxxiv, pp. 203–14.

CIAN, V., 1887. 'Pietro Bembo e Isabella d'Este Gonzaga', *Giornale storico della letteratura italiana*, ix, pp. 81–136.

CICOGNA, A. E., 1824–53. *Delle iscrizioni veneziane*, 6 vols., Venice.

CLARK, K., 1930. 'Italian drawings at Burlington House', *Burlington magazine*, lvi, pp. 175–187.

—— 1932. 'Giovanni Bellini or Mantegna?' letter in *Burlington magazine*, lxi, pp. 232–5.

COLAZIO, M., 1486. *Matthei colacii . . . ad . . . Dominicum maurocenum de verbo Civiltate*, etc., Venice.

CROWE, J. A., and CAVALCASELLE, G. B., 1881. *The life and times of Titian*, 2 vols., London.

—— —— 1912. *History of painting in North Italy*, edited by Tancred Borenius, 3 vols., London.

D'ARCO, C., 1857. *Delle arti e degli artefici di Mantova*, 2 vols., Mantua.

DAVIES, M., 1945. *National Gallery Catalogues, The early Netherlandish School*, London.

—— 1961. *National Gallery Catalogues, The earlier Italian Schools*, London.

DÜRER, A., 1956. *Schriftlicher Nachlaß*, ed. H. Rupprich, i, Berlin.

DÜSSLER, L., 1935. *Giovanni Bellini*, Frankfort o. M.

—— 1949. *Giovanni Bellini*, Vienna.

EINEM, H. VON, 1956. 'Die Menschwerdung Christi des Isenheimer Altars', *Kunstgeschichtliche Studien für Hans Kaufmann*, pp. 152–71, Berlin.

FAHY, E. P., jr., 1964. 'New evidence for dating Giovanni Bellini's *Coronation of the Virgin*', *Art bulletin*, xlvi, pp. 216–8.

FIOCCO, G., 1933. 'Mantegna o Giambellino?' *L'Arte*, N.S. iv, pp. 185–99.

—— 1949. 'I disegni di Giambellino', *Arte veneta*, iii, pp. 40–54, Venice.

—— 1958. Review of Meiss's *Andrea Mantegna as illuminator*, *Paragone (Arte)*, 99, anno ix, pp. 55–8.

—— 1959. *L'arte di Andrea Mantegna*, 2nd ed., Venice.

FOGOLARI, G., 1932. 'Disegni per gioco e incunabili del Giambellino', *Dedalo*, xii, pp. 360–90.

FRIZZONI, G., 1913. 'A plea for the re-integration of a great altarpiece', *Burlington magazine*, xxii, pp. 260–9.

—— 1914. 'Opere di pittura venete lungo la costa meridionale dell'Adriatico', *Bollettino d'arte*, viii, pp. 23–40.

FRY, R. E., 1900. *Giovanni Bellini*, London.

F. S., 1891. 'Aneddoto', *Nuovo archivio veneto*, ii, p. 382.

GALLO, R., 1949. 'I polittici già nella cappella del coro di S. M. della Carità', *Arte veneta*, iii, pp. 136–40.

GAMBA, C., 1937. *Giovanni Bellini*, Milan.

GAYE, G., 1839–40. *Carteggio inedito d'artisti dei secoli XIV, XV, XVI*, 3 vols, Florence.

GIBBONS, F., 1962 (1). 'Giovanni Bellini and Rocco Marconi', *Art bulletin*, xliv, pp. 127–31.

—— 1962 (2). 'The Bellinesque painter Marco Bello', *Arte veneta*, xvi, pp. 42–8,.

—— 1963. 'New evidence for the birth-date of Gentile and Giovanni Bellini', *Art bulletin*, xlv, pp. 54–8.

—— 1965. 'Practices in Giovanni Bellini's workshop', *Pantheon*, Jhrg. xxiii. pp. 146–55.

GOLOUBEW, V., 1912. *Les Dessins de Jacopo Bellini au Louvre et au British Museum*, 2 vols., Brussels.

GRONAU, G., 1909. Articles under 'Bellini' in Thieme–Becker, *Allgemeines Lexikon der bildenden Künstler*, iii, pp. 252–66, Leipzig.

—— 1921. 'Lauro Padovano', *Collectanea variae doctrinae Leoni S. Olschki*, p. 101–12, Munich.

—— 1928. *Die Spätwerke des Giovanni Bellini*, Strasbourg.

—— 1930. *Giovanni Bellini* (Klassiker der Kunst), Stuttgart.

GRONAU, H. D., 1949. 'Ercole Roberti's St Jerome', *Burlington magazine*, xci, pp. 243/4, London.

HABICHT, V. C., 1931. 'Giovanni Bellini und Rogier van der Weyden', *Belvedere*, N.S. x (1), pp. 54–7.

HADELN, D. VON, 1910. 'Sansovinos Venetia als Quelle für die Geschichte der venezianischen Malerei', *Jahrbuch der k. preußischen Kunstsammlungen*, xxxi, pp. 149–58.

—— 1925. *Venezianische Zeichnungen des Quattrocento*, Berlin.

—— 1932. 'Giovanni Bellini or Mantegna?', *Burlington magazine*, lxi, pp. 229–30, London.

HARTLAUB, G. F., 1942. 'Die Spiegel-Bilder des Giovanni Bellini', *Pantheon*, xxix, pp. 23–41.

HARTT, F., 1940. 'Carpaccio's Meditation on the Passion', *Art bulletin*, xxii, pp. 25–35.

—— 1959. 'The earliest work of Andrea del Castagno', part 2, *Art bulletin*, xli, pp. 225–36.

HEINEMAN, F., 1959. *Giovanni Bellini e i belliniani*, 2 vols., Venice.

HENDY, P., 1932. 'Two Giovanni Bellini drawings', *Burlington magazine*, lxi, pp. 62–7.

—— and GOLDSCHEIDER, L., 1945. *Giovanni Bellini*, London.

HETZER, T., 1957. *Aufsätze und Vorträge*, 2 vols., Leipzig.

HILL, G. F., 1929. *Drawings by Pisanello*, Brussels.

HORSTER, M., 1963. 'Mantuae Sanguis Preciosus', *Wallraf-Richartz Jahrbuch*, xxv, pp. 151–80.

HOURTICQ, L., 1919. *La Jeunesse de Titien*, Paris.

JANSON, H. W., 1952. 'Apes and ape lore', *Studies of the Warburg Institute*, xx, London.

KRAUSE, E., 1926. *Die Mythen-Darstellungen in der venezianischen Ovidsausgabe von 1497*, Würzburg.

KRISTELLER, P., 1901. *Andrea Mantegna*, English edition by S. Arthur Strong, London.

LAUTS, J., 1940. *Antonello da Messina*, Vienna.

—— 1941. 'Zu Piero dei Franceschi's verlorenen Fresken in Ferrara', *Zeitschrift für Kunstgeschichte*, x, pp. 67 ff.

—— 1953. 'A note on Piero della Francesca's lost Ferrara frescoes', *Burlington magazine*, xcv, p. 166, London.

LONGHI, R., 1914. 'Piero dei Franceschi e lo sviluppo della pittura veneziana', *L'Arte*, anno xvii, pp. 198–22 and 241–56.

—— 1927. 'Un chiaroscuro e un disegno di Giovanni Bellini', *Vita artistica*, ii, p. 133.

—— 1946. *Viatico per cinque secoli di pittura veneziana*, Florence.

—— 1949. 'The Giovanni Bellini exhibition', *Burlington magazine*, xci, pp. 274–83.

LORENZI, G. B., 1868. *Documenti per servire alla storia del Palazzo Ducale di Venezia*, Venice.

LUDWIG, G., 1902. 'Giovanni Bellinis sogenannte Madonna am See in den Uffizien, eine religiose Allegorie', *Jahrbuch der k. preußischen Kunstsammlungen*, xxiii, pp. 163–86.

—— and BODE, W., 1903. 'Die Altarbilder der Kirche S. Michele di Murano und das Auferstehungsbild des Giovanni Bellini in der Berliner Galerie', *Jahrbuch der k. preußischen Kunstsammlungen*, xxiv, pp. 131–46.

—— and RINTELEN, F., 1906. 'Venezianischer Hausrat zur Zeit der Renaissance', *Italienische Forschungen*, i, pp. 169–361.

—— 1911. 'Archivalische Beiträge zur Geschichte der venezianischen Kunst aus dem Nachlaß Gustav Ludwigs', ed. W. von Bode, G. Gronau, D. von Hadeln, *Italienische Forschungen*, iv, Berlin.

LUZIO, A., 1880. 'Disegni topografici e pitture dei Bellini', *Archivio storico dell'arte*, anno i, pp. 276–8

—— and RENIER, R., 1891. 'Buffoni, nani e schiavi dei Gonzaga ai tempi d'Isabella d'Este', *Nuova antologia di scienze, lettere ed arti*, cxviii, pp. 618–50, and cxix, pp. 112–46.

—— —— 1899. 'La coltura e le relazioni letterarie di Isabella d'Este Gonzaga, II, Le relazioni letterarie', *Giornale storico della letteratura italiana*, xxxiv, pp. 1–97.

—— 1900. 'I ritratti d'Isabella d'Este', *Emporium*, xi, pp. 344–59 and 427–42.

MALAGUZZI-VALERI, F., 1904. *Gio. Antonio Amadeo*, Bergamo.

MALIPIERO, D., 1843–4. 'Annali veneti dall'anno 1457 al 1500', *Archivio storico italiano*, vii.

MARIACHER, G., 1961. 'Il paliotto argenteo del SS. Salvatore a Venezia', *Scritti di storia dell'arte in onore di Mario Salmi*, i, pp. 423–44, Rome.

MARLE, R. VAN, 1923–39. *The Italian schools of painting*, 19 vols., The Hague.

MEISS, M., 1945. 'Light as form and symbol in some XV-century paintings', *Art bulletin*, xxvii, pp. 175–81.

—— 1951. *Painting in Florence and Siena after the Black Death*, Princeton.

—— 1956. 'Jan Van Eyck and the Italian Renaissance', *Venezia e l'Europa, atti del XVIII congresso internazionale di storia dell'arte, Venezia 12–18 settembre 1955*, pp. 58–69, Venice.

—— 1957. *Andrea Mantegna as illuminator*, New York.

—— 1960. 'Toward a more comprehensive Renaissance paleography', *Art bulletin*, xlii, pp. 97–112.

—— 1963 (1). 'French and Italian variations on an early fifteenth-century theme: St Jerome in his study', *Gazette des beaux-arts*, vie série, lxii, pp. 147–70.

—— 1963 (2). 'A lost portrait of Jean de Berry by the Limbourgs', *Burlington magazine*, cv, pp. 51–3.

—— 1964. *Giovanni Bellini's St Francis in the Frick Collection*, Princeton.

—— 1966. 'Once again Piero della Francesca's Montefeltro altarpiece', *Art bulletin*, xlviii, pp. 203–6.

MEZZETTI, A., 1965. 'Le storie di Enea del Dosso nel "Camerino d'Alabastro" di Alfonso d'Este', *Paragone (Arte)*, anno xvi, 189–90, pp. 71–84.

(MICHIEL, M.), 1884. 'Notizie d'opere di disegno', ed. G. Frizzoni, Bologna.

MIDDLEDORF, U., 1962. 'Un rame inciso del Quattrocento', *Scritti di storia dell'arte in onore di Mario Salmi*, ii, pp. 273–89, Rome.

—— 1904. 'La Madonna degli alberetti', *Emporium*, xx, pp. 109–20.

MOLMENTI, P., and LUDWIG, G., 1907. *The life and works of Vittorio Carpaccio*, translated by Robert H. Hobart Cust, London.

MOMMSEN, T. E., 1952. 'Petrarch and the decoration of the Sala Virorum Illustrium in Padua', *Art bulletin*, xxxiv, pp. 95–116.

MORELLI, G., 1892/3. *Critical studies of Italian painters*, translated by C. J. Ffoulkes, 2 vols., London.

MORASSI, A., 1958. 'Scoperta d'un Cristo Benedicente del Giambellino', *Arte veneta*, xii, pp. 45–52.

MORETTI, L., 1958. 'Di Leonardo Bellini, pittore e miniatore', *Paragone (Arte)*, 99, anno ix, pp. 58–66.

MOSCHETTI, A., 1913. 'Un quadrennio di Pietro Lombardo a Padova', *Bollettino del Museo Civico di Padova*, xvi, pp. 1–99.

—— 1928. 'Lauro Padovano', Thieme–Becker, *Allgemeines Lexikon der bildenden Künstler*, xxii, p. 461, Leipzig.

(MOSCHINI, G. A.), 1831. *Vita di Giovanni Bellini descritta da cav. Carlo Ridolfi, riprodotta con emende e con giunte nelle sponsalizie Papadopoli–Mosconi*, Venice.

MOSCHINI, V., 1943. *Giambellino*, Bergamo.

MUCHALL-VIEBROCK, T., 1942. 'Andrea Mantegna als Zeichner', *Pantheon*, xxix, pp. 73–8.

MURARO, M., 1956. 'L'esperienza veneziana di Paolo Uccello', *Venezia e l'Europa, atti del XVIII congresso internazionale di storia dell'arte, Venezia 12–18 settembre 1955*, Venice.

—— 1959 (1). 'Domenico Veneziano at San Tarasio', *Art bulletin*, xli, pp. 151–8.

MURARO, M., 1959 (2). 'A cycle of frescoes by Squarcione in Padua', *Burlington magazine*, ci, pp. 89–96.

NICOLINI, F., 1925. *L'arte napoletana del Rinascimento*, Naples.

PACCAGNINI, G., 1961. *Andrea Mantegna, catalogo della mostra*, Venice.

PÄCHT, O., 1956. 'René d'Anjou et les van Eyck', *Cahiers de l'Association internationale des études françaises*, no. 8, pp. 41–67.

—— 1963. 'Zur Entstehung des Hieronymus in Gehaus', *Pantheon*, Jhrg. xxi, pp. 131–42.

PALLUCCHINI, R., 1949. *Giovanni Bellini, catalogo illustrato della mostra*, Venice.

—— 1959. *Giovanni Bellini*, Milan.

—— (n.d.). *I Vivarini*, Venice.

PANOFSKY, E., 1939. *Studies in iconology*, New York.

—— 1953. *Early Netherlandish painting*, 2 vols., Harvard, Cambridge, Mass.

PAOLETTI, P., 1893. *L'architettura e la scultura del Rinascimento in Venezia*, 3 vols., Venice.

—— 1894. *Raccolta di documenti inediti per servire alla storia della pittura veneziana nei secoli XV e XVI*, fascicolo 1, Padua.

—— 1929. *La Scuola Grande di San Marco*, Venice.

PARKER, K. T., 1927. *North Italian drawings of the Quattrocento*, London.

—— 1928. 'An attribution to Giovanni Bellini', *Old master drawings*, iii, pp. 19–23.

PINO, P., 1946. *Dialogo della pittura* (1548), ed. R. and A. Pallucchini, Venice.

PLANISCIG, L., 1921. *Venezianische Bildhauer der Renaissance*, Vienna.

POPE-HENNESSY, JOHN, 1952. *Fra Angelico*, London.

—— 1955. *Italian Gothic sculpture*, London.

—— 1958. *Italian Renaissance sculpture*, London.

POPHAM, A. E., and POUNCEY, P., 1950. *Italian drawings in the . . . British Museum, the fourteenth and fifteenth centuries*, 2 vols, London.

PRATILLI, L., 1939–40. 'Felice Feliciano alla luce dei suoi codici', *Atti del Reale istituto veneto di scienze, lettere ed arti*, xcix, parte ii, pp. 34–105, Venice.

PUPPI, L., 1962. *Bartolomeo Montagna*, Venice.

RASMO, N., 1946. 'La Sacra Conversazione belliniana degli Uffizi e il problema della sua comprensione', *Carro minore, rivista di coltura*, nos. 5 and 6, pp. 229–40, Trento.

RICCI, C., 1908. *Jacopo Bellini e i suoi libri di disegni*, 2 vols., Florence.

RIDOLFI, C., 1914–24. *Le meraviglie dell'arte* (1648), ed. D. von Hadeln, 2 vols., Berlin.

RING, G., 1949. *A century of French painting*, London.

ROBERTSON, G., 1950. 'Giovanni Bellini', letter in *Burlington magazine*, xcii, pp. 25–6.

—— 1954. *Vincenzo Catena*, Edinburgh.

—— 1960. 'The earlier work of Giovanni Bellini', *Journal of the Warburg and Courtauld Institutes*, xxiii, pp. 45–59.

RÖTHLISBERGER, M., 1956. 'Notes on the drawing books of Jacopo Bellini', *Burlington magazine*, xcviii, pp. 358–64.

RUSKIN, J., 1903–12. *The works of John Ruskin*, ed. E. T. Cook and Alexander Wedderburn 39 vols., London.

SABELLICO, M. A., (n.d.). *De Venetae urbis situ*, Venice.

SALMI, M., 1950. 'Riflessioni su Paolo Uccello', *Commentari*, i, pp. 22–33.

SANSOVINO, F., 1581. *Venetia . . . descritta*, Venice.

SANUTO, M., 1879–1903. *Diarii*, 58 vols., Venice.

SAXL, F., 1939. 'Pagan sacrifices in the Italian Renaissance', *Journal of the Warburg and Courtauld Institutes*, ii, pp. 346–67.

—— 1957. *Lectures*, 2 vols., London.

SCHEFOLD, E., 1943. *Die Bildnisse der antiken Dichter, Redner und Denker*, Basle.

SEILERN, A., 1959. *Italian paintings and drawings at 56 Princes Gate*, London.

TIETZE, H., and TIETZE-CONRAT, E., 1944. *The drawings of the Venetian painters of the 15th and 16th centuries*, New York.

—— —— 1949. 'The *Allendale Nativity* in the National Gallery', *Art bulletin*, xxxi, pp. 11–20.

VASARI, G., 1878–85. *Le vite de' più eccellenti pittori, scultori ed architettori* (1568), ed. G. Milanesi, 9 vols., Florence.

VENTURI, A., 1924. 'Giambellino, nuove ricerche', *L'arte*, xxvii, pp. 137–40.

—— 1926. 'Tre ignorati quadri di Giambellino', *L'arte*, xxix, pp. 68–72.

VERDIER, P., 1953. 'L'allegoria della Misericordia e della Giustizia di Giambellino', *Atti dell'Istituto veneto di scienze, lettere ed arti*, cxi, pp. 97–116.

WAETZOLDT, W., 1950. *Dürer and his times*, London.

WALKER, J., 1956. *Bellini and Titian at Ferrara*, London.

WESCHER, P., 1945. *Jean Fouquet und seine Zeit*, Basle.

WILDE, J., 1929. Die 'Pala di San Cassiano' von Antonello da Messina, *Jahrbuch der kunsthistorischen Sammlungen in Wien*, N.F. iii, pp. 57–72.

WIND, E., 1948. *Bellini's Feast of the Gods*, Harvard.

—— 1950. 'The eloquence of symbols', *Burlington magazine*, xcii, pp. 349–50.

WINTERNITZ, E., 1946. 'A *Lira da Braccio* in Giovanni Bellini's *Feast of the Gods*', *Art bulletin*, xxviii, pp. 114–15.

WITTKOWER, R., 1939. '"Eagle and serpent", a study in the migration of symbols', *Journal of the Warburg and Courtauld Institutes*, ii, pp. 293–325.

YRIARTE, C., 1896. 'Isabelle d'Este et les artistes de son temps, V. Relations d'Isabelle avec Giovanni Bellini', *Gazette des beaux-arts*, 38th year, 3rd series, xv, pp. 215–28.

(ZANETTI, A. M.), 1771. *Della pittura veneziana*, Venice.

ZILIOTTO, B., 1950. *Raffaele Zovenzone, la vita, i carmi*, Trieste.

# Topographical Index of works by or ascribed to Giovanni Bellini

*Note.* This is an index and not a catalogue. All works whose attribution to Giovanni Bellini is discussed are included irrespective of whether the attributions are here accepted or rejected. (The same consideration applies to the lists of works given under the names of other artists in the General Index.) The page references for the main discussion of each work are given in heavy type; plate references are given in Roman numerals.

Paris, Musée du Louvre:
(1158) *Virgin and Child with St Peter and St Sebastian,* LXXVIII *b*, **96.**
(1158A) *Young Man,* LXXXVIII *b*, **107.**
(1158B) *Christ Blessing,* XVIII *b*, **36**, 112, 113.
Cabinet des Dessins, *Pietà with St John and Two Maries,* V *b*, 25.
*Jeremiah and St Francis,* **120-1.**
Pavia, Museo Malaspina, *Madonna,* **37.**
Pesaro, Musei Civici:
Bust of Father, XCIV *a*, **113.**
Head of Baptist, XXVIII *b*, **53.**
Crucifixion, XXXVII *a*, **53.**
Coronation of the Virgin, XLVI–LI, 43, 52, 60, **66–72,** 78, 79, 83, 85, 86, 90, 94, 95, 107, 114.
Philadelphia, Museum of Art, Johnson Coll. *Madonna,* XX *a*, **37-8.**

Rennes, Musée, *Pietà,* drawing, 25.
Rimini, Palazzo Comunale, *Pietà,* XLI, **62-4,** 78, 94, 107, 154.
Rome, Galleria Borghese, *Madonna,* **116.**
Rome, Pinacoteca Capitolina, *Young Man,* LXXXVII *a*, **107.**
Rome, Pinacoteca Vaticana, *Pietà,* XLVII *b*, 43, 67, **71.**
Rossie Priory, Perthshire, Lord Kinnaird (formerly), *Double Portrait,* **110.**
Rotterdam, Boymans Museum:
*Seated Man,* drawing, XI *b*, **27.**
*Madonna,* drawing, X *b*, **27.**
Rovigo, Accademia dei Concordi, 141, *Madonna,* **79.**

Stockholm, Nationalmuseum, *Christ in Tomb,* XCV *b*, **113.**
Stuttgart, Gemäldegalerie, *Pietà,* **98.**
Switzerland, Private Coll., *Christ Blessing,* **113, 115.**

Toledo, Spain, Cathedral, *Pietà,* **98.**
Toledo, Ohio, Museum of Art, *Christ bearing the Cross,* CXII *a*, **124.**

Venice, Accademia:
(38) S. Giobbe *Madonna,* LXVI and LXVII, **83-7,** 88, 93, 99, 101, 116.
(54) *St Ursula,* XXXV *a*, **49.**
(87) *Head of Christ,* frag. LXXIX *a*, **92.**
(166) *Deposition,* CXX, **154,**
(583) *Madonna,* LXIII *b*, **79-80.**
(591) *Madonna with Sleeping Child,* XL *a*, 56, **60-2,** 64, 78, 88 n., 120.
(594) *Madonna,* LXV, **80,** 93.
(595) *Five Allegories,* LXXXIV, LXXXV, and LXXXVI *a*, 13, 16, **103-6,** 126.
(596) *Madonna degli alberetti,* LXXIII, 14, 83, **92,** 93, 95.
(610) *Madonna with St Paul and St George,* LXXVII, **95-6.**
(612) *Madonna with Red Cherubim,* LXXIV, **93-4.**

(613) *Madonna with two Female Saints,* LXXVI, **94,** 98.
(621, 621 *A*, *B*, and *C*) Four *triptychs* from the Carità, XXI and XXII, 14, 36, **39-43,** 66, 72, 79, 121.
(734) *Annunciation,* LXXX, 83, **96-7,** 100, 102, *St Peter,* 97.
(881) *Giovanelli Sacra conversazione,* XCVI, 96, **115.**
(883) *Donà delle Rose Pietà,* XCVII, **114,** 115, 120.
(114) *Young Woman,* drawing, XLV *a*, **65.**
(115) *Pietà,* drawing, VI *b*, **24,** 36.
(162) *Standing Saint,* drawing, IX *b*, **25,** 54.
Venice, Fondazione Querini Stampalia:
*Presentation in Temple,* LVI, **75-6,** 94, 98.
*Virgin and Child with Baptist,* **153.**
Venice, Museo Civico Correr:
(27) *Transfiguration,* XII, 15, 16, **30-1,** 32, 52, 91.
(28) *Crucifixion,* XIII *b*, **31-2.**
(29) *Crucifixion,* I, **15,** 17.
(39) *Pietà,* XVIII *a*, **35-6,** 37, 52.
(1836) *Frizzoni Madonna,* XLIII *a*, 52, 56, **60,** 78, 88 n.
Venice, Doge's Palace:
*Pietà,* XXIV *b*, 14, **46-7.**
Paintings in Sala del Maggior Consiglio (destroyed), 3, **81-3,** 85, 90, 95, 97.
Venice, Palazzo Cornaro (formerly), *Supper at Emmaus,* (destroyed), LXXXI *b*, 97.
Venice, Donà delle Rose Collection (formerly), *Unfinished Madonna,* 153 n.
Venice, Churches, Carità:
(formerly) *Altar of S. Giovanni Evangelista* (lost), 47, **53-4,** 99.
S. Francesco della Vigna, *Madonna with Saints and Donor,* CVI *a*, 110-1, **122.**
S. Giovanni Crisostomo, *St Jerome between St Christopher and St Augustine,* CXIII, **128-31,** 154.
S. Giovanni dei Cavalieri, *Baptism,* **113,**
SS. Giovanni e Paolo, *Polyptych of St Vincent Ferrer,* XXV–XXVIII *a* and XXIX, 14, 29, 36, **43-6,** 50-2, 66, 89, 131.
*Madonna enthroned with Saints* (destroyed), XXXIX *b*, 45, **59-66,** 78.
S. Maria dei Frari, *Triptych,* LXVIII, 83, **87-9.**
S. Maria dell'Orto, *Madonna,* LX *a*, **78.**
S. Salvatore, *Supper at Emmaus,* LXXXI *a*, 97.
S. Zaccaria, *Madonna and Saints,* frontispiece and XCVIII, I, 85, 87, **116-7,** 121.
Venice, Ospedale Civile, *Martyrdom of St Mark,* CIX, 83, 114, **125.**
Venice, Scuola di S. Girolamo (formerly), *Scenes from life of St Jerome* (lost), 14.
Verona, Museo Civico di Castelvecchio:
(77) *Madonna with Standing Child,* LXII, 49, **79.**
(110) *Madonna with Sleeping Child,* LXIV *a*, 78.
*Presentation in Temple,* LXXXII *b*, 99.
Vicenza, S. Corona, *Baptism,* XCIII, 99, **111,** 115, 116, 120, 121, 122, 132, 154.
Vienna, Kunsthistorisches Museum (451), *Venus* or *Lady at her Toilet,* CXVIII, 13, 132, **152,** 153.

# General Index

Plate references are given in roman numerals

PLATE I

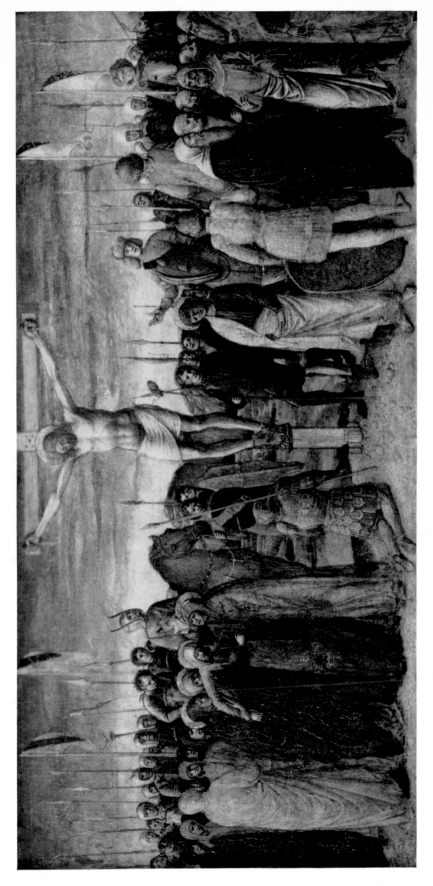

Jacopo or Giovanni Bellini, *Crucifixion*. Wood, 28·5×57. Venice, Museo Civico Correr

PLATE II

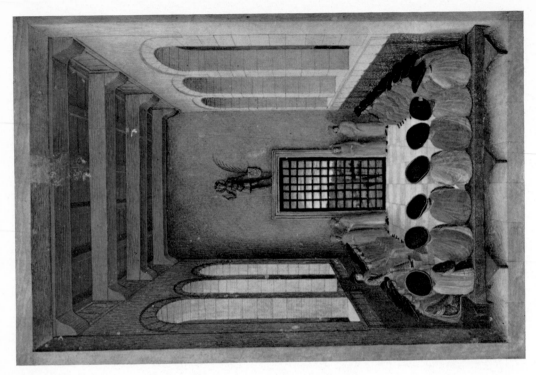

b. Andrea Mantegna or Giovanni Bellini, *Chapter of the Order of the Crescent.* Vellum, 18·7 × 13. Paris, Bibliothèque de l'Arsenal, MS. 940

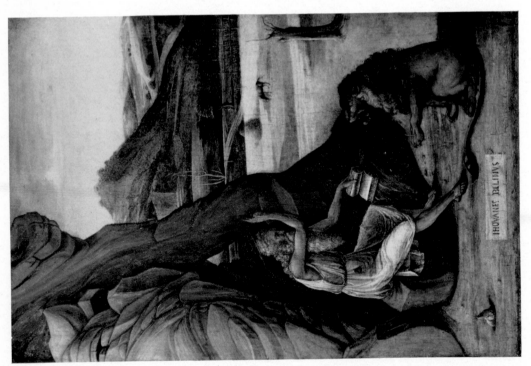

a. Giovanni Bellini, *St Jerome.* Wood, 44·8 × 35·8. Signed IHOVANES BELINVS. Birmingham, Barber Institute of Fine Art

PLATE III

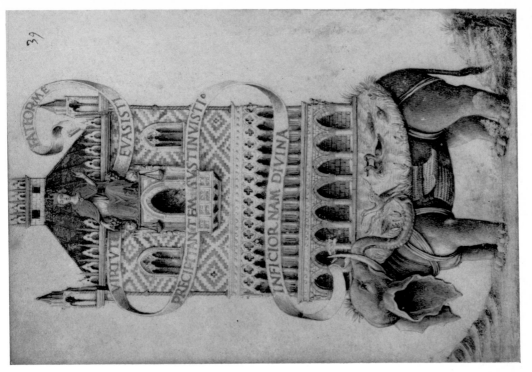

*b.* Andrea Mantegna or Giovanni Bellini, *Allegory.* Vellum, 18·7 × 13.
Paris, Bibliothèque de l'Arsenal, MS. 940

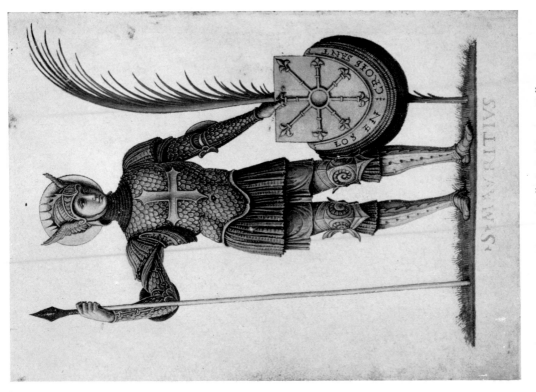

*a.* Andrea Mantegna or Giovanni Bellini, *St Maurice.* Vellum, 18·7 × 13.
Paris, Bibliothèque de l'Arsenal, MS. 940

PLATE IV

*b.* Andrea Mantegna or Giovanni Bellini, *Portrait of a Man.* Wood, 24×19·1.
Washington D.C., National Gallery of Art, Samuel H. Kress Collection

*a.* Andrea Mantegna or Giovanni Bellini, *Jacopo Antonio Marcello.*
Vellum, 18·7×13. Paris, Bibliothèque de l'Arsenal, MS. 940

PLATE V

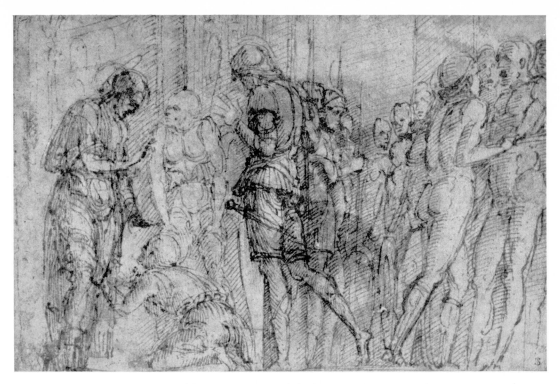

*a.* Andrea Mantegna, *St James led to Execution.* Pen and ink on paper, 15·5×25·4. Donnington Priory, Newbury, G. M. Gathorne-Hardy Esq.

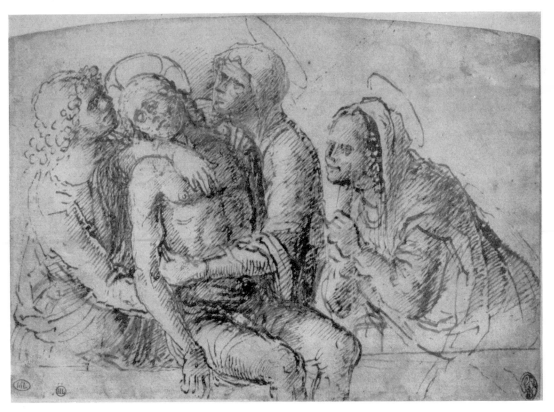

*b.* Andrea Mantegna or Giovanni Bellini, *Pietà.* Pen and ink on paper, 13·1×18·1. Paris, Musée national du Louvre

PLATE VI

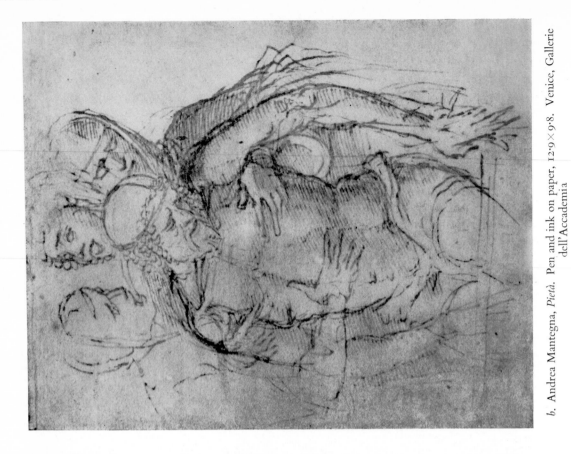

PLATE VII

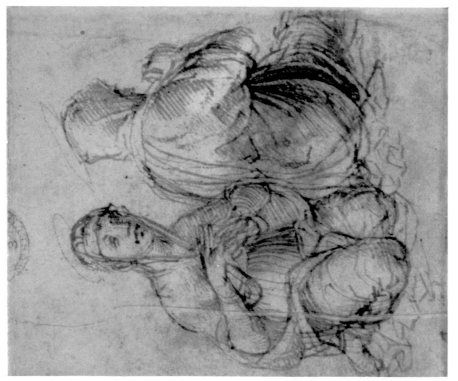

*b.* Andrea Mantegna, *Studies for Entombment* (verso of VII*a*). Pen and ink on paper. London, British Museum

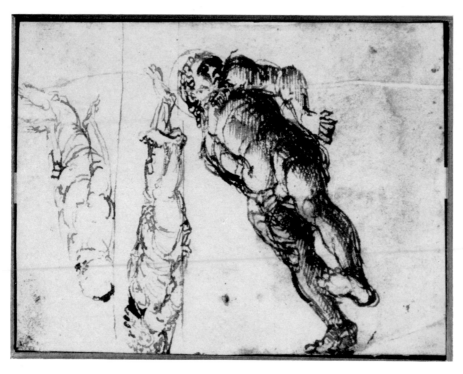

*a.* Andrea Mantegna, *Studies for Entombment* (recto). Pen and ink on paper, 12·2 × 8·9. London, British Museum

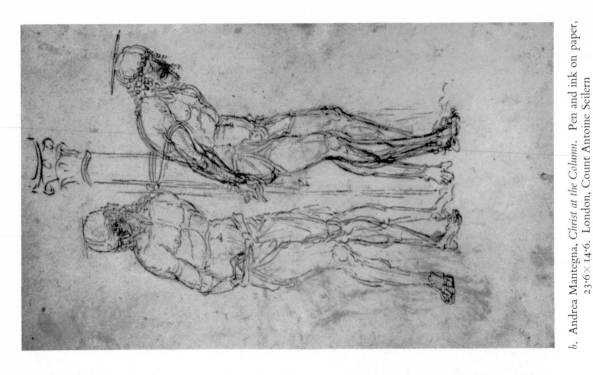

b. Andrea Mantegna, *Christ at the Column.* Pen and ink on paper,
23·6 × 14·6. London, Count Antoine Seilern

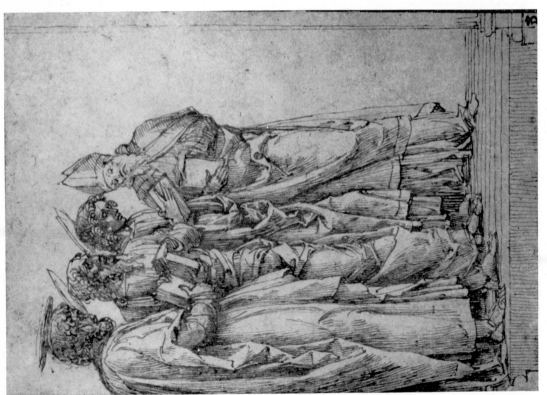

a. Andrea Mantegna, *Study for S. Zeno Altarpiece.* Pen and ink on paper,
19·5 × 13·1. Chatsworth, The Trustees of the Chatsworth Settlement

PLATE IX

*a*. Giovanni Bellini or Andrea Mantegna, *Standing Saint*. Pen and ink on paper, 17·2 × 7. London, British Museum

*b*. Andrea Mantegna, *Standing Saint*. Pen and ink on paper, 20·5 × 9·1. Venice, Gallerie dell'Accademia

PLATE X

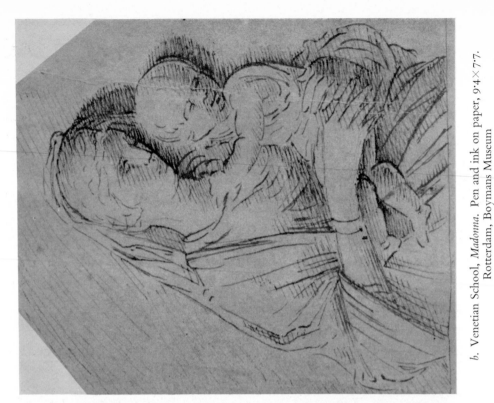

*b.* Venetian School, *Madonna.* Pen and ink on paper, 9·4×7·7. Rotterdam, Boymans Museum

*a.* Andrea Mantegna or Giovanni Bellini, *Studies for Figure of the Baptist.* Pen and ink on paper, 17·5×19. Col. J. W. Weld

PLATE XI

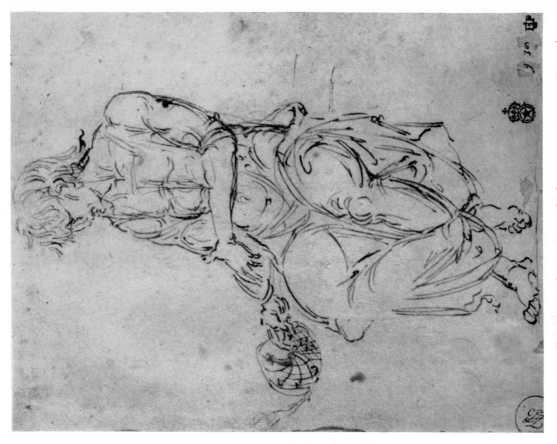

b. Giovanni Bellini (?), *Seated Man*. Pen and ink on paper, 18·5 × 14. Rotterdam, Boymans Museum

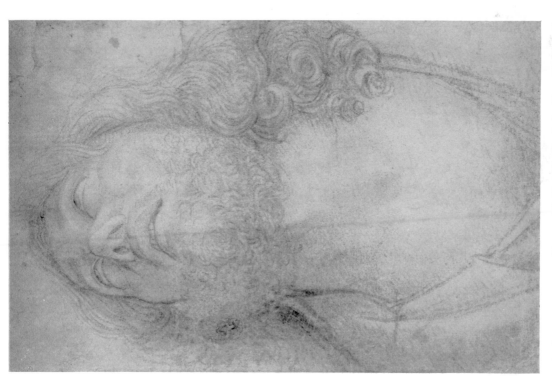

a. Andrea Mantegna or Giovanni Bellini (?), *Head of a Man*. Black chalk on paper, 38·9 × 26·1. London, British Museum

PLATE XII

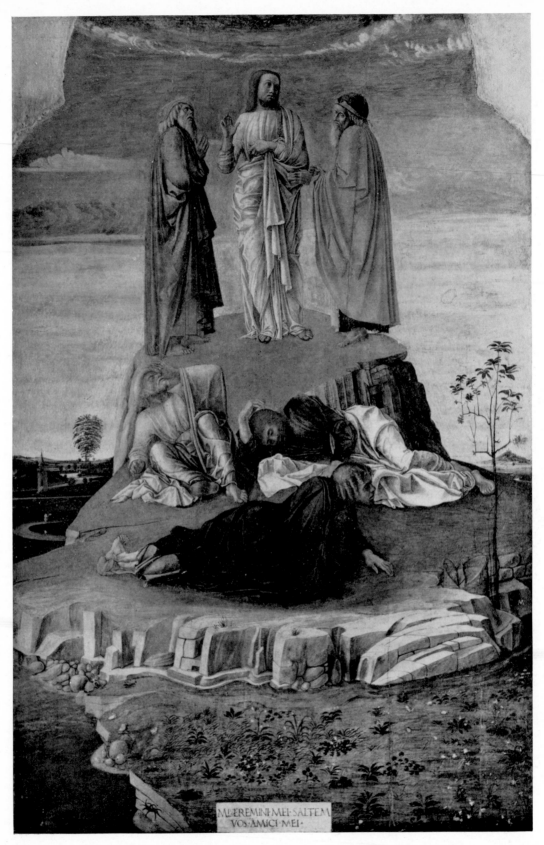

Giovanni Bellini, *Transfiguration*. Wood, 134×68. Venice, Museo Civico Correr

PLATE XIII

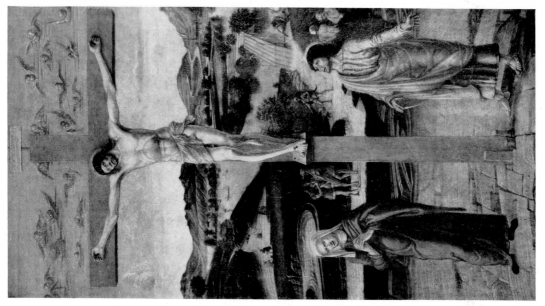

b. Giovanni Bellini, *Crucifixion*. Wood, 54×30. Venice, Museo Civico Correr

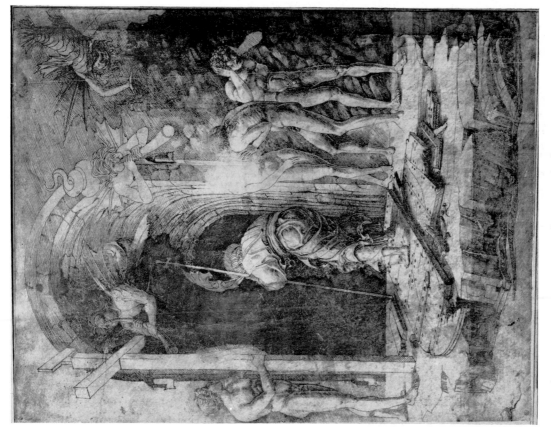

a. Andrea Mantegna, *Descent into Limbo*. Pen and ink on paper, 37·2×28. Paris, École nationale supérieure des Beaux-Arts

PLATE XIV

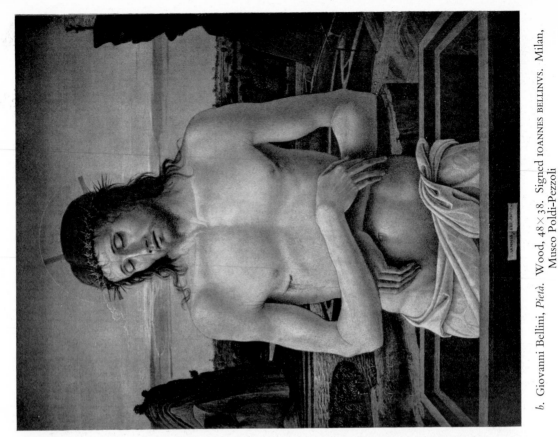

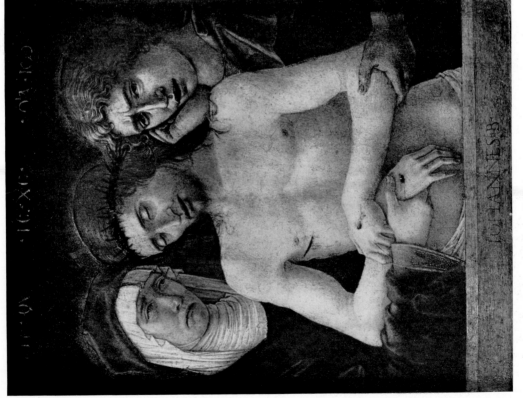

*b.* Giovanni Bellini, *Pietà.* Wood, 48×38. Signed IOANNES BELLINVS. Milan, Museo Poldi-Pezzoli

*a.* Giovanni Bellini, *Pietà with Virgin and St John.* Wood, 42×32. Signed IOHANNES. B. Bergamo, Accademia Carrara

PLATE XV

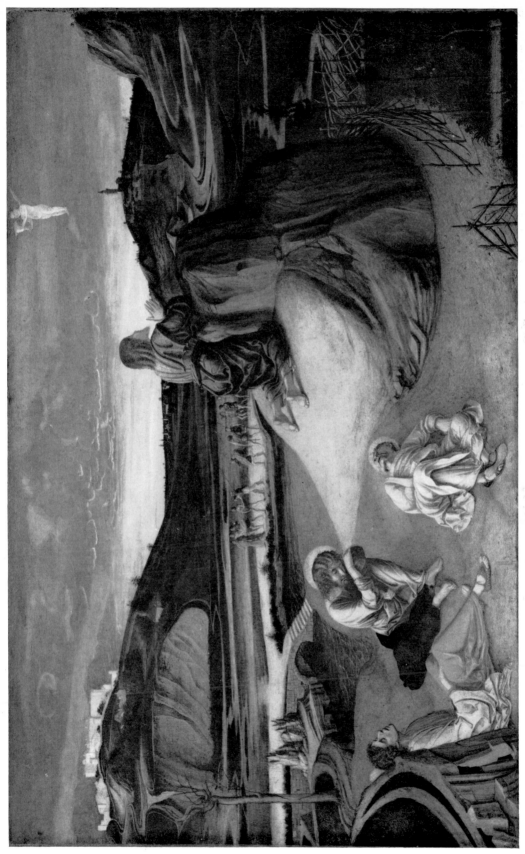

Giovanni Bellini, *Agony in the Garden.* Wood, 81 × 127. London, National Gallery

PLATE XVI

*a*. Jacopo Bellini, *Agony in the Garden*. Lead point on paper, double opening of album, each leaf, 41·5 × 33·6.
London, British Museum

*b*. Andrea Mantegna, *Agony in the Garden*. Wood,
70 × 92. Tours, Musée

*c*. Andrea Mantegna, *Agony in the Garden*. Wood,
63 × 80. London, National Gallery

PLATE XVII

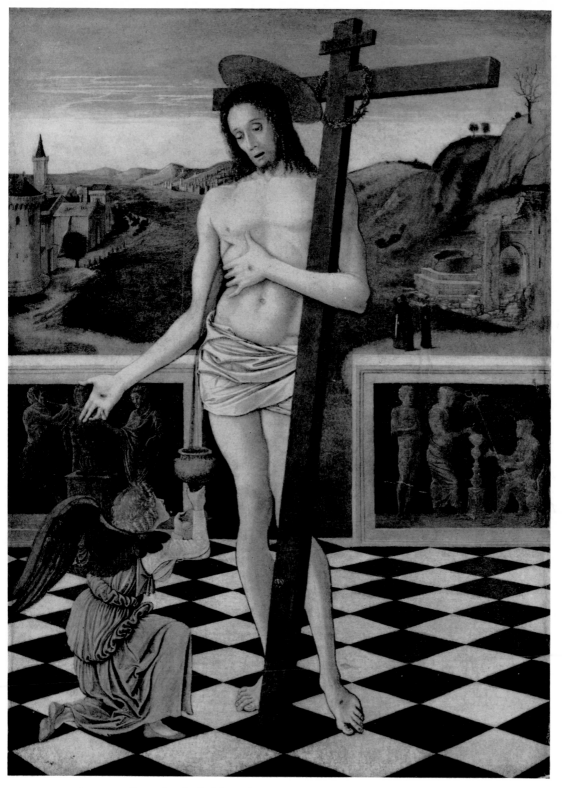

Giovanni Bellini, *The Blood of the Redeemer*. Wood, 47×34. London, National Gallery

PLATE XVIII

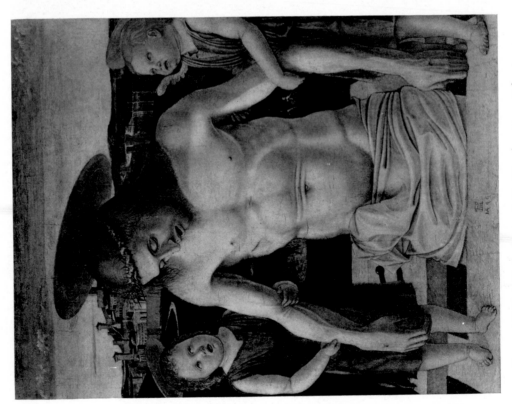

*b.* Giovanni Bellini, *Christ Blessing.* Wood, 58×44. Paris, Musée national du Louvre

*a.* Giovanni Bellini, *Pietà with two Putti.* Wood, 74×50. False signature AD/1499. Venice, Museo Civico Correr

PLATE XIX

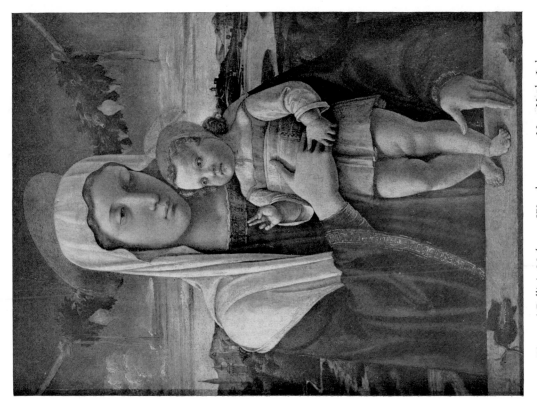

PLATE XX

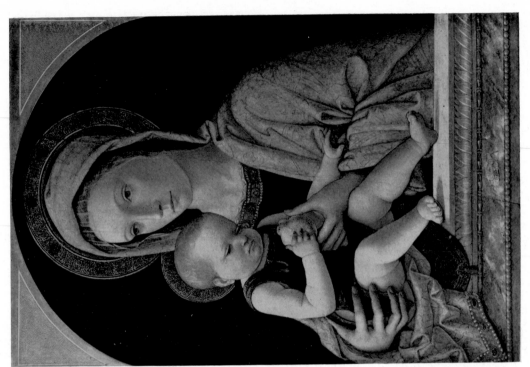

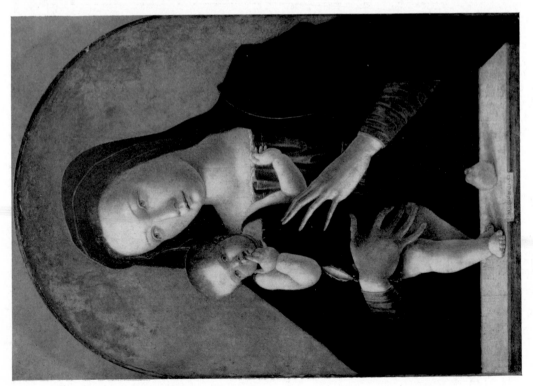

*b.* Giovanni Bellini, *Trivulzio Madonna.* Wood, 78×54. Mutilated signature IO . . . ES BE . . . VS F. Milan, Museo d'Arte Antica

*a.* Giovanni Bellini, *Madonna.* Wood, 64·5×44·2. Signed IOANNES BELLINVS. Philadelphia, John G. Johnson Collection

PLATE XXI

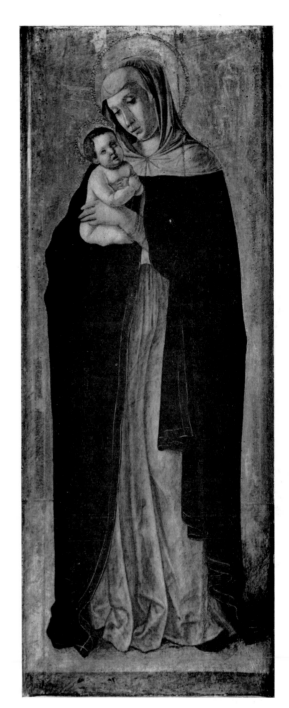

*a*. Studio of Jacopo Bellini (?), Giovanni Bellini and others (?), *Baptist*, from triptych of S. Lorenzo. Wood, 105×45 (surmounting shell cut). Venice, Gallerie dell'Accademia

*b*. Studio of Jacopo Bellini (?), Giovanni Bellini and others (?), *Madonna* from triptych of the Madonna. Wood, 127×48 (surmounting shell omitted). Venice, Gallerie dell'Accademia

PLATE XXII

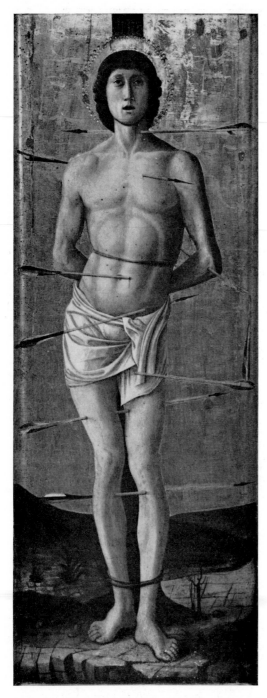

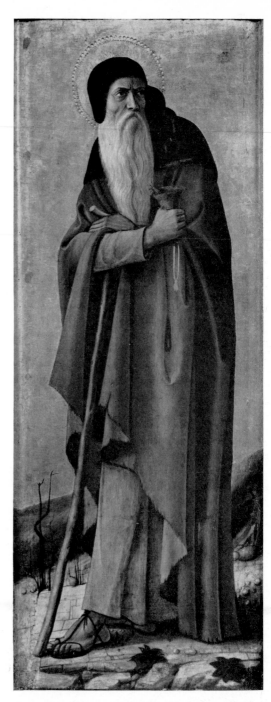

*a*. Studio of Jacopo Bellini (?), Giovanni Bellini and others (?), *St Sebastian*, from triptych of St Sebastian. Wood, 103×45 (surmounting shell cut). Venice, Gallerie dell'Accademia

*b*. Studio of Jacopo Bellini (?), Giovanni Bellini and others (?), *St Anthony Abbot*, from triptych of St Sebastian. Wood, 127×48 (surmounting shell omitted). Venice, Gallerie dell'Accademia

PLATE XXIII

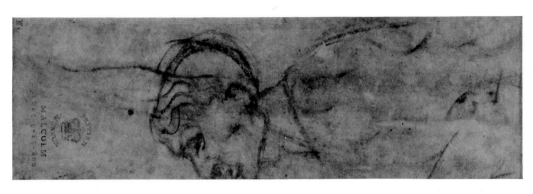

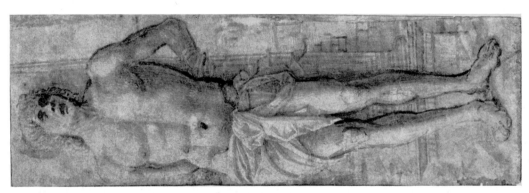

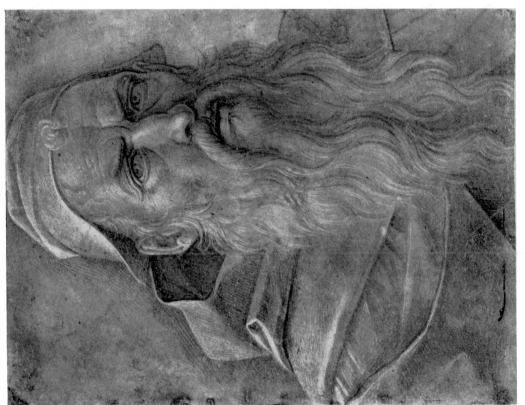

*a.* Giovanni Bellini (?), *Head of an Old Man.* Brush and ink, heightened with white on blue paper, 26×19. Windsor Castle, Royal Library. By gracious permission of Her Majesty Queen Elizabeth II

*b.* Giovanni Bellini (?), *St Sebastian.* Brush and ink, heightened with white on pink-tinted paper, 18·6×5·8. London, British Museum

*c.* Giovanni Bellini (?), *Head of a Man* (verso of xxiii*b*). Black chalk. London, British Museum

PLATE XXIV

a. Studio of Jacopo Bellini (?), Giovanni Bellini and others (?), *Lunette with Trinity between St Augustine and St Dominic*, from triptych of *The Nativity*. Wood, 60×166. Venice, Gallerie dell'Accademia

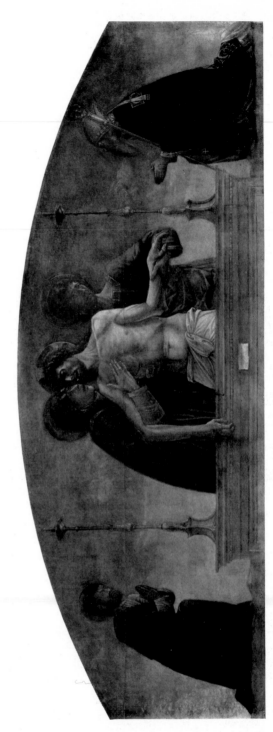

b. Studio of Giovanni Bellini (Lauro Padovano?), *Pietà with Virgin, St John, St Mark, and St Nicholas*. Canvas, 115×317. Signed IOHANES BELLINVS. Venice, Palazzo Ducale

PLATE XXV

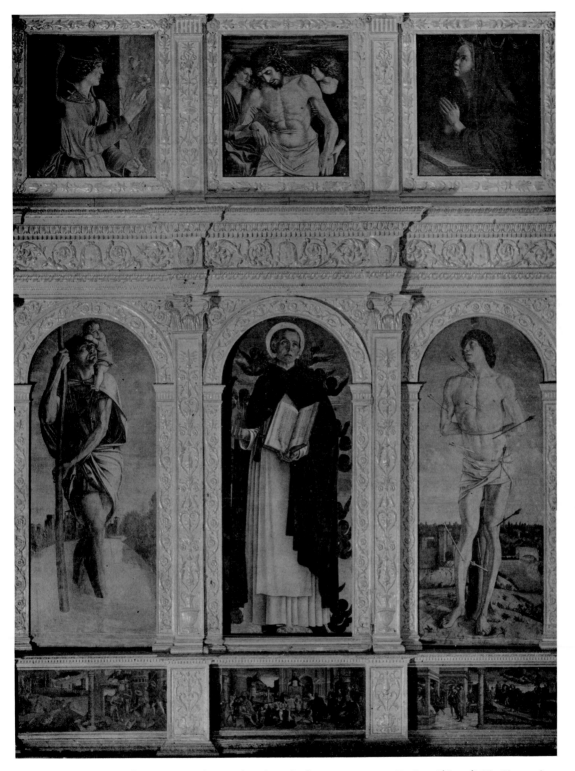

Studio of Giovanni Bellini (Lauro Padovano?), *Polyptych of St Vincent Ferrer*. Venice, Chiesa di SS. Giovanni e Paolo

PLATE XXVI

c. Studio of Giovanni Bellini (Lauro Padovano?), St Sebastian. Wood, 167×67. Venice, Chiesa di SS. Giovanni e Paolo

b. Studio of Giovanni Bellini (Lauro Padovano?), St Vincent Ferrer. Wood, 167×67. Venice, Chiesa di SS. Giovanni e Paolo

a. Studio of Giovanni Bellini (Lauro Padovano?), St Christopher. Wood, 167×67. Venice, Chiesa di SS. Giovanni e Paolo

PLATE XXVII

b. Studio of Giovanni Bellini (Lauro Padovano?), *Annunciate Virgin.*
Wood, 72×67. Venice, Chiesa di SS. Giovanni e Paolo

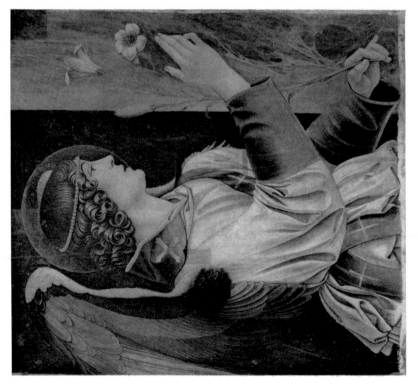

a. Studio of Giovanni Bellini (Lauro Padovano?), *Angel of Annunciation.*
Wood, 72×67. Venice, Chiesa di SS. Giovanni e Paolo

PLATE XXVIII

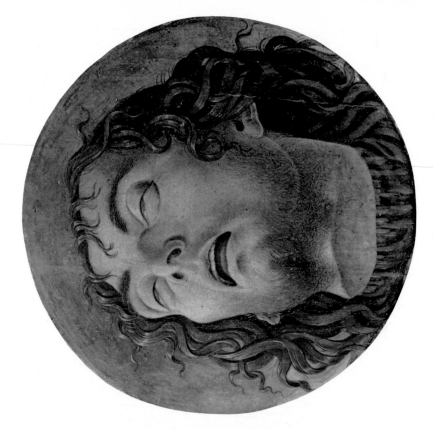

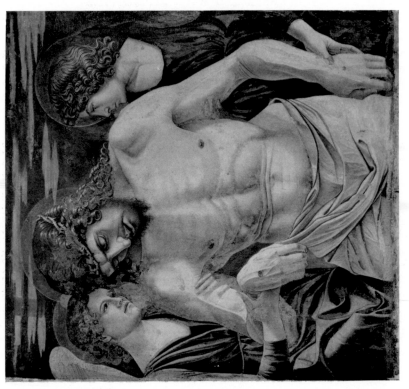

*b.* Marco Zoppo or Giovanni Bellini (?), *Head of Baptist.* Wood, diameter 28.
Pesaro, Museo Civico

*a.* Studio of Giovanni Bellini (Lauro Padovano?), *Pietà with two Angels.*
Wood, 72×67. Venice, Chiesa di SS. Giovanni e Paolo

PLATE XXIX

*a.* Studio of Giovanni Bellini (Lauro Padovano?), *Scene from life of St Vincent Ferrer.* Wood, 36×60. Venice, Chiesa di SS. Giovanni e Paolo

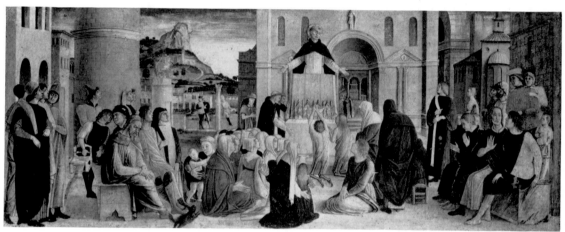

*b.* Studio of Giovanni Bellini (Lauro Padovano?), *Scene from the life of St Vincent Ferrer.* Wood, 36×60. Venice, Chiesa di SS. Giovanni e Paolo

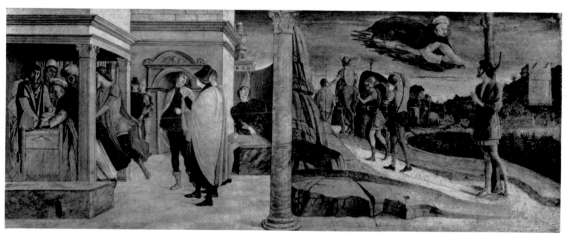

*c.* Studio of Giovanni Bellini (Lauro Padovano?), *Scene from the life of St Vincent Ferrer.* Wood, 36×60. Venice, Chiesa di SS. Giovanni e Paolo

PLATE XXX

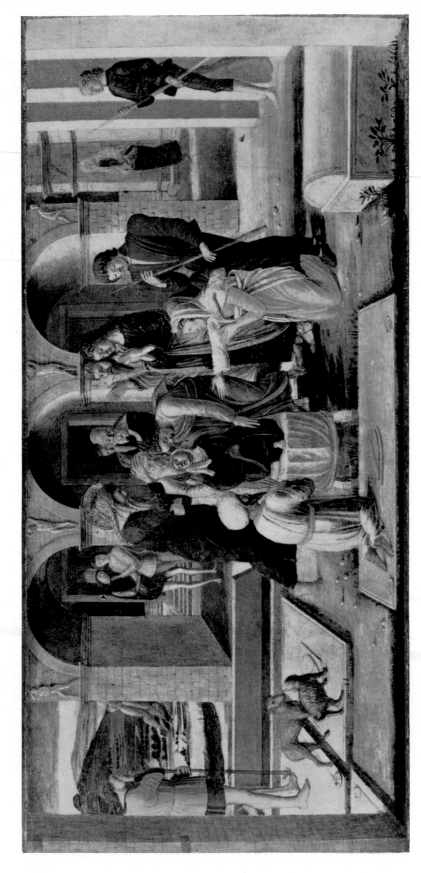

Studio of Giovanni Bellini (Lauro Padovano?), *Legend of Drusiana* (central scene). Wood, three scenes on one panel 32×202. Munich, Wittelsbacher Ausgleichsfonds

PLATE XXXI

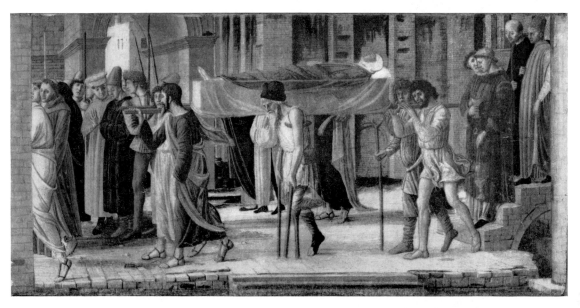

*a.* Studio of Giovanni Bellini (Lauro Padovano?), *Legend of Drusiana* (right-hand scene). Wood, three scenes on one panel 32 × 202. Munich, Wittelsbacher Ausgleichsfonds

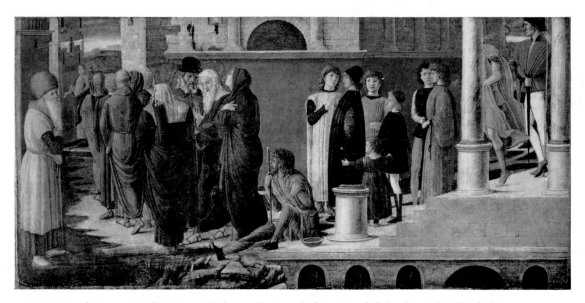

*b.* Studio of Giovanni Bellini (Lauro Padovano?), *Legend of Drusiana* (left-hand scene). Wood, three scenes on one panel 32 × 202. Munich, Wittelsbacher Ausgleichsfonds

PLATE XXXII

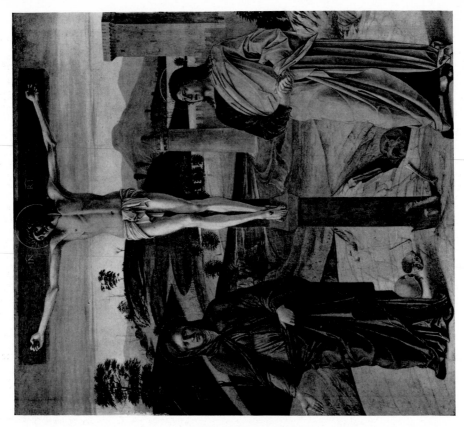

b. Studio of Giovanni Bellini (Lauro Padovano?), *Crucifixion*. Wood, 70×63. Formerly Florence, Contini Bonacossi Collection

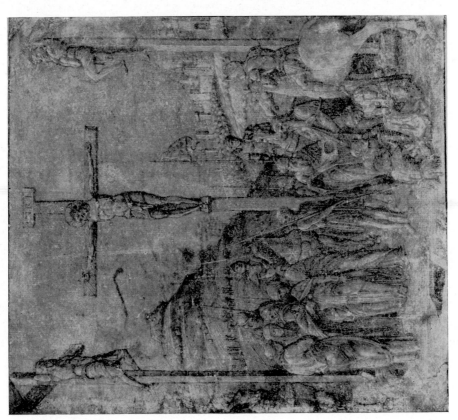

a. Lauro Padovano (?), *Crucifixion*. Pen, ink, and wash, heightened with white, on grey prepared paper, 24×21·5. London, British Museum

PLATE XXXIII

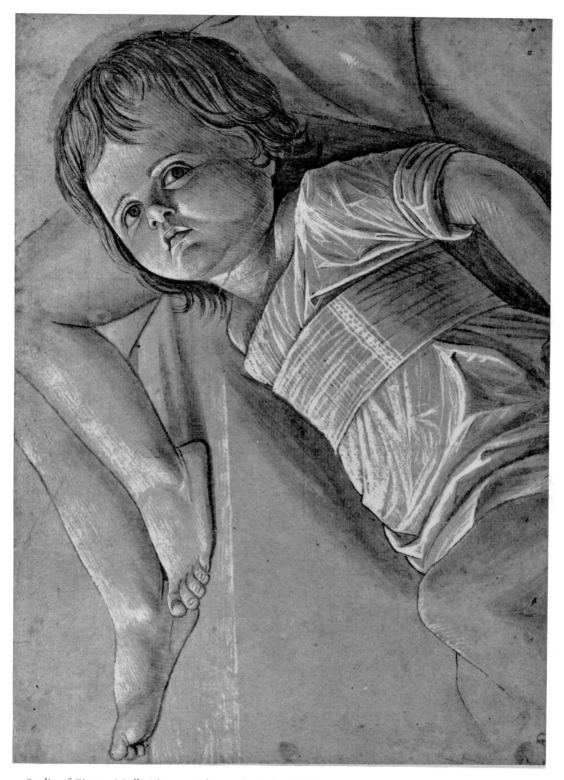

Studio of Giovanni Bellini (Lauro Padovano?), *Study of Child*. Brush and wash heightened with white on blue paper, 20·6×28·6. Oxford, Ashmolean Museum

PLATE XXXIV

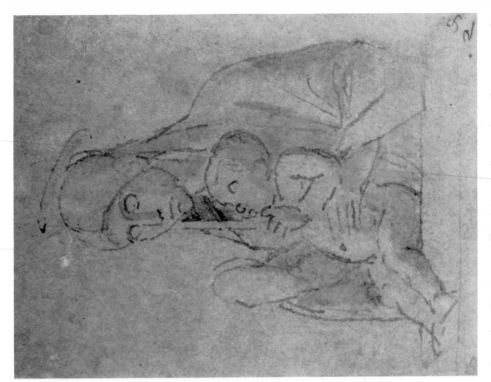

b. Studio of Giovanni Bellini (Lauro Padovano?), *Madonna*. Pen and wash on blue paper, 12·8×9·6. London, British Museum

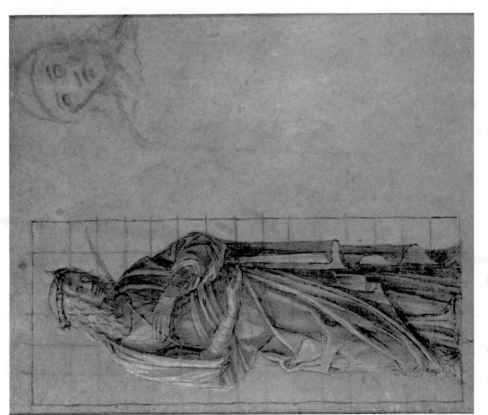

a. Studio of Giovanni Bellini (Lauro Padovano?), *Female Saint and study of a head* (verso of XXXIII). Pen and wash—the head in black chalk. Oxford, Ashmolean Museum

PLATE XXXV

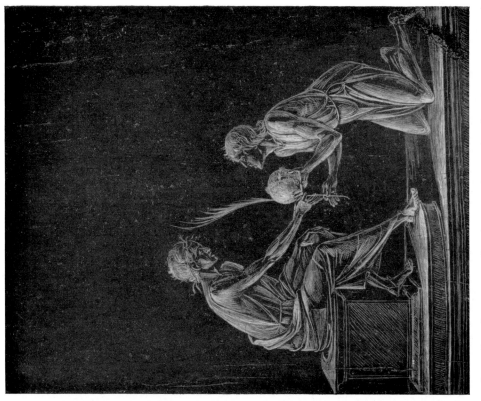

*b.* Studio of Giovanni Bellini (Lauro Padovano?), *Classical Scene. Wood,* 31 × 25. Formerly Florence, Contini Bonacossi Collection

*a.* Lauro Padovano (?), *St Ursula.* Wood, 61 × 42. False signature CATTERINA VIGRI F. BOLOGNA, 1456. Venice, Gallerie dell'Accademia

PLATE XXXVI

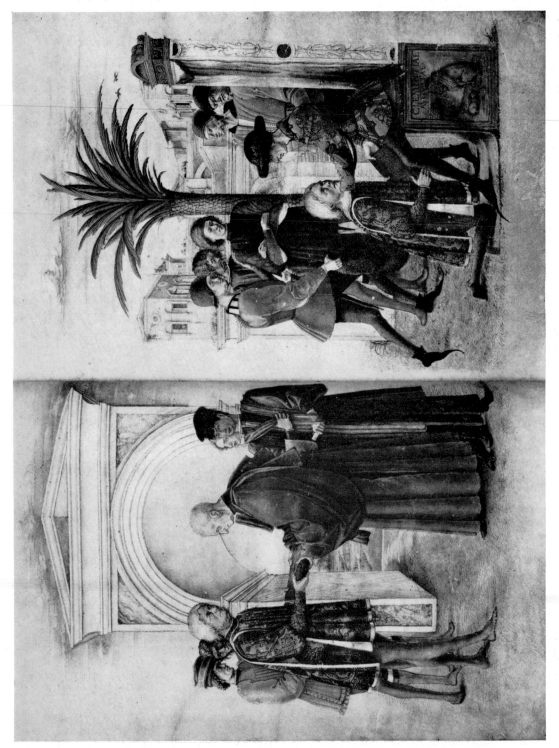

Lauro Padovano (?), Jacopo Antonio Marcello receives the manuscript of Strabo from Guarino. He presents it to King René of Anjou. Vellum, each leaf 37×25. Albi, Bibliothèque Rochegude, MS. 4

PLATE XXXVII

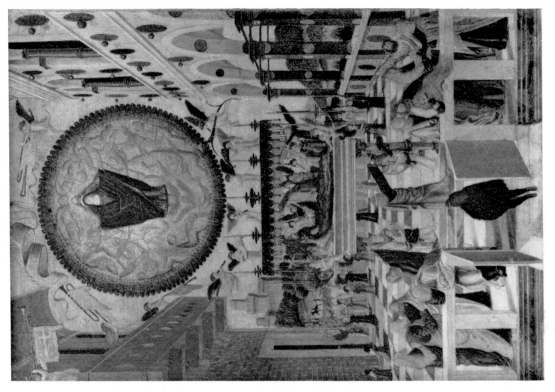

*b.* Gerolamo da Vicenza, *Dormition and Assumption of the Virgin.* Wood, 33'5 × 22'5. Signed HIERONIMVS VINCENTINVS/PINCSIT/VENETIIS. 1488. London, British Museum

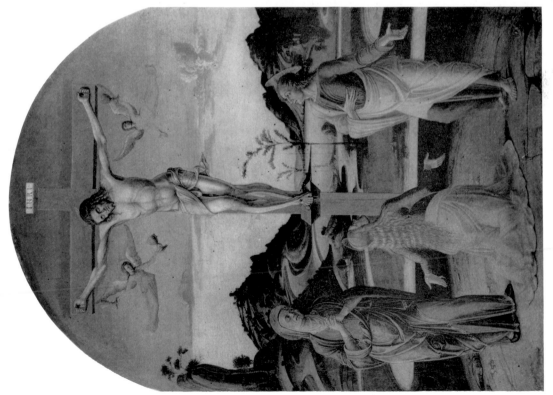

*a.* Venetian School (?), *Crucifixion.* Wood, 72 × 52. Pesaro, Museo Civico

PLATE XXXVIII

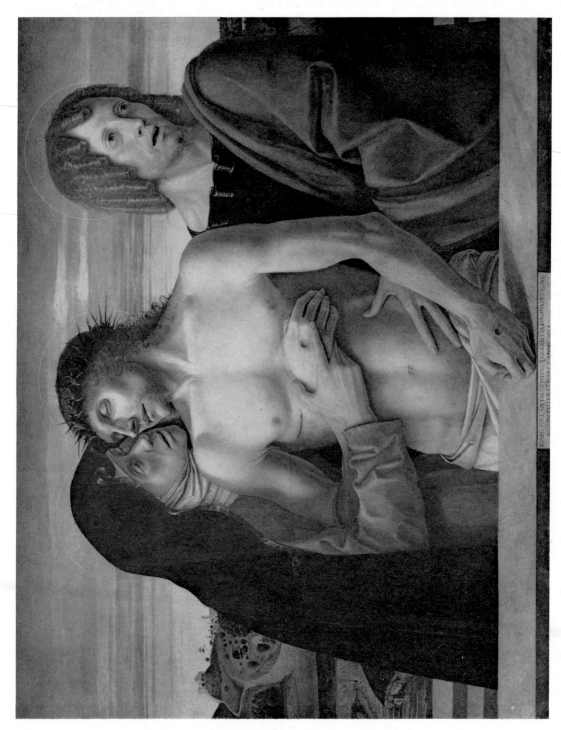

Giovanni Bellini, *Pietà with Virgin and St John.* Wood, 86×107. Inscribed HAEC FERE QVVM GEMITVS TVRGENTIA LVMINA PROMANT/BELLINI POTERAT FLERE IOANNIS OPVS. Milan, Pinacoteca di Brera

PLATE XXXIX

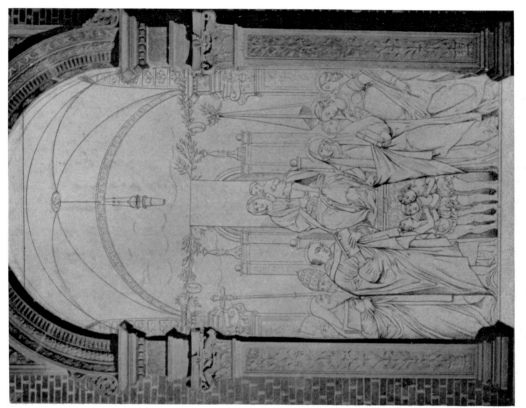

b. Photomontage showing Zanotto's engraving of Giovanni Bellini's burnt altar-piece in the original frame, still in the church of SS. Giovanni e Paolo

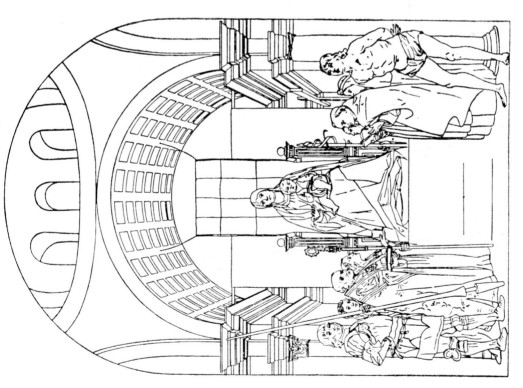

a. Antonello da Messina, *Pala di San Cassiano* (reconstruction after Wilde)

PLATE XL

*a.* Giovanni Bellini, *Madonna with Sleeping Child.* Wood, 120×63. Signed IOANNES BELLINVS. P. Venice, Gallerie dell'Accademia

*b.* Giovanni Bellini, *S. Giustina.* Wood, 129×55. Milan, barone Bagatti Valsecchi

PLATE XLI

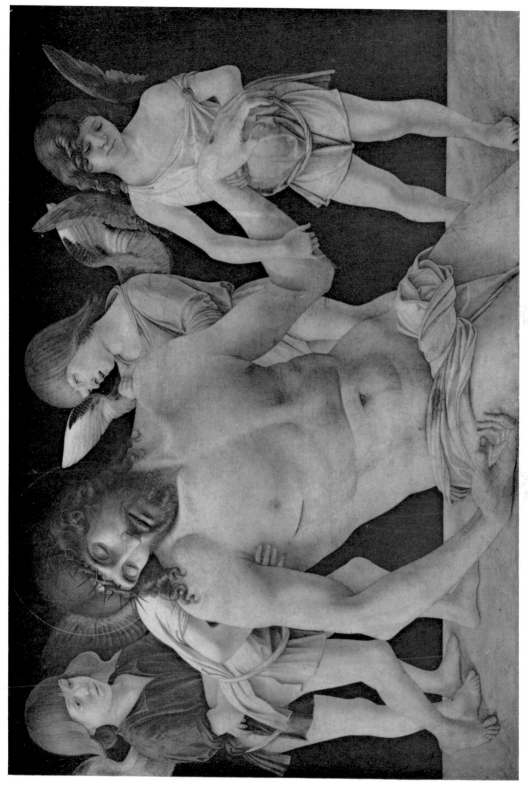

Giovanni Bellini, *Pietà with four Boy Angels.* Wood, 91 × 131. Rimini, Museo Civico

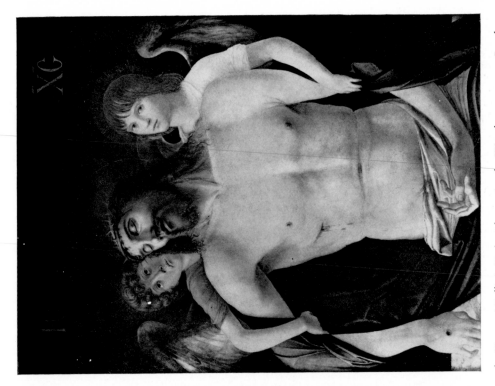

b. Giovanni Bellini, *Pietà with two Angels*. Wood, 94·5 × 71·5. London, National Gallery

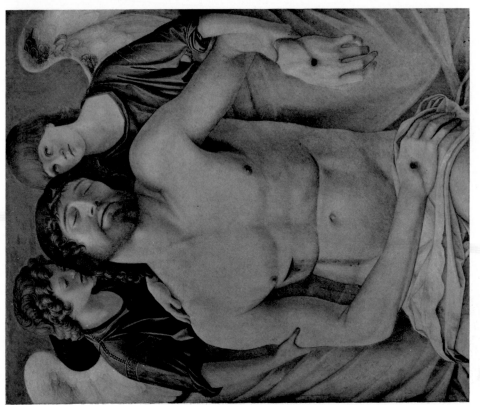

a. Giovanni Bellini, *Pietà with two Angels*. Wood, 82 × 66. Berlin, Stiftung preußischer Kulturbesitz, Staatliche Museen, Gemäldegalerie

PLATE XLIII

b. Giovanni Bellini, *Madonna and Child*. Wood, 61 × 43. Mutilated signature IOANNES BELLINVS P. Boston, Isabella Stewart Gardner Museum

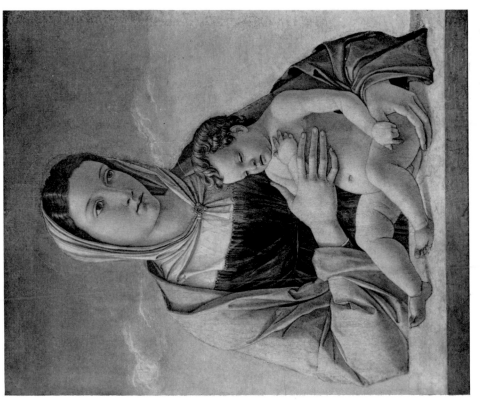

a. Giovanni Bellini, *Frizzoni Madonna*, Canvas (transferred from wood), 52 × 42. Venice, Museo Civico Correr

PLATE XLIV

b. Pietro Lombardo, *Annunciate Virgin.* Marble. Venice, Chiesa di S. Giobbe

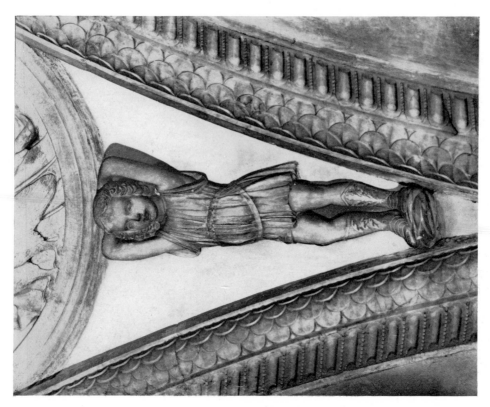

a. Pietro Lombardo, *Putto.* Marble. Venice, Chiesa di S. Giobbe

PLATE XLV

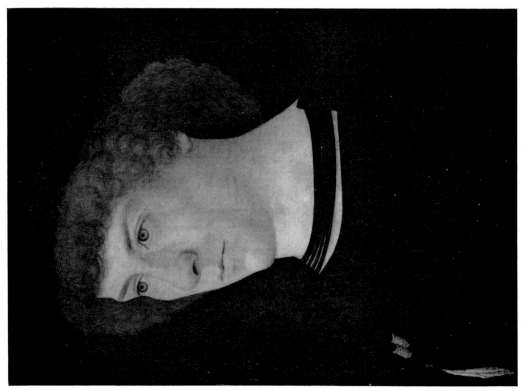

b. Giovanni Bellini, *Portrait of Jörg Fugger* 1474. Wood, 26×20. Florence, Contini Bonacossi Collection

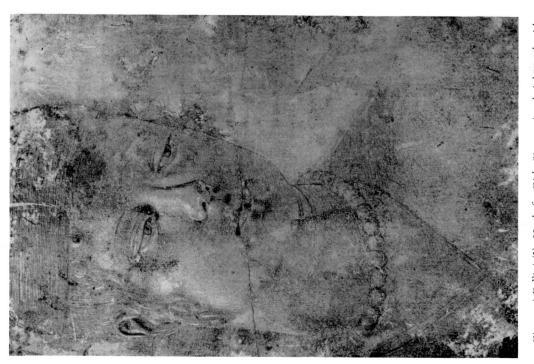

a. Giovanni Bellini (?), *Head of a Girl*. Silver-point, heightened with white on grey-green prepared paper, 20·8×13·8. Venice, Gallerie dell'Accademia

PLATE XLVI

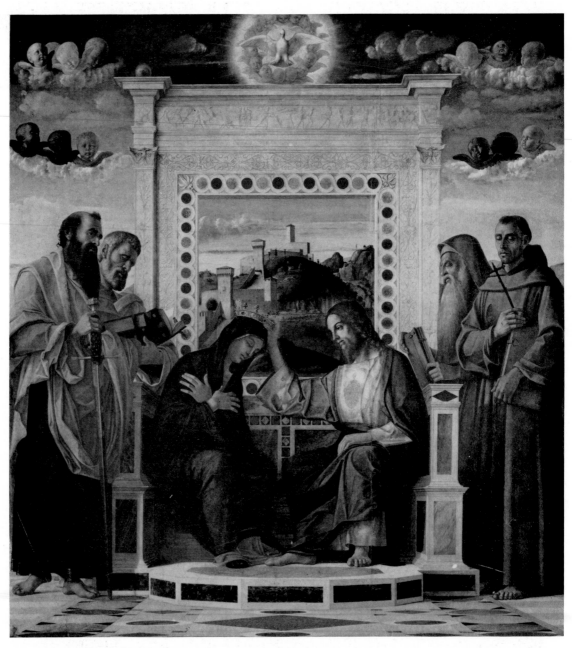

Giovanni Bellini, *Coronation of the Virgin*. Wood, 262×240. Signed IOANNES BELLINVS. Pesaro, Museo Civico

PLATE XLVII

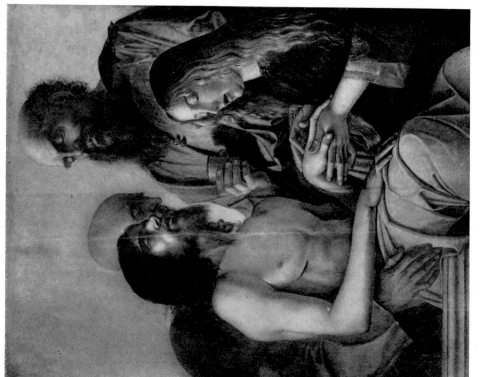

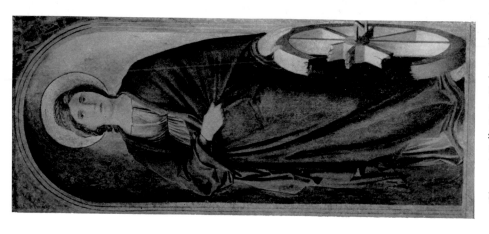

*c.* Giovanni Bellini, *St Louis of Toulouse* (from frame of Pesaro Coronation). Wood, 61 × 25. Pesaro, Museo Civico

*b.* Giovanni Bellini, *Pietà* (from top of Pesaro Coronation). Wood, 107 × 84. Vatican, Pinacoteca

*a.* Giovanni Bellini, *St Catherine* (from frame of Pesaro Coronation). Wood, 61 × 25. Pesaro, Museo Civico

PLATE XLVIII

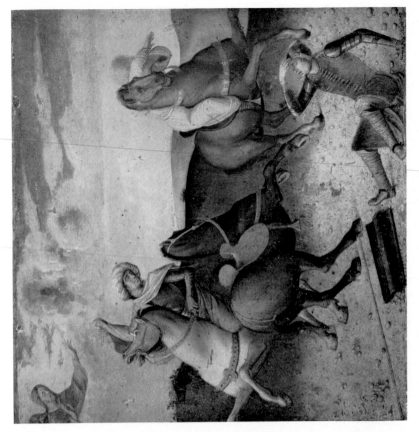

*b.* Giovanni Bellini, *Conversion of St Paul* (predella panel from Pesaro *Coronation*). Wood, 40×42. Pesaro, Museo Civico

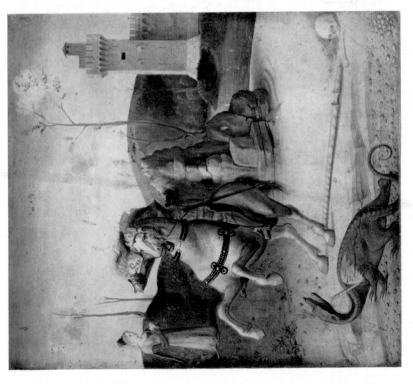

*a.* Giovanni Bellini, *St George and the Dragon* (predella panel from Pesaro *Coronation*). Wood, 43×36. Pesaro, Museo Civico

PLATE XLIX

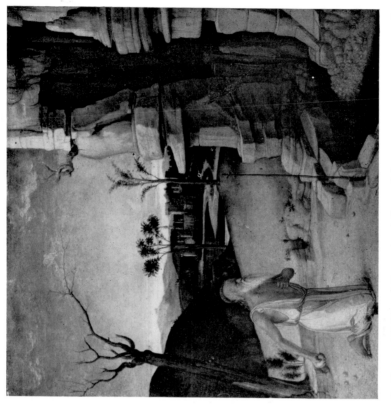

b. Giovanni Bellini, *St Jerome* (predella panel from Pesaro *Coronation*). Wood,
40 × 42. Pesaro, Museo Civico

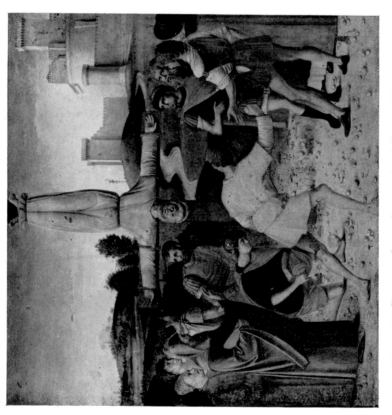

a. Giovanni Bellini, *Crucifixion of St Peter* (predella panel from Pesaro
*Coronation*). Wood, 40 × 42. Pesaro, Museo Civico

PLATE L

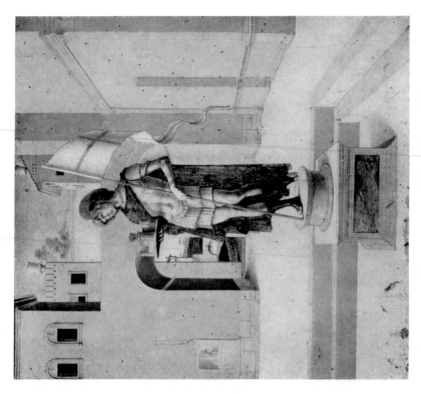

b. Giovanni Bellini, *St Terentius* (?) (predella panel from Pesaro *Coronation*). Wood, 43 × 36. Pesaro, Museo Civico

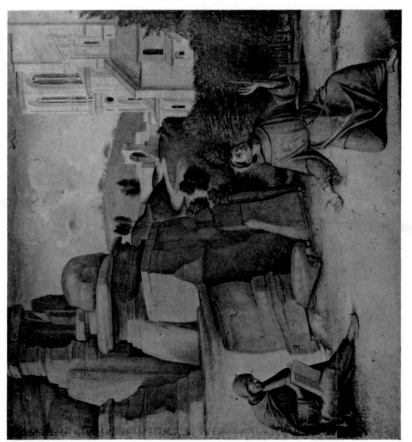

a. Giovanni Bellini, *Stigmatization of St Francis* (predella panel from Pesaro *Coronation*). Wood, 40 × 42. Pesaro, Museo Civico

PLATE LI

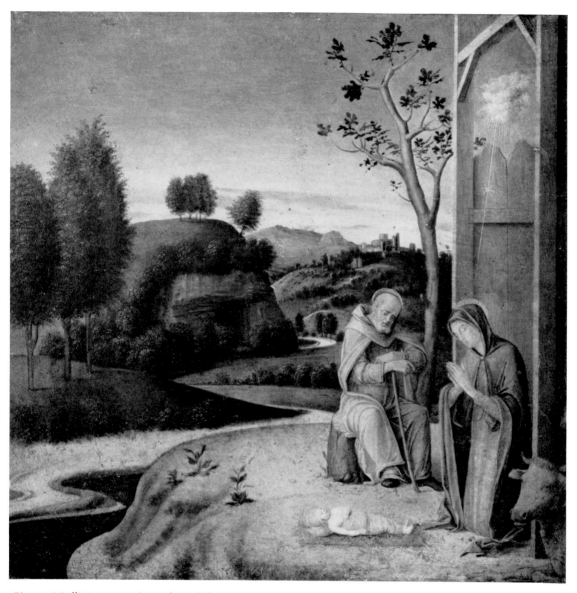

Giovanni Bellini, *Nativity* (central panel from predella of Pesaro *Coronation*). Wood, 40×42. Pesaro, Museo Civico

PLATE LII

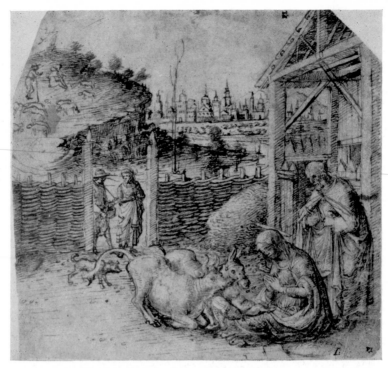

*a.* Giovanni Bellini (?), *Nativity*. Pen and ink on paper, 20·1 × 21·2. London,
Count Antoine Seilern

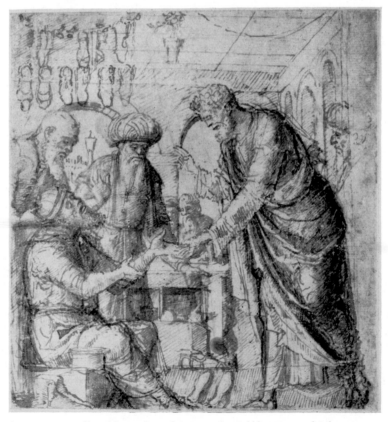

*b.* Giovanni Bellini (?), *Healing of Anianus the Cobbler*. Pen and ink on paper,
18·4 × 17·3. Berlin, Stiftung preußischer Kulturbesitz, Staatliche Museen,
Kupferstichkabinett

PLATE LIII

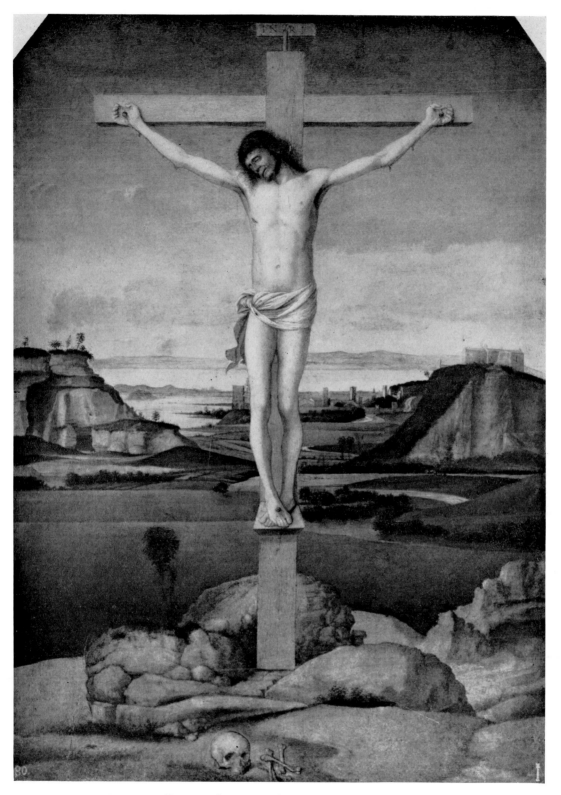

Giovanni Bellini, *Crucifixion*. Wood, 57×45. Florence, principe Corsini

PLATE LIV

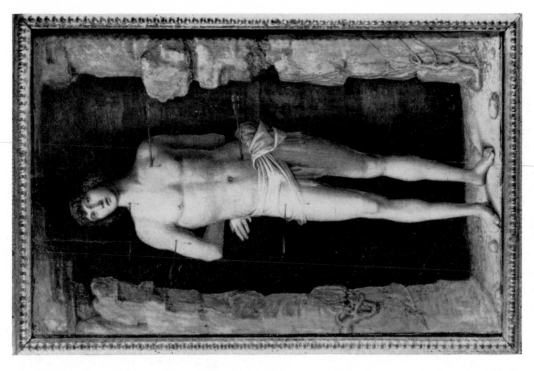

b. Giovanni Bellini, *St Sebastian*. Wood, 54×33. Arezzo, Pinacoteca Comunale

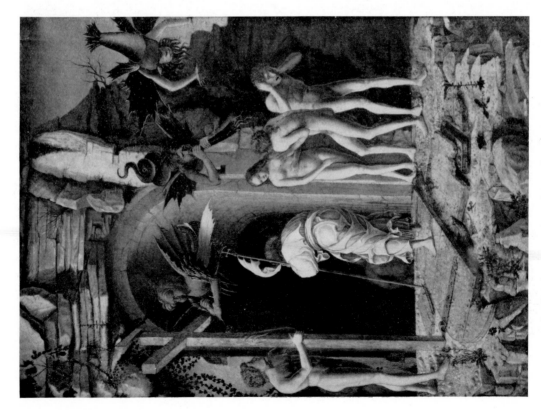

a. Giovanni Bellini, *Descent into Limbo*. Vellum (on wood), 52×37·5. Bristol City Art Gallery

PLATE LV

Giovanni Bellini, *Resurrection*. Canvas (transferred from wood), 148×128. Berlin, Stiftung preußischer Kulturbesitz, Staatliche Museen, Gemäldegalerie

PLATE LVI

Giovanni Bellini (after Andrea Mantegna), *Presentation in the Temple*. Wood, 80×105. Venice, Fondazione Querini Stampalia

PLATE LVII

Giovanni Bellini, *St Francis*. Wood, 124×142. New York, Frick Collection

PLATE LVIII

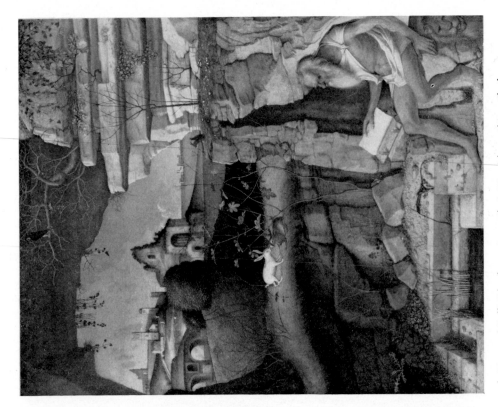

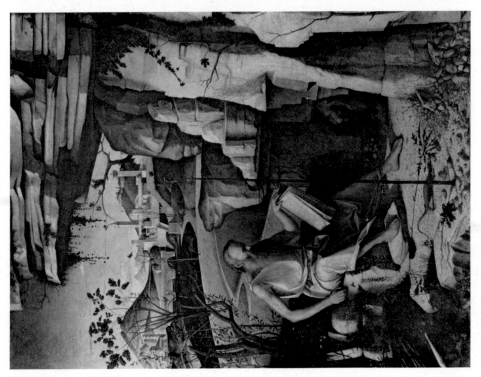

*b.* Giovanni Bellini (and an assistant?), *St Jerome* (1505?) inscribed. MCCCCV. Wood, 48 × 39. Washington D.C., National Gallery of Art, Samuel H. Kress Collection

*a.* Studio of Giovanni Bellini, *St Jerome.* Wood, 145 × 114. Florence, Contini Bonacossi Collection

PLATE LIX

*b*. Giovanni Bellini, *Lochis Madonna*. Wood, 47 × 34. Signed
IOANNES BELLINVS. Bergamo, Accademia Carrara

*a*. Giovanni Bellini, *Crespi Madonna*. Wood, 60 × 45. Cambridge, Mass.,
Fogg Art Museum

PLATE LX

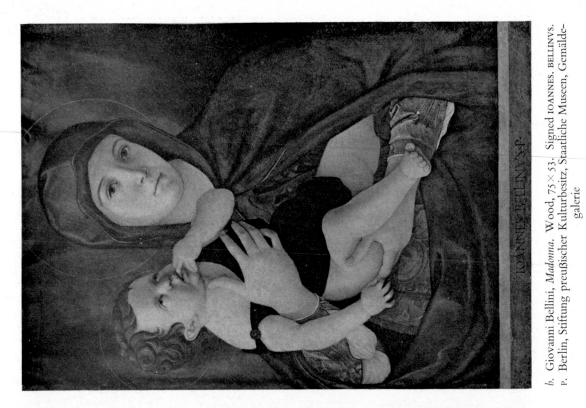

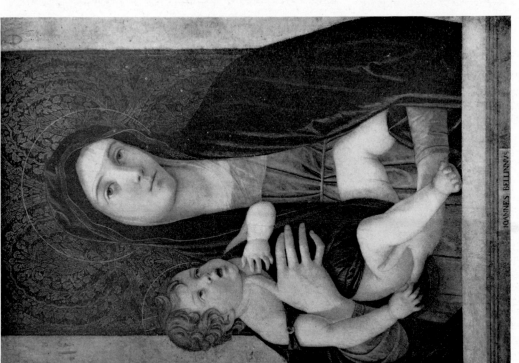

b. Giovanni Bellini, *Madonna*. Wood, 75 × 53. Signed IOANNES. BELLINVS. P. Berlin, Stiftung preußischer Kulturbesitz, Staatliche Museen, Gemälde-galerie

a. Giovanni Bellini, *Madonna*. Wood, 75 × 50. Signed IOANNES BELLINNVS. Venice, Chiesa di S. Maria dell'Orto

PLATE LXI

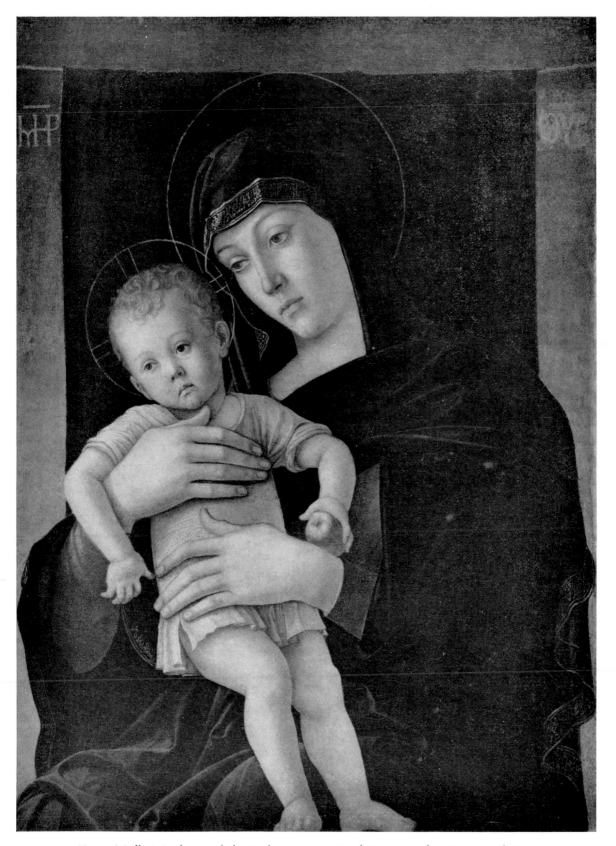

Giovanni Bellini, *Madonna with the Greek Inscription*. Wood, 82×62. Milan, Pinacoteca di Brera

PLATE LXII

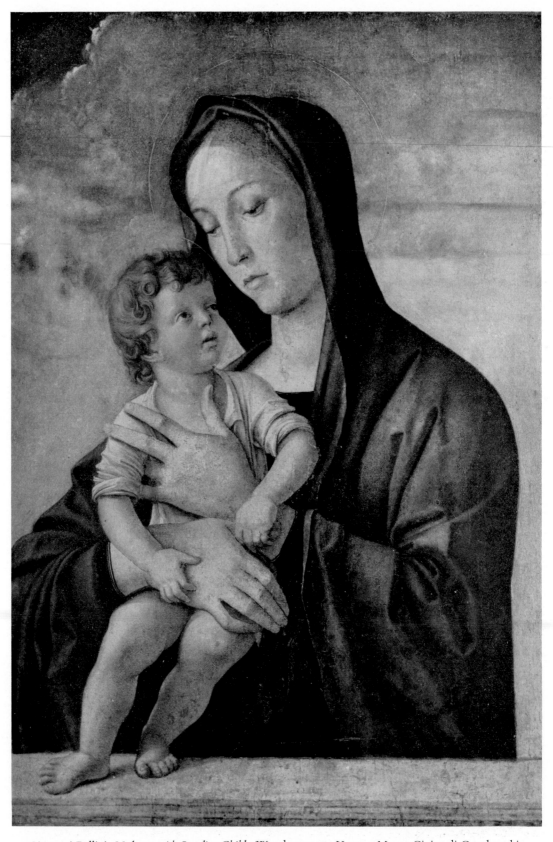

Giovanni Bellini, *Madonna with Standing Child*. Wood, 77×57. Verona, Museo Civico di Castelvecchio

PLATE LXIII

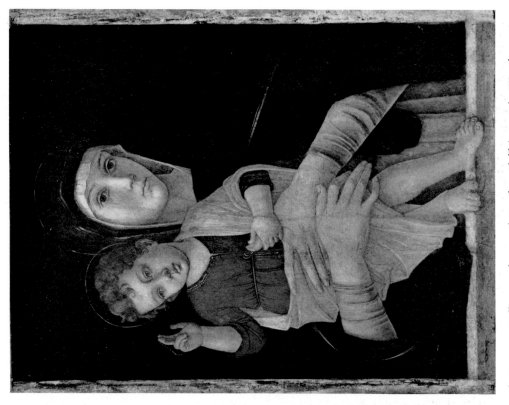

*b.* Giovanni Bellini, *Madonna with Standing Child* (no. 583). Wood, 79×63. Venice, Gallerie dell'Accademia

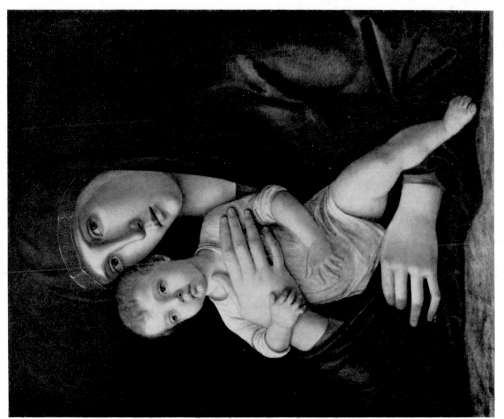

*a.* Giovanni Bellini, *Madonna*. Wood, 53×43. Washington D.C., National Gallery of Art, Samuel H. Kress Collection

PLATE LXIV

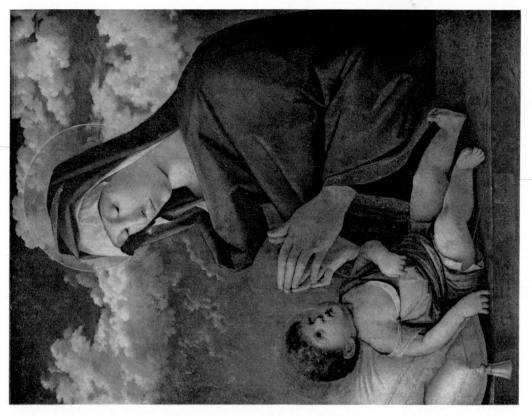

b. Giovanni Bellini, *Madonna in Red.* Wood, 82×62. Formerly falsely signed
IOANNES BELLINVS PINXIT. London, National Gallery

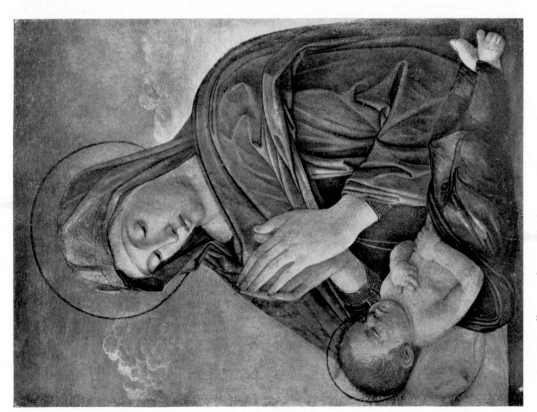

a. Giovanni Bellini, *Madonna with Sleeping Child.* Wood, 75×53. Verona,
Museo Civico di Castelvecchio

PLATE LXV

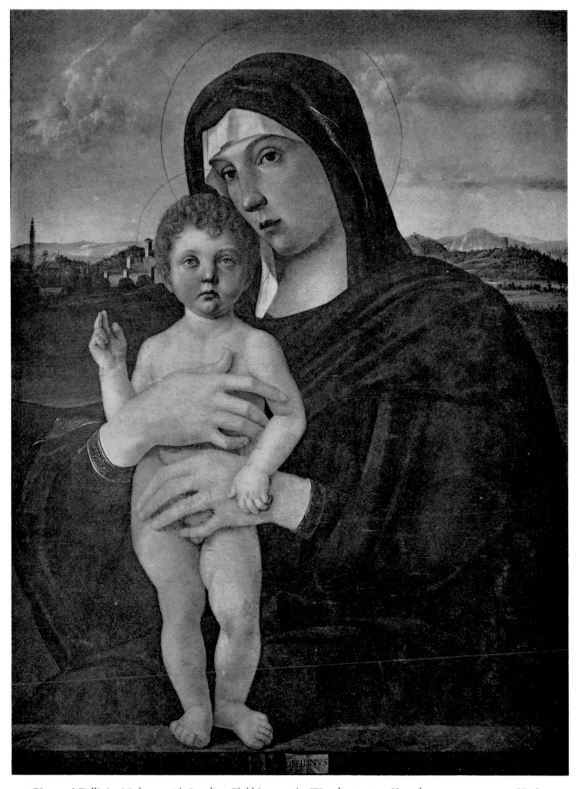

Giovanni Bellini. *Madonna with Standing Child* (no. 594). Wood, 78 × 60. Signed IOANNES BELLINVS. Venice, Gallerie dell'Accademia

PLATE LXVI

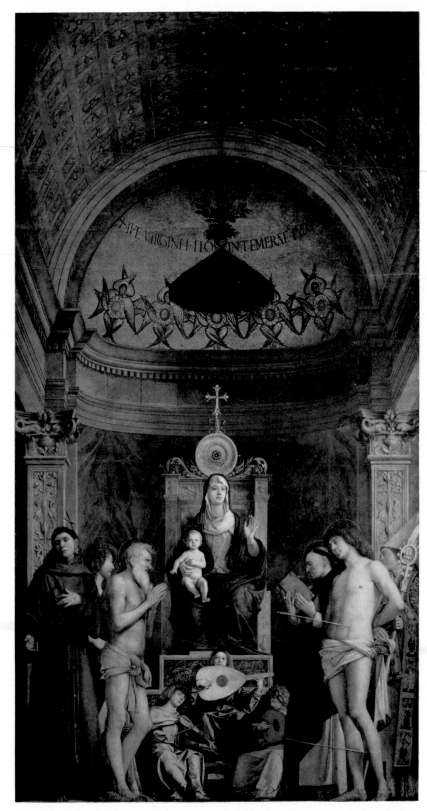

Giovanni Bellini, *Enthroned Madonna* from S. Giobbe. Wood, 471 × 258. Signed
IOANNES/BELLINVS. Venice, Gallerie dell'Accademia

PLATE LXVII

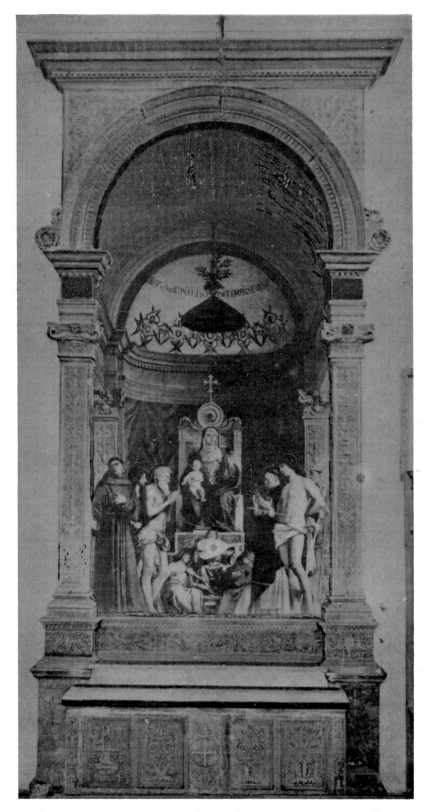

Photomontage showing the S. Giobbe *Madonna* restored to its original frame,
still in the church

PLATE LXVIII

Giovanni Bellini, *Triptych with Madonna and Saints*. Wood, central panel 184×79, side panels 115×46. Signed IOANNES BELLINVS/F/ 1488. Venice, Chiesa di S. Maria dei Frari, Sagrestia

PLATE LXIX

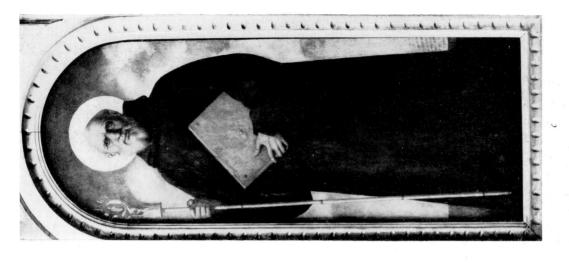

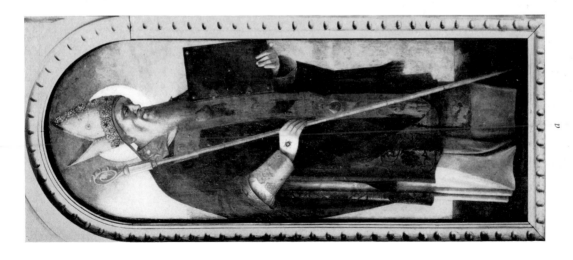

*a* and *c*. Giovanni Bellini, *St Augustine* and *St Benedict*. Wood, each panel 108·7 × 42·3. Zagreb, Strossmayerova Galerija
*b*. Giovanni Bellini, *St Peter Martyr*. Wood, 194 × 84. Signed IOANNES BELLINVS. Bari, Pinacoteca Provinciale

PLATE LXX

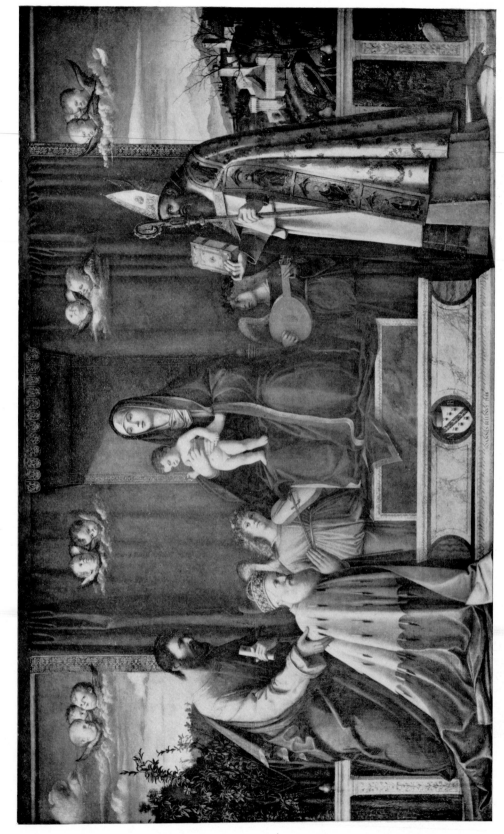

Giovanni Bellini, *Madonna with Doge Agostino Barbarigo.* Canvas, 200×320. Signed IOANNES BELLINVS 1488. Murano, Chiesa di S. Pietro Martire

PLATE LXXI

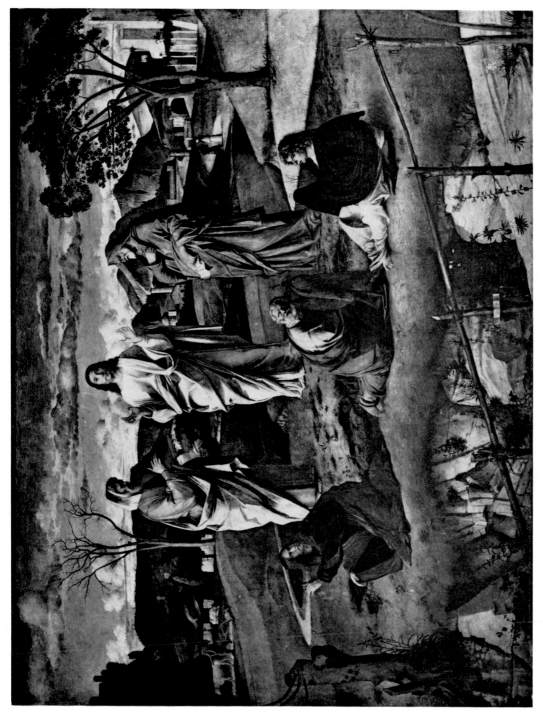

Giovanni Bellini, *Transfiguration*. Wood, 115×150. Signed IOANNES BELLI. Naples, Pinacoteca del Museo Nazionale

PLATE LXXII

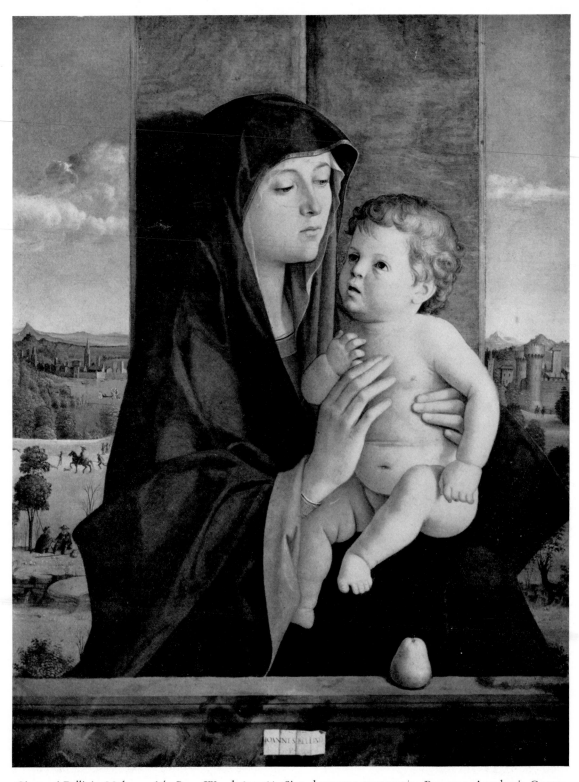

Giovanni Bellini. *Madonna of the Pear*. Wood, 83 × 66. Signed IOANNES. BELLINVS/P. Bergamo, Accademia Carrara

PLATE LXXIII

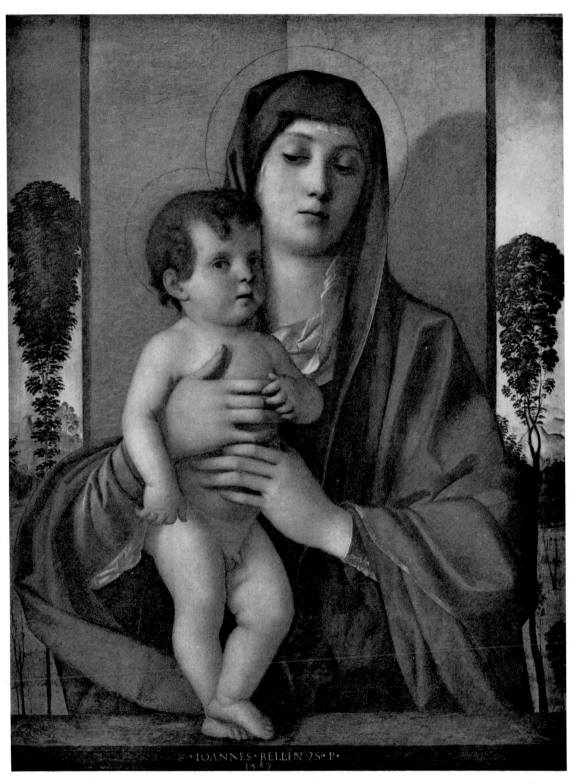

Giovanni Bellini, *Madonna degli alberetti*. Wood, 74×58. Signed IOANNES. BELLINVS. P./1487. Venice, Gallerie dell'Accademia

PLATE LXXIV

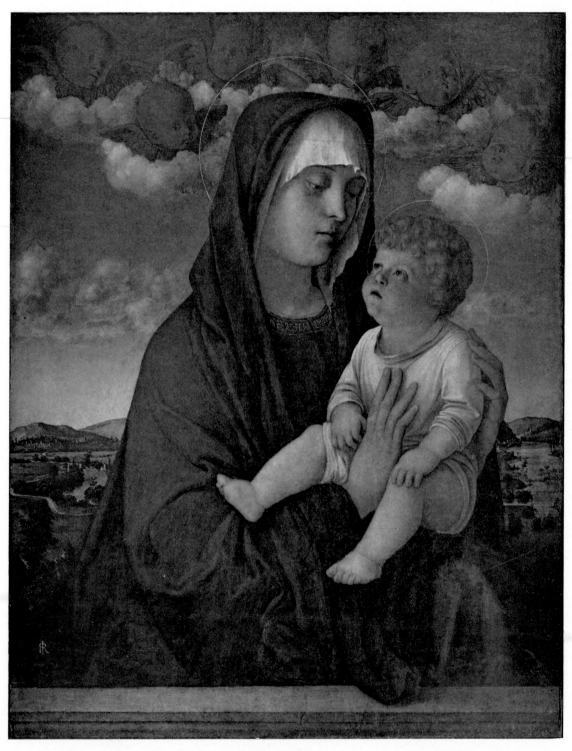

Giovanni Bellini, *Madonna with Red Cherubim*.  Wood, 77×60.  Venice, Gallerie dell'Accademia

PLATE LXXV

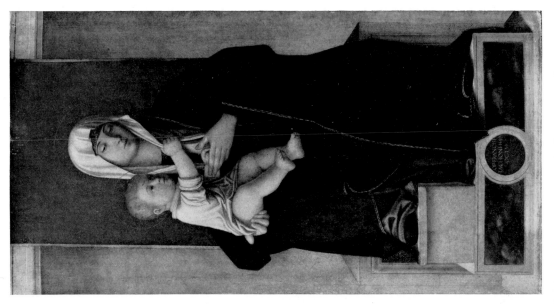

b. Francesco Tacconi, *Madonna.* Wood, 100×53.
Signed OP. FRANCISI./TACHONI. 1489./OCTV. London,
National Gallery

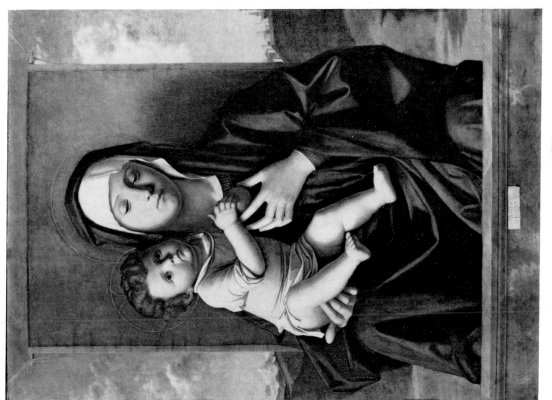

a. Giovanni Bellini, *Madonna with the 'Pomegranate'.* Wood, 91×65. Signed
IOANNES/BELLINVS. P. London, National Gallery

PLATE LXXVI

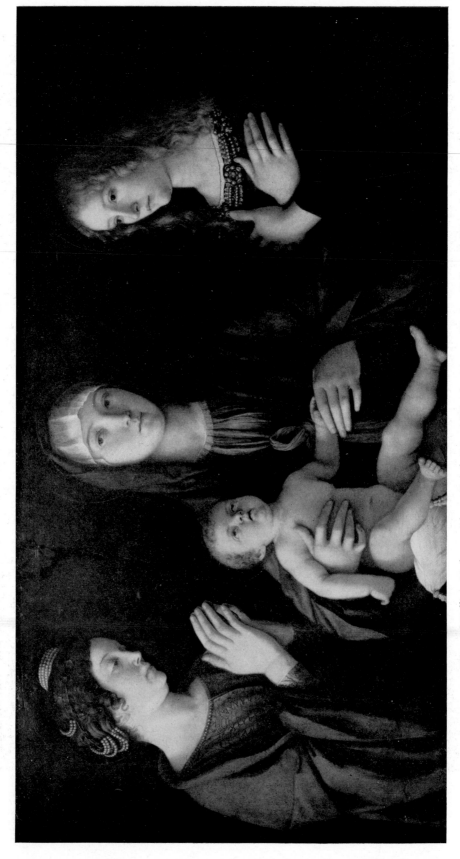

Giovanni Bellini, *Madonna with two Female Saints.* Wood, 58 × 107. Venice, Gallerie dell'Accademia

PLATE LXXVII

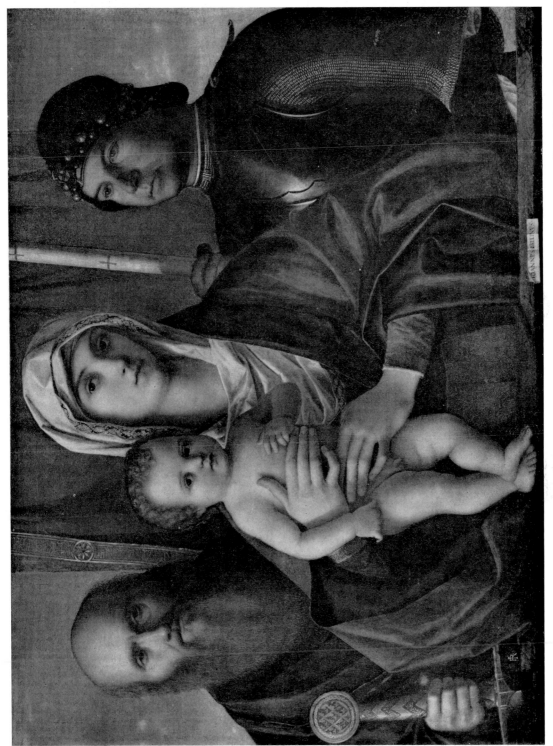

Giovanni Bellini, *Madonna with St Paul and St George*. Wood, 66 × 88. Signed IOANNES BELLINVS. Venice, Gallerie dell'Accademia

PLATE LXXVIII

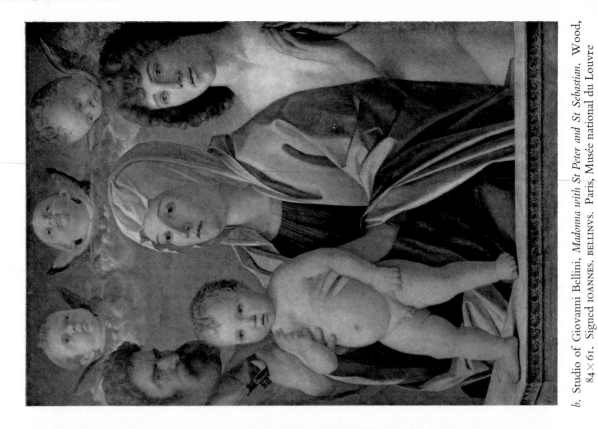

*b.* Studio of Giovanni Bellini, *Madonna with St Peter and St Sebastian.* Wood, 84×61. Signed IOANNES. BELLINVS. Paris, Musée national du Louvre

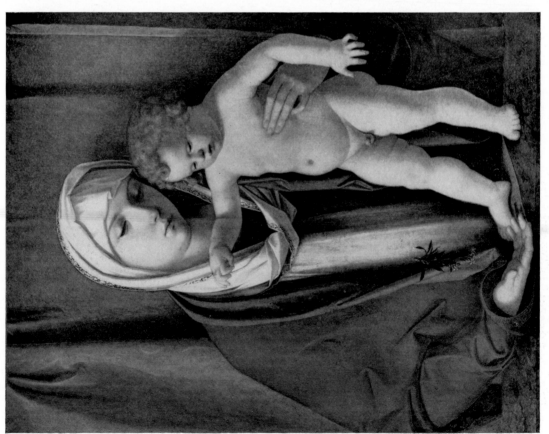

*a.* Studio of Giovanni Bellini, *Barberini Madonna.* Wood, 62·2×47·6. Glasgow Art Gallery and Museum, Burrell Collection

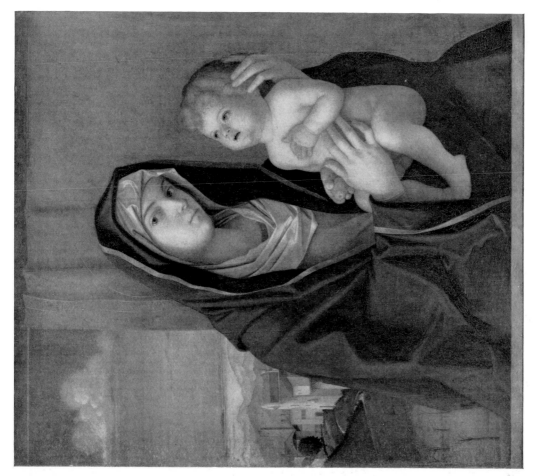

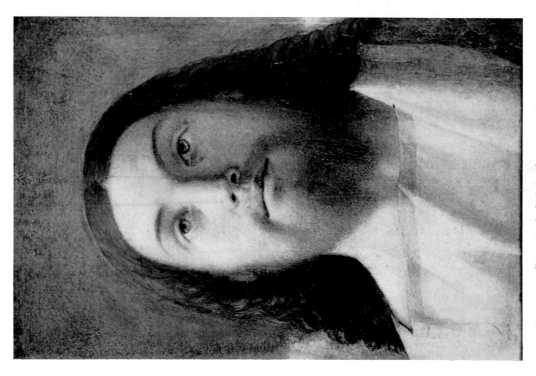

PLATE LXXIX

*b.* Giovanni Bellini, *Madonna.* Wood, 89·9×71·1 (parapet with signature IOANNES BELLINVS omitted). New York, Metropolitan Museum of Art, Rogers Fund

*a.* Giovanni Bellini, *Head of Christ* (fragment). Wood, 33×22. Venice, Gallerie dell'Accademia

PLATE LXXX

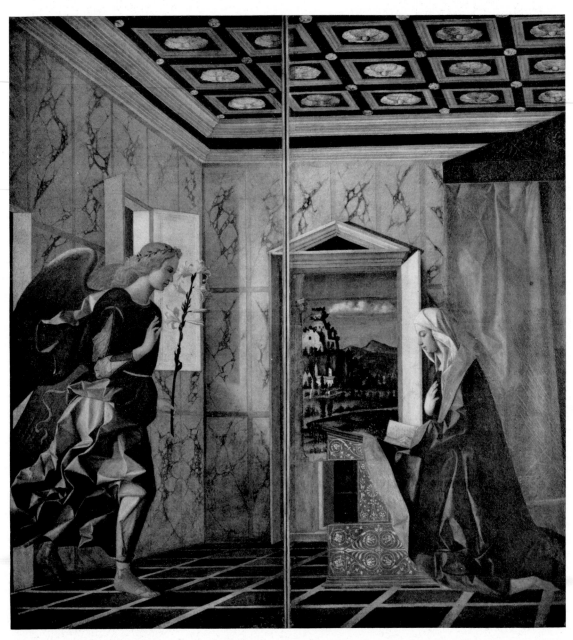

Giovanni Bellini and assistants (?), *Annunciation* from S. Maria dei Miracoli.  Canvas, each compartment 224 × 106.
Venice, Gallerie dell'Accademia

PLATE LXXXI

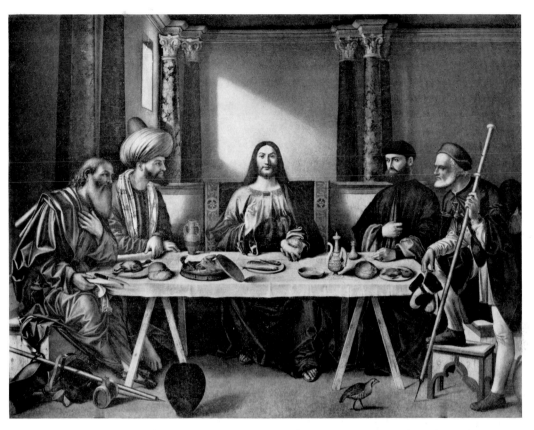

*a.* Studio of **Gio**vanni Bellini, *Supper at Emmaus.* Wood, 260×375. Venice, Chiesa **di S**. Salvatore

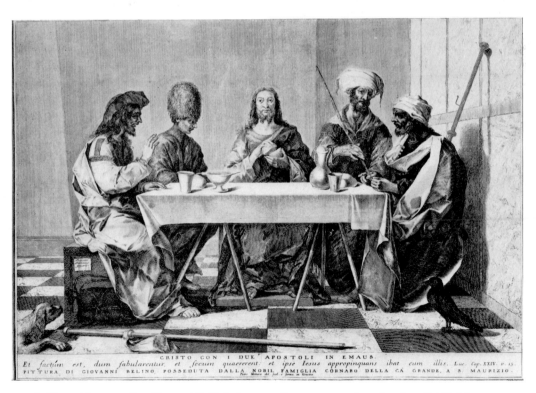

*b.* Pietro Monaco, after Giovanni Bellini, *Supper at Emmaus*, engraving. London, British Museum

PLATE LXXXII

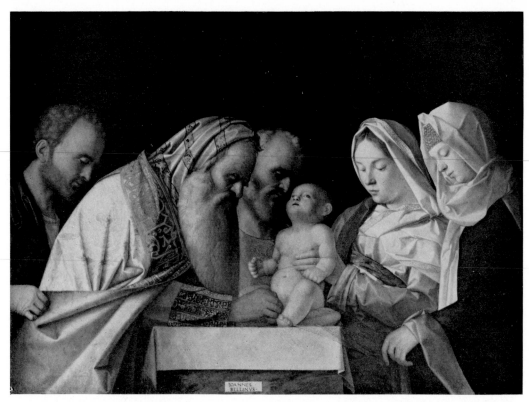

*a.* Studio of Giovanni Bellini, *Circumcision.* Wood, 75 × 102. Signed IOANNES BELLINVS. London, National Gallery

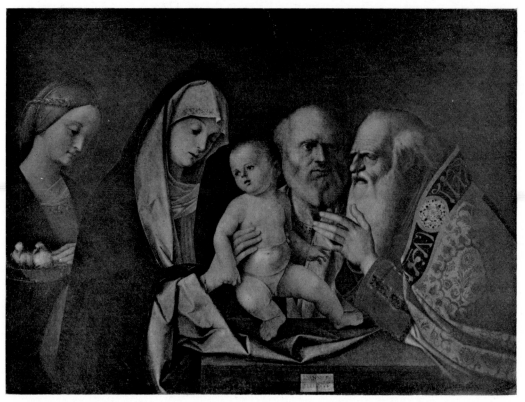

*b.* Studio of Giovanni Bellini, *Presentation in the Temple.* Canvas, 76 × 105. Signed IOANNES. BELLINVS. Verona, Museo Civico di Castelvecchio

PLATE LXXXIII

Giovanni Bellini, *Sacred Allegory—A Meditation on the Incarnation.* Wood, 73 × 119. Florence, Galleria degli Uffizi

PLATE LXXXIV

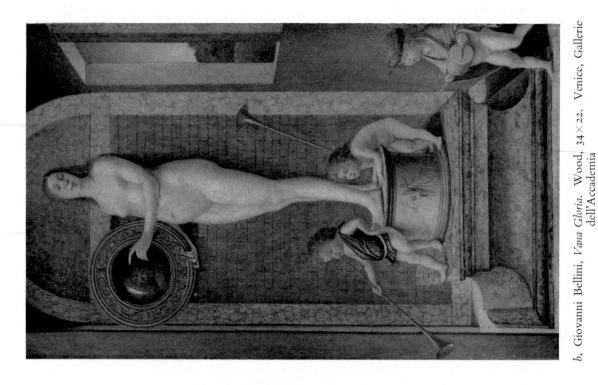

PLATE LXXXV

b. Giovanni Bellini, *Servitudo Acediae.* Wood, 34×22. Signed
IOANNES. BELLINVS. P. Venice, Gallerie dell'Accademia

a. Giovanni Bellini, *Comes Virtutis.* Wood, 32×22. Venice, Gallerie
dell'Accademia

PLATE LXXXVI

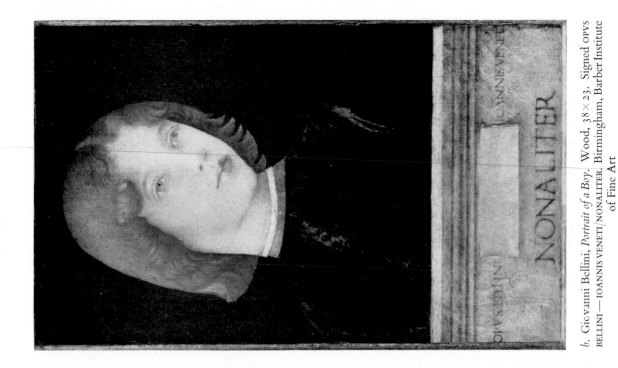

b. Giovanni Bellini, *Portrait of a Boy*. Wood, 38 × 23. Signed OPVS
BELLINI — IOANNIS VENETI/NONALITER. Birmingham, Barber Institute
of Fine Art

a. Giovanni Bellini, *Nemesis*. Wood, 27 × 19. Venice, Gallerie
dell'Accademia

PLATE XC

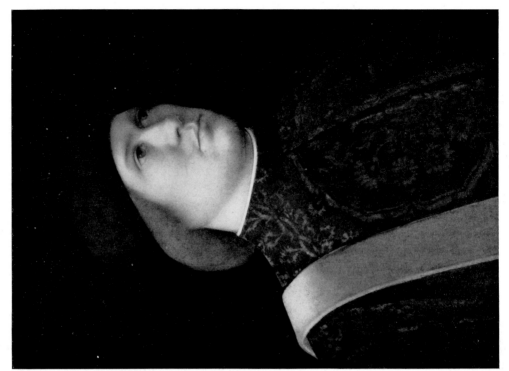

*b.* Giovanni Bellini, *Portrait of a Man.* Wood, 48·3 × 34·3. Formerly
Mrs. Derek Fitzgerald

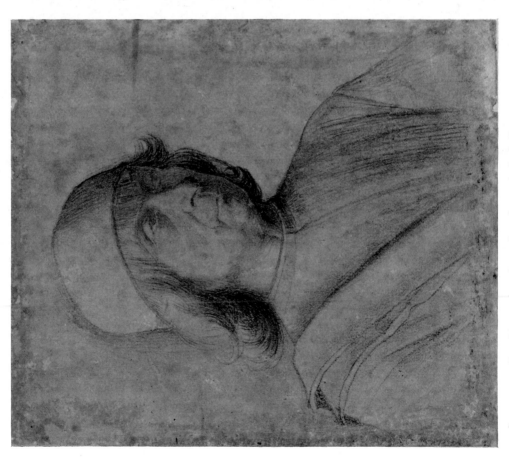

*a.* Giovanni Bellini (?), *Portrait of Gentile Bellini.* Black chalk on paper, 23 × 19·5.
Berlin, Stiftung preußischer Kulturbesitz, Staatliche Museen, Kupferstichkabinett

PLATE LXXXIX

Giovanni Bellini, *Portrait of Doge Leonardo Loredan*. Wood, 61·5×45. Signed IOANNES BELLINVS. London, National Gallery

PLATE LXXXVIII

b. Giovanni Bellini, *Portrait of a Young Man*. Wood, 32×26. Paris, Musée national du Louvre

a. Giovanni Bellini, *Portrait of a Young Man in Red*. Wood, 32×26·5. Washington D.C., National Gallery of Art, Mellon Collection

PLATE LXXXVII

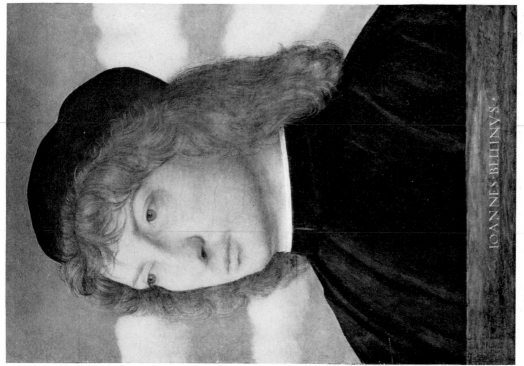

*b.* Giovanni Bellini, *Portrait of a Man.* Wood, 30×20. Signed IOANNES. BELLINVS. Washington D.C., National Gallery of Art, Samuel H. Kress Collection

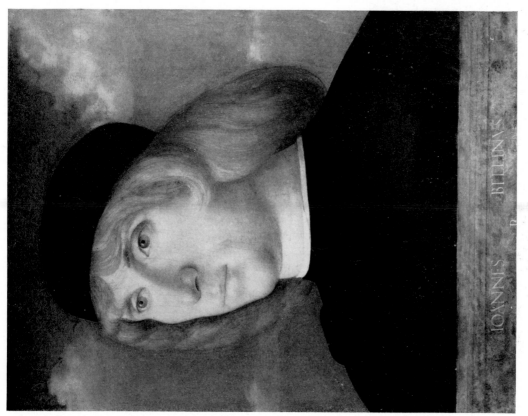

*a.* Giovanni Bellini, *Portrait of a Man.* Wood, 34×25. Signed IOANNES BELLINVS/P. Rome, Galleria Capitolina

PLATE XCI

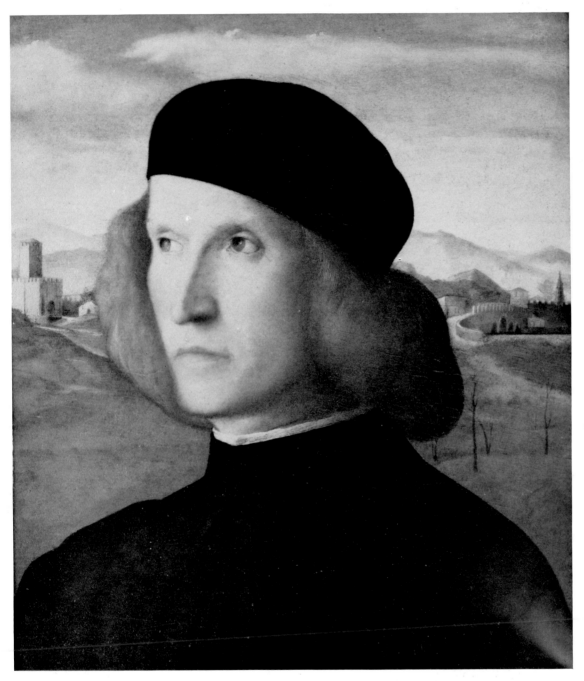

Giovanni Bellini, *Portrait of a Man* (Pietro Bembo?). Wood, 43·8 × 35·1. Joannes Bellinvs (parapet with signature Joannes Bellinvs omitted). Hampton Court Palace. Reproduced by gracious permission of her Majesty the Queen

PLATE XCII

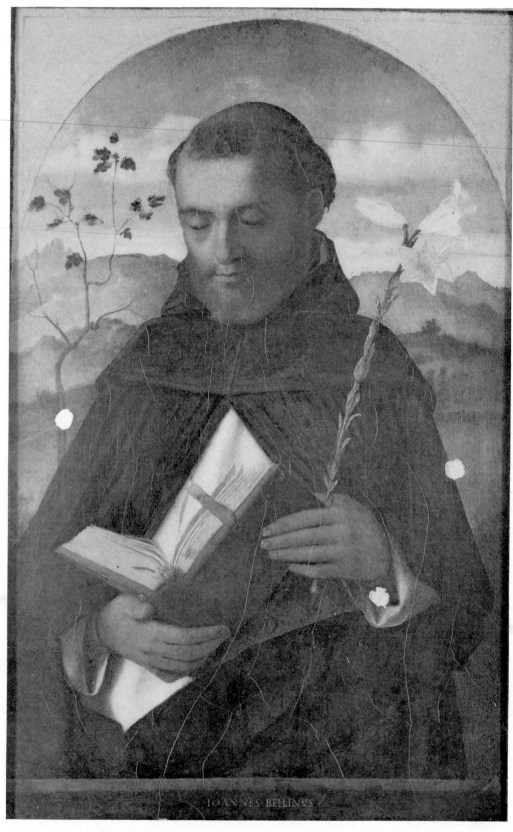

Giovanni Bellini, *St Dominic*. Wood, 43 × 28. Signed IOANNES BELLINVS. New York,
Mr. and Mrs. Charles V. Hickox

PLATE XCIII

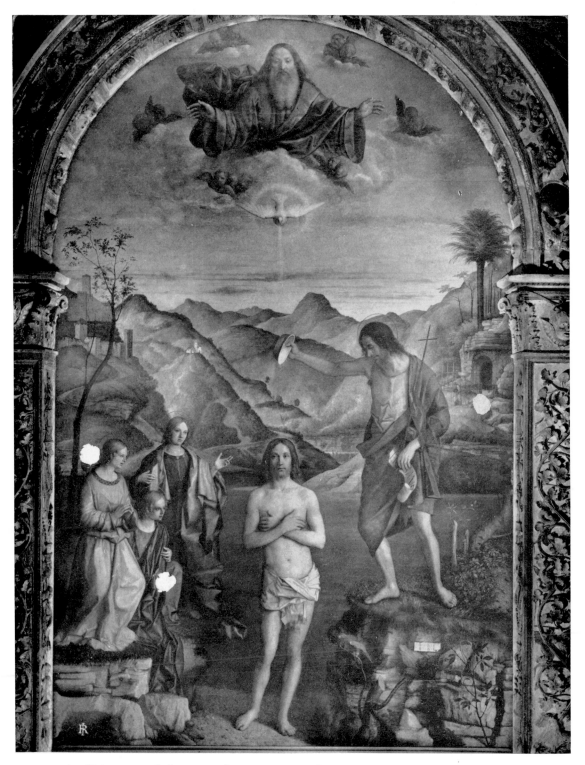

Giovanni Bellini, *Baptism of Christ*. Wood, 410×265. Signed IOANNES./BELLINVS. Vicenza, Chiesa di S. Corona

PLATE XCIV

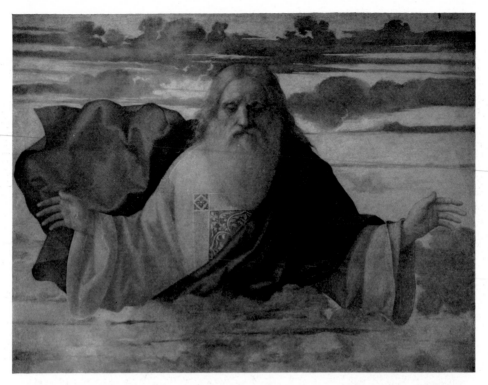

*a.* Giovanni Bellini, *God the Father* (fragment?). Wood, 101 × 132. Pesaro, Museo Civico

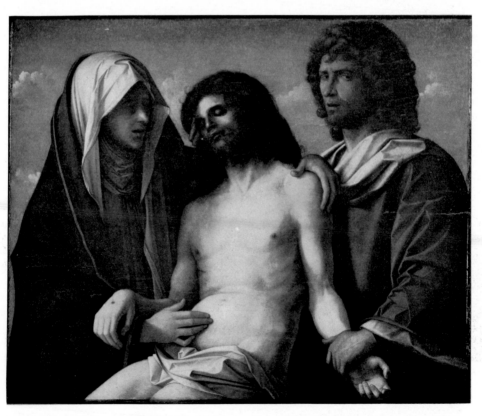

*b.* Studio of Giovanni Bellini, *Pietà with Virgin and St John.* Wood, 68 × 86. Berlin, Stiftung preußischer Kulturbesitz, Staatliche Museen, Gemäldegalerie

PLATE XCV

b. Giovanni Bellini, *Christ in the Tomb.* Wood, 107×70.
Signature illegible. Stockholm, Nationalmuseum

a. Giovanni Bellini, *Crucifixion.* Wood, 81×49. Florence, conte
Niccolini da Camugliano

PLATE XCVI

Giovanni Bellini, *Madonna with Baptist and Female Saint.* Wood, 37 × 76. Signed IOANNES BELLINVS. Venice, Gallerie dell'Accademia

PLATE XCVII

Giovanni Bellini, *Pietà*. Wood, 65 × 87. Signed IOANNES/BELLINVS. Venice, Gallerie dell'Accademia

PLATE XCVIII

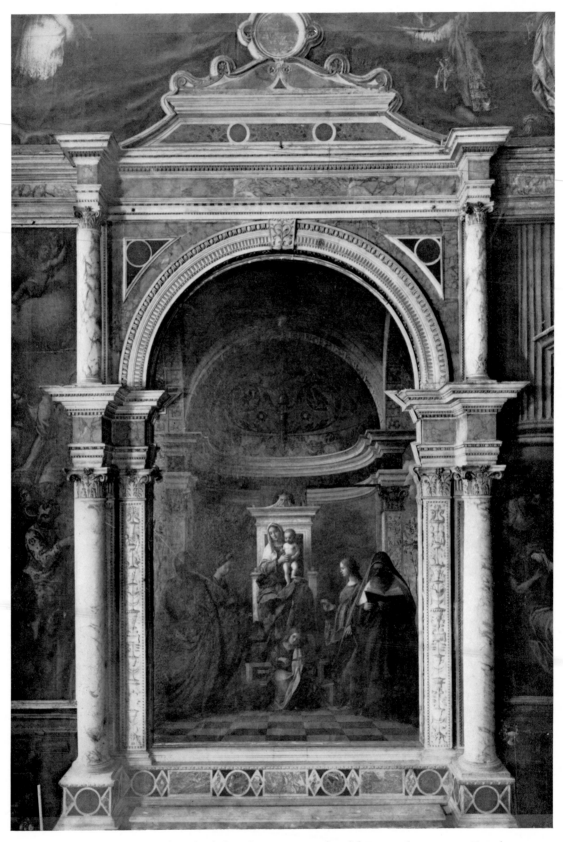

Giovanni Bellini, *Enthroned Madonna* (with frame), Canvas, transferred from wood, 500×235. Signed IOANNES BELLINVS/MCCCCCV. Venice, Chiesa di S. Zaccaria

PLATE XCIX

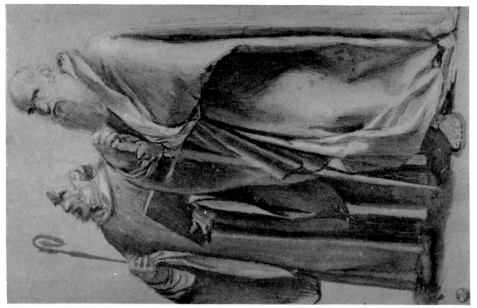

b. Giovanni Bellini (?), *Two Saints*. Pen and wash on paper, 28·2 × 18·1. Florence, Galleria degli Uffizi, Gabinetto dei disegni

a. Giovanni Bellini, *Madonna with Saints and Donor*. Wood, 92·5 × 80. Signed IOANNES BELLINVS/MCCCCCV. Formerly Cornbury Park, Mr Oliver Vernon Watney

PLATE C

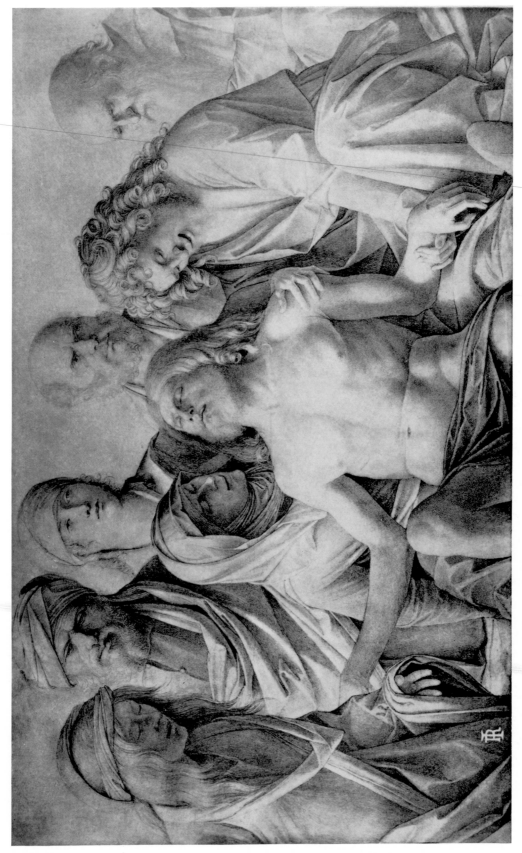

Giovanni Bellini, *Pietà with Maries and Apostles.* Wood, 76 × 121, grisaille. Florence, Galleria degli Uffizi

PLATE CI

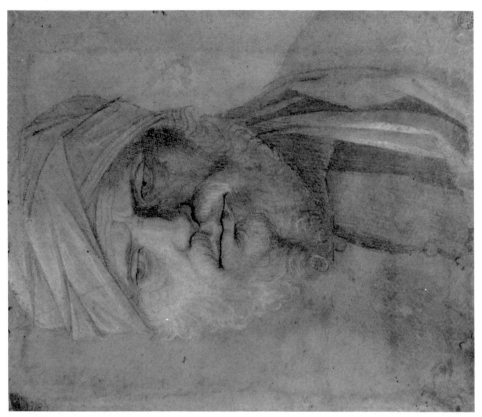

b. Studio of Giovanni Bellini, *Man's Head*. Brush and wash heightened with white on blue paper, 22·5 × 18·5. Florence, Galleria degli Uffizi, Gabinetto dei disegni

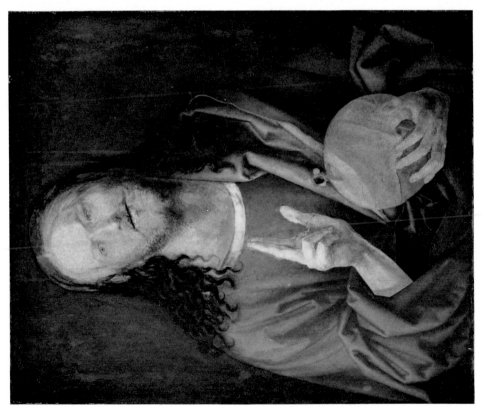

a. Albrecht Dürer, *Salvator Mundi*. Wood, 58·1 × 47. New York, Metropolitan Museum, Michael Friedsam Collection

PLATE CII

Giovanni Bellini, *The Madonna of the Meadow*. Wood, transferred to new support, 67×86. London, National Gallery

PLATE CIII

Back of the paint-film of the *Madonna of the Meadow* during transfer to new support

PLATE CIV

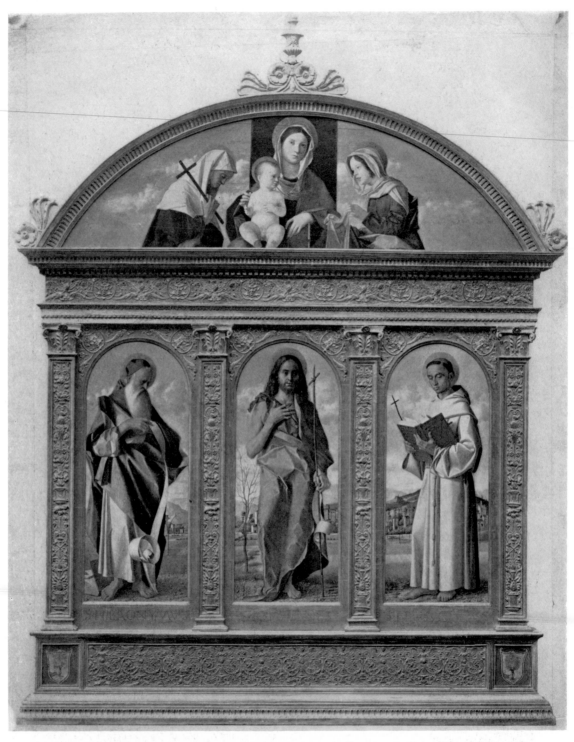

Giovanni Bellini, *Triptych*. *Baptist between Jeremiah and St Francis*. *Virgin between St Helena and St Veronica in the Lunette.*
Wood, Lunette 47 × 164, lower panels each 93 × 37. Formerly Berlin, Kaiser-Friedrich-Museum, destroyed 1945

PLATE CV

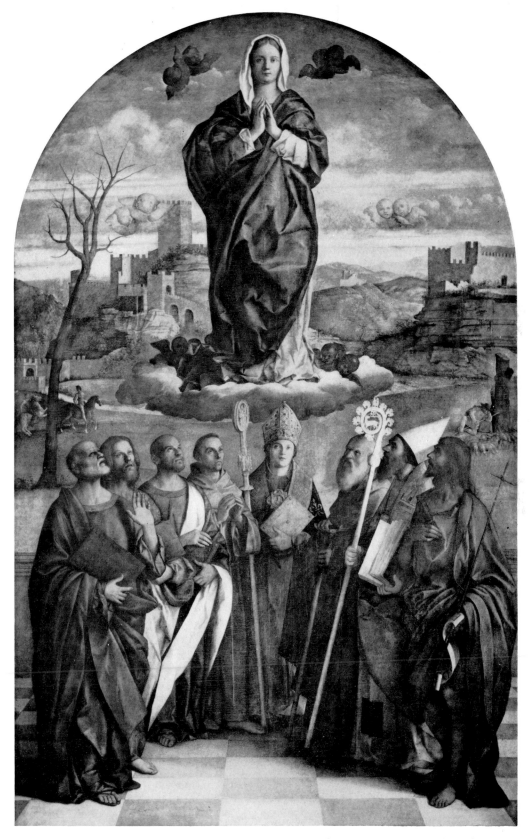

Giovanni Bellini and Assistants. *The Immaculate Conception*. Wood, 350×190. Murano, Chiesa di S. Pietro
Martire

PLATE CVI

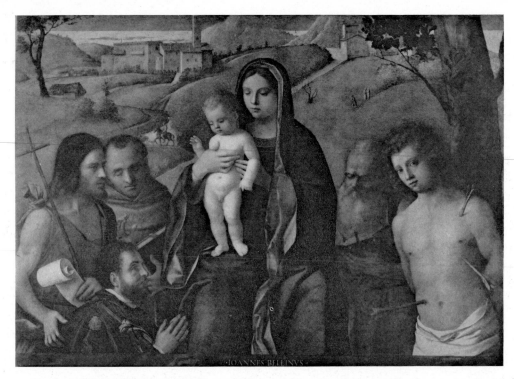

*a.* Giovanni Bellini and Assistants, *Madonna with Saints and* (repainted) *Donor.* Wood, 90 × 145. Signed
IOANNES BELLINVS/M.D. VII. Venice, Chiesa di S. Francesco della Vigna

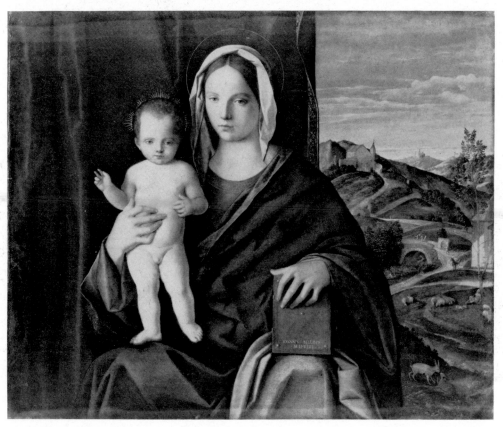

*b.* Giovanni Bellini and Assistants, *Madonna.* Wood, 83 × 104. Signed IOANNES BELLINVS/.MDVIIII.
Detroit, Institute of Arts

PLATE CVII

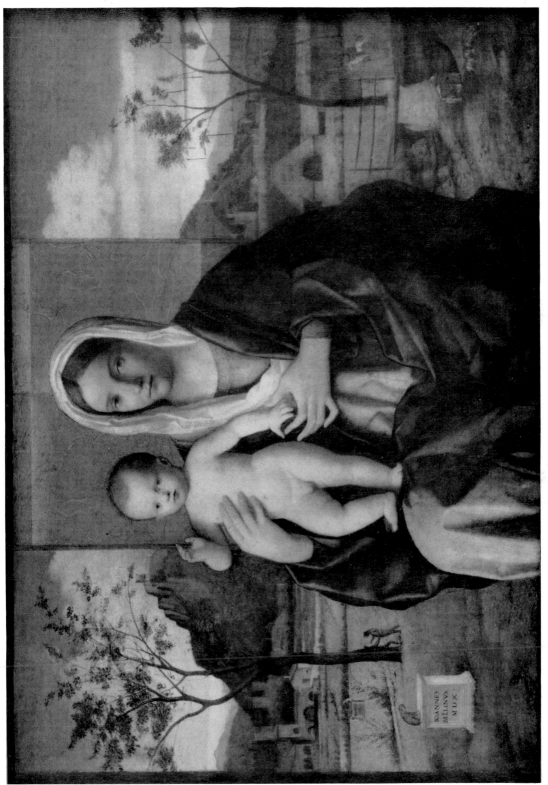

Giovanni Bellini, *Madonna*. Wood, 85 × 118. Signed IOANNES/BELLINVS/MDX. Milan, Pinacoteca di Brera

PLATE CVIII

*a.* Gentile and Giovanni Bellini, *St Mark Preaching in Alexandria.* Canvas, 347×770. Milan, Pinacoteca di Brera

*b.* Giovanni Bellini (?), *Incident in the life of P. Cornelius Scipio.* Canvas, 74·8×356·2. Washington D.C., National Gallery of Art, Samuel H. Kress Collection

PLATE CIX

Giovanni Bellini and Vittorio Belliniano, *Martyrdom of St Mark*. Canvas, 362×771. Signed MDXXVI/VICTOR/BELLINIĀVS. Venice, Ospedale Civile, Deposito delle Gallerie dell'Accademia

PLATE CX

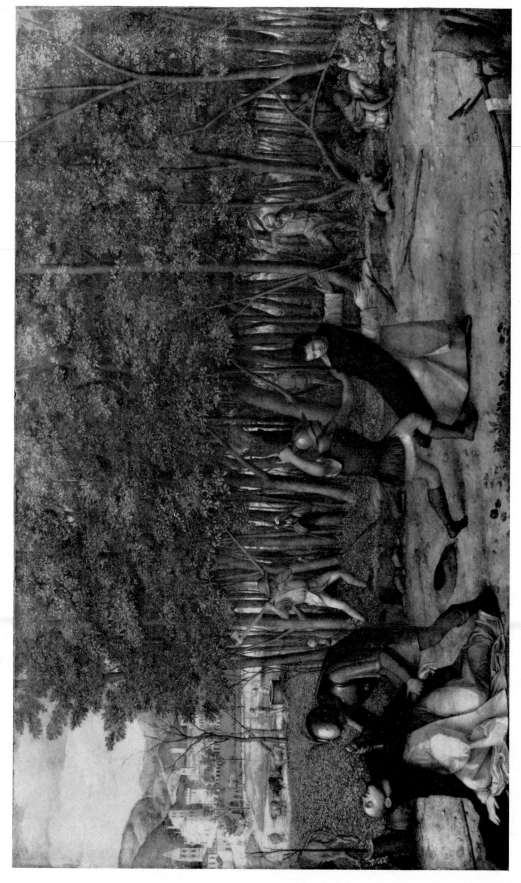

Giovanni Bellini, *Death of St Peter Martyr*. Wood, 100×165. London, National Gallery.

PLATE CXI

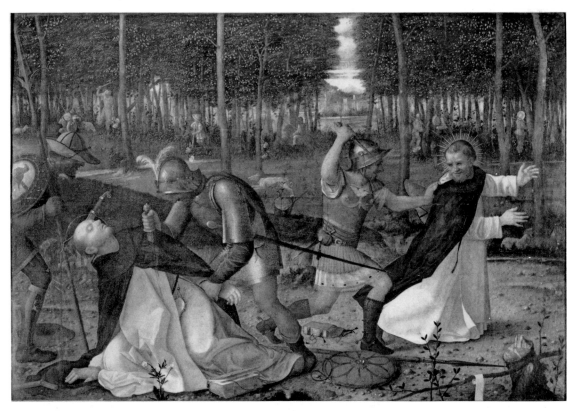

*a.* Follower of Giovanni Bellini, *Death of St Peter Martyr*. Wood, 67·3 × 100·4. London, Courtauld Institute of Art

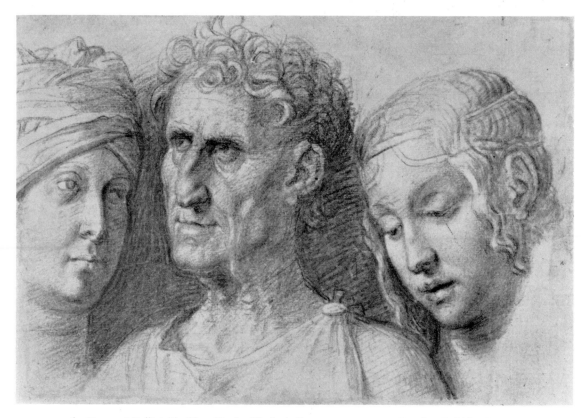

*b.* Giovanni Bellini (?), *Three Heads*. Black chalk on paper, 13 × 20. London, British Museum

PLATE CXII

PLATE CXIII

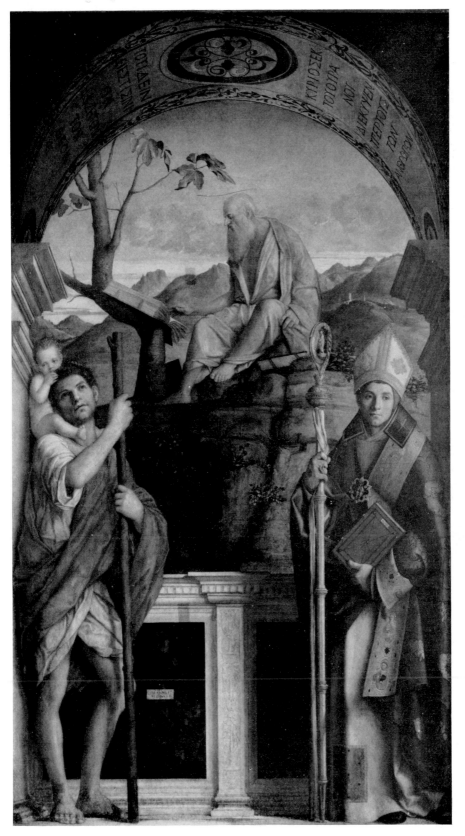

Giovanni Bellini, *St Jerome with St Christopher and St Augustine* (or *Louis*).  Wood, 300 × 185.
Signed MDXIII/IOANNES BELLINVS. P.  Venice, Chiesa di S. Giovanni Crisostomo

PLATE CXIV

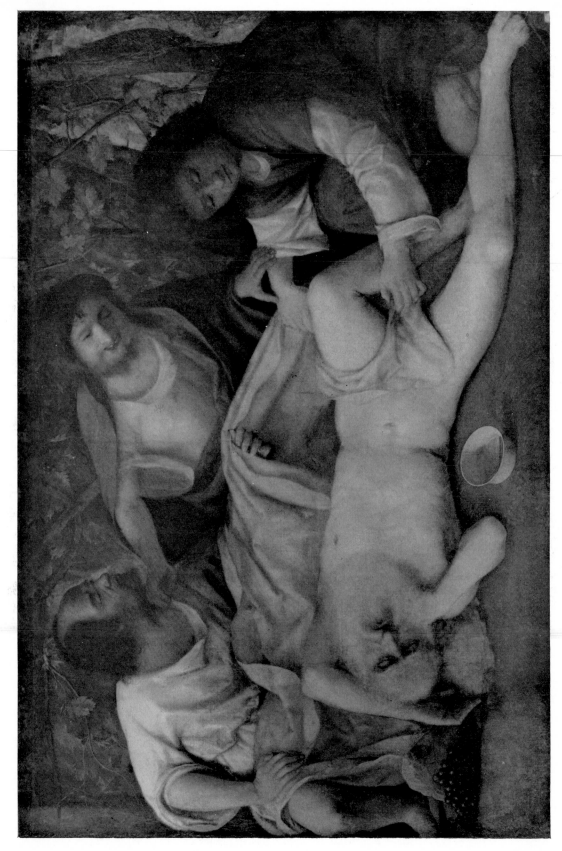

Giovanni Bellini, *The Drunkenness of Noah*. Canvas, 103 × 157. Besançon, Musée

PLATE CXV

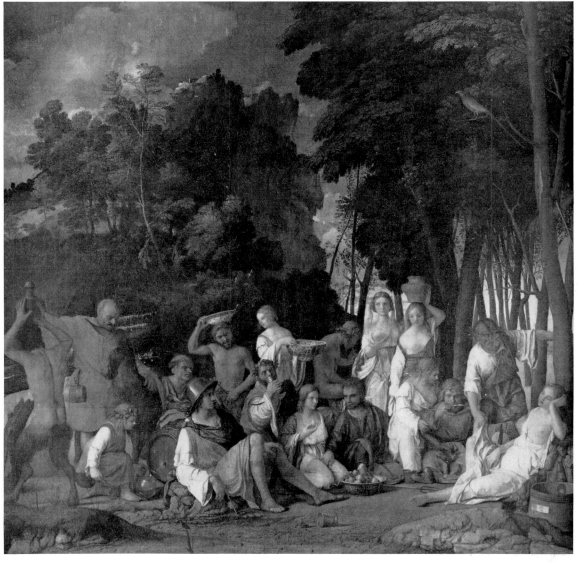

Giovanni Bellini and Titian, *The Feast of the Gods*. Canvas, 170×188. Signed ioannes bellinus venetus/p. MDXIIII. Washington D.C., National Gallery of Art, Widener Collection

PLATE CXVI

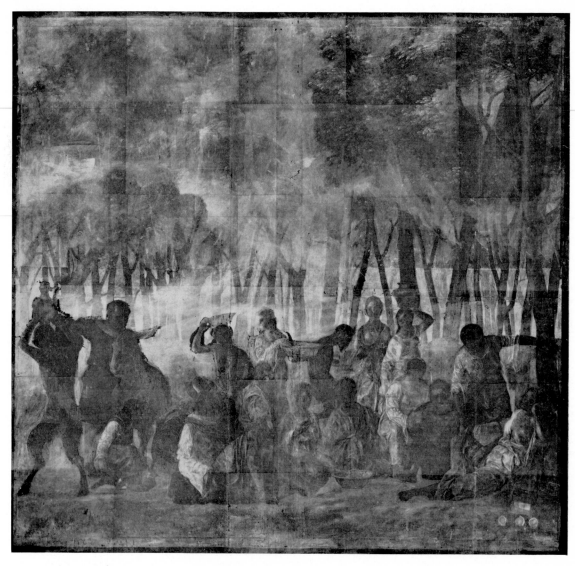

X-ray Mosaic of the *Feast of the Gods*

PLATE CXVII

*a.* Marcantonio Raimondi. Engraving after Raphael's design for the *Parnassus* (B. 247). London, British Museum

*b.* Giorgione, *The Three Philosophers.* Canvas, 123·8 × 144·5. Vienna, Kunsthistorisches Museum

PLATE CXVIII

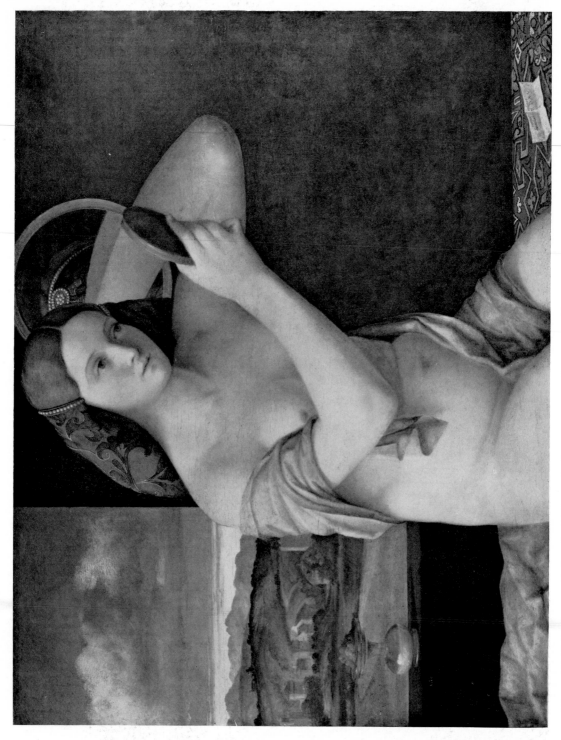

Giovanni Bellini, *Venus or Lady at her Toilet*. Wood, 62×79. Signed Joannes Bellinus/faciebat M.D.X.V. Vienna, Kunsthistorisches Museum

PLATE CXIX

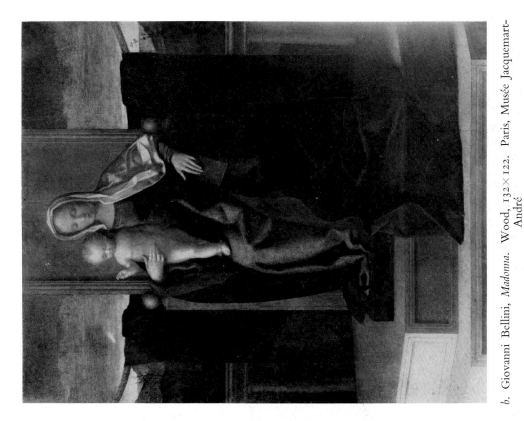

b. Giovanni Bellini, *Madonna*. Wood, 132×122. Paris, Musée Jacquemart-André

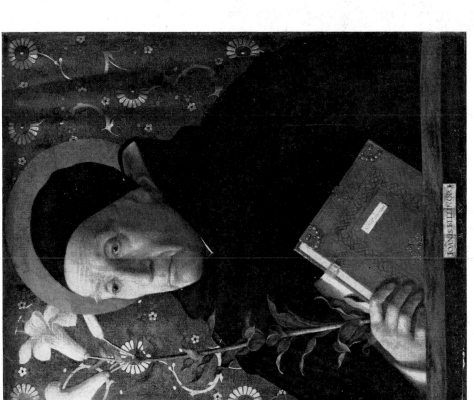

a. Giovanni Bellini, *Portrait of a Dominican as St Dominic*. Canvas, 63×49·5. Signed IOANIS BELLINI OP./M.D.XV. London, National Gallery

PLATE CXX

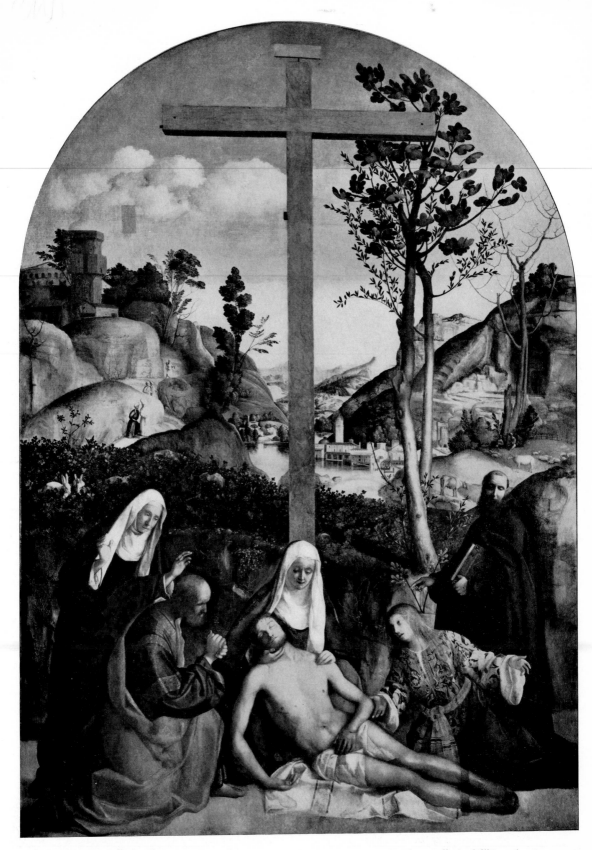

Giovanni Bellini and Rocco Marconi, *Deposition*. Canvas, 444 × 312. Venice, Gallerie dell'Accademia